—The— Stroudwater Canal A HISTORY

Michael Handford

AMBERLEY

First published 1979. This edition published 2013.

Amberley Publishing
The Hill, Stroud
Gloucestershire, GL5 4EP

www.amberley–books.com

British Library Cataloguing in Publication Data.
A catalogue record for this book is available from the British Library.

ISBN 978 1 4456 1943 9
E-Book ISBN 978-1-4456-1961-3

Typeset in 10pt on 12pt Minion Pro.
Typesetting and Origination by Amberley Publishing.
Printed in the UK.

Contents

Foreword

I am always pleased to hear from anyone with any helpful suggestions, corrections or criticisms of this book. The basic research took eight years but, like most historians, I often stumble across new information about the canal, people in the text, the Stroud area or the local woollen industry. So I am especially glad to hear from any reader with additional information which has somehow or other escaped my attention. During the last ten years, several previously unknown letters, documents and letters relating to the canal have been discovered in this way and I have no doubt that readers will draw my attention to some more. There are few good photographs of the canal so news of these is always very welcome. In the last few days I have discovered two major boards of photographs of the canal and I hope to make these available in the next few years.

I am grateful not only to those many kind people who have already written to me with such assistance but also to Dr Bernard Alford and Professor William Ashworth of the University of Bristol for their encouragement and constructive criticisms. I am similarly indebted to the late Enid Airy, John Benn, Iris Capps, the late Charles Hadfield, Geoffrey Hoare, the late Humphrey Household, Eric Hutchings, Geoffrey Martin, Alan Payne, Derek Pratt, the late Frederick Rowbotham, John Stephens, Raymond Tudor, Lionel Walrond, the late Dudley Wilson, Stanley White and many other people too numerous to mention individually for their help, advice and hospitality. It is a great source of pleasure to know that many of them are now valued personal friends.

My research would have been much less rewarding as well as much less enjoyable without the unstinting guidance, good humour and friendship of Brian Smith and all the staff at the Gloucestershire County Records Office, Mrs Voyce and the staff at the Gloucester reference library as well as the staff of the British Museum, Public Record Office, Avon County Record Office and the Bristol Reference Library. The Social Science Research Council made it possible for me to work full time on the records of the Company of Proprietors of the Stroudwater Navigation between September 1968 and August 1970 and I am glad to record my thanks for their financial assistance. Finally I owe a special debt of gratitude to my long-suffering wife, Judy, now happily resigned to the view that 'all roads lead to Stroud.'

When I began this book in 1968 there was no real interest in the future of the Stroudwater Canal and its neighbour the Thames & Severn Canal. Since then the formation of the Stroudwater Canal Society in 1972 and its successor, the Cotswold Canals Trust, have brought about major changes in public attitudes to the future of these two important canals. The main objective of this book is to stimulate further public interest in the complete restoration of these canals and I would urge anyone interested in their future to join the canal trust as soon as possible. I will gladly send a membership form to anyone who cares to write to me.

I have taken the opportunity to insert a few minor revisions and additions to the first seven chapters as a result of additional information which has come my way since January 1976.

M. A. Handford

Abbreviations used in the Text

ACRO	Avon County Record Office
BGAS	Bristol and Gloucestershire Archaeological Society
BRL	Birmingham Reference Library
BM	British Museum
DNB	Dictionary of National Biography
EHR	Economic History Review
GCL	Gloucester City Library
GCRO	Gloucestershire County Record Office
GJ	Gloucester Journal
GNQ	Gloucestershire Notes and Queries
JHC	Journal of the House of Commons
JHL	Journal of the House of Lords
PRO	Public Record Office
VCH	Victoria County History

The Stroudwater Canal:
A Chronology

1730	First Stroudwater Canal Act
1741?–1751?	The Cambridge Canal
1755	The Dallaway Scheme
1759	Second Stroudwater Canal Act
1759–1763?	The Kemmett Canal
1774–1775	Construction of Stroudwater Canal starts
1776	Third Stroudwater Canal Act
1779	Canal opened to Wallbridge
1783	Thames & Severn Canal Act
1789	Thames & Severn Canal opened
1793	Gloucester & Berkeley Canal Act
1794	Construction of Gloucester & Berkeley Canal begins
1820	Gloucester & Berkeley Canal reaches Saul Junction: Junction Lock constructed on the Stroudwater Canal
1827	Gloucester & Berkeley Canal opened throughout
1845	Great Western Railway opened from Swindon to Gloucester
1927	Thames & Severn Canal closed from Inglesham to Chalford
1933	Thames & Severn Canal closed Wallbridge to Chalford
1954	Stroudwater Canal closed
1972	Formation of Stroudwater Canal Society, now the Stroudwater, Thames & Severn Canal Trust
1978	Restoration work begins on Stroudwater Canal at Eastington
1979	Bicentenary of opening of Stroudwater Canal

Consulting Engineers, Engineers and Surveyors, Under Surveyors, Clerks, Treasurers and Lock-Keepers

Consulting Engineers

1729 – 30	John Hore
1750	?
1755	Thomas Yeoman, John Willets, Thomas Chin, Thomas Bridge, Richard Gibbs, Joseph Parsons, Benjamin Holt.
1759	Thomas Bridge
June 1774	Thomas Dadford Jnr and John Priddey
September 1774	Thomas Yeoman

Engineers and Surveyors

1750	?
1759 – 63	Thomas Bridge
January – February 1775	Samuel Jones of Boston
February 1775 – August 1776	John Priddey
July 1776 –November 1777	Edmund Lingard
January 1778	Thomas Danford Jnr
February 1778 –May 1778	Thomas Frewin
July 1778 –July 1779	Benjamin Grazebrook

Under–Surveyors

December 1774 – April 1776	Benjamin Grazebrook and Richard Hall
April 1776 – July 1779	Joseph Grazebrook

Clerks

December 1774–April 1776	Benjamin Grazebrook Senior Clerk
December 1774–Aprl 1776	Richard Hall Junior Clerk
April 1776	Joseph Grazebrook

Treasurers

December 177–March 1775	Richard Colbourne
March 1775	John Colbourne

Lock-Keeper at Framilode Lock House

12 December–26 December 1776	Samuel Collins Jnr
26 December 1776–28 August 1777	John Pashley
28 August 1777	Benjamin Bashley

Lock-Keeper at Bristol Road Wharf House

January 1777	Joseph Grazebrook

Superintendents

January 1777–July 1779	Edward Edge, Superintendent of Masonry
November 1777–July 1779	Samuel Smith, Superintendent of Cutting
November 1777–July 1779	John Gleave, Superintendent/Inspector of Puddling

The Stroudwater Canal: Locks

Originally only twelve locks were built on the Stroudwater Canal during the years of construction between 1775 and 1779. Junction Lock was added in 1820 when part of the Framilode to Whitminster pound was raised near Saul village to enable the Stroudwater and Gloucester & Berkeley Canals to meet on one level. From the River Severn to Stroud the lock names on the Stroudwater Canal are:

Framilode Lock
Junction Lock
Whitminster Lock
Bristol Road Lock
Westfield Lock
Court Orchard Lock (later Dock Lock)
Turnpike Lock
Lower Nassfield Lock (later Blunder Lock)
Upper Nassfield Lock
Ryeford Double Locks
Franklins Locks (later Lower Dudbridge and Upper Dudbridge Locks)

Chapter One
An Introduction

The Stroudwater Canal was constructed from the River Severn at Framilode to Wallbridge near Stroud between 1775 and 1779. It was built as a branch canal from the nearest navigable waterway to bring coal to the prosperous Stroud woollen trade at a crucial point in the history of the industry.

Seven or eight centuries earlier when the woollen trade had first emerged as a distinct local industry the fuel required for domestic fires and for heating the water in the dyeing vats came from timber gathered in neighbouring woodlands. As the local population and cottage industry grew slowly during the medieval period these supplies were gradually augmented by small amounts of coal brought down the River Severn from West Midlands pits, landed at Framilode and then transported overland by cart or packhorse train. Local roads were not significantly better or worse than any other roads elsewhere at this time and they were probably adequate to carry these small amounts of coal and other goods while the local domestic woollen industry remained a small scale industry based in weavers' cottages. By the beginning of the eighteenth century, however, the Stroud woollen industry had grown to such an extent that it was beginning to exhaust local wood supplies and coming to rely more and more on larger and larger volumes of coal brought down the Severn. Local roads, even newly turnpiked and improved local roads could not carry this burgeoning volume of heavy goods. Who could find the carts, the horses, the men and the boys, the stables and the hay, the saddlers and the wheelwrights to carry such a volume? The need now was for a new form of transport which could carry these bulk loads cheaply, reliably and efficiently and at the same time guarantee permanently improved access to those now vital pits of Shropshire and Staffordshire.

The Stroudwater Canal was therefore conceived, constructed and originally operated not as part of some grand trunk canal between the Severn and the Thames but as a branch canal from the long navigable River Severn and the coal supplies it carried to the growing industrial area centred on Stroud. Barely eight and a quarter miles long, the Stroudwater rarely hit the waterways headlines during its long years of successful and profitable operation or subsequent placid decline. It is only in recent years with the emergence of a large and vigorous canal trust dedicated to its complete restoration that any serious national interest has emerged in the future of the canal. The skill and dedication of volunteers have made complete restoration of the seventy-five mile canal link between Reading and Bath a distinct probability by the early 1980s. If the well-established expertise and impressive fundraising abilities of the Kennet and Avon Canal Trust are not to wither away, it is possible they may then turn their attention to their neighbour – the Stroudwater, Thames & Severn Canal Trust. Even if this does not occur it seems likely the complete restoration of the Stroudwater, Thames & Severn Canals will become the major national priority of the hundreds of thousands of individuals now concerned with the future of our waterways heritage.

The Stroudwater Canal holds a highly unusual and possibly unique place in the development of this heritage of inland waterways. First of all, it stands in direct contradiction to the long disproved but still widely accepted claim that the canal age began only with the opening of the Bridgewater Canal in

1761. The Stroudwater was first planned as a canal in the late 1720s and this makes it one of the oldest successful canal schemes in the country.[1] Secondly, the canal is still owned by its original promoters – the Company of Proprietors of the Stroudwater Navigation formed originally in 1730. Although the last dividend was paid over half a century ago and the canal itself has been derelict since the early 1940s, the company still draws revenue from the sale of water, leasing fishing rights and from investment and property income. The proprietors meet each May in Stroud to examine their assets, appoint directors and invest their small annual profit in the local building society. It is possible, therefore, that the Company of Proprietors of the Stroudwater Navigation is the oldest surviving canal company in the world. Thirdly, the visit of Frederick Louis, Prince of Wales, to the private navigation built by Richard Owen Cambridge in the 1740s may be the earliest recorded use of a man-made canal for pleasure traffic in western Europe. Fourthly, it seems certain the Kemmett Canal demonstrates the earliest known use of container traffic on any inland waterway.

The comprehensive records of this long established company are preserved intact apart from a shortage of detailed material for the years 1953–54 when the navigation was closed by Act of Parliament. Some records from this period have recently been located and only a few days ago I traced a crucial witness who left the Stroud area about thirty years ago. The reasons for a surprising shortage of documents are no longer a mystery. These documents, transcripts and diaries, throw a disturbing light on the conduct of certain individuals, some of whom are no longer alive and none as far as I know still connected with the canal company. It is perhaps advisable that the contents of these papers should remain private for the time being.

The earlier records of the canal company provide a detailed and informative insight into the formation and operation of one of the first canal companies in England, into the methods of canal promotion, construction and finance, into the character and thought processes of a number of influential local entrepreneurs and also into the general workings of some aspects of eighteenth-century life as well. Few people could study these records without marvelling at the range of human experiences these promoters felt during the middle decades of the eighteenth century. It is all there – the selfishness and the selflessness, the generosity and the greed, the efficiency and the incompetence, the organisational brilliance and the rank stupidity, the humour and the despair.

These records chart the close relationship between industrial development in the Frome valley around Stroud, a transport innovation resulting from that development and the effect this new navigation had on the life of the local community. They provide an almost ideal case study of the relationship between one predominant local industry and one transport innovation all within a highly localised area. The Stroudwater Canal was planned by the woollen interests, financed largely from the profits of that trade, promoted and built almost exclusively for the needs of the woollen industry. Although the prosperity of the local woollen trade was determined by external factors such as national and international demand, rising living standards in England as a whole, foreign competition and the like, it is still possible to argue that the history of the canal is not seriously complicated by the intrusion of any important non-local factors which blur the basic relationship between growth of the local woollen industry and the local transport improvements that industry introduced. The Stroudwater was a local canal planned by local men with local capital for essentially local reasons. It therefore fits snugly into the same pattern as most other early navigations of eighteenth-century England.

Projected Populations of Selected Gloucestershire in the Frome Valley Parishes

	1719	1743	1801	%Change 1719 – 1743		%Change 1743 – 1801		%Change 1719 – 1801
Arlingham	400	372	506	–	7	+ 36.2		+ 26.5
Avening	600	856	1507	+	42.7	+ 76.1		+ 151.2
Bisley	32,000	4,905	4,227	+	53.3	– 13.8		+ 32.1
Eastington	450	767	988	+	70.4	+ 28.8		+ 119.6
Frampton	500	600	860	+	20.0	+ 43.3		+ 72.0
Frocester	250	262	362	+	4.8	+ 38.2		+ 44.8
Minchinhampton	1,800	4,000	3,419	+	122.2	– 14.5		+ 89.9
Painswick		3,300	3,150			4.5		
Pitchcombe	80	90		+	12.5			
Randwick	400	650	856	+	62.5	+ 31.7		+ 114.0
Rodborough	750	1481	165	+	97.5	+ 12.0		+ 121.1
Sapperton	320	300	351	–	6.3	+ 17.0		+ 9.7
Saul	130	151	349	+	16.2	+ 131.1		+ 186.4
Standish	500	400	504	–	20.0	+ 26.0		+ 0.8
Kings Stanley	1,100	1,257	1,434	+	14.3	+ 14.1		+ 30.4
Leonard Stanley	400	512	590	+	28.0	+ 15.2		+ 47.5
Stonehouse	500	759	1412	+	51.8	+ 86.0		+ 182.4
Stroud	3,000	4,000	5,422*	+	33.3	+ 35.5		+ 80.9
Wheatenhurst	200	231	287	+	15.5	+ 24.2		+ 43.5
Woodchester	460	792	870	+	72.2	+ 9.8		+ 89.1
Totals (excluding Painswick and Pitchcombe)	14,960	22,295	25,602					

* Stroud town only

At the same time it is important to stress that the Stroudwater Canal was not built in isolation from the rest of national life. It is only one in a long series of transport innovations which have already included the development of river navigations, the construction of turnpike roads, canals and railways, the growth of motorised transport, air services and hovercraft and will doubtless include other innovations by the end of the twentieth century. All these innovations stem from a series of fundamental changes in the structure, character and organisation of English life which originated several hundred years ago. Although the origins and development of these agricultural and industrial revolutions are still imperfectly understood, some social changes could have increased the pressure on existing transport facilities in seventeenth and eighteenth century Stroud. These symptoms of agricultural and industrial change include a growing population, increasing urbanisation, industrial expansion and higher living standards.

What evidence is there that these symptoms were evident in the Stroud area at this time? Although there are no reliable local population figures before the first national census in 1801, rough estimates based on surveys by contemporary writers like Atkyns in 1712, Furney in 1743 and Rudder in 1779 provide tentative evidence of the growth of population in the Frome valley during the eighteenth century. [2] This evidence strongly suggests that the years 1712 to 1743 were characterised by rapid population growth but followed by a period between 1743 and 1801 of slower population growth.

The evidence for more and more people living in towns rather than villages in the Frome valley area during this period is more equivocal. Stroud contained 20% of the population in the area in 1712, 18% in 1743 and 21% in 1801. The nine largest parishes in 1712 contained 80% of the population, 82% in 1743 and 80% in 1801. The true pattern of changes in population distribution at this time may be confused by the relative decline of several larger and older woollen parishes on the scarp of the Cotswolds like Bisley, Minchinhampton and Painswick as more and more of the woollen industry began to concentrate in mills on valley sites like Stroud and Stonehouse where a larger and more secure water supply was available.

If both these symptoms of a growing population and increasing urbanisation had operated in the Stroud area during the eighteenth century they would certainly have affected the existing local transport network. Increasing urbanisation, for example, would create new problems of supply. During the Middle Ages the overwhelming majority of people had lived in rural areas and between eighty and ninety per cent of the population were engaged in agriculture. These predominantly rural, predominantly agricultural communities were also predominantly self-sufficient for most of their own food and raw materials. Most villages grew the bulk of their own food, ground their own com and baked their own bread, brewed their own beer wove most of their own cloth often from fleeces of their own animals, built their own houses from local stone or traded with neighbouring villages at nearby markets to acquire their own needs.

When people began to leave their rural locations and live in towns or larger villages, these expanded communities now needed larger supplies of food and raw materials and they required them in quantities greater than the immediate locality could often supply. More people in towns meant, quite simply, more food consumed in towns, especially since many of the new residents had forsaken farming, taking up craft production and were therefore now buying most of their own food for the first time rather than growing it themselves. The towns had long relied on their neighbouring rural areas to supply them with most of their food but to supply this larger volume of food and raw materials created by this gradual population influx into towns and larger villages they now needed to augment their supplies from more distant sources of production as well. So for the first time towns required a cheap and effective form of transport to carry these larger volumes of bulk cargoes over greater distances.

Similarly a growing population, also increasingly concentrated in towns, reinforced this nucleation of

demand already encouraged by the processes of urbanisation. In any given area of pre-industrial England there was only a small demand for food and raw materials from each of a large number of tiny scattered rural and agricultural communities. In the same given area of industrial England this was replaced by a large volume of rapidly expanding demand for food and raw materials from one increasingly populous, increasingly urban, increasingly industrial community – the local town. This nucleation of demand–to one large and growing local centre rather than to any number of smaller ones – strengthened the need for cheap, reliable and specific transport routes capable of carrying bulk cargoes rather than a variety of different, often poor quality, often unreliable and occasionally varying routes capable of carrying only small quantities at a time.

This substantial and continued increase in the volume of traffic altered the whole basis of local transport. While the demand for food and raw materials like coal remained small, while annual production of raw materials and finished goods was counted only in thousands of tons and while needs were scattered around hundreds of dispersed village settlements in many localities, then goods traffic by packhorse or small cart – expensive, inefficient, perhaps even ludicrous though it appears to modern eyes – served the needs of the community well enough. Small volumes of mixed goods carried over a variety of minor routes to numerous small settlements did not need the substantial investment of money in specific transport routes like canals or railways which were only needed to carry large volumes of goods over fixed routes to particular points. Large scale production and the growing consumption of food and raw materials like coal, on the other hand, were a different matter altogether particularly once the increasing urbanisation of a growing population with higher living standards and the growth of manufacture in localised areas led to this centralisation or nucleation of demand. A large potential demand was now created at only one point and this could not be met without improvements in transport facilities. At this stage better transport facilities became not only desirable – they had always been that – but essential if these new industrial townships like Stroud were able to continue their industrial growth.

Higher living standards, too, produced their own effect on the development of local transport networks. With higher living standards people demanded a wider range of goods to choose from and each person now expected to buy a greater volume of goods than he had done when living standards were lower. Both these requirements also needed a more organised and systematic transport system to cope with them.

The growth of manufacturing industry in eighteenth century England was undoubtedly one of the most influential of these four symptoms of economic development. The growth of industry needed larger and larger volumes of raw materials such as coal to be carried to the site of manufacture as well as larger and larger volumes of finished goods to be moved away to the customer.

A later chapter will supply evidence of substantial local industrial development and improving living standards in eighteenth-century Stroud.[3] Put briefly it amounts to a considerable expansion of the woollen industry and an increasing opulence of many local clothiers despite some serious periodic fluctuations in trade and occasional reports of severe distress. Even though these so-called 'gentlemen clothiers' were in a numerical minority – there were far more poorer clothiers and modest weavers – it seems probable their prosperity reflected the general rising living standards of the locality. The increasing wealth of the gentlemen clothiers certainly encouraged local consumer industries like hat and shoe making, which must have provided extra employment for other inhabitants of the town.[4]

These and other aspects of industrialisation working both in concert and independently all led to growing pressures on the existing transport facilities in the now bustling eighteenth century town of Stroud.

Chapter One References

1 Willan, T. S. *River Navigation in England 1600–1750*. Willan quotes JHC 11, 711 claiming it refers to an attempt to build a navigation to Stroud before the end of the seventeenth century but this reference refers to the River Stour and not the River Stroud. The error is repeated in R. A. Lewis's 'The Navigation to Stroud', GSIA *Newsletter 6, 35*, and in Humphrey Household's *The Thames & Severn Canal*. I am grateful to Charles Hadfield for confirmation of the four points listed in the same paragraph .

2 Atkyns, Sir Robert *The Ancient and Present Stale of Glostershire* 1712, Furney, R., *A History of Gloucester 1743*, Rudder, S., *A New History of Gloucestershire* 1779. Rudder uses Furney's figures for his population totals and therefore his figures are not listed in the details of parish populations. The figures for Painswick and Pitchcombe are excluded from all the calculations in the text and in the list of populations since their figures are incomplete.

3 See Chapter Four

4 GJ 23 May 1727 Stephen Jefferys, chapman of Minchinhampton, has brought a 'large Parcel of Mens and Womens Fine Hose' from the makers in Leicester and a 'large Quantity of Right French Brandy', GJ 18June 1728 Richard Fernley, shopkeeper of Minchinhampton, has sold 'linen, woollen, millinery and groceries', GJ 17March 1730 Lawrence Hunt, wigmaker, has moved from Cirencester to Painswick 'where–Gentlemen may be furnish'd with all sorts of Perukes of the best Fashion at Reasonable Rates', GJ 18 August 1730 Mr Harris, chandler of Stroud, GJ 13 October 1730 John Witt, shoemaker of Nailsworth, GJ 6 February 1733 S. Peates, shopkeeper in Stroud, GJ 9 October 1733 Ezra Jackson, hatmaker in Stroud, is selling his shop stock and tools 'It 1s a very good Place for a Hat-maker, their being none of that Trade in the Town', GJ 30 April 1734 All sorts of hats for sale wholesale at the late dwelling house of William Addy, hatmaker in Stroud, GJ 7 May 1734 William Addy sells felt hats 'of all Sorts for Men and Boys.

Chapter Two
River Navigation, Turnpike Roads and the 'Favourite Project'

To set the Stroudwater in some sort of contemporary national context it is useful to outline briefly the main transport innovations – both achieved and planned – which preceded it.

Although rivers were probably used intermittently for transport before the occupation, the first reliable evidence of transport improvement in England comes from the period of Roman rule. Apart from a comprehensive road network, Roman engineers built the Cardyke and Fossdyke canals linking the rivers Witham, Trent and Ouse to bring grain from the fenlands to their important garrison town at York.

Centuries later, Magna Carta, signed in 1215, mentions certain English rivers were navigable in their natural state and that these so-called 'publick rivers' should be kept free of any obstruction hindering normal navigation.

Magna Carta probably refers to the middle and lower courses of major English rivers like the Ouse below York, the Trent below Nottingham, the Thames below Oxford and the Severn at least as far as Worcester and possibly beyond, as well as the lower courses of smaller rivers … the Dee below Chester, the Avon below Bristol, the Nene below Peterborough, the Medway below Maidstone and other rivers of comparable size.

Once the pressures of early industrialisation began to operate on the public rivers, attention was gradually focused on extending the system of inland waterways to help cope with the growing demands of an expanding industrial economy. During the whole of the sixteenth century there were only eight Acts dealing with river navigations. Once the seventeenth century got under way there was no shortage of plans for river improvement and for extending work to include rivers not navigable in their natural state.[1]

The navigation of the River Nene, for example, was extended upstream after 1606. Some locks were built on the River Thames in the early 1600s and the channel widened and deepened in places. Three more locks were added in 1635. In the period 1634–38 a number of improvements got under way. These included the Great Ouse, Lark, Tone, Stour, Wey, Warwickshire Avon and the Soar. After 1660 there was a period of rapid economic expansion and with it a need for better transport facilities. There were dozens of river improvement Acts passed in the years 1661–64 although not all legal hopes were turned into physical reality. There were, though, improvements to the Mersey, Weaver, Stour, Salwarpe, Wey, Lugg, Medway, Welland, Wiltshire Avon, Itchen, Great Ouse and Mole as well as many others. There was a further spate of improvements in the 1670's, a second group in 1689–1713 and a third covered the years 1719–21.

The volume of traffic on roads and navigable rivers continued to increase – though not always steadily – during the sixteenth, seventeenth and early eighteenth centuries as the pace of industrialisation quickened.[2] In an effort to meet this seemingly insatiable demand Parliament passed an Act for enlarging and improving the common highways in 1662. A year later the first Act to establish a turnpike trust became law. This Act gave powers to a group of prominent local individuals to convert the great

North Road – the old Ermine Street built by the Romans over a thousand years before – into a toll road where it ran through the counties of Hertfordshire, Cambridgeshire and Huntingdonshire.

A second turnpike Act was passed in 1696 – this time for the London to Colchester Road – and after 1702, when Parliament made provision for cheapening and simplifying the passage of turnpike acts, there was an immediate upsurge of interest. The third turnpike Act in 1698 was for the road between Birdlip and Crickley in Gloucestershire. Between 1701 and 1750, four hundred and eighteen turnpike Acts were passed. This rose to over 1,600 between 1751 and 1790 and to over 2,400 between 1790 and 1830. By about 1720 the country found itself with a growing mileage of turnpike roads and about a thousand miles of river improvements.

Transport improvements were a popular subject for public discussion in seventeenth and eighteenth century England. There was for example never any shortage of ideas for a Severn/Thames link canal during the seventeenth and eighteenth centuries. The two rivers were among the most important navigations in the kingdom and it was perhaps to be expected that an increase in river traffic and the persistent problems of supplying an expanding metropolis with coal might encourage pamphleteers, speculators and adventurers to consider a link canal and eulogise the benefits a new navigation could bring. The earliest known reference to the idea can be traced back to an unspecified date towards the end of Queen Elizabeth's reign when a 'Mr Hill and Mr Rowland Vaughan were said to design' such a scheme.[3] In 1610, seven years after the old Queen's death, Thomas Procter published a pamphlet in London urging the construction of a through waterway and emphasising the improved access to Forest of Dean coal which would result.[4] By this stage it seems probable the idea was well known, at least in London and commercial circles, since Procter assumes his readers have some prior knowledge of the subject.

It is not certain whether any of these early pioneers ever examined the Cotswold terrain or any of the five possible routes via the Cherwell, Evenlode, Chelt, Frome or Bristol Avon which penetrate the limestone escarpment on the east side of the Severn valley. What is certain is that during the 1620s Henry Briggs, professor of astronomy at Oxford University, rode over the watershed between the Thames and Bristol Avon finding it 'a levell ground and easie to be digged'. Briggs also considered the 'chardge of cutting between them' but 'not long after this …' John Aubrey, the noted diarist, writes, 'he dyed'.[5] Briggs' survey and estimate probably encouraged other parties, including the intrepid Mr Hill, to try his luck again. In 1633 he submitted a petition to Charles I for a navigation either between the Thames at Cricklade and the Avon at Malmesbury, or between the Kennet at Marlborough and the Avon at Chippenham, or between the Chum at Cirencester and the Frome near Stroud.[6] Although Hill proposed to survey the various routes, select the most suitable and suggest a probable cost before he began construction, evidence suggests he barely finished his pamphlet let alone started on any plans.

Eight years later, on 21 July 1641, the water poet Jobn Taylor set forth from London with a friend in a small portable boat aiming to reach the Severn by using the tributaries of the Thames.[7] By 11 August he had reached Cirencester 'where the River was so dry … it would beare my boate no further'.[8] Taylor hired a cart to transport his boat across the watershed reaching the Frome at Stonehouse about five hours later. This river, he maintained, and the Churn 'might be cut into one, and so Severne and Thames might be made almost joyned friends', though he had little doubt that 'sloth and covetousness … the bane of all good endeavours and laudable Actions' might hinder any execution of the project. Taylor unloaded his boat at Stonehouse, placed it on the Frome and continued his journey to the Severn. His vivid descriptions of the difficulties of navigating the Frome in its natural state illustrate some of the problems Richard Owen Cambridge of Whitminster and John Kemmett of Tewkesbury were to face when they tried to complete their own navigations. Perhaps understandably, Taylor's book is called his 'Last Voyage and Adventure …'

with passing and wading, with haling over high bankes at fulling mills (where there are many) with plucking over sunke trees, over and under strange Bridges of wood and stone, and in some places the brooke was scarce as broad as my Boate, it being often times impeached with the boughes and branches of willows and Alder Trees, which grew so thicke, hanging over and into the brooke, so that the day light … could scarce peepe through the branches, that in many places all passages were stop'd; so that I was sometimes forced to cut and hew out my way with a hatchett; with this miserable toyle all the day I gat at night to a Mill called Froombridge … whereas (for our comfort) was neither Victualing house, meale, drinke or lodging … [until] a good gentle-woman [took us in]. Munday … [13 August] I took leave at Froombridge Mill, and (falling to our old work againe of haling and draweing from Mill to Mill, and from one hindrance to another), I came at last to Whitminster'.

John Taylor was not inclined to begin the project himself.

The fertile mind of Dorset gentleman Francis Mathew was rarely short of bright ideas for new navigations. On 20 July 1655 he addressed a pamphlet 'To his Highness, Oliver, Lord Protector … under whose wing I fly for protection and assistance' advocating a new navigation between the Thames and Bristol Avon by way of Malmesbury. Mathew neglected to mention that he had not only previously flown to Charles I for protection and assistance but raised a troop of horses for the King in the Civil War as well. Mathew had been imprisoned for his opposition to the Parliamentary cause and lost his estates into the bargain. Now out of prison, Mathew saw his numerous navigational schemes as a chance to rehabilitate himself and perhaps regain his sequested lands.[9] It is possible Cromwell may have encouraged Mathew for Thomas Congreve, writing in 1717, claimed 'Cromwell offered £20,000 at the Navy Office … if the City of London would join in financing 'this designed Cutt …'and Mathew himself claimed he had completed a survey 'upon Commission from his Highness'.[10] In any event between July 1655 and 12 January 1656, when he presented his ideas to Parliament, Mathew did complete a survey and found the distance between the source waters of the two rivers (upon exact measure by chains) not to be full three miles'. Originally, Mathew claimed, he had thought the distance was four or five miles suggesting, perhaps his earlier ideas were based more on map perusals than any surveys in the field.

Even when Mathew applied his undoubted optimism and energy to produce a survey of the route his conclusions were based on the flimsiest understanding of construction and costs. The report itself, for instance, was totally devoid of any appraisal of the terrain or the problems of water supply. Mentioning the idea of using locks or 'saffes', Mathew launched into encouraging state support for the project. 'Such great and publick Works', he declared, 'are not to be attempted by private men, or any particular Corporation. But most fit it were, that the State itself should be the sole Undertaker' adding for good measure that 'the proffits to the state would rise to a vast Sum' enabling them to repay the costs of construction within a year.

Aubrey, who knew Mathew, thought it an 'ill survey' and called Mathew 'an simple honest man'. Perhaps Aubrey had Mathew's proposals for carriage on the proposed navigation in mind. These were to be carried by a fleet of three hundred Billanders each carrying thirty tons of coal. Each wharf was to have its own fleet of fifty boats which were 'to sail up the River, every Squadron by itself, having each its Admiral and Rear-Admiral, carrying their Flags of proper Colours, none of the said Squadron sailing before his Admiral, nor behind his Rear-Admiral; and this to prevent disorder as they pass through the Country'. When Mathew's Bill came before Parliament in January 1656 it passed the Commons but failed to impress the more sober judgement of their lordships in the House of Peers. It is possible the City of London may have failed to provide any financial support for the project and Mathew found it impossible to raise the balance elsewhere. For a while, therefore, this was all that was heard of Francis Mathew.

When the economy began to revive after the restoration of the monarchy in 1660, there was a spate of Bills for improving rivers and the whole subject became a popular matter for debate not only at Westminster but also in the country at large. The period after 1660 marked the first serious and concerted attempts to improve the rivers of England and develop them as a widespread means of transport to serve the developing needs of an industrialising economy. The emphasis now was on large scale river improvements, extensions to the existing system of river navigations and thoughts – though only thoughts for the moment – about joining rivers together systematically to form some sort of nationwide network. The idea of a Severn/Thames link canal got its fair share of attention in these river conscious days and several unsuccessful Bills were introduced to promote the undertaking.

Having taken expert advice from several competent surveyors this time and with the backing of a number of influential supporters including the respected engineer Andrew Yarranton and even His Majesty himself who reputedly 'espoused it more than anyone else', the indomitable Francis Mathew promoted a new Bill in February 1662 for 'clearing the Passage by Water from London to Bristol'.[11] Although this Bill passed two readings in the Commons, there is no record of it emerging from committee.

During 1664 several other promoters tried to seek powers to construct a waterway link. In April, for instance, 'A Bill for making the river navigable from Bristoll to London was this day read for First time' and was ordered to be read again the following Friday.[12] To all appearances, however, the Bill was not read again and is not even mentioned in House of Commons Journals. On 13 December of the same year a Bill 'for Making of certain Rivers navigable into the River Seaverne and from thence into the River Thames' was read a first time and a second reading fixed for the following Monday. On the same day a second Bill for the same purpose was also read a first time.[13] Eleven days later, on 24 December, the Bills were read again and the House ordered both should go to the same committee which would decide on the best Bill, agree to the appointment of undertakers and set a time limit on the work.[14] At this stage their passage becomes obscure. Congreve thought the Bill passed the Commons again but failed at the second reading in the Lords even though there are no Parliamentary records to support such a view. The committee to which the Bills were referred was mentioned four times early in 1665, once suggesting it 'be revived', but nothing further is heard of either Bill.[15] It is possible both Bills were lost when Parliament was prorogued shortly afterwards.

It is also possible that Francis Mathew was involved in some of these Bills, for by April 1668 he had the project before Parliament again. Among other things, this new Bill proposed 'an Inland passage … from Bristoll … to London … at an estimated cost of £60,000.[16] It was introduced into the House of Lords by the Earl of Bridgewater, great-grandfather of the later third Duke, and named the undertakers as Francis Mathew, 'sole Inventor', Thomas Baskerville his assistant, the Duke of Albermarle, Earl Craven and several other prominent supporters of the earlier 1662 Bill. Although this Bill only got a first reading, Mathew was still promoting the link in 1670 when he published another pamphlet.[17] Unabashed by the change of government since his petition to Cromwell and claiming he had suffered grievously for his support of the monarchy during the Commonwealth Mathew now flew for protection and assistance to Charles II and addressed his pamphlet 'To the King's Most Excellent Majesty, and the Honourable Houses of Parliament', calling for a 'Mediterranean Passage by water From London to Bristol … for the great Advancement of Trade and Traffique'. Using popular knowledge of newly built canals in Italy, Belgium and the Netherlands, Mathew claimed the benefits they had effected could easily by extended to England. There was, for example, the 'Wonderful Improvement to … Trade, and great Relief to the Land, and most remarkably to be perceived, by the supply of many places with the great Benefit of Coal (which without this means cannot be had).' Extra coal supplies for the capital, too, would avert any repetition of

event during the Dutch wars when London was brought 'near to … Insurrection' by an 'incredible want of Coal'. Mathew was convinced that 'divers rivers may be moulded [to] admit Vessels of Thirty Tun burden … at less than half the Rates now paid for Land carriage' while the highways themselves 'now so unnecessarily plowed up by Waggons of Prodigios Burthens … will be much preserved'.

Mathew proposed the Bristol Avon should be made navigable from Bristol to Calne or Malmesbury in Wiltshire and then a five mile canal should carry the navigation from there to Lechlade on the Thames. Some of Mathew's more fanciful ideas, like his plan for an inland navy, were now dropped and there was some attention paid to questions of land purchase, construction of towpaths, locks and so on. Although he still required some government finance for his scheme, Mathew proposed himself as undertaker claiming the project was 'so Heroick that 'tis beyond the Level of any others to attempt'. No government money was forthcoming and nothing more is heard of Mathew and his schemes.

Seven years later, in 1677, Andrew Yarranton published his own proposals for a Severn/Thames link dedicating them to Thomas, Lord Windsor, 'From the great Incouragement your Lordship hath been pleased to afford me, in those indefatigable Pains you have taken in the Survey of several Rivers, and contriving with me effectually which way these might be rendered so far navigable'.[18] Recalling his involvement with an earlier Bill ten years before, Yarranton claimed 'foolish Discourse at Coffee-houses laid asleep that design as being a thing impossible and impractical'. Yarranton claimed certain proven abilities as a promoter or navigations. Various wealthy men, including Sir Walter Kirtham Blount, had employed him to survey rivers and during the summer of 1677 Yarranton's son, Robert, had twice surveyed the Cherwell and the Thames. As a result of this survey Yarranton thought it practicable to make the Cherwell navigable to Banbury for £10,000 and the Stour navigable from Shipton to the already navigable Warwickshire Avon and Severn for about £4,000. The two navigations would be only eight miles apart at Banbury and since the land carriage between them was over 'good, hilly found dry land', an effective communication between Severn and Thames would result. This was estimated to reduce the cost of carriage by half and ensure plentiful supplies of corn and malt for the capital. Yarranton's proposals also outlined a Bill to empower an incorporated company of artisans to make the Cherwell navigable, plans for perfecting the Thames navigation, ideas for preventing fires, expanding timber supplies, how to 'Out–do the Dutch without Fighting' putting the poor to work, methods for improving the Royal Navy, to fortify Tangier and prevent massacres of London inhabitants. Yarranton's proposals, were more methodical than Mathew's but his link proposals never came to fruition.

Even so the general interest in a Severn/Thames link continued. A glimpse into the debate records 'Sir James Long's Objections were made new in 1683–84 who are said to be answered in 1664 by a Mr Ayliffe and Mr Sails who were for an Inland Navigation Between Avon and Isis by a cut to be made from Malmesbury to Summerford upon Isis near Cricklade'.[19] This interest continued into the eighteenth century when Thomas Congreve, writing in 1717, proposed a combination of river improvements and canals to complete a Severn/Thames and Severn/Trent union. These include a large reservoir near Wolverhampton which would feed various canals falling to the rivers Penk, Sow, Trent and Stour to carry the navigations in several directions.[20] His preferred route for a Severn/Thames link was from Cricklade to the Avon between Great Somerford and Malmesbury.

The Severn/Thames link idea was not short of further publicity in the early eighteenth century. The numerous references to Forest of Dean coal indicate how seriously supplies of fuel still figured in the minds of promoters and pamphleteers. None of these or earlier schemes lacked imagination but, equally, none was sufficiently practical to encourage any genuine interest. And, in any event, the clothiers of Stroud and district had their own views on transport improvements and the relevance of these extended, cross-country schemes.

Chapter Two References

1 Willan, T. S., *River Navigation In England 1600–1750* Manchester 1964
 Skempton, A. W., 'Canals and River Navigations before 1750', in Singer, C. (ed) *History of Technology* Vol. 3 Oxford 1957

2 Jackman, W. T., *Development of Transportation in Modern England* 1962,
 Dyos, H. J. and Aldcroft, D. H., *British Transport; an Economic survey from the seventeenth to the twentieth century.* Leicester 1971

3 Congreve, Thomas, *A Scheme ...* p. 13 1717 B.M. 101.k.I.
 Household, Humphrey, *The Thames & Severn Canal pp. 17–52 University of Bristol thesis.*

4 Procter, Thomas, *A Profitable Worke to this whole Kingdome* 1610 B.M. C.31.d.6.

5 Dick, O. L. (ed.) *Aubrey's Brief Lives* pp.38–39 1950

6 Hill,? *Mr. Hill's Petition ... for the Contrying of Navigation betweene the Rivers of Thames and Seaverne* 1633 PRO SP 16/238/3

7 This and all subsequent dates in the text are new style calendar. The old style date is 10 July 1641

8 Taylor, John, *John Taylor's Last Voyage and Adventure* 1641 Taylor probably means he came 'at last to Framilode' since it was unlikely he would abandon his voyage so near its destination. In any event no 'haling and draweing from Mill to Mill' between Fromebridge and Whitminster was possible. There were no mills between Fromebridge and Whitminster Mills.

9 Mathew, Francis *To His Highness, Oliver ...* 1656 B.M. 1028.h.20 Also published in book form 1656

10 Congreve op. cit.

11 Yarranton, Andrew, *England's Improvement by Sea and Land* pp.64–65, 187–189 1677, JHC Vol 8 pp.362, 370, 546 PRO SP 44/13 p.74

12 JHC Vol II p.711, JHL Vol 12 pp.222, 521

13 JHC Vol 8 p.571

14 JHC Vol 8 p.576

15 JHC Vol 8 p.595 It is mentioned on Feb. 4,17,24,27.

16 House of Lords Record Office M.s Bill '14 April 1668' JHL Vol 12 pp.221–22

17 Mathew, Francis, *To the King's Most Excellent Majesty ...* 1670 Bristol City Library Braikenridge collection B9272/BL 8c. Also in B.M. 1028.h.22

18 Yarranton *A Coffee-House Dialogue* B.M. T88x No 19, *A Continuation of a Coffee-House Dialogue* BM 1852. b.2.41
 England's Improvement Justified BM 1852. b.2.51, *The Coffee-House Dialogue Examined and Refuted* BM T.3x. 18.
 In fact it was fifteen years earlier not ten.

19 Congreve op. cit

20 Congreve op. cit.

Chapter Three
Cloth and Clothiers

These schemes for linking the Severn and Thames seemed of limited relevance to the inhabitants of the neighbourhood of Stroud and particularly to the determined group of wealthy gentlem n clothiers who formed the backbone of the local entrepreneurial elite. These influential local industrialists were not interested in any 'Heroick' canal joining the two basins of England's largest rivers.[1] They wanted an improvement in local transport conditions so coal supplies could be brought cheaply and easily to their mills. There were no major difficulties in bringing coal down the Severn from the Staffordshire and Shropshire pits to either Gloucester or Framilode. The Severn was navigable in its natural state and there was plenty of evidence that a growing number of carriers were operating regular services on the river specifically addressed to 'Gentlemen, Clothiers and Traders'.[2] The main problems arose in trying to transport coal cheaply in sufficient quantities from Gloucester and Framilode to Stroud over roads noted for their poor condition in the best of weathers and occasional impassability during the winter months.

Some of the rising demand for coal in the Stroud area dunng the seventeenth and eighteenth centuries came from the domestic needs of a growing population. By far the greater part of the increased demand, however, came from the requirements of a substantial, long established and prosperous local woollen industry which formed the basis of the Stroud economy.[3] Samuel Rudder, the Gloucestershire historian, himself noted the 'great consumption of coal … amongst the clothiers and dyers' was the main source of demand for the fuel and this is confirmed by many other writers.[4] The fine quality woollen cloth industry, Rudder explained, had 'long been established in these parts'.[5] It had probably originated before the Domesday Book of the late eleventh century and grown to prominence towards the end of the fifteenth century when a technical innovation spurred by a larger demand – the mechanisation of fulling previously done by hand – introduced a new factor into the processes of manufacture. At this point access to new fuel supplies became crucial and the industry began to migrate westwards from older woollen centres – like Northleach, Chipping Camden, and Cirencester – to take advantage of the fast flowing streams draining down the Cotswold scarp to the Severn. The numerous streams and steep topography of the Stroud area were well suited to these new methods of production and from then onwards the woollen industry gradually assumed a greater importance in the local economy.[6] From the mid-seventeenth century onwards, Gloucestershire, and neighbouring parts of adjoining counties, became the single most important area for woollen cloth production in the whole of England until Yorkshire pre-empted that dominance over a century later.

The success of the Gloucestershire trade was based on the production of a high quality cloth and on an assured home market just at a time when a growing population with higher living standards could afford such products and when the import restrictions of some continental countries were tending to reduce the volume of cloth exported from England. Concentration on a high quality cloth brought a number of advantages. In the first place quality cloths fetched a higher price in both domestic and export markets and brought a larger financial return to the clothier. The production of quality cloth,

too, created a reputation so well known that few other areas even attempted to compete. Stroud, for example, was particularly famous for the fineness of its local cloth and for the celebrated Stroud scarlets which were well known in mainland Europe and greatly in demand in the Levant where, among other things, they were used for making Turkish fezs. Daniel Defoe called these scarlets the finest that could be found 'anywhere in England; perhaps in … the world'.[7] Even assuming this was an exaggeration, it does illustrate the way in which a high quality cloth like this could penetrate, and in some cases capture, quite distant markets. The consistent application of techniques learnt over several centuries in the Stroud woollen industry meant that for many years after the origin of the Yorkshire woollen trade even moderate quality Gloucestershire cloth was superior to cloths produced elsewhere. Well into the eighteenth century the main sources of fine quality cloth in England were these western centres of production.

Gloucestershire concentration on the home market rather than the export trade gave it a useful edge over its nearby competitors.[8] During the early seventeenth century, for example, Wiltshire produced about 60% of the undyed white cloth, sent mostly for export to the Netherlands and Germany, compared with only 28% from Gloucestershire. In times of disturbance, therefore, such as the periodic continental wars or the Civil War in England when exports were interrupted, Gloucestershire suffered correspondingly less than areas relying more heavily on the export trade. In any event Gloucestershire cloth exports, unlike Somerset and Wiltshire exports, went less to areas like Flanders, France and Portugal where import taxes and other restrictions were being levied to encourage domestic cloth production. The more usual destination for Gloucestershire exports was to Mediterranean countries, the Levant and to India through the channels of the East India Company where there was a ready market for quality cloth without any significant competition from domestic sources or any trade restrictions to protect it. Cloth factors in Aleppo, for example, found cloth from western districts of England not only preferable but frequently refer to the demand for 'Stroudwater scarlets' in letters to Gloucestershire suppliers.

The success of these two factors in encouraging the expansion of the local woollen industry is reflected by the available evidence. By 1712 the number of cloths produced in Gloucestershire showed a considerable increase on the total of a hundred years before. The estimated three hundred and fifty to four hundred clothiers in the county was an increase of at least a hundred on the later seventeenth century. The number of looms in the county had doubled over the same period. Small wonder then that in the same year Sir Robert Atkyns could say the 'clothing trade is so eminent in this county that no other manufacture deserves a mention' and his comment was equally apt for the rest of the century.[9] The period of greatest prosperity for the woollen industry were the years 1690 to 1760 when it was a widely accepted claim that the local woollen industry was then 'the most considerable of any in this kingdom'.[10]

The eminence of the woollen cloth industry in the county at this time was most apparent in the neighbourhood of Stroud where the River Frome, or 'Stroudwater' as it was often then called, provided an ideal source of water power for the clothing mills. Stroud itself, with a population of around 3,000 in 1712, was moving towards the status of a small town as it grew in prosperity and was already developed as 'a sort of capital to the clothing villages' not infrequently lampooned for its growing pretensions.[11] Reliable estimates suggest that the clothing industry employed about 40% of the able–bodied male population of the county in the early seventeenth century and that by 1775 an estimated 'fifty thousand Inhabitants were scattered within a narrow Circle … making Stroud the Center, who are chiefly employed in that Staple Trade, the Woollen Manufacture'.[12] Giving evidence before the House of Commons considering the 1730 Bill to build a Stroudwater Navigation, Edward Baghot claimed that

over 30,000 cloths were produced in the neighbourhood each year. Fifty years later Rudder estimated the value of annual production at around £200,000.[13] By this time there were over a hundred mills engaged in woollen manufacture within thirty miles of the town and all were agreed that the 'trade of this part of the country, though frequently fluctuating, is … considerable'.[14]

The crucial importance of the woollen industry in creating the preconditions for local transport innovation can hardly be exaggerated. Its significance is obvious if we recall that by the late 1720s, when plans for a navigation were first mooted, Stroud had over three centuries of successful sustained economic development behind it. The local commercial climate too, so keen on improvements in the woollen industry, provided a fertile background for innovation to be extended to other areas like transport. The woollen industry had also encouraged the growth of a local market economy and the financial institutions, albeit informal ones, essential for any substantial capital investment by a small community. It can hardly be incidental that one of the first banks in the county was formed in Stroud by local industrialists who had backed the canal. Most important of all the woollen industry created the demand for better transport facilities and the wealth to satisfy that demand. The woollen industry provided the need, the cash and – equally important – the expertise in the guise of local clothiers to carry the Stroudwater project to fruition.

These clothiers were the key men in this west of England woollen industry. Their success was based on an expanding home market for quality cloth and from an expanding population with progressively higher living standards as the years wore on. It was in this domestic branch of the trade that most clothiers prospered, grew rich and left their mark on the local economy. Their position was reinforced by an increasing demand from Blackwell Hall in London, the main export centre for woollen cloth. Factors there required regular quantities and standard qualities of high grade cloth for export. Gradually the more successful cloth manufacturers in areas like Stroud abandoned the Actual cloth manufacture themselves, reorganised production to increase output and adopted the role of middlemen between own hired hands producing the cloth at home and the centres of demand at Blackwell Hall and elsewhere.

Unlike their Yorkshire counterparts, who usually produced their own cloth in their own cottages alongside any workmen they might employ, the Stroud clothiers concentrated on controlling labour and materials, coordinating all the processes of manufacture and generally managing cloth production. They used their money to buy wool, originally from sheep grazed on the surrounding hillsides, but later from Spain and Ireland as well when trade expanded beyond the capacities of local wool producers, and then paid spinners and weavers to produce the cloth for them. The most prosperous and respectable clothiers, the 'gentlemen clothiers' as they were called, all used this domestic cottage industry or 'putting out' system whereby all production, apart from fulling done by hired labour in the clothiers' own mills, was done by workers in their own homes. The clothier, Rudder wrote, would be the 'Person with a great stock and large credit [who] buys the wool, pays for the spinning, weaving, Milling, Dyeing, Shearing, Dressing etc. That is, he is Master of the whole Manufacture from first to last, and probably employs a thousand persons under him'.[15] There are, however, some reservations to this as a typical picture of Gloucestershire woollen manufacture in the eighteenth century.

In the first place most clothiers did not operate on this lavish scale although certainly no clothier could be considered respectable unless he employed at least thirty to forty looms.[16] It is true that the thirty or so master clothiers in the Stroud area did dominate the local industry but there were also much larger numbers of lesser clothiers varying from the well-to-do with a couple of dozen looms to worker clothiers actually producing the cloth themselves on a few looms and owning the cloth at all stages of manufacture. Many of these lesser clothiers had no mills of their own but sent the cloth out to specialists for some production processes. A great many of them, still buying their own wool and

working as independent craftsmen, considered themselves more weavers than clothiers. A few clothiers even worked on a part time basis although the farmer-clothier was an exception by the mid-eighteenth century. It was, though, easy for any successful weaver or man of modest means to establish himself in the clothing trade since no great amount of capital was required to enter the industry. Recent calculations estimate the probable sum at around £500 to set up as a clothier of substance which, considering the county's reserves of gentry and successful tradesmen, would not be a serious obstacle for large numbers of local people.[17] In any event while the industry boomed and there was plenty of work for all, most established clothiers welcomed new manufacturers of quality cloth which could only enhance the reputation the local industry already enjoyed. The Gloucestershire clothiers, however, not only sought to differentiate themselves from their employees but also recognised distinctions within their own ranks by dividing themselves into classes and varying the subscription to their Society 'according to the extent and magnitude of the trade carried on by them'.[18]

The second reservation is that the manufacture of woollen cloth was not exclusively a cottage industry in the eighteenth century. Manufacture was divided between the mill – usually owned by the clothier himself – and the cottage of the spinners and weavers he employed. Some initial processes such as cleaning and scouring the wool were done in the mill before it was sent out to the spinners and then handed on to the weavers. They in turn sent the raw unfinished cloth back to the mill for the final processes of felting, gigging and dyeing. As the eighteenth century progressed, more and more of these processes were concentrated in the mills and fewer and fewer distributed to spinners and weavers in their own homesteads.

'The clothiers', writes Esther Moir, 'formed a distinctive and most important section of Gloucestershire society. There were constant fluctuations in their ranks. Small businesses rose and fell, for among the lesser clothiers, who … frequently had only a … rudimentary organisation, bankruptcies and failures were common.[19] Sir Robert Atkyns spoke of the many good estates in their hands and Timothy Exell described them as 'rich and opulent men; they were not only worth their thousands, but their tens of thousands, and their scores of tens of thousands'.[20] Rudder claimed that of the thirty master clothiers in the Stroud area alone many had acquired 'Very large fortunes … in this business' and that 'it was no extraordinary thing to have clothiers in that county worth ten thousand to forty thousand pounds a man'.[21]

The. economic and social origins of the clothiers varied a good deal since they were drawn from several levels of society. Some were landowners in sheep breeding districts like the Cotswolds who adopted the trade of clothier as a profitable outlet for their own wool. Some were woolmen or weavers of initiative who had ploughed back their profits in the clothing trade and expanded their interests accordingly. Some woolmen may have been encouraged to turn to the thriving clothing trade as the export markets for raw wool became more uncertain. Other clothiers were former city merchants, often from Bristol or Gloucester, who had made their fortunes in some other trade and now sought to follow an accepted route to the status of gentleman by buying land in the county, combining it with a profitable and respectable association with the clothing trade to confirm or enhance their rise up the social scale.[22] Still others might be members of the cadet branch of a local aristocratic or noted gentry family who sought income and station in an industry 'still considered as a lucrative and genteel employment'.[23]

In some cases the position was reversed with clothier families joining the ranks of the gentry. Some wealthy and established clothiers retired from the management of their mills and lived the life of country gentlemen. Sir Onesiphorus Paul and Nathaniel Winchcombe, for instance, inherited enough money from their family clothing interests to bear 'the port and carriage of a gentleman' and had really put any active involvement in the clothing trade behind them. The diary of Nathaniel Winchcombe is

more a record of bunting, partridge shooting and tea parties than of any mill supervision. It was only about one day in ten that he 'stays at home and superintends men'.[24] Camden noticed that some clothiers had even taken this a stage further. Several 'of the most ancient families among the nobility', he wrote, 'had their rise from the clothing trade'.[25]

Sir Onesiphorus Paul typifies the easy transition from trade to land which some other clothiers followed at the same time as junior branches of some local landed or aristocratic families took the reverse movement into the highly respected clothing trade. His father, Onesiphorus Paul, was a well-known local clothier who took an active interest in the management of his mill at Woodchester where he invented an improved type of napping and perfected several other technical improvements in the dyeing and finishing processes. Before long he became a leading manufacturer in the Stroud area and one of the wealthiest local clothiers. In 1750 he entertained the Prince of Wales to breakfast on the morning the Prince visited Richard Owen Cambridge at Whitminster and inspected his 'own private navigation'. Ten years later Onesiphorus Paul was appointed High Sherriff of the county and knighted for his services. His son, also named Onesiphorus, was left a large fortune which enabled him to lead a life of extravagant leisure, putting the clothing trade behind him completely and leaving the management of the Woodchester mill to his cousin Ohadiah. Following his Grand Tour, completed in 1768, he divided his attentions between London, Bath and Gloucestershire where he enjoyed the life of a country gentleman until his own appointment as High Sherriff in 1780. From then onwards he devoted the rest of his life to the service of his county.[26]

For all his unguarded follies in the earlier days of his youth, Sir Onesiphorus Paul became a vigorous and far-seeing local magistrate deeply involved in social and prison reform. In remembering his life, however, it is easy to place too much emphasis on the social role of the clothiers and neglect their very real contribution to the economic life of the county. Most clothiers, even the substantial gentlemen clothiers, did take a close interest in the management of their businesses and were justifiably proud of the many improvements and innovations they introduced. They developed new types and varieties of cloth, found new domestic markets when their export trade was challenged, welcomed improved processes of manufacture and built their great mills which expanded production and employment in the valley of the Frome. It is generally accepted that machinery for woollen manufacture was introduced earlier in Gloucestershire than in other parts of the country and several writers stressed the importance of the clothiers' innovatory role when they asserted that the local cloth 'owes much of its unrivalled excellence to … [the] ingenious and spirited improvements' of clothiers like Sir Onesiphorus Paul.[27]

The social positions of wealthy gentlemen clothiers and local gentry families were hardly to be distinguished. Clothiers and gentlemen sat side by side as equals on the local bench although most clothiers rarely attended more than once a year probably on account of their business commitments. There were many 'good marriages … between clothier and gentry families. Thomas Pettat, the Kings Stanley clothier, married Miss Paul of Woodchester, a daughter of Sir Onesiphorus Paul, and acquired an additional fortune of £12,000 through her dowry. Another clothier, Thomas Clutterbuck, did even better; he married a sister of the Earl of Dysart, a young lady with a personal fortune of £20,000. [28] The close connection between gentry and the most established clothiers are implied in many other contemporary references. The petitions from Cirencester, Stroud and Bisley in favour of the 1730 Stroudwater Bill all come from 'several Gentlemen, Clothiers and other Chief Inhabitants'.[29] The *Gloucester Journal* is liberally sprinkled with dozens of reports of 'a young Gentleman, bred a Clothier', 'the gentlemen, clothiers and other wealthy inhabitants of Stroud', houses or 'genteel messuages … to let or for sale suitable for a gentleman or a clothier … as well as an advertisement by a 'Gentleman of undoubted reputation' prepared to invest up to £1,500 for a partnership with any reputable clothier in the neighbourhood of Stroud.[30]

With increasing wealth and a social position in the community came the trappings and duties of respectability. Many clothiers acquired large estates in the locality and built great houses occasionally away from their mills but more usually 'near the river where their respective mills stand' and not in the town of Stroud itself. William Dallaway, chief promoter of the 1774–76 Stroudwater scheme and first chairman of the successful company, lived at Biggs Place near Chalford. Joseph Wathen, member of a rich and established Stroud clothing family and later a director of the canal company, lived at New House near Stroud. The Field and Gannicock's belonged to Fream Arundell and William Knight respectively, both substantial clothiers and prominent Stroudwater shareholders. George Hawker, another shareholder and wealthy clothier, built Rodborough Fort, a habitable folly, on top of nearby Rodborough Hill. Rudder soon complained, however, that some of these seats 'in compliance with the taste of the present age, are left by their owners for the greater part of the year, to partake more largely of the pleasures of the metropolis, and other places of public entertainment'.[31]

Gentlemen clothiers and their wives organised and attended the fashionable subscription balls held in the great ballroom of the George Hotel, Stroud, during the winter season. They attended the best social engagements in the district similar to that given in the spring of 1749 when a company of weavers waited upon Giles Gamer and Samuel Hawker Esquires, who went to the George Inn where an 'elegant entertainment' was provided to which 'a great number of the neighbouring Gentlemen and principal inhabitants of the Town' were invited. The peace was read and Captain George Hawker's company of volunteers, raised during the '45 rebellion of the Jacobites, fired a volley in celebration.[32]

Some clothiers gave lavish entertainments of their own. 'On Thursday last', the *Gloucester Journal* dryly reports, 'Thomas Baylis Esq. of New Mills near Stroud in the County gave a grand concert and ball … at which upwards of 300 gentlemen and ladies were present. After the concert the company sat down to a cold collection of 231 dishes provided with the utmost elegance that the season and county could afford. The excellent order and regularity which prevailed over the whole of the evening's entertainment was no less admired than the hospitality and politeness of the generous Mr Baylis'.[33] Nor were visits to the fashionable spas of Bath or Cheltenham to be excluded although even the wealthiest and most eminent clothiers might cause amusement when they attempted to cut a dash in their finery. The Woodchester clothier, Sir Onesiphorus Paul, and his lady seemed like some 'stray bees from the hive of fashion' to Gilly Williams for in November 1764 he wrote to George Augustus Selwyn, London wit and MP for Gloucester, that they were 'the finest couple that has ever been seen here since Bath was built. They have bespoke two whole length pictures, which some time or another will divert us. His dress and his manner are beyond my painting; however, they may come within Mr Gainsborough's'.[34]

Gentlemen clothiers also frequented the Three Choirs Festivals as well as race meetings at Cirencester, Cheltenham, Bath and other fashionable centres. It is probable clothiers valued these gatherings more as chances to rub shoulders with the 'quality' and as a confirmation of their own enhanced social position rather than for any genuine interest in the arts or sports involved.[35] Groups of clothiers paid for extensions to the Stroud parish church of St. Lawrence on at least two occasions. Five clothiers were also churchwardens. When Mrs Hawker, wife of the 'eminent Dudbridge dyer' and clothier, passed on, it was certain that 'the loss … will be most severely felt by every poor family in the neighbourhood'.[36] Many clothiers, like Mr Small of Stroud, left 'a plentiful Estate' behind them. Some indications of clothiers personal property comes from reports of thefts mentioned in the local newspaper. John Clissold of Vatch Mill was robbed of five gold rings of which three were set with precious stones. Samuel Clutterbuck lost two large silver spoons, two silver teapots and a silver saltcellar from Kings Stanley and Thomas Clutterbuck lost a valuable silver watch some time later.[37]

The wealthy clothiers, then, were an accepted *nouveau riche* whose relatively rapid rise to fortune was charted unknowingly by Sir Robert Atkyns.[38] Writing in 1712 he complained he could find few families of

over a hundred years standing in the county. He failed to appreciate that several clothier families which had emerged from the late sixteenth century onwards would form the backbone of one of the most important economic groups in eighteenth-century Gloucestershire life. Occasional professional or personal rivalries apart, there is every indication that the keen business interests of the clothiers caused them to act as a cohesive force in local affairs. If they were not joining forces to present 'an Humble Address … to his Majesty', acting as guarantors and executors for each other, encouraging intermarriage between the sons and daughters of different respectable clothier families, grouping together and offering rewards to protect their cloth from loss or damage as it lay drying on tenters in the open air, they were safeguarding their wealth from the periodic violence of the militant clothworkers or acting in concert for other reasons through their own Society of .Clothiers.[39] They were, after all, men of wealth and social position who had used their ability and financial acumen to rise through the social ranks and often take prominent public posts.

The clothiers, then, were a numerous, influential, monied, respectable, highly innovatory and organised group in the local Stroud community willing and able to use their position to join with other prominent inhabitants such as landowners to plan and finance improvements which would consolidate their economic position, guarantee them ample supplies of one of their vital raw materials at competitive prices, enable them to increase their already lucrative production, line their own pockets with the useful addition of waterway dividends and perhaps incidentally, bring advantage to the county as a whole.

It was these key men in this dominant local industry, the Stroud clothiers, who were the prime innovators of all five attempts to build a navigation from the Severn to Stroud. Apart from Kemmett's scheme for a machine navigation in 1759, when their influence was exerted indirectly through their role as commissioners appointed under the terms of the 1730 Act, the clothiers were directly involved in canvassing support for a navigation by issuing leaflets and pamphlets, holding public meetings, publicising the idea through their own personal contacts and trading links, writing to the local press, hiring engineers to produce a survey and estimate of the probable cost, paying any professional fees involved, raising the finance for construction from their own resources and through their financial contacts in Stroud, Gloucester, Bristol and London, finding and appointing undertakers to construct the waterway, outlining proposed legislation, promoting the necessary Parliamentary Bills, giving evidence before the committees of both Houses, drafting articles to establish a canal company, appointing clerks to be responsible for the day to day running and often electing themselves as directors through their own substantial holdings of shares. When it came down to it, it was only the persistence of this determined group of men that brushed aside the many disappointments in the years to come and eventually brought their canal triumphantly to Stroud in July 1779.

Chapter Three References

1 Mathew 1670 op.cit.
2 GJ 28 August 1739, 24 January 1744, 28 January 1746, 22 July 1746 etc.
3 Mann, Julia de Lacey *The Cloth Industry in the West of England from 1640 to 1880* Oxford 1971
 Bowden,–P. J., *The Wool Trade in Tudor and Stuart England* 1962
 Exell, T., *Brief History of the Weavers of the County of Gloucester* 1838 GCL J 13.8
 Ponting, K. G., *A History of the West of England Cloth Industry* 1957
 Tann, J., *Gloucestershire Woollen Mills* Newton Abbot 1967
4 Rudder, S., *A New History of Gloucestershire* Cirencester 1779 712
 Dallaway, W., *The Case of the Stroudwater Navigation* Stroud 1775 GCL JX

14.21 mentions coal used for both dyeing and finishing of cloth

Perry, R., 'The Gloucestershire Woollen Industry in the Eighteenth and Nineteenth Centuries' unpublished Ph.D. thesis University of London 1947 mentions coal was used by the dyers for heating water and in the drying rooms JHC 21 437–38 Edward Bagbot's evidence stated 'great Quantities … are used in dyeing, as well as for the use of Families thereabouts.'

GCRO CA 19 *The New Navigation or Stroudwater Triumphant* suggests domestic use:

 'By the river came the coals to dress your meat' GCRO Hyett Pamphlet 353

A Prophecy of Merlin lists both uses:

 'No more of chilling frost and snow,

 No more complain should Boreas blow,

 No more lament the forge and anvil,

 For want of glowing coals must stand still'

GCRO Hyett Pamphlet 353 *The British Merlin*

 'To warm your nails or make your kettle boil'

GCRO Hyett Pamphlet 353 *Sabrina Loquitor*

 'And sulph'rous kitchens cold and empty grown

5 Rudder op.cit 711

6 Perry, R., *The Gloucestershire Woollen Industry* BGAS 66 45–137 Gloucester 1945

 Moir, E., *The Cloth Mills of the Stroud Valley* History Today 9 310–25 1959

 Hadfield, Alice Mary and Charles, *The Cotswolds : a new Study* especially article by Lionel F. J. Walrond called *Wool, Woolmen and Weavers*

7 Defoe, Daniel, *Tour Through England and Wales* 2 43

8 Mann op.cit Chapters 1 and 2

9 Atkyns, Sir Robert, *The Ancient and Present State of Glostershire* Gloucester 1712 21

10 VCH *Gloucestershire* II p.160 Perry 1945 op.cit

 Rudder op.cit 711

 JHC 28 399 'The Petition of the Commissioners for the Stroudwater Navigation' 1759

11 Pococke, Bishop, *Travels through England* 2 270 1751

 Rudder op.cit 711–12

 GCRO Hyett Pamphlet 353 The Chronicles and Lamentations of Gotham:

 'For lo, the elders assembled and said

 Let us rise us up a name, let us be a great city and a mighty people … GCRO Hyett Pamphlet 353 *A Prophecy of Merlin*:

 'the great City of Stroud …'

 GCRO CA 19 *The New Navigation or Stroudwater Triumphant*:

 'For tho' the regions round once slighted Stroud By envious fame esteemed poor and proud,

 It will not long be so …'

 And future ages shall be proud to tell,

 Their distant friends, that they in Stroudshire dwell'

12 Perry op.cit calculating from John Smith's *Names and surnames of all the able and sufficient men in body … within the County of Gloucester* Gloucester 1608: GCRO D1180 5/1 Dallaway, William, *The Case of the Stroudwater Navigation* 1

13 JHC 21 437/38

 GCRO D1180/5/1 *An Answer to the Reasons Offered Against a Bill* 1730

 Rudder op.cit 711/12

14 GCRO D1180 5/1 Dallaway, William, *The Case of the Stroudwater Navigation* 1: Rudder op. cit. 711–12 15 (Joseph is his first name)

15 Tucker, Joseph, *Instructions to Travellers* Gloucester 1758 37

16 Moir, E., *Local Government in Gloucestershire* BGAS 1969 36

17 Mann op.cit 98

18 GCL JF 13.24
 Gough, J. W., *The Rise of the Entrepreneur* Batsford 1969 34/35

19 Moir op.cit 24

20 Atkyns op.cit 21/22

21 Rudder op.cit 711

22 Moir op.cit 24
 Gough op.cit 34/35

23 GCRO D1180 5/1 Dallaway, William, *The Case of the Stroudwater Navigation* 1

24 Moir op.cit 50 quoting GCRO D149 Winchcombe family papers, ACC 980

25 Moir op.cit 24 quoting Rudder 711/12

26 Finberg, H. P. R. (ed), *Gloucestershire Studies* Leicester 1957 includes two articles by Moir. *The Gentleman Clothiers* and *Sir George Onesiphorous Paul*

27 Hirst, W., *History of the Woollen Trade for the Last Sixty Years* 1844 12
 British Family Antiquity II Appendix 9 1811

28 GJ 11 May 1731, 29 May 1759

29 GCRO D1180 5/1 Petitions from Cirencester, Stroud and Bisley

30 GJ 19 October 1724, 1 February 1726, 8 October 1728, 27 July 1731, 26 September 1732, 23 March 1736, 16 November 1736, 13 December 1737, 6 January 1741, 1 October 1751, 2 May 1763, 1 August 1763, 19 January 1767, 10 April 1769, 28 January 1771 etc.

31 Rudder op.cit 420, 714

32 GJ 28 February 1749

33 GJ 11 April 1768

34 Jesse, J. H., *George Selwyn and his Contemporaries* 1882 I312/13
 Boucicault, Dion *London Assurance* Act 2, scene 1

35 GJ 30 July 1781, 13 August 1781, 3 September 1781, 17 September 1781 etc.

36 Fisher, P. H., *Notes and Recollections of Stroud* Stroud 1871
 GNQ 5 p.70/71
 GJ 17 September 1770

37 GJ 5 July 1725, 28 March 1732, 23 September 1746, 27 May 1759

38 Atkyns op.cit 20/21

39 GJ 7 June 1725 'Mr Nathaniel Beard, Clothier of … Rodborough, is excluded the Benefit of this Advertisement'. GJ 4 June 1722, 11 June 1722, 7 June 1725, 3 October 1727, 21 February 1744, 10 March 1747, 23 May 1749, 28 January 1752, 24 July 1753, 18 December 1753, 29 September 1754, 8 March 1757, 25 October 1757,
 GCRO Hyett Pamphlet 353 *The New Navigation* … says clothiers were 'smote with the love of gain'

Chapter Four
The First Attempt

The first known attempt to build a navigation to Stroud probably originated sometime during the late 1720s. Evidence of a general contemporary interest in the scheme, comes from the *Gloucester Journal* of 28 February 1730 announcing that 'The River Stroudwater ... is to be made Navigable, which occasions no small joy to the Clothiers in that Part of the County'. A few days later, on 15 March, a Bill 'for making Navigable the River Stroudwater ... from the River Severn at or near Framiload, to Walbridge near the Town of Stroud' was introduced into the House of Commons by the local MP, Sir John Dutton, and given a first reading.[1] The preamble to the Bill states that it would 'be of great Advantage not only to the Clothing Trade of the said County, but likewise to the Publick, by opening a Trade and Commerce between the City of Bristol and the several Market Towns and other Places near the said River Stroudwater, whereby the Poor will be much better employed, the Highways greatly preserved, and the Woollen Manufacture ... much improved and increased'.

Certainly an extensive trade and commerce already existed between Stroud and neighbouring areas primarily because 'the Lands [around Stroud], though well cultivated, are not supposed to produce One Fourth of the Necessaries of Life for the Consumption of the Inhabitants; in consequence of this, vast Quantities of Corn are brought from Gloucestershire, Herefordshire, the Vale of Evesham, the Cotswold Hills, and other Places; Wheat Barley, Oats, Beans, Flour, Butter and Cheese are all brought from distant Parts by Land Carriage ... Great Quantities of Wool and Yarn are also brought from Cirencester, Tetbury, and other Places'.[2] Equally 'great quantities' of oil, dyeing materials, wool yarn, groceries, wares, deals and timber were carried to Stroud from Bristol.[3] In fact it was confidently asserted that 'the cloathing parts of the County [are] in a great degree dependent on remote parts for a weekly supply of many thousand bushels'.[4]

The most important import of all was coal. Whether the coal was landed from trows at Gloucester, where 'the best Sorts ... are conveniently Stack'd for the Loading of Waggons', or at Mary Cullis' yard at Framilode which she had taken over on the death of her husband Thomas, or whether it came from Coalpit Heath nearer Bristol, the coal still had to be carried overland to Stroud.[5] Coal usually came by waggon in summer and on horseback during the winter when road travel was more difficult. In either event the price of coal in Stroud was considered little short of extortionate. There are several estimates of the volume of coal used around Stroud in the eighteenth century. In 1730 John Cripps suggested a navigation might carry up to 10,000 tons a year.[6] In 1755 John Dallaway mentioned that 3,700 tons of coal had been sold at Framilode and adjacent wharves alone the previous year and that about 3,000 tons of this had been used in Stroud and in the valley west of the town.[7] Twenty years later his eldest son, William Dallaway, thought about 12,500 tons were now used each year in the immediate vicinity of Stroud and district.[8]

It was equally apt for the Bill to mention the local poor for there were many cases of hardship among those employed in the more menial tasks of cloth production although the general prosperity of the industry and the militancy of the woollen cloth workers helped keep wages somewhat above the level of

subsistence. In times of depression, though, clothiers thought nothing of laying off thousands of workers. On occasions like this, when most workers were severely under employed or without work altogether, it was considered 'One Third … fully employed, would be more than sufficient for the whole Clothing Trade'. [9] At one time a Stroud charitable fund was set up to help the local poor and was soon reporting it had assisted over 10,000 people.[10] At another James Clutterbuck refered to how the 'numberless poor creatures, ready to perish with hunger in Bisley and Chalford Bottoms particularly afford melancholy proof how many wretches of the cloathing districts are prompted (by despair) to wander about and drift to the hedges … rather than starve under their own ineffectual roofs'.[11] In times of unusually high wheat prices the gentry, the wealthiest clothiers and others able to subscribe, opened a special fund to help the poor buy their greatest necessities. Equally there were sufficient 'poor manufacturers' of Stroud to meet together in a 'great concourse' to try and obstruct attempts to apply for an Act of Parliament 'for the recovery of small debts in that neighbourhood'.[12] Even employment was not always a guarantee of tolerable living standards. Rudder refers to the 'poor women and children' working in the spinning branch of the clothing trade.[13]

Part of this poverty among the local industrial workers, aggravated as it was by occasional depressions in the cloth trade, probably stemmed from the heavy dependence on imported foods. The extra costs of transporting food to Stroud from the producing districts tended to keep average local prices above those normally prevailing in Gloucester. In times of general prosperity for the cloth trade these higher prices may have held no great significance for the majority of workers. When trade turned down temporarily, however, cloth workers had fewer local food sources to call on and were obliged to rely on higher priced imports. Then these higher prices were bitterly resented and sometimes led to serious breaches of the peace. Some of the widespread dependence on imported foods originated from a shortage of farmland in the narrow valley bottoms around Stroud and from the surrounding hilly countryside not generally suited to successful cultivation without improvement. Some of the dependence could even have come from the general prosperity of the cloth trade which encouraged workers to neglect farming for more profitable employments. A navigation, the promoters promised, would employ the poor during the building period, provide an expansion of trade and so create additional employment and 'very much assist and relieve the numerous Poor emply'd in the Woollen Manufactury by lowering the Price of Corn, Malt, Provisions, Wood and Coal etc'.

The main stimulus for constructing a navigation, however, came from both the inadequacy and the cost of existing local transport facilities. The references in the Bill to the much needed 'preservation of the Highways' therefore form one of the most pertinent parts of the whole preamble. Indications of the state of local roads, such as they were, are widely scattered through the contemporary literature. Edward Baghot declared the roads were so had that 'wheel Carriages for Goods can't pass above Four Months in the Year'.[14] Other sources mention the 'great Difficulty of the Winter-season … by reason of the Hadness of the Roads'.[15] As late as 1750 loaded waggons took a whole day to travel from Stroud to Chalford, only four miles apart, because the existing poor road wound a devious route through the nearby hills.[16] Samuel Rudder, usually a reliable judge of local conditions, declared there could not be 'a more infamous turnpike road' than the Bristol to Gloucester road where the 'several miles of it' crossed the low lying clay lands of the River Frome near Chippenham Platt about five miles west of Stroud.[17] In the winter of 1776 Rudder 'saw a chaise mired in it, about half a mile from the Swan Inn … and was there told, that a horse had like to have been smothered in the same place two days before, but was luckily saved … Several causes were considered to operate to this evil; the scarcity of stone the remissness of the [turnpike] commissioners; and the total ignorance of the surveyor'. Giving evidence before the Commons committee sitting on the Stroudwater Bill of the same year, Thomas Yeoman, the

noted engineer, commented on the 'hadness' of the surfaces and stated that in his view he had never seen 'worse Turnpike roads'.[18] Even later in the century William Marshall commented that in the heavy clay lands of the Vale of Gloucester drainage difficulties turned the inadequate road foundations into 'mere quagmires with ditches on either side full of water'.[19]

The irregularity, the inefficiency and the unreliability of local road transport might have been bearable had it not been for 'the Heavy Burden which Land Carriage lays upon many of the Necessaries of Life more especially on heavy Goods such as Corn, Salt, [and] Coals … that are oppressed with the Expence' involved. The whole situation would be much improved, the promoters argued, if carriage was rendered cheap, free and easy 'so reducing the price of every article of Life to the poor of that neighbourhood, who are very numerous, and, a most necessary part of inhabiting such a trading country, in the single article of Coals which are so essentially necessary in every family'.[20]

The considerable differences in cost between road and water transport in eighteenth-century England were a direct result of their different efficiencies. For whereas 'A Barge, that will bring up Seventy Tons of Coals, will employ Four Men, Six to Eight Hours to navigate from [the] Severn to Wallbridge being … little more than Eight Miles', this same tonnage of coals 'brought by Land Carriage upon Waggons, will employ Thirty–five Waggons at least, One Hundred and Forty Horses, Thirty-five Carters, besides Boys, One whole Day, it being above Ten Miles (by road)'. In the winter, when most coal was carried on horseback at two hundredweights a time, this same Barge Load brought by road will require Seven Hundred Horses and one hundred Men reckoning Seven Horses to a Drift: but the Fact is, there are seldom more than Five, and often less than that Number; all will be employed One whole Day to make the like Conveyance'.[21] Although this estimate of the comparable amounts of energy needed to move the same volume of goods by different means is inaccurate, it does exaggerate the numbers of men and horses engaged in land carriage. Most commodities, one source claims, were brought not by regular stage waggons but by farmers who kept horses for other purposes as well.[22]

Nevertheless the improved access, greater reliability as well as the potential savings in time, effort and cost were not lost on the clothiers of Stroud who needed to import coal in such quantities. A navigation, they claimed, would be a 'cheaper way to bring all useful materials to a great Number of Cloth Mills (which] … cannot now be had but by a very expensive Land Carriage'.[23] A substantial reduction in the cost of one of the most important materials in cloth manufacture would enable clothiers to lower prices and expand production or, alternatively, to increase their profits.

There are plenty of examples of the relative cost of water and land transport in the Stroud area at this time. In 1730 Edward Baghot declared that 'Land Carriage from Gloucester to Stroud is more expensive than the water Carriage from Bristol to Gloucester; and that but Four Pence [1½p] per Hundredweight is paid for Water Carriage from Bristol to Gloucester being 30 miles, and Eight Pence [3½p] per Hundredweight for Carriage by Land from Gloucester to Stroud'.[24] ln the same year John Taylor confirmed that the cost of land carriage from Framilode to Wallbridge was 11s 0d (55p) for two tons including a toll of 1s 3d (6p).[25] In 1755 John Dallaway estimated that coal carriage from Framilode to Stroud cost 7s 0d (35p) a ton in the summer and at least 8s 0d (40p) a ton in the winter when tolls were raised to discourage wheeled traffic which cut into the sodden road surfaces. To encourage the use of horses, which caused little wear on surfaces, animals were exempted from the additonal winter toll.[26] By comparison Dallaway estimated carriage by canal from Framilode to Stroud would cost only 3s 6d (17½p) a ton. It was not unknown for some land carriage costs to rise as high as 1s 6d (7½p) a ton mile and although there were attempts to reduce this cost by using larger carts, it was not long before local turnpikes realised the damage heavier vehicles did and were banning the use of more than six horses as an indirect method of controlling the use of heavier carts.[27] Even this was not wholly successful for

shortly afterwards the several turnpikes of Stroud, Cainscross and Wheatenhurst were asking for an additional £1 0s 0d for each waggon drawn by six horses.[28]

Later in the century the relative costs of land and water transport were much the same. In 1776 Daniel Chance reported that coals from Framilode to Stroud cost 6s 6d (32½p) a ton to transport plus an additional toll of 2s 6d (12½p) in winter. From Wallbridge to the centre of Stroud alone costs could range from 2s 0d (10p) to 2s 6d (12½p) a ton. About the same time William Dallaway confirmed the situation had hardly changed from the days of Edward Baghot. 'The Land Carriage from Bristol to Stroud' he wrote, 'is £2 per Ton, and round by Gloucester, which is partly by Water and partly by Land, it is £1 per Ton and upwards. The Freight of Goods from Bristol to Wallbridge by this Navigation, (besides the Conveyance being much quicker than around by Gloucester) will, at the highest, be no more than 10s 0d (50p) … per Ton.'[29]

The high transport costs per unit, a direct result of the inadequate local transport system, were reflected in the equally high costs of goods on sale in Stroud. It was a regular complaint that 'Corn … in the County of Gloucester (and more so in the manufacturing Part) is dearer than in any other Part of England'.[30] The 'Price of Corn' Edward Baghot declared 'is always Four Pence (1½ hp) per Bushel dearer in Stroud than in any other Markets in the County; which, if the intended Navigation is completed, will become as cheap [in Stroud as] … it is sold at Gloucester, where it is generally sold at Six Pence (2½p) per Bushel'.[31] Edward Owen, the barge owner who plied a regular trade from the Shropshire pits, sold his coal for 10s 6d (52½p) a ton at Gloucester and for 11s 0d (55p) a ton at Framilode. At the same time William Dallaway could complain that coal at Wallbridge – even assuming it was always available – cost 19s 0d (95p) a ton in the summer and up to £12s 0d (£1.10p) in winter as a direct result of the extra land carriage costs from the Severn.[32] Few local residents except perhaps corn-dealers or coal-merchants expressed much satisfaction with prices nearly double those prevailing a few miles away in Gloucester. From gentlemen clothiers to impoverished weavers, all complained bitterly about the costs of food and raw materials in Stroud.

William Dallaway calculated that if a new navigation were built coal could be sold at Wallbridge for only 15s 0d (75p) a ton while another contemporary source suggests a probable price of around 13s 4d (67p) a ton. [33] If these calculations are correct then the savings on transport costs for coal alone would be in the region of up to £4,000 a year in the Stroud area. Since several surveys suggested a navigation could be built for around £20,000 the savings just on coal transport would repay the costs of construction within five years. The gentlemen clothiers of Stroud stood to gain most from a new navigation. Within the local community they alone had the wealth to finance the project. When the clothiers added the improved access to raw materials which would result, and when they calculated the lower prices for other goods which would come from cheaper transport facilities, it became increasingly clear to them as the eighteenth century progressed that they could ill afford to delay this innovation any longer. By this stage the will to build a navigation and the capital to finance it were already in existence.

In addition to this, however, there were two additional factors strengthening the need for improved transport facilities. Firstly there were reports of persistent shortages of food and raw materials in the Stroud area which made it essential to extend the catchment area for imports still further. Secondly, there was a rapidly growing demand for increasing volumes of raw materials as the woollen industry prospered.

Despite repeated complaints of high prices for food, coal and other raw materials William Dallaway asserted that even 'at these … Prices … a sufficient supply … [cannot] often … be procured'. [34] He blamed this situation on 'the Hadness of the Roads in the Winter Season' which made road transport difficult, expensive and unreliable. Shortages like this led to 'a rapid Decrease of our Woods' and 'raised the Price of [coal] … at least One Quarter, within the last Twenty Years'. Over a longer time scale Dallaway thought

wood for fuel had doubled in price between 1730 and 1775. Even local stiles were not safe from the nocturnal scavenging of poor weavers and landless labourers.[35] Shortages also led to periodic interruptions in production either because raw materials such as coal were temporarily unavailable or because woollen workers were away from their employment searching for fuel or agitating about food prices:'[36] 'On Saturday', the *Gloucester Journal* reports, 'a great number of weavers and others, from the parish and neighbourhood of Stroud, being assembled in a riotous manner, came to this city, with a design to compel the farmers to sell their wheat at 5s 0d (25p) … a bushel'.[37] This, in turn, might only aggravate the supply position. Apart from labour lost as a result of arrest and imprisonment, clothiers found their employees in an even worse plight. Farmers, too intimidated to return to the market, withheld even 'this supply [of corn] …for fear of the mob; and now the poor wretches are almost perishing for want of sustenance'. Corn prices reached 7s 6d (37½p) a bushel against a seasonal average of 6s 0d (30p) as a result of this Action.[38]

Persistent shortages were paralleled by an increase in demand. A thriving local woollen industry and an expanding population produced a growing demand for food, coal and other raw materials. This placed an additional strain on a transport network already overburdened with existing demands. John Dallaway noted that the decrease in woodlands 'occasions Coal to be every Day more in Demand, and the great price of it is very sensibly felt by all, especially the poor'.[39] His concern was echoed by his son William twenty years later who considered the loss of woodlands 'necessarily increases the Consumption of Coals'. All in all the demand for coal, as well as the price, was estimated to have doubled between 1730 and 1775.[40] It had been difficult enough to supply a limited demand for coal when conditions were more favourable in the summer. To meet a growing demand using two hundredweight bags on horseback in winter would prove virtually impossible.

It was against this background of heavy imports, high prices, scarcities, growing demand, inadequate supplies and expensive land carriage costs that the idea for a navigation to Stroud began to emerge. The gentlemen clothiers of Stroud had already noticed how water transport was used more extensively elsewhere in the country, how existing navigations had been improved, how navigations had been extended upstream by further improvements and how men's thoughts had turned to building new navigations as trade had in creased and techniques of construction improved. Most important of all they noticed that these new navigations could increase the supply of raw materials and cut transport costs dramatically. The demand for high quality Stroud woollen cloth already existed. To increase their production, the local clothiers needed a larger volume of coal to use in the dyeing and finishing processes and they needed the coal at the cheapest possible price if they were not to be priced out of the market by the emerging competition from cheaper Yorkshire cloth. A navigation would solve all their immediate problems and break through the ceiling on the expansion of their industry created by the combination of periodic coal shortages and high prices.

Sometime during the late 1720s therefore – possibly early in 1729 – a group of nine local gentlemen and clothiers came together to consider the steps necessary for promoting an Act of Parliament to provide them with powers of construction. These nine men, eventually named as undertakers in the Act, were John Peach, William Capel, William Edwards, Joseph Cambridge, Thomas Bond, Thomas Arundell, Daniel Watkins, Samuel Hawker and Samuel Yeats. The scanty evidence available on these men suggests that they were all local men of wealth and social position who were primarily connected with the clothing trade.

John Peach of Minchinhampton near Stroud was a clothier of repute who died in 1737.[41] William Capel of Stroud was also a clothier who owned a fulling mill near the town. In 1739 he became a churchwarden of Stroud parish church.[42] Apart from his death in 1774, little is known of the shadowy figure of William Edwards of Shurdington near Cheltenham although the details of his burial suggest a man of rank and

consequence.[43] Joseph Cambridge of Minchinhampton was a former Customs and Excise officer who attained the rank of a gentleman later in his life. He died in 1772.[44] Thomas Bond and Thomas Arundell were both Stroud clothiers of substance.[45] On his death in 1742 at the age of forty-eight, Thomas Arundell left each of his daughters a bequest of £300.[46] Daniel Watkins, born in 1688, was a gentleman of Bisley near Stroud who died in 1736.[47] The two remaining undertakers are somewhat better documented. Samuel Hawker of Rodborough, born in 1693, was an important landowner named as one of the three principal inhabitants of the parish. As early as 1735 he had been sufficiently wealthy to buy the house and manor of Cowley in Gloucestershire for £4,410. Six years later, in 1741, he became Sheriff of Gloucestershire and also held the post of Justice of the Peace by this time. When he died in 1760 he left the house and manor of Cowley to his son, George Hawker (Captain George Hawker) who was himself involved in later attempts to build a navigation. Among his many bequests, Samuel Hawker left at least £2,800 between his other children.[48] Samuel Yeats, the son of John Yeats, a well-to-do dyer of Minchinhampton, was born in 1699. John Yeats had been sufficiently well endowed to leave £100 in his will to educate the poor children of the parish. Samuel Yeats, already connected with the woollen industry, built up enough capital as a clothier at New Mills, Minchinhampton, for his own son, also called Samuel, to bring £4,000 into his marriage with the heiress Mary Osborne and to bind himself to her trustees to add a further £4,000 within six months. Samuel Yeats the younger inherited sufficient wealth to make him a 'generous benefactor' to the local Quakers and to the poor of the parish in general, although he was reproached several times by the Friends for his wordly conduct which was known to have included a passion for horse racing.[49] The first Stroudwater poem, 'Sabrina Speaks', suggests one of the main promoters was young in years and wise in counsel though it does not indicate which of these promoters is the one in mind.[50]

The motives of these nine local men were twofold. In the first place they believed that a once and for all capital investment would reduce their substantial transport costs and enable them to import more coal at greatly reduced prices. In the second place a navigation was expected to produce a generous return on their investment particularly if the demand for existing goods increased and if it became possible to import new varieties of goods at competitive prices which had previously been excluded from the local market by the cost of land carriage. The group of promoters also had one small additional advantage – at least five of them had grouped together on at least one previous occasion to offer a reward for information leading to the recovery of stolen cloth.[51]

Once these promoters had decided to build a navigation and apply to Parliament for the appropriate powers, one of their first tasks was to seek expert advice from an engineer who already had experience of improving rivers for navigation elsewhere and whose name was preferably widely known and respected. Their attention was drawn to John Hore of Newbury. Hore's earliest experience of engineering may have been gained as a millwright since his family were established Newbury maltsters.[52] John Hore had also been involved in making the River Kennet navigable from Reading on the Thames to Newbury 'in Berkshire over the period 1718–23. His experience in building the Kennet Navigation was particularly relevant for the problems facing the budding Stroudwater proprietors. The original intention of the Kennet undertakers had been to reduce the consumption of water involved in navigation and ease the passage of boats, by building locks at the weirs on the existing river but it soon became clear to them that 'the circuitous course of the river very much extended the distance between the two towns' of Reading and Newbury and that an improvement only to the existing river would not produce an efficient navigation.[53] The Promoters of the Kennet navigation therefore adopted a much more ambitious scheme which John Hore suggested to them. This included the construction of pound locks and new cuts to avoid the most devious meanders of the river, shorten the route and to by pass at least some of the mills on the river itself.[54]

The Kennet Navigation, completed in 1723, had twenty locks and was eighteen-and-a-half miles long of which only seven were original river and the remainder artificial cuts. In common with so many improvements to inland navigation in England during this period, the Kennet occupies an intermediate place between the simple river improvements of earlier times and the artificial canals with independent water supplies. To contemporaries of the period it was irrelevant whether the new waterways were the more simple river improvements, hybrid schemes like the Kennet or Wey with several features of the later canals incorporated in them or wholly artificial constructions. In the case of the Stroudwater, the failure of the undertakers to distinguish between a canal and a river navigation eventually led to expensive litigation. To the waterway improvers of the time all the new navigations carried goods with comparable efficiency and any distinction between a river and a canal navigation seemed to be either trivial irrelevant or of little consequence.

The use of short artificial cuts to bypass the most difficult sections of river was a long established principle years before the Duke of Bridgewater was born. So were the ideas of locks, weirs and towpaths. Inland navigation itself in Britain had an even longer history. The idea of artificial inland waterways was an already well established principle on the continent by the late seventeenth century, seventy or so years before Francis Egerton began to busy himself with his affairs at Worsley. The Canal du Midi, for example, was built during the late seventeenth century and it was by no means the first of such waterways. In England the Exeter Canal, opened in the mid sixteenth century, to supersede an unsatisfactory river navigation, was the first artificial canal since the Romans had cut their Foss and Car Dykes about fifteen centuries before. Around 1700 the short Mackworths Canal had been built from the River Neath to the Melyn works with an artificial water supply but no locks. By 1736 Thomas Steers, Liverpool's first dock engineer, was building the Newry Canal in Ireland as a link between Dublin and the County Tyrone coalfield. The Newry Canal was finally opened in 1742 with an artificial cut, locks, towpath and an artificial water supply.

Those who suggest that the so called canal age began in 1761 when the Bridgewater Canal was opened from Worsley to Manchester ignore the centuries of inland navigation which preceded it. They forget the many examples of river improvement and canal building in Britain and on the continent which used all the techniques Francis Egerton used so profitably at a later date. They neglect the fact that the whole genesis and practise of canal construction had a much earlier origin and they presuppose some fundamental difference in concept between river improvements and canal construction. Even if we ignore the many canal engineers who gained their apprenticeship on the river navigations, the evidence of Thomas Steers alone indicates how much the canal engineers owed to their experience with river improvements. Significantly, too, many of the earlier outlines for river improvements included plans for artificial cuts to avoid difficult meandering stretches of river. It was, after all, only a small step from a short artificial cut on a river, to longer artificial cuts, to an admixture of artificial cuts and original river like the Soar in Leicestershire, to a predominantly manmade cut with a few subsidiary river lengths and finally to an almost wholly artificial cut on the lines on which the Stroudwater was eventually built. From here to the wholly artificial cut with an independent water supply was a step of comparatively little importance.

The promoters of many waterway improvements were largely unaware of any distinction, real or imagined, between improved rivers and navigable canals. The Sankey Navigation, for example, was originally planned as a river navigation but ended up as a wholly artificial waterway without any of the promoters being aware of the difference. The same sort of transformation overcame the Stroud water during the many years its construction was talked about although here the change of technique was brought to the attention of the proprietors in a particularly forcible manner. In any case the significant period of early canal building was in the early and middle eighteenth century precisely at the time when river improvements were at their most active. All the evidence suggests that any separate division into

canal and river ages is somewhat less than accurate. The traditional opening of the canal age in 1761 is not only irrelevant and highly misleading but a travesty of the known facts as well.

Despite some earlier misgivings and periodic financial embarassments, the proprietors of the Kennet Navigation were well pleased with the success of the waterway John Hore constructed and they had 'no thought of discontinuing him.'[55] Hore won a considerable reputation for his work on the Kennet and during the period 1725–27 was successfully involved in making the River Avon navigable from Bristol to Bath. It seems probable that it was during this period or shortly afterwards, when the success of the Avon scheme was a favourite talking point in polite Gloucester society, his name first came to the attention of the gentlemen and clothiers of Stroud and this may have been the spark which set them talking and thinking about a navigation to Stroud. It is even conceivable some gentlemen clothiers visited the Avon while it was being built and perhaps even conversed informally with Hore.

On the River Avon Hore had used short cuts again to bypass weirs and meanders and had 'adopted and executed a navigation, of which … there then existed no model in England.'[56] In addition to this, Hore prepared two schemes for improving the River Chelmer in Essex during 1729–30. One of these schemes was estimated to cost £9,355 'by making the old stream useful.' The other, costing an estimated £12,870, would be built 'by cutting thro' the higher Grounds … and making an entire new Navigable Canal.' Hore had no hesitation in recommending this second plan for 'notwithstanding the Difference' in cost he thought the 'New Cut more advisable, not only for the more easy and quiet working, but also for the Interest of the Landholders and Millers.'[57] It is clear, therefore, that by the time the Stroudwater promoters contacted him, Hore's ideas and engineering experience had led him progressively away from basic improvements to pre-existing rivers towards using artificial cuts to supplement, and in some cases largely replace, the course of the river under consideration.

John Hore probably realised at first glance that the tiny River Frome, with its small and restricted water supply, would be difficult to use for an effective navigation. In any event it would raise serious objections from the millowners who feared a loss of water supply and a consequent disruption of their trade if river water was used for locks. A navigation using artificial cuts would certainly be more efficient and might help to stem some of the more strident opposition of the millowners. Writings to Thomas Bond and the other undertakers in February 1730, John Hore suggested that 'To prevent much damages [to the mills] … I humbly conceive your intended New cut may be made from Wallbridge on the north side of the said river and be carryd into ye Old River below Bonds Mills and to be continued … (widening of same to a proper breadth for navigation) near unto your Head of Easton Mill by making a short Cut and Erecting a Turnpike or lock to pass by the last said Mill and to fall again into ye old River at a convenient distance below ye said Mill tail and be carried therein unto Froombridge, and from thence a New Cut to be made on ye south side of ye old river directing its course towards ye rising ground so s to fall into a large Ditch that parts ye [parishes] of Witminster and Frampton and so on to fall into ye Severn.'[58] Hore evidently envisaged his Stroudwater navigation would be largely independent of the main river except where it crossed from the north to the south bank of the river. The navigation would be eight-and-a-half miles long with twelve locks including one at Framilode which would be made 'sufficient effectually to prevent all Inundations 'by the tide which flowed up the Frome and with an average drop of seven foot six inches for each lock. The new cuts and the widened river would be thirty–three feet wide and five feet deep and be capable of taking craft up to sixty tons. Including full compensation for injuries to neighbouring lands and allowing £2 an acre and thirty years purchase price for all lands needed for the navigation Hore estimated that 'the whole Expence … will be under Twenty Thousand Pounds.'[59] Although the 1730 Act speaks of opening locks to provide 'flashes' of water, it is unlikely Hore proposed to use flash locks instead of the more expensive but more efficient pound

locks. In the first place, Hore had already built pound locks successfully on both the Kennet and Avon navigations and found them a great improvement on the earlier more primitive flash locks. In any case pound locks had already become a familiar sight on other rivers which had been made navigable and on the Exeter and Newry canals. Thirty-three years later Charles Vallancey was able to declare that 'we have arrived to such perfection in the Construction of these and in so simple a Manner, that … nothing more need be desired on this Subject.'[60] Secondly, flash locks were particularly wasteful of water, something which the undertakers were anxious to minimise in order to reduce the strident opposition of the millowners. Thirdly, a four inch diameter pipe, which Hore suggested would be sufficient to supply the navigation with water without prejudice to the mills, would only supply a navigation with pound locks. Finally it would be impossible for any flash locks to operate on a fall of seven foot 6 inches and far more than twelve locks would be required to climb the valley of the Frome to Stroud.

The promoters were sufficiently impressed with Hore's plan to embody it in a Parliamentary Bill which passed its first and second readings in the House of Commons in March 1730.[61] By this stage Hore had produced a more detailed outline of the proposed cuts and at least one individual was 'satisfied with [the] plan of Cutts thro' his estate.'[62] The Bill suggested tolls of 3s 6d (17½p) a ton on coals, corn, malt and grain from Framilode to Wallbridge and 5s 0d (25p) a ton on other goods with suitable reductions for shorter distances. Although these tolls were higher per ton mile than those incorporated in some later canal acts, they were still much cheaper than any other form of transport available in the locality. The Bill included the rights to build 'Locks, Wears [and] Pens' and powers to build 'such new Cutts … adjoining or near unto the same River … as they shall think fit and proper for Navigation' without any limitation on their number, length or breadth but leaving it entirely to the discretion of the undertakers who could also 'clear, scour, open and enlarge or straiten the said river' according to the plan already approved. The Bill provides for the undertakers to build the navigation 'at their proper Costs and Charges' but only hints at the organisation of the company when it refers to the prohibition on any proprietor being at 'Liberty to assign his Share or Interest till such Time as the … Navigation shall be perfected'. The implication is that the undertakers would form a company of proprietors and raise the capital themselves through an issue of shares. The language of the Bill, deliberately or otherwise, was couched in vague and indeterminate phrasing on this and several points of construction. At a later date opponents of the Stroudwater scheme were able to frustrate the proprietors by claiming that this Act entitled 'An Act to make the River Stroudwater Navigable' was invalid for any other type of construction. This 1730 Bill also included powers to build winches to draw boats up the waterway, probably because a horse towing path was not included in the plan at this stage.

The Bill also appointed 227 Commissioners 'for settling, determining and adjudicating on all questions, matters and differences which might arise' between the undertakers and any other persons including rulings on disputes over the valuations of lands required for the canal or any damages caused by construction. The Commissioners included the mayors and aldermen of the cities of Bristol and Gloucester as well as a heavy sprinkling of Gloucestershire respectability, local aristocrats, gentry, gentlemen and other noted citizens such as wealthy clothiers. It was a condition of their appointment that they should hold a personal estate of £2,000 or property worth a rent of £50 a year at least and when Robert Stephens, a petitioner opposing the Bill, protested that qualifications for commissioners on other navigations were usually much higher and might rise to rents worth £100 or £200 a year, William Halliday explained 'the inhabitants of that part of the Country were chiefly Clothiers of substance, and that being concerned in Trade, they had not large Real Estates though they had very good Personal Estates.'[63] The commissioners had absolute authority over the undertakers in the last resort and any seven of them could meet together after giving the appropriate notice in the *Gloucester Journal* and exercise their powers of supervision, direction and adjudication. It was normal practice to appoint commissioners for any new or improved navigations to ensure the undertakers

proceeded under some sort of local jurisdiction, to make sure adequate compensation was awarded and to act as a court of last resort for all decisions concerning the navigation. If for any reason, a person declined to accept the mediation of the commissioners, any seven or more of them could ask the county sheriff to summon a jury of twenty four 'able and sufficient Men' who, after summoning witnesses and assessing the issue, could pronounce a binding verdict. The commissioners had self-perpetuating powers and could appoint new members to keep up their numbers at any time. Their final function, which proved crucial later on, was that if the undertakers did not begin to make the navigation by 5 July 1732 or finish it by 5 July 1740 then the powers granted to the promoters devolved back to the commissioners who could appoint new undertakers at their discretion.

In any event the Bill was presented to Parliament with a formidable collection of supporters. Petitions from Cirencester, Malmesbury, Leonard Stanley, Painswick, Tetbury and Minchinhampton, the traders of Bristol, the city of Bristol, and the 'Owners and Occupiers of Mills' on the River Frome all came out strongly in favour of the Bill and asked Parliament to approve it without further delay.[64] Supporters of the Bill claimed that of 27,490 cloths produced in the Stroud area in 1729 only clothiers producing 1,700 cloths were opposed to the navigation. All the owners of the seventy one mills east of the town and all the clothiers east of the town too were equally unanimous. Of the nineteen mills west of Stroud on the intended navigation, two were neutral (one cloth, one com), nine were against (eight cloth, one corn) and eight were in favour (five cloth, two corn, one oil).[65] The most impressive petition came from Stroud and Bisley, signed by 794 'Gentle men, Clothiers and other Chief Inhabitants and Traders' who confidently asserted the great benefits the new navigation would bring. A saving of £6,000 a year in transport costs was the figure most widely suggested as the essence of the petitioners' claim.[66] By comparison the opponents of the Bill seemed insignificant. Fearing the loss of the coal trade, the corporation of the city of Gloucester and several city gentlemen claimed it would injure their ancient rights and privileges.[67] A few gentlemen and clothiers of the Stroud area who feared some damage to their mills also petitioned against the Bill, suggesting it would 'destroy the manufacture of Cloth in those parts to the undoing of some Thousands of Persons that depend thereon' or, if they were owners of lands, feared leakage from the navigation would damage the rich farmland and turn it into bogs or that 'such extensive powers vested in the under takers will put the Country under the arbitrary Will of the Proprietors and give them Power of destroying property of their fellow subjects as Fancy, Caprice or Spite shall incline them.'[68] The remaining opposition came from Walter Yate, of Framilode Mills who claimed his 'ancient Mills on the said Water, … and the lands adjoining to the said River, will be very much damaged or destroyed.'[69] The committee of the House considering the Bill heard all these petitions and the evidence of John Hore, Edward Baghot, William Halliday and several others.[70]

The most serious criticism of the new navigation made by the opponents of the scheme was that it would allow water to bypass their mills which were dependent on the river for water power. It was nine of the millowners in the Frome valley west of Stroud who formed the nucleus of the opposition to the Bill. According to them the navigation would leave them with insufficient water to work their mills in the summer. However inaccurate their criticism might be, the virulence of their attack on the whole idea of a navigation suggests that serious water supply problems may have already begun to develop as the growth of the woollen industry made heavier demands on the available supplies of water and that the millowners believed the problem would be aggravated by any further major abstractions. If no shortage of water existed it is hard to justify the advertisements in the *Gloucester Journal* such as that for a cloth mill at Kings Stanley where 'in the driest summer there can be no want of water' and other periodic references to disputes over water rights.[71] The objections of the landowners was that 'the meadows on each side of the canal would be turned into bogs or morasses by the water overflowing the banks, or

weeping through them' and there is certainly some evidence suggesting techniques of making artificial cuts watertight were in need of some improvement when it was suggested that ditches would help to keep adjacent fields drained and prevent oozing from the banks.[72]

Opposition to the Bill from local land and mill owners proved strong enough to induce the promoters to offer several concessions. The promoters agreed not to make cuts through any house, mill or garden enclosed within walls on 5 April 1730 especially the house, garden or yard of John Small at Wheatenhurst. Owners of lands within five miles of the navigation also gained the right to carry manure free of tolls. The crucial concession, however, was one to prevent any craft using the waterway during the period of lowest water from 25 August to 26 October each year without the consent of the majority of millowners concerned. Other clauses added to the Bill ensured the expenses of any meeting for determining damages would be paid by the undertakers and directing that all such damages awarded should be paid within three months of a judgement.[73] On 30 April 1730 the Bill passed its third and final reading in the Commons and was sent on to the Lords where, with the keen support of Lord Bathurst of Cirencester, an amendment to 'restrain the Power given to the Undertakers' was defeated. The Bill passed the Lords unchanged on 6 May and received the Royal Assent on 26 May.[74] The passage of the Bill through Parliament had been followed closely in Stroud for the *Gloucester Journal* reported 'there were great Rejoicings there, and in the neighbouring Towns, upon receiving the News of the House of Commons passing their Bill for making the River Stroud Navigable.'[75]

The rejoicings were premature for the undertakers appointed by the Act never even began to build the navigation 'nor was there any public meetings of the Commissioners held at the George Inn or elsewhere.'[76] Even among contemporaries there is some doubt about the real reasons why no progress was made with the 1730 scheme. One source, admitting that the Act was promoted with 'great spirit' thought it could have failed for want of money, or through some misunderstanding among the proprietors, or from the supposed loss of water to the millers.'[77] It is certainly easier to indicate those factors which did not cause the navigation to fail. In the first place, the lack of a suitable qualified engineer could not seriously be suggested as a possible explanation. John Hore was already an experienced and successful engineer of repute by the time he outlined his scheme for a Stroudwater Canal. Secondly it is unlikely a shortage of finance hindered the promoters. Although it is possible they launched the scheme hoping a bandwagon effect would produce the necessary capital, it seems improbable they would have promoted a Parliamentary Bill if they were aware of some possible financial embarrassment. Even if the promoters themselves were short of capital, and it is not possible to prove in detail how individual promoters stood financially, there is plenty of contemporary evidence to suggest that clothiers in general who stood to gain most from a navigation were producing a healthy surplus over and above their immediate needs of consumption. Among men of such substance it is hard to believe the full sum could not have been raised by using their personal credit standing or by pledging their mills, stocks of materials and houses as guarantees. Forms of running credit and finance were already well established within the woollen areas and the first bank in the west of England, opened by James Wood in Gloucester in 1716, had been involved in the formalisation of this procedure. Even if the promoters themselves found the burden too heavy it seems certain the £20,000 could have been raised from the thousand or so petitioning gentlemen, clothiers and chief inhabitants of the neighbourhood. In the unlikely event that this source would also prove insufficient, there were still more than enough people in the Stroud area who stood to gain so much from a navigation that the necessary cash or credit could easily have been raised by some form of subscription.

Among the several references alluding to the failure to build a navigation, two points are regularly repeated. First that there was, or might have been, some disagreement between the promoters.[78]

Secondly 'an Apprehension that the method of making Rivers navigable by Locks would be detrimental to the Mills.'[79] It seems probable therefore that any difference of opinion between the promoters centred on whether or not the Hore scheme – more expensive than a simple river navigation – would still damage the mills and result in heavy compensation.[80] Whatever the situation was, all the available evidence suggests it was the opposition of some millowners below Stroud, who had petitioned against the Bill and threatened to claim substantial damages for any interruption of their work, who made the undertakers think again.[81] Several considerations would have been in the minds of the undertakers. First, the construction of the navigation could cause some physical damage or inconvenience to the mills if the proposed scheme went ahead. Since the Act obliged them to pay full compensation, including the commissioners' expenses, any damage could become an expensive liability. Secondly, this compensation might be still higher if, once completed, the navigation changed the levels at which the mills used water for power. Thirdly – and this was the point on which the millowners were particularly vocal – water taken for the navigation would come from the Frome which the millowners already claimed was insufficient for their needs. Any further depletion of that already inadequate source might actually inhibit their production. In this event the compensation to the millowners might begin to bite deeply into the £20,000 needed for construction. The problem of water supply for the mills seems to have been most acute during the drier months of the late summer when there was 'not a sufficient supply of water to keep them going more than Two-Thirds, and sometimes not more than Half, their Time.'[82] Even supporters of the navigation were obliged to admit that a shortage existed though they affirmed it was 'less than two months a year.'[83] The gentlemen and clothiers of Stroud and district were not able to find an alternative scheme which would be acceptable to all parties and which would minimise damage and compensation to the millowners. As it was the 'scheme for making the River Stroudwater navigable … was laid aside' because it was 'generally concluded that making it Navigable was an impractical scheme'. Any further considerations were 'totally neglected … for many years.'[84]

Chapter Four References

1 GCRO D1180 5/2 Reprint of 1730 Act
2 GJ 17 February 1730: 3 Geo II cl3
3 GCRO D1180 5/2 Dallaway, William, *The Case of the Stroudwater Navigation* 1
4 JHC 21 437–38
5 GJ 6 October 1766
6 GJ 12 July 1726, 29 April 1765, 6 October 1766
7 JHC 21 437–38
8 GCRO D1180 5/2 Dallaway, John, *A Scheme to make the River Stroudwater Navigable* 3, 4
9 GCRO D1180 5/2 Dallaway, William *The Case of the Stroudwater Navigation* 1
10 GCL JX 14 21 Dallaway, Wm, *A State of the Case, and a Narrative of Facts, relating to the late Commotions, and Rising of the Weavers in the County of Gloucester* 1757
11 GCRO D1180 5/2 Dallaway, William, *The Case of the Stroudwater Navigation* 1
12 GJ 23 February 1767
13 GJ 21 October 1765
14 Rudder 711–12
15 GCRO D1180 5/1 *Reasons Offered For the Bill* 1730
16 JHC 21 437–38

17 GCRO D1180 5/1 *Reasons Offered For the Bill* 1730

18 Fisher, P. H., *Notes and Recollections of Stroud* 151 Stroud

19 Rudder 813

20 GCRO D1180 5/1 Minutes on the Second Reading of the Stroudwater Bill 12 February 1776

21 Marshall, Wm The Rural Economy of Gloucestershire 114–151789

22 GCRO D1180 5/2 Dallaway, John A Scheme to make the River Stroudwater Navigable 1, 2:6/2 Copy of evidence laid before the Jury

23 GCRO D1180 *S/2* Dallaway, William, *The Case of the Stroudwater Navigation*

24 GCRO D1180 5/2 *The Case of the Opposition*

25 GCRO D1180 5/1 *Reasons Offered For the Bill*

26 JHC 21 437–38 These are old pence equivalent to roughly 1½p and 3½p

27 GCRO D1180 5/1 Minutes on the Second Reading of the Stroudwater Bill 8 February 1776 The toll was thirteen-and-a-half old pence

28 GCRO D1180 5/2 Dallaway, John *A Scheme to make the River Stroudwater Navigable* 3 GJ 21 October 1746 The Commissioners of the Stroud, Stonehouse and Eastington turnpike charged 12½p extra for each waggon using the road from November to March

29 GJ 18 April 1749:GCRO D1180 5/1 Benjamin Grazebrook giving evidence in Minutes on the Stroudwater Navigation Bill 19 February 1776

30 GJ 15 February 1754

31 GCRO D11805/2 Dallaway, William *The Case of the Stroudwater Navigation* 1

32 GCRO D1180 5/2 Dallaway William *The Case of the Stroudwater Navigation* 1

33 JHC 21437–38. This evidence contradicts that of reference 41. Since contemporary wheat prices were around ten times the prices Baghot mentions for Gloucester (Ashton, T. S., *An Economic History of England: the Eighteenth Century* Table 1) it is possible Baghot was referring to 'a tenth of a bushel' which the Parliamentary clerk misheard.

34 GCRO D1180 5/1 Minutes on the Stroudwater Navigation Bill 19 February

35 GCRO D1180 6/2 Copy of evidence laid before Jury 19 February 1776, Minutes on the Stroudwater Navigation Bill 19 February 1776. Edward Owen suggested 56p to 61p at Wallbridge

36 GCRO D1180 5/2 Dallaway, William, *The Case of the Stroudwater Navigation* 1

37 GCRO Hyett Pamphlet 353 *The British Merlin*
 'For you no more shall fetch the neighbouring stile,
 To warm your nails or make your kettle boil.'
 GCRO CA 19 *The New Navigation*
 'For since they've nearly cut down all the wood ' and
 'No more shall steal your fuel from the wood'

38 GCL MR 5.2(2) *A Prophecy of Merlin*
 'No more lament the forge and anvil,
 For want of glowing coals must stand still.'

39 GJ 15 September 1766

40 GJ 6 October 1766

41 GCRO D1180 5/2 Dallaway, John, *A Scheme to make the River Stroudwater Navigable* 3

42 GCRO D1180 5/1 Dallaway, William, *The Case of the Stroudwater Navigation* 2

43 GCRO P217/CH/3/1 Assignment of the Charities left by the Wills of John Yeats and Benjamin Cambridge: GJ 10 October 1732, 24 May 1724

44 GJ 3 October 1727, 8 May 1739, 30 October 1739

45 GNQ 4 278

46 GCRO P217/CH/4/1 Three leases and deeds relating to Joseph Cambridge: GCL Wills 1742 162

47 GJ 24 May 1724, 8 November 1736

48 BGAS 66 217
 GCL Wills 1742 162
 GJ 24 May 1724, 2 January 1739

49 GCRO D1801/2 Sheet listing his age and date of death

50 GCRO DC/E88/17, DC/E88/18, D69 Z77 deeds and mortgages of the Hawker family: GJ 24 May 1724, 27 July 1736, 3 January 1744, 28 January 1752, 1 May 1752, 18 September 1753, 21 October 1760
 GNQ 4 517, 7 63

51 GCRO P217/CH/3/1, D1340 BI/AR, Yeats family documents
 GCL Wills 1729 57
 BGAS 58 78–80
 GJ 24 May 1724, 15 May 1744, 10 March 1747, 28 January 1752, 1 May 1752, 25 May 1756

52 GCRO CA 19 *Sabrina Loquitor* 'A satrical poem written by [the Rev. William Deighton, BA, Rector of Eastington] a Gentleman very respectable for his learning and good sense; who living near the centre of the sphere of action, was intimately acquainted with the main springs, and each particular movement of the operation'
 GCRO Hyett Pamphlet 353

53 GJ 24 May 1724

54 Household, H. G. W., The Thames & Severn Canal thesis for the University of Bristol 1954
 Skempton, A.W., *The Engineers of the English River Navigations 1620–1760*
 Trans. Newcomen Soc. 29 25–54

55 Mavor, Wm *A General View of the Agriculture in the County of Berkshire* 438 1808

56 Pound locks have a set of gates at each end of the lock operated independently so that the locks themselves may be emptied or filled to the level of water above or below the lock. Flash locks have a single gate or set of gates which operate by flushing water from the level above the lock to the level below it and by attempting to drop the general river level above the lock to that below it. Considerations of speed, safety, efficiency and water conservation make pound locks infinitely preferable.

57 Pressnell, Leslie, *Studies in the Industrial Revolution* article by T. C. Barker on 'The Beginnings of the Canal Age in the British Isles': PRO holds the records of the Kennet and Avon Canal. This reference comes from Kennet Navigation Minute Book 143

58 Mavor 438

59 Willan, T. S., *Bath and the Navigation of the Avon* Proceedings of the Somerset Archaeological Society Bath Branch 139–40 1934–38
 BM 816.m.8.58 John Hore's schemes for River Chelrner Willan 94

60 GCRO D1180 5/1 John Hore's letter address to 'Mr Thomas Bond Clothyer near Stroud' dated 3 February 1730

61 JHC 21437–38 This report suggests the locks would be seven-foot six-inches wide but since this would be inconsistent with the proposed size of vessel, it is possible this is another clerical error which should refer to the average fall at the locks. Willan, T. S., *River Navigation and the Trade of the Severn Valley 1600–1750*
 EHR 8 72

62 Vallancey, Charles *Inland Navigation* Dublin 1763

63 JHC 21 497–98, 503

64 GCRO D1180 5/1 John Hore's letter addressed to 'Mr Thomas Bond Clothyer near Stroud' dated 3 February 1730

65 House of Lords Committee Book 10 121–23 dated April 23 1730

66 JHC 21 545–51
 Sabrina Loquitor also mentions Bristol support

67 GCRO D1180 5/1 An Answer to the Reasons Offered Against the Bill

68 GCRO D1180 5/1 The Stroud and Bisley petitions

69 JHC 21 509, 512
 Sabrina Loquitor mentions Gloucester opposition

70 JHC 21 509, 512: GCRO D1180 5/1 Reasons offered against a Bill

71 JHC21509

72 House of Lords Witness Book dated 22 April 1730. The committee examined John Hore, John Bridges, Thomas Adderley, William Halliday, Nathaniel Cambridge, Edward Baghot, Richard Parker, Samuel Sansom and John Crips. The listed witnesses for the opposition were Robert Stephens, William and Ann Dyer, John Hammonds, Giles Clutterbuck, Giles Nash, Thomas Phillips, Stephen Merrett and Lewis Ball

73 GJ 12 September 1732

74 *GCRO D1180 5/1 Reasons Offered against a Bill*
 An Answer to the Reasons Offered Against a Bill

75 JHC 21 545–46

76 JHC 21 423, 437, 509, 545, 546
 JHL 23 542–44, 547, 550, 579

77 GJ 1April 1730

78 GCRO D1180 5/4 21 Papers relating to 1730 Act

79 Phillips, John, *A General History of Inland Navigation* 1795 *Gentleman's Magazine* 30 167–68

80 GCRO D1180 5/1 Dallaway, William, *The Case of the Stroudwater Navigation* 2: GJ 30 September 1755

81 JHC 28 398–99, 424–25 William Lane appointed a commissioner in 1730
 GCRO D1180 5/2 Dallaway, John, *A Scheme to make the River Stroudwater Navigable* 1
 Rudge, T., *The History of the County of Gloucester* 1803 130 Gloucester Rudder 712

82 GCRO D1180 5/2 Dallaway, John, *A Scheme to make the River Stroudwater Navigable* 1: The Case of the Opposition 3

83 Allnutt, Z., *Useful and Correct Accounts of the Navigations of Rivers and Canals West of London* 14 'from the opposition of the Millowners thereon, the intended works were prevented from being done' 1810
 Priestley, J., *Historical Account of the Navigable Rivers, Canals and Railways through Great Britain* 644 1831 'from the opposition of the millers, arising from the fear of losing their water'
 Dallaway, Wm, *The Case ...* 'at last the scheme was found impracticable and was totally deserted'
 Annual Register 3 142–24 Josiah Tucker wrote 'the property of the various mills upon it became an insurmountable objection'

84 JHC 35 502–3

85 GCRO D1180 5/1 Dallaway, William, *The Case of the Stroudwater Navigation* 4

86 GCRO D1180 5/1 Dallaway, William, *The Case of the Stroudwater Navigation* 2

Chapter Five
'His Own Private Navigation'

The first attempt to build a navigation to Stroud had ended in failure leaving the local gentlemen clothiers with their original problem of inadequate and expensive transport facilities. These existing facilities still limited the quantity of coal which could be brought up from the Severn by cart or pack horse train. This limitation in turn still discouraged any rapid expansion of the woollen trade and kept the idea of transport innovation forefront in the minds of local clothiers who could see for themselves only too clearly that persistent shortages of a vital and expensive raw material hampered the true potential of their industry.

Some clothiers turned their attention to improvements in road conditions and became involved in promoting local turnpikes. This often improved the quality of local transport conditions but failed to reduce the cost of land carriage or supply the regular quantities of coal the clothiers needed because of limits on cart weights, shortages of animals and the like. A waterway linking the Severn and Stroud remained the only real solution. This alone would allow coal to be brought cheaply and easily to the clothiers' doorsteps. The clothiers were always aware of this and in the years after 1730 made several attempts to build a waterway to Stroud. Three of these attempts, in 1755, 1756–63 and 1774–75, either had the express support of those involved in the 1730 scheme or drew most of their support from the same clothing interests. None of these attempts was successful although the Kemmett scheme of 1759-63 did leave part of the Frome near the Severn in a navigable condition as late as 1775. For the moment, though, the interest of the undertakers appointed by the 1730 Act fell into abeyance and left the initiative to anyone else prepared to concern themselves with waterway improvements.

Richard Cambridge, a local landowner, became interested in such ideas around 1740 when he decided to embark on an extensive programme of improvements to his estates at Whitminster. Born in London in February 1717, Richard Cambridge was the son of Nathaniel Cambridge, a member of the cadet branch of an old Gloucestershire family who became a successful merchant specialising in trade with the Middle East and Turkey.[1] Shortly after his son was born Nathaniel Cambridge died leaving young Richard in the care of the widow, Meriel, and her brother, Thomas Owen. Educated first at Eton, where his many friends included Lord Sandwich and Horace Walpole, Richard Cambridge went up to St John's College, Oxford, in 1734. Here he concentrated more on an active social life and his interest in literature than on any detailed or rigorous application to his studies. Leaving Oxford in 1737 without taking a degree, Cambridge joined Lincoln's Inn but again gave no serious attention to his studies. At the age of twenty-four he married Mary Trenchard, the second daughter of George Trenchard Esq. of Woolverton in Dorset and MP for Poole.

Shortly after his wedding in 1740 Richard Cambridge settled with his bride at the family seat of Whitminster House in Gloucestershire where his life, 'though easy and independent, was never idle or useless'.[2] Here, in his house on the banks of the River Frome, Cambridge lived the life of a country gentleman of ease and taste, always busy, always interested in something or other, always tolerant and generous and urbane.'[3] Richard Cambridge was already well known as a cultivated man but at

Whitminster 'be continued to cultivate polite literature ... and added to his growing reputation as a poet and man of letters. Although his 'considerable wit, great conversational powers, and much literary taste' kept him occupied, Richard Cambridge spent a great deal of time reorganising, landscaping and improving his large Whitminster estate and in 'heightening the beauties of the scenery around his seat'.[4]

Since the roads around the estate left a good deal to be desired, Cambridge decided to improve the local transport facilities as part of his general plans for development. This would have the added advantage of facilitating the movement of materials around the estate, especially stone, an essential material for some of the changes Cambridge planned. With this in mind he turned to the small River Frome which ran through the estate grounds on its way to the Severn less than two miles away. 'The stream ...' his son wrote, 'he made navigable for boats, not only as far as his own property extended, but, by the permission of his neighbours, for a distance of near three miles, and thus obtained, for his private use, at a very inconsiderable expense, what was undertaken forty years afterwards ... by the Stroud-Water Company'. Using this navigation, Cambridge 'was enabled to convey with ease the stone and other materials requisite for the various works and improvements carrying on upon his estate, he had also boats of pleasure suited to the size and the nature of the river, by which he transported himself and his friends to others of a different construction, adapted to the navigation of the Severn'. George Cambridge considered that 'Such was his turn for mechanics, that it might be called the favourite of his pursuits'.[5]

The most detailed account of this navigation comes from the reports of the Prince of Wales' visit to Whitminster in July 1750. 'It happened about the time when the improvements at Whitminster were completed that Frederick the late Prince of Wales, accompanied by his Princess, his daughter the present Duchess of Brunswick, and a large party, made a visit to Lord Bathurst at Cirencester.' During their stay at his seat, Lord Bathurst signified his intention of bringing 'their Royal Highnesses to see his place, and pass a day upon the water'. Travelling from Cirencester by way of Hampton and breakfasting at Woodchester with the wealthy clothier Onesiphorus Paul, the royal party were received by Richard Cambridge 'in his smaller boats, at the head of his own private navigation, and after landing to view the house and garden, continued their passage to the Severn, where they were conducted to the Venetian barge, on board of which, having taken their station in the most beautiful reach of the river, the whole party sat down to a well-served dinner'. After the meal the party took 'as long a sail as the time would admit, [then] returned by the same conveyance to the spot where they had embarked'.[6] There was no doubt of the success of this visit for the Prince and Princess were 'always graciously pleased to speak of this as one of the pleasantest parties in which they had ever been engaged'.

The Venetian barge was the largest vessel Richard Cambridge owned and 'was built upon the plan of those made use of in the Venetian state; the cabin ... was large enough to receive commodiously near thirty people ... [and] was very handsomely fitted up'. The means of propulsion is not mentioned but it was probably similar to another of his boats which was a 'twelve oared barge built after a plan of his own', rowed by 'his own domestics or the labourers employed in the various works'. The use of oars is confirmed in *Archimage*, a poem written by Cambridge around 1748, and which is sub-titled as including a 'Description of the Author and four of his Boat's Crew'.[7] Edward Cave, editor of *Gentleman's Magazine*, suggests a different propulsion method was used on the Frome. Cave visited Whitminster in July 1750, shortly after the royal party, and was taken 'down part of his River to the Severn' and was then 'towed back again to sup and repose'.[8]

Richard Cambridge also designed other boats including a fifty foot catamaran 'which owed its origin to the flying prow' and was 'the boat most entitled to notice ... in this flotilla'. Several other boats were

built for carrying materials on the navigation. These smaller, shallow draught boats were probably those used to carry the Price of Wales and his party down the navigation to the Severn and back again.

The precise details of the navigation Richard Cambridge built are unknown. It seems likely he improved the existing River Frome by clearing away the trees and vegetation which overhung the river and which had so impeded John Taylor's attempt to navigate the Frome in a sculling boat in 1641. Edward Cave, however, stated that at Whitminster at least Cambridge had diverted the river into an artificial channel which went past his door.[9] The route of the navigation is equally uncertain but it probably ran from Framilode joining a short artificial channel, parallel to the then existing river but slightly nearer the house, close to Whitminster House. This artificial channel, now filled in, probably ran from where the Frome divides on its way to the Severn as far as Whitminster weir. From here the Cambridge navigation followed the Frome to Fromebridge Mill near Bristol Road or even the Bristol Road itself a few hundred yards further on. Several pieces of evidence suggest a terminus at or near Bristol Road.

In the first place George Cambridge maintains that the navigation was built for 'a distance of near three miles' whereas Whitminster itself was barely two miles from the Severn. Bristol Road, on the other hand, is 'near three miles' from the Severn. Secondly the itinerary of the royal party would have brought them onto the Bristol Road, one of the few roads in the neighbourhood, where the party were received at 'the head' of the navigation. Thirdly the reports mention the party boarded the small boats at the head, set out in the direction of the Severn and on the way stopped to view the house and garden at Whitminster. The navigation, therefore, must have extended eastwards of Whitminster House. Finally, George Cambridge confirms his father extended the navigation not only through his own estate but also through the lands of neighbouring owners who gave their permission for the work.

Since the cost of construction was 'inconsiderable' it seems likely no locks were constructed. In any event, if locks had been proposed, it is likely millowners may have renewed their vocal opposition to the plan. There is, however, no evidence of how the navigation passed Framilode, Whitminster and possibly Fromebridge Mills. It is possible Cambridge evaded these difficulties by terminating the waterway just below Fromebridge Mill near Bristol Road. At Framilode the navigation could have terminated at a basin or wharf above the mill. The tidal range here would have allowed Cambridge's larger river barges to moor just below the mill and effect an easy transition from boat to barge. At Whitminster the navigation may also have been disconnected at the change of level with a small terminus for loading and unloading both above and below the mill and separate boats on each pound.[10] Perhaps, too, this apparent discontinuity partly explains the royal party's perambulation around the house and gardens at Whitminster although they would probably have alighted to view the improvements whether or not a direct waterway connection existed.

It is also a matter of speculation whether the navigation used any new cuts, whether it had any direct navigable connection with the Severn, who apart from Cambridge was responsible for the design and construction, whether the millowners objected and, if so, how their views were overcome, whether Cambridge sought or was granted permission from the commissioners appointed under the 1730 Act who still retained a right to appoint new undertakers, whether any of the commissioners or earlier undertakers aided, advised or encouraged him in this venture or whether neighbouring landowners helped pay any of the costs. William Whitehead's poem, however, suggests knowledge of the Cambridge navigation was not limited to the Whitminster area and, since Cambridge was active in the social life of the county, it seems certain the earlier undertakers and other men of comparable interests in the locality would at least have been aware of it.

The Cambridge estate records are lost so it is also uncertain what types of traffic were carried on the waterway, where most traffic originated or whether Cambridge encouraged traffic apart from those for

his own estate. It is not even possible to be certain about when the navigation was built or how long it took to construct. In all probability it was started soon after Cambridge arrived at Whitminster around 1740–41. George Cambridge confirms it was built about forty years before the successful Stroudwater company opened its canal in 1779. This places construction sometime early in the 1740s. Logically Cambridge would have started the navigation before the general estate improvements began so he could bring in materials much easier. In any event the navigation must have been completed by the time of the royal visit in 1750 when all the general estate improvements were also finished.

What is certain is that Cambridge never envisaged his navigation as part of some longer waterway between the Severn and Stroud although he might have welcomed an extension built by a properly constituted canal company. The navigation be built was primarily for his own personal use as part of the estate improvements. It was, in the words of his son, his 'own private navigation'. In 1751 Cambridge left Whitminster for London moving shortly afterwards to Twickenham where he lived happily with his wife until his death in 1802. The reason for their move is unknown but it was perhaps connected with the death of his uncle and former guardian, Thomas Owen, in 1748 who left a substantial legacy to his nephew on condition he added the name Owen to his own. Cambridge let his estates at Whitminster but allowed the house there to fall into ruins until it was repaired in the nineteenth century.

Although this private navigation may soon have silted up without his supervision Richard Owen Cambridge remained involved in later proposals for navigations in the Frome valley. In 1756, for example he was appointed a commissioner of the navigation to help replace some who had died since 1730. There is some evidence to suggest that when John Dallaway produced his *Scheme To Make the River Stroudwater Navigable* that be proposed using the existing Cambridge navigation west of the Bristol Road and only constructing new cuts on the river between Bristol Road and Stroud.[11] The unsuccessful Kemmett navigation of 1759–63, which planned to use cranes instead of locks, probably negotiated with Cambridge for its use and perhaps modified his existing waterway. Although Cambridge did not buy any shares in the successful company of proprietors in 1776 his support as one of the major landowners in the district was particularly welcome and was 'shown … by the … acknowledged assistance which … [he] gave to the Stroud [water company]'.[12] Large parcels of his land at Whitminster were bought by the new proprietors in 1775 and Cambridge was most amenable to their suggestions for a canal navigation through his lands. On several occasions, too, he agreed to allow the proprietors to vary the line at Whltminster and sold them extra pieces of land for the purpose. Cambridge's interest in canals and his estates remained with him throughout his life although by 1794, when he wrote to Nathaniel Winchcombe in Stroud, he complained the proposed Gloucester & Berkeley Canal would be 'of no utility' since vessels could use the Severn free of tolls. Although he still declared himself in favour of canal construction, Cambridge felt he must oppose this new scheme lest it should make the flooding on his estate worse than that already caused by the now open canal to Stroud.[13]

Chapter Five References

1 Cambridge G. O., *The Works of Richard Owen Cambridge* Stroud 1803 Altick, Richard 'Richard Owen Cambridge; Belated Augustan' unpublished Ph.D. thesis for the University of Pennsylvania 1941
 DNB 5 276–77
2 Cambridge, G. O., 11–14

3 Altick, Richard 2

4 Johnson, Samuel (ed), *The Works of the English Poets* 18 227–33 Stroud 1810 The poem by William
 Whitehead, written about 1751, is addressed to Richard Owen Cambridge. Whitehead was one of
 Cambridge's many literary friends.
 'That Caesar did three things at once
 Is known at school by every dunce,
 But your more comprehensive mind
 Leave pidling Caesar far behind.
 You spread the lawn, direct the flood,
 Cut vistas through or: plant a wood,
 Build China's barks for Severn's stream,
 Or form new plans for epic fame,
 And then, in spite of wind or weather,
 You read, row, ride and write together.'

5 Cambridge G. O., ll–14

6 GJ 24 July 1750

7 Johnson, Samuel 240–42
 'But with his wondrous and all–powerful breath,
 And the bare motion of his felon hand,'
 and
 'Als his behests four vizards sage obey
 Each waving in his hand a powerful wand.'

8 *Gentleman's Magazine* 20 331

9 Fisher, P. H., Notes and Recollections of Stroud 122–23 Stroud 1871

10 Cambridge, G 0 11–14

11 See Chapter Seven

12 GCRO D149 E 86

13 GCRO D149 E 86

Chapter Six
The Dallaway Scheme

The strength of the opposition to the 1730 Act and the failure of the undertakers to get any serious construction work underway led to a good deal of local scepticism about the proposed waterway and many of the principal inhabitants concluded the determined views of the millowners made it an impractical scheme.[1] Not everyone shared this opinion however. John Dallaway of Brimscombe, a gentleman and wealthy clothier of repute, had always been a strong supporter of the Stroudwater scheme. His connections with the proposal stemmed from his prominence as a local clothier interested in improving transport facilities for the thriving woollen industry and from his appointment as a commissioner under the original Act of Parliament.

The 'Spirit for such an Undertaking' began to revive sometime in late 1754 or early 1755 possibly encouraged by the increasingly important part industry now played in the national economy and the relatively less important part now held by agricultural and related interests. The news that 'in the Ensuing Parliament, there will be a far greater Number of Merchants and Trading gentlemen than ever before appeared in the House of Commons' perhaps tempted Dallaway to wonder whether these more powerful industrial and commercial interests would not help him override any opposition from some of the millowners on the Frome.[2] Locally, too, the woollen industry was in a strong position and pressing once again on limitations like transport which hampered further expansion. 'There is at this Time the *Gloucester Journal* reported 'as great a demand for Woollen Goods for Exportation as has been known for many Years past' and as a result all hands were employed in the western woollen trade.[3]

Dallaway attempted to encourage this revival of interest by promoting a subscription among his friends and business associates to cover the expense of re-surveying the river and calculating the probable cost of construction. Although there is no clear indication of the identity of all the supporters of Dallaway's survey, they would probably include several of the new commissioners appointed the following year to supplement those from the 1730 Act. Many of these original commissioners were now incapacitated, no longer active or long since dead. Attendance records at later meetings of the commissioners after 1755 suggest that the regular attenders such as William and James Dallaway, Richard and Samuel Arundell, Samuel Hawker, Joseph Wathen, Richard Aldridge the Younger, Dean Paul and Peter Leversage may have been among his leading supporters.[4]

William Dallaway, an eminent clothier, was the eldest son of John Dallaway and worked as a partner with his father in their prosperous woollen business. Through his wealth and position, he became a leading county citizen holding the post of High Sheriff of Gloucestershire in 1766 and later becoming the main force behind the schemes of 1775–76. James Dallaway, one of two younger brothers, was also a successful partner in the family business and eventually went into partnership with John Hollings, the Stroud mercer, to establish the first local bank. Both the Dallaway brothers were instrumental in raising the £20,000 thought necessary to build the navigation twenty years later in 1775. All the family occupied an ancient house at Brimscombe called Biggs Place which adjoined their extensive Clothing mills.[5] Samuel and Richard Arundell were also local clothiers although there is some evidence to

suggest Richard Arundell was involved in other trades like baking bread and selling turnip seed.[6] The Samuel Hawker referred to may be the same man as the one involved in the 1730 navigation or else a close relative, probably his son. In any event he too was a clothier with mills at Wallbridge near Stroud.[7] Joseph Wathen, described as a gentleman and clothier, built up a flourishing woollen trade in the Stroud area and became a leading citizen of the town. The remaining three supporters of consequence had a more mixed background. Richard Aldridge the Younger was a mercer also involved in tallowchandling. Peter Leversage was a local gentleman heavily involved in turnpike improvements and Dean Paul may have been the Stroud surgeon referred to in several instances.[8] Despite this slightly wider spread, the basic pattern of support for the navigation remains comparable to that of 1730. All the supporters lived in Stroud or its immediate neighbourhood. All of them were men of position and substance and the majority were directly involved in the woollen industry or some other branch of trade.

To survey the river and estimate the probable cost of construction, John Dallaway employed three different groups of engineers from different backgrounds and with different experience. The work on surveying the river, which was certainly started before September 1755, was undertaken by John Willets, Thomas Chin, Thomas Bridge, Richard Gibbs, Joseph Parsons, Benjamin Holt and, most notably, Thomas Yeoman, the well-known engineer who was also involved in later attempts to make the Stroudwater navigable.[9] Although Dallaway never mentions why he employed three different groups of surveyors, it seems possible that he was attempting to find a scheme acceptable to the millowners. However, there is some suggestion that since they were employed at different times during that year Dallaway may have been dissatisfied with earlier plans and decided to take a second and then a third opinion.[10] Whatever the reason, the news of a revival of interest in building a navigation began to spread and an advertisement in a September issue of the *Gloucester Journal* announced the surveyors had found a scheme not only practicable but comparatively simple to construct.[11] It was certainly true that the projected navigation would not involve any serious engineering problems. The proposed route lay across a broad, low-lying plain for the most part rising to only a hundred feet or so above sea level at Wallbridge. No tunnels or heavy lockage were required and what few aquaducts were needed were little more than glorified culverts. There were, in short, no difficulties which might in other circumstances have raised the price of construction to prohibitive levels.

It soon became clear, however that the virulent opposition which had fought the 1730 scheme remained as active as ever. In early October an unsigned advertisement in the *Gloucester Journal* alleged that the estimates already circulating of the probable cost of construction were highly inaccurate since they failed to include the heavy legal charges which would be incurred in arbitrating the substantial damages resulting from construction, that the scheme was wild and impracticable and that the suggested benefits were altogether chimerical and uncertain.[12] John Dallaway quickly defended his scheme and asked the public to show a little patience as the entire scheme would be published as soon as several more surveyors had completed their estimates and proposals.[13] Further public discussion continued in a later issue when an unnamed Stroud manufacturer and millowner defended the scheme at great length laying particular emphasis on the plans for more than adequate compensation for any damages and on the more serious issue of water supply for the mills on the Frome. The new scheme, he suggested, would not lead to any loss of water supply and even if it did the undertakers were proposing to build a reservoir at the head of the canal at Wallbridge to store water from the Frome which normally ran to waste on Sundays when the mills were not working. This alone would be more than adequate to provide a sufficient water supply for the navigation.

The idea for a reservoir, specifically built to use water the millowners could not use, indicates clearly that the problem of water supply was the main division of opinion between supporters and opponents of

the scheme. The plan for a reservoir was a deliberate attempt to allay the fears of those millowners who thought a navigation would use supplies of water desperately needed by the mills themselves in the drier months by abstracting water and so reducing the volume of the Frome. Even so some millowners still claimed construction would damage their weirs and that this would have the same effect by reducing the head of water needed to supply the power. The idea of a reservoir seems to have come from Thomas Yeoman who later declared he had been convinced such an arrangement would be necessary at the head of the canal since his first survey in 1755.[14] Dallaway himself even claimed a reservoir would actually supply the mills with more water than they might lose through the operation of locks by conserving Sunday water which normally ran to waste.

John Dallaway's detailed proposals were contained in a pamphlet completed on 8 December 1755 and published by Mr Bond, the Stroud bookseller, for 6d (2½p) a copy in the first week of January 1756. Is In this Dallaway marshalled all the familiar arguments for the navigation. Coal carriage from Framilode to Stroud, now costing 7/– (35p) a ton in summer and 8/– (40p) a ton in winter, could be cut to only 3/6d (17½p) if a navigation was built. Cheaper transport costs would increase the supply of articles already bought in the locality and produce an additional range of goods previously excluded by the vessels of up to seventy tons burthen as far as Fromebridge – by example of the French who had recently expanded their waterways network to advantage – and the possibility a navigation to Stroud might bring the Thames and Severn project closer to fruition, were argued as points in favour of the waterway. The plan proposed the new navigation should use the existing River Frome wherever possible, widening and deepening the course to allow vessels of up to seventy tons burthen as far as Fromebridge, nearly three miles from Framilode, and of up to forty tons burthen as far as Stroud. The navigation would follow the Stonehouse branch of the river which the surveyors thought would be cheaper and easier than the alternative Stanley Water branch. Since the nine-and-a-half mile navigation would pass fourteen mills between Stroud and the Severn, Dallaway suggested a lock and short cut should be built at each mill to bypass the existing weir. In addition two more locks would be built, one each at the parting and joining of the river branches. By this time the principle of pound locks was well established on inland navigations in Britain and it is certain Dallaway intended to use them in his scheme. Their clear advantages produced not only a more efficient and effective waterway but helped to minimise two of the millowners' greatest fears, pound locks used only one lock full of water for each boat and would not destroy existing weirs or alter water levels. Apart from the sixteen pound locks Dallaway planned four staunches or flash locks at Eastington, Leonard Stanley, Ryeford and Dudbridge.[16] Their precise function is not certain though it is probable they were planned to prevent any significant changes in water level on particular stretches. In a field at Wallbridge, Dallaway planned his two-acre, two-feet-deep reservoir to collect enough water every Sunday while the mills were idle to fill forty one locks if sufficient care was taken with the water. The reservoir would release a 'proper bore' continuously during the following week and so help to regulate the supply of water to the mills.

The surveyors finally agreed on an estimate of £8,145 for construction. This was substantially less than the £20,000 suggested in 1730. Part of the difference might be accounted for by the intention to use the existing river rather than dig an artificial cut. At least one supporter of the navigation claimed it was the result of improvements in the techniques of constructing navigations since the earlier date.[17] Erring on the side of caution the surveyors recommended Dallaway and his friends should raise £10,000 to cover any unexpected additional expense and to provide for emergencies. The estimate included purchasing nine acres of land at £50 each, spending £1,000 to build the first lock at Framilode sixty feet long, fifteen feet wide and sufficiently strong to withstand the powerful Severn tides. Whitminster and Fromebridge Locks would be built to the same size but would cost only £450 each. The other thirteen locks, probably

planned with smaller dimensions, would cost £300 apiece apart from the lock at Lodgemore which would cost £350. Since these costs alone add up to £6,300 it seems likely Dallaway did not intend to spend any considerable sums on the existing river but to concentrate his resources on achieving a satisfactory change of levels. Surprisingly Dallaway planned to spend only £200 cutting the works and widening the river. This suggests either a serious underestimate by the surveyors – unlikely in view of the number and reputation of the surveyors involved – or that little work of this sort was needed on the river particularly perhaps on the lower reaches where the Cambridge improvements might still be generally intact.

Dallaway proposed that the £10,000 needed for construction should be raised by a subscription of a hundred shares of £100 each with a deposit of £25 on each share. During the period of construction, estimated at five years, and the early years of operation the navigation undertakers would pay 5% interest on the loan. After payment of interest, the profits of the navigation should be paid into a sinking fund which would pay off the cost of construction, within seventeen years and so eliminate the loans. Once the construction costs were repaid and the 5% interest paid up to date tolls were to be reduced to minimal levels sufficient only to keep the works in full repair. In short Dallaway envisaged the navigation would be a work of improvement financed by the locality rather than a profit malting venture designed to 'gratify the lucrative Views of Private Adventurers'.

Until both Joan and interest were fully repaid, Dallaway suggested tolls of 2/- (10p) a ton from Framilode to Wallbridge or only 1/- (5p) a ton as far as Fromebridge. To encourage return cargoes, which were not expected to be substantial, export tolls were set 1/- (5p) a ton from Wallbridge and 6d (2½p) a ton from Fromebridge. The total annual toll income was established at £1,175 of which £650 would come from coal imports alone and around £175 from general exports. Traffics, which were expected to increase once the new facilities were operational, might include 7,000 tons of coal a year, 1,500 tons of corn and 2,000 tons of assorted goods. Exports, estimated at around 3,500 tons a year, would consist primarily of corn malt, meal and other goods. Finally Dallaway recommended in his pamphlet that a meeting of the remaining commissioners appointed under the 1730 Act should be held at the George Inn at Stroud as soon as possible to appoint new commissioners and encourage the attendance of those willing to promote the undertaking. Dallaway realised the executive authority for supervising the construction remained not with the former company of proprietors or any board of undertakers but with the old commissioners of the navigation. They alone could fill vacancies in their ranks by appointing new commissioners and so prolong their corporate identity. Since, in the final analysis, only the commissioners could exercise the powers of the Act and appoint new undertakers it was essential for Dallaway to arrange a successful meeting of commissioners if his scheme was to proceed.

Following the publication of his proposals, John Dallaway was active in attempting to get the remaining commissioners to meet together. In this be was hampered by at least three major difficulities. In the first place it was no easy task to arrange a meeting of sufficient commissioners to form a quorum of thirteen. About one hundred and sixty commissioners had either died since their initial appointment, moved were away from home, were uninterested or refused to act. If Dallaway was unable to collect a quorum the commissioners would not be able to approve his scheme. Worse still without a quorum the commissioners could not appoint any new members to perpetuate their authority. If this lapsed a new Act of Parliament would be essential to recreate a new executive authority. All this would delay construction considerably. The second difficulty was that Dallaway had to encourage the acceptance and appointment of new undertakers to ensure their powers remained viable. Thirdly, he had to get the newly appointed undertakers to approve his outline plans, agree to open a subscription of £10,000 and appoint himself and probably his main supporters as undertakers responsible for building the navigation.

Dallaway was anxious to ensure that any new commissioners were sympathetic to his plans and in the months following publication he probably spent some considerable time encouraging his supporters to stand as commissioners and inducing other prominent and favourable individuals to do the same. It is significant chat many of the members of leading clothier families were nominated as commissioners later in the year. In any event John Dallaway was ready to go ahead by 13 July 1756 when he inserted an advertisement in the *Gloucester Journal* asking all the remaining commissioners to meet at the George Inn on Friday 3 August at 11 a.m. to appoint new undertakers and announcing that proposals for establishing a fund of £10,000 would be exhibited at the same time and place. However, opposition to the scheme for any navigation remained as active as ever and shortly afterwards another advertisement appeared suggesting commissioners should not attend the meeting and so deprive it of a quorum or give any assistance to this hazardous, precarious, and perhaps impracticable Scheme'. The advertisers threatened to call a meeting of those likely to suffer from a navigation 'to consider the most proper Means to defeat the Attempt'.[18]

Nevertheless the meeting at the George Inn went ahead as planned although only ten commissioners attended including John Dallaway himself and the meeting had to be adjourned until 3 September since it failed to meet the minimum quorum of thirteen. All commissioners were once again informed of the urgency of the business under discussion. As a result the meeting on 3 September was more successful and the fourteen commissioners then present appointed nearly one hundred and thirty new commissioners capable of exercising all the powers of the 1730 Act including the appointment of undertakers. From then onwards only John Dallaway and Richard Aldridge the Elder of the commissioners originally appointed made anything other than an occasional appearance at meetings of the commissioners. Eleven commissioners never attended again and the remaining two only attended on two subsequent occasions several years later. As on previous occasions the list of new commissioners included a cross section of the local respectability and men of substance. County names such as the Duke of Beaufort, Lord Berkeley, Lord Bathurst and Lord Chedworth were in evidence. More significant were the large numbers of successful and prosperous businessmen, especially clothiers, many of whom were financially involved in building a navigation at a later date and most of whom were known to be sympathetic to the idea of a Stroudwater Navigation and could be expected to give Dallaway their full support. These included Richard Aldridge the Younger, William and James Dallaway, John Colborne, Samuel, George and Richard Hawker, John and William Holbrow, Dean Paul, Peter Leversage, James Winchcombe, Joseph Wathen, Thomas and Samuel Baylis, Richard Owen Cambridge Esq., as well as Fream, Samuel and Richard Arundell and a host of other names of minor clothiers and county landowners. As on previous occasions, all commissioners had to swear to holding a personal estate worth £2,000 or property worth £50 a year at least.

It seemed a confident enough start to the new plan for a navigation to Stroud although there is no confirmed record of any mention of any detailed consideration of the proposals or of any subscription to raise £10,000 at this meeting. However the Dallaway scheme seems to have run into serious difficulties at about this point for at two subsequent meetings in January and July 1757 insufficient commissioners attended to form a quorum and no business was transacted. There were at least two immediate problems which might have given the supporters grounds for second thoughts and account for the passage of nearly a year without any material progress. In the first place the Seven Years War, which had broken out in 1756, had driven up interest rates. In December 1755 Dallaway had been confident he would have no difficulties in raising the £10,000 required and that the 5% interest be planned to offer would be more than 'sufficient Encouragement to induce those who had Money to spare to become Subscribers'. By July 1756 be was proposing an interest rate of 6% should be paid.[19] A more serious factor was that the position

of the clothing industry had deteriorated while the plans were under consideration, perhaps because of the dislocations of war, so that by the date of publication of Dallaway's scheme he was suggesting that a navigation might help to remedy the 'low state of our Manufacture [which] is well known'. By early 1757 it was calculated that about £50,000 had been lost locally through bankruptcies and the fall in foreign trade resulting from growing French competition based on cheaper labour.[20] The riots lootings and general disturbances which resulted from the rising of local distressed weavers and other cloth workers eventually involved the military. The prolonged dispute and bitterness kept the clothiers and other principal inhabitants of the neighbourhood fully occupied for some months.

By the early months of 1758, however the worst of the rioting and the clothing crisis had passed and although a meeting at the George Inn on 6 January again failed to provide a quorum a meeting on 3 February received a Proposal for making the said River Navigable, to be immediately undertaken and executed.'[21] A further meeting of commissioners was arranged for Thursday 2 March at 11 a.m. 'in order to take such Proposal into Consideration', inviting any others who had any proposals to make the river navigable to attend and state their case after which 'the most advantageous Proposal for the Good of the Publick will then be accepted'.

At the meeting on 2 March it was finally resolved that the proposals offered by John Dallaway should be the plan adopted to make the river navigable and that they should open a public subscription of £10,000 dividing into a hundred £100 shares.[22] A committee of twelve was appointed, including most of the names of supporters and newly appointed commissioners listed above, to draw up articles for opening the subscription at the George Inn on Friday 7 April at 1 p.m. where, it was hoped, 'those who are inclined to promote an Undertaking salutary to Trade, and beneficial to the Poor ... [may] encourage the same by their Attendance', especially as it was agreed to allow the £100 to be paid in 'easy payments'. In addition a further seventy two new commissioners were appointed to ensure attendance figures were kept up to strength.

Initially the subscription met a favourable response. On the first day it received 'considerable Encouragement.'[23] By 15 April it was 'above half filled up.'[24] Soon afterwards investors were urged not to delay if they wanted to make sure of a holding though the advertisement probably included more bravado than accuracy.[25] By 17 May, however, the commissioners were losing a little confidence. They announced the subscription would stay open for those who had still not had the opportunity to subscribe.[26] By 26 May, when the committee appointed to supervise the fund reported to the commissioners that only £6,900 had been promised, it was obvious the Dallaway scheme was not likely to proceed. The disappointment was already clear to John and William Dallaway who did not even attend the meeting. James Dallaway, who did attend, was present for the last time. By late June, although the commissioners were still prepared to meet and try to fill up the subscription, they were also prepared once more to 'consider the alternative Proposals offered for making the said River Navigable'. These 'alternative Proposals' were submitted by John Kemmett, Arthur Wynde, James Pynock and Thomas Bridge.[27]

Although the immediate cause of failure for the Dallaway scheme came from insufficient money subscribed to begin construction, the underlying cause for this financial reticence must lie elsewhere. The prosperous gentlemen clothiers of Stroud, though perhaps a little rattled by the Seven Years War, were not short of capital or sources of credit. The most likely reason for the shortage of cash is that the Dallaway scheme foundered on the same problems which halted the 1730 promoters and which forced them to question the suitability of locks to effect a change of level. This severe re-assessment was undoubtedly induced by some of the millowners on the Frome below Stroud who maintained any navigation with locks would interrupt their water supplies, damage mills and weirs, change water levels and cut the amount of water power they could generate. If any of these repeatedly articulated fears held

any substance, the promoters would face substantial claims for compensation. Perhaps the promoters wondered whether these claims alone would make the Dallaway scheme impractical.

Nevertheless the Dallaway scheme retains a general interest since it shows a considerable departure from the earlier ideas of John Hore and a return to the concept of making the Frome navigable rather than building an artificial canal. As the commissioners them selves admitted, the way was still open for someone else to suggest a scheme which would reconcile the conflicting interests of promoters and millowners. And that was where John Kemmett came in.

Chapter Six References

1 GCRO DI 180 5/l Dallaway, John, *A Scheme to make the River Stroudwater Navigable*: GCL R13 1755 identical copy
2 GJ 14 May 1754
3 GJ 25 November 1755
4 GCRO D1180 Cl/l Commissioners minutes 13 August 1756, 3 September 1756, 7 January 1757, 8 July 1757, 6 January 1758, 3 February 1758, 2 March 1758, 26 May 1758, 30 June 1758, 4 August 1758, 29 September 1758, 1 December 1758, 12 January 1759, 8 April 1761, 28 August 1761
5 Gray, lrvine, *James Dallaway* BGAS 81 208–10
6 GJ 4 February 1746, 3 July 1759
7 GJ 27 JuJy 1736
8 GJ 26 October 1736, 4 May 1738, 12 September 1752, 6 February 1753
9 GJ 30 September, 1755
10 GJ 14 October 1755
11 GJ 30 September 1755
12 GJ 7 October 1755
13 GJ 28 October 1755
14 GCRO D1180 5/1 Minutes of the Committee of the Stroudwater Navigation. Gray, Irving, *James Dallaway* BGAS 81 208–10
15 GCRO D 1180 5/2 Dallaway, John Front Cover
16 GJ 30 December 1755
 The Dallaway plan, however, shows sixteen locks and four staunches. The text proposes fourteen locks and two staunches.
17 GJ 28 October 1755
18 GJ 27 July 1756
19 GJ 13 July 1756
20 GJ 8 March 1757 announcing the publication of William Dallaway's *A State of the Case and Narrative of the Facts Relative to the Late Rising of Weavers*.
 For further details of the disturbances and the decline of trade see GJ 21 December 1756, 8 March 1757, 4 October 1757, 25 0ctober 1757, 19 Deccmber 1758.
 Bankruptcies of Stroud and district clothiers listed in the *Gloucester Journal* were
 1732 1 GJ 19 February
 1744 1 GJ 27 November
 1746 1 GJ 23 December
 1750 2 GJ 13 March, 8 May

1753 1 GJ 14 August

1755 2 GJ 24 June, 11 November

1756 4 GJ 10 February, 24 February, 8 June

1757 1 GJ 15 March

1758 3 GJ 31 January, 1 February, 18 April

1760 1 GJ 30 December

1761 1 GJ 17 March

1768 3 GJ 16 May, 23 May, 6 June

1771 4 GJ 3 June, 1 JuJy, 18 August, 16 September

1772 5 GJ 9 March, 11 May, 7 September, 5 October, 23 November

1773 3 GJ 17 May, 24 May

21 GJ 14 February 1758

22 GCRO D1180 CI/l Commissioners minutes 2 March 1758:
 GJ 28 March 1758

23 GJ 11 April 1758

24 GJ 18 April 1738

25 GJ 25 April 1758

26 GJ 23 May 1758

27 GCRO D1180 CI/1 Commissioners minutes 26 May 1758

Chapter Seven
'A Chimerical, Crack-Brained Fellow'

As the Dallaway scheme began to falter, the Stroudwater commissioners were obliged to take stock of the situation. Despite continued efforts by different promoters and two sets of commissioners over a quarter of a century they were still unable to get a navigation built between the Severn valley and Stroud. This left the woollen trade, now reviving after the disturbances of the mid-1750s, without the innovation of the cheaper and more reliable transport links it needed if the industry was to meet a growing demand for its products in full. With the summer of 1758 wearing on it became increasingly clear to the commissioners that they would be unable to raise enough capital to proceed with the scheme John Dallaway prepared although as late as 27 June they were still considering proposals to fill the subscription and raise the full £10,000.[1] The commissioners, too, were only too aware of the loudly articulated fears and repeated assertions by some of the millowners drawing their power from the River Frome below Stroud who once again maintained that any navigation with locks would lead to a severe loss of water, deplete the power available at their mills and so damage not only a few local woollen mills but several other small industrial works on the river as well.[2] Somehow or other the commissioners had to find an alternative scheme which would minimise financial costs and compensation, build the much needed waterway and allay the opposition of some of the millowners at the same time.

The idea for an alternative scheme originated from Thomas Bridge of Tewkesbury, one of the engineers who assisted Dallaway in surveying the Frome and producing the scheme of 1755. Bridge conceived the idea of using cranes instead of locks to effect the change in level.[3] It is probable Bridge originally thought of this idea as a direct result of the difficulties the commissioners were encountering with the millowners. Although it is not possible to date the origin of Bridge's ideas, it would probably come from some time after the opposition to the Dallaway scheme became public in the autumn of 1755. Collaborating with Dallaway, Bridge had no doubt noticed the remains of the recent Cambridge navigation during his survey and wondered how the local landowner had managed to overcome the objections of the millowners. If, as seems likely, Cambridge never built any locks on his private navigation he must have used some other method of moving the materials for his estate improvements around the mills at Framilode and Whitminster. Cambridge probably used estate labour to move the materials from the lower to the upper pound although it is not entirely improbable that with his interest in innovation Cambridge used other methods, perhaps even small cranes, to supplement his workers. Whatever the detail of transhipment, Bridge must have realised that Cambridge had implemented a principle which would meet all the millowners' renewed objections. From then onwards Bridge undoubtedly championed the idea of a navigation without locks and set about devising some method to tranship the goods in larger volumes than Cambridge alone had needed.

Bridge's patented plan for a machine navigation shows a platform and superstructure erected on piles driven into the ground. The superstructure contained two pivoting cranes based on wheels running on the platform, a central axle with one single and one double grooved pulley. These pulleys supported three ropes … one to the crane hoist, another to a windlass near the platform and a third to a hanging

bucket. A flow of water was conducted through the platform floor to fall into the bucket. As it filled, the bucket was supposed to weigh more than the cargo attached to the crane hoist. The bucket then descended lifting the cargo out of the boats. When the bucket descended to the lowest possible level, it struck a pin which opened a flat valve which in turn emptied the bucket allowing it to rise again dropping the now unloaded crane hoist back into the cargo hold. A ratchet and catch prevented the bucket rising unexpectedly if it emptied of water by accident and a windlass was installed to allow boatmen to assist the work of the bucket if the cargo was heavier than the contents of the bucket. This method of hoisting by means of a balancing bucket of water had been patented in 1750 by Michael Meinzies although Thomas Bridge was the first man to try and apply the principle to navigation.[4] Bridge claimed it would take only twenty minutes for cargoes to be exchanged on a machine navigation adding for good measure that boats on the Avon took at least forty minutes to pass a lock.[5] This was an accurate if selective truth. The locks on the Warwickshire Avon were the old fashioned flash locks which were laborious to operate. Bridge omitted to mention that the pound lock, by then a standard feature of all improved navigations, had already reduced the locking time to only a few minutes.

Three other Tewkesbury men considered the innovation sufficiently practical to form a partnership with Bridge and offer themselves as builders of machine navigations. John Kemmett, who became leader of the group, was an ironmaster. His partnership with Bridge probably developed soon after Bridge conceived the crane idea. Bridge could have conveyed the idea to Kemmett who lived in the same small town, to ask whether or not it was possible to build such a machine of iron. Kemmett was certainly an experienced ironmaster and perhaps already a personal friend or business associate of Bridge. Living in Tewkesbury, where the navigable Avon met the navigable Severn, it is even conceivable Kemmett already supplied cranes or other equipment as part of the riverside facilities at Tewkesbury or elsewhere. Whatever the origin of their relationship it seems probable Kemmett agreed to build the cranes and that both men then looked round for other men to join the partnership. James Pynock, a grocer, and Arthur Wynde usually referred to as a surgeon although Bigland calls him a herbalist and classes him with 'other persons of inferior note', soon made up the number.[6] Pynock and Wynde, both two local tradesmen who were known to both Bridge and Kemmett, no doubt joined the partnership anticipating a generous return on their investment. Although there are no records of any of the partners' assets or their shares in the business, later evidence suggests that Kemmett at least provided some of the working capital.[7] Apart from Bridge's connection through Dallaway, none of the partners had any known links with Stroud.

It is not certain when the conception of a navigation without locks first came to the attention of the Stroudwater commissioners. Joseph Tucker, then Dean of Gloucester and a strong supporter of Bridge's scheme, maintained that Bridge had been considered a 'chimerical, crack-brained fellow' for some time suggesting that the machine idea was at least a couple of years old in 1760.[8] Since Bridge was already involved in the Stroudwater plans, it seems likely he first offered his idea to the commissioners at an earlier date, probably around late 1755 or early 1756, but that his suggestions were dismissed with light–hearted scorn. It is certain, however, that Kemmett and partners were in contact with both the proprietors of the Calder & Hebble and Don navigations during the autumn of 1758.[9] Although Calder & Hebble proprietors turned the partners down flat and 'Declined explaining themselves tho' invited to Do it', the Don proprietors expressed some interest in the idea and asked for more detailed information. The partners, however, do not seem to have responded to their request perhaps because of their growing influence with the Stroudwater commissioners nearer home. At any event, by 30 June 1758 the commissioners were prepared to consider the further proposals which had been laid before them and by 4 August they had given Kemmett proposals sufficient serious thought to appoint the four men as undertakers to build a machine navigation.[10]

Joseph Tucker wrote about the navigation in the Annual Register. Whenever possible it would follow the line of the then River Frome and in particular the large millpond reservoirs which existed at all the mills. These millponds held up a considerable volume of water behind the mill weir which often stretched upstream to approach the neighbouring mill where another millpond was available to use as the basis of the navigation. Even though some of the millponds might require widening, straightening or strengthening – an improvement no millowner was likely to oppose – the depth and length of the millponds formed a ready-made navigation for a good length of the route. Short cuts would be built from the river below the mill weir towards the millponds at a higher level above the weir. These two levels were then separated by a strong bank or wall about twelve feet thick. On this bank the partners erected their double headed cranes able to operate either singly or in unison. Specially constructed boats, capable of carrying eight boxes each holding about a ton of goods, ran on each independent pound. At the change of level at each pound end the boxes would be individually unloaded by one crane head, transferred by either the same or the other crane head to the higher or lower level as the case may be, reloaded into boats on the other level and so continue their journey along the navigation to the next change of level where the process of unloading and reloading would be repeated. No method of propulsion was mentioned for the boats although it is probable they were towed by men.

The agreement between the commissioners and the new undertakers provides that the four partners would build a navigation from Framilode to Wallbridge at their own cost. Once the navigation was completed and operating satisfactorily, the commissioners would purchase it for £10,000 provided any later improvements in design were incorporated in the machine at the expense of the undertakers for the next ten years. If the navigation was not completed by 29 September 1761 the undertakers would forfeit all the works including the cranes to the commissioners without any compensation although the commissioners could extend the period for completion at their own discretion.

Several imponderables cloud this period of the Kemmett partnership. There is, for example, no evidence of whether the undertakers had anything approaching £10,000 to use as capital or whether they intended to use some limited initial capital of their own to get the project under way and then rely on the operating profits of the navigation as their main source of capital. Joseph Tucker's optimistic report suggests the undertakers ran into financial difficulties soon after they had spent about a quarter of their own original estimate which presumably was less than the £10,000 they intended to charge the commissioners.[11] Bearing in mind the length of navigation which did become operable, an expenditure of around £2,000 is not wholly unlikely. It is equally uncertain what induced the partners to accept such a one sided contract unless they were firmly convinced their plans were so sound that the penalty clauses would never apply. It is not even certain how the commissioners intended to pay the £10,000 for the navigation in 1761 although it is logical to suppose they would have raised a subscription similar to that used for the Dallaway scheme and then divided it into equal shares. If the completed navigation was successful, there is no reason to assume they would have any difficulty in raising the full amount.

The consideration which the commissioners gave to this unusual and highly unorthodox plan is another imponderable. It could be the clearest possible indication of the growing urgency for improved transport facilities in the Stroud area and of the strength of the opposition which some millowners could muster to a navigation of the conventional type. At the same time the commissioners could have argued among themselves that, however foolish the scheme might be, they had nothing to lose and everything to gain by giving the partners their head. The very severity of the contract could itself be an indication not of desperation on the part of the commissioners but of a continued scepticism about whether the Kemmett scheme would ever reach any successful conclusion. Perhaps both motives were uppermost in the minds of the commissioners. What is certain is that the commissioners determined

not to part with any of the £10,000 purchase price until the completed navigation was operating entirely successfully.

Negotiations to buy land for cuts and banks on which to erect the cranes began almost at once but when some of the millowners, perhaps still not entirely convinced any navigation was in their interests, challenged the validity of these operations under the 1730 Act the undertakers took the opinions of several counsel. Counsel advised a new Act would be required to give the undertakers powers to construct a navigation using cranes instead of locks. In January 1759 the commissioners undertook to pay an extra £150 over the £10,000 already agreed towards the extra legal and Parliamentary expenses but cannily reserved their right to hold on to this additional sum until the navigation was completed. In February 1759 the new Bill 'to amend and explain an Act made in the Third Year of His Present Majesty's Reign' was introduced into the House of Commons. It explained that since 'there are several Fulling and Corn Mills upon the ... River, and the making such River navigable, in the usual and accustomed Method ... might be prejudicial to the Working of the ... Mills ... no locks were envisaged on the new navigation. In other respects the powers of the 1730 Act were confirmed and transferred.

Apart from petitions from the corporation of the city of Gloucester, anxious to remain the port for the supply of coal to Stroud, and from 'several principal manufacturers of woollen cloth' still fearing a loss of water supplies, the Bill met negligible opposition during its Parliamentary passage.[13] The new undertakers appeared before the several committees and gave their evidence. Thomas Yeoman, too, gave evidence in favour of the Bill which, after a desultory passage, received the Royal Assent early in April 1759. Construction began soon afterwards.

It is possible to determine most of the route of the Kemmett navigation. In general the undertakers followed the line of the Cambridge navigation below Bristol Road which had probably been straightened a little a decade before. Although the Cambridge navigation had been disused for some time, it is unlikely it was wholly unusable especially since it had followed the course of the River Frome. In any case it would be to the undertakers' advantage to use improvements from an earlier date rather than straighten the river anew at additional expense.

The navigation probably left the Severn at the present Frome exit at Framilode proceeding inland to Framilode Mill where the familiar Kemmett pattern of a bypass canal around the mill, stone or brick bank between the bypass canal and the millpond to carry the crane, and small basins above and below the bank for boats to moor as they transhipped from the lower to the higher level. Until the flood prevention scheme of 1972–73, the remains of this pattern were still clearly evident at Framilode and are fortunately preserved on a mid-nineteenth century tithe map in the Gloucester City Library.[14] At Framilode, too, come two small pieces of evidence which help fill in the documentary void Left by the Kemmett navigation. Firstly, a field adjacent to the river exit is known as Kemmett's Orchard, suggesting either that Kemmett owned property there or, more probably, the field was acquired by the undertakers.[15] Secondly, local Framilode legend insists navvies working on a navigation accidentally set fire to a property they had occupied with or without the consent of the owners. Since the records of the company formed in 1774 make no reference to any such event either in the committee minutes or as compensation in the accounts, the legend – if accurate – must refer to the Kemmett period of construction and would probably date from 1759 when the work started at Framilode . Records of Burnt House Farm itself, which is reputed to be the replacement building, suggest the property was already standing in 1775 so that any rebuilding or compensation must have occurred before that date. Finally, some confirmatory evidence of the legend comes from the foundations of a small burnt out property in the grounds of Burnt House Farm close to the canal at Framilode. All in all, the legend fits the known facts and probably dates from around this period.[16]

From Framilode Mill the navigation most likely followed the course of the pre-1972 Frome as far as Whitminster House where repeated changes in water levels and river courses make it more difficult to disentangle the Kemmett line. Fortunately again, a mid-nineteenth century tithe map for Whitminster parish shows enough of the watercourses to indicate the usual by pass canal, a stone bank and at least one of the basins although here again it is not possible to be certain that parts of the bypass canal were not in existence before 1759 as an overflow channel. Evidently the partners had cleared the navigation as far as Whitminster by September 1760 when they were advising that 'great encouragement will be given to day labourers to be employed on the said river by applying to Thomas Bridge at the George … Inn at Whitminster'.[17] From Whitminster to Fromebridge the navigation followed the still existing straightened Frome for about half a mile before turning across the valley to follow the line of the pre-1972 Frome. At various points along this recently improved stretch of river it is possible to trace the line of the old river through marshy meandering depressions on the ground which leave and rejoin the new river as well as by examining the relative ages of fences.

At Fromebridge, where John Kemmett and company were also working in September 1760, the main feature of the navigation are faithfully preserved on a 1782 map.[18] The author was able to examine the stone dividing wall between the millpond and the lower basin when water levels were lowered in the autumn of 1974 before the Sever River Board added an extra weir. The division of labour implied in the advertisement suggests Bridge was mainly responsible for recruiting navvies and clearing the river while Kemmett and his assistants went ahead strengthening the banks and erecting the cranes at the change of level.

The line from Fromebridge Mill to Churchend is both the best documented section of the Kemmett navigation and the easiest to trace on the ground. A 1776 map in the Stroudwater collection shows the 'River in its prest. state' and 'the way the River ran before Mr Kemmett cut it straight'.[19] The map shows nineteen meanders which Kemmett eliminated from his navigation and lists the names of the landowners the partners dealt with: the late Mr Blanch, Mr Stephens, Richard King, Richard Clutterbuck, John Hugh Smith, Mr Philips, Mr Small and John Kemmett himself. The acreage bought totalled a little over eight acres but there is no mention of the prices paid. Kemmett's ownership of land at this point almost certainly suggests he had brought the land from the previous owners before construction started on this length. It is barely conceivable Kemmett chanced to own land in Eastington Mead so convenient for improvement well before the machine navigation was considered. Apart from the large meander immediately on the Stroud side of the motorway, which Kemmett cut through, the waterway followed the line of the existing River Frome until it approached the Eastington Road. Most of the meanders which Kemmett eliminated are still clearly visible on the ground. Meadow Mill, built in the early nineteenth century, did not exist when the Kemmett navigation was constructed and is therefore not shown on the 1776 map.

Near Eastington Road where the river divides, the navigation used or improved the southern channel to Meadow Bridge round the back of the caravan park. From here it ran on to Churchend Mill, where the bank and lower basin in particular are well preserved. Although most of the lower basin has silted up over the years, it is possible to discern the original outline from an abrupt change of slope. From the millpond at Churchend the route ran along the line of the present Frome to Bonds Mill where a similar southern channel carried it round the mill to the lower basin, the dividing wall and the upper millpond. From here the navigation follows the Bonds Mill millpond parallel to the new canal as far as the railway line where it curves away slightly. On the Stroud side of the railway it continues along the line of the Frome and approaches though does not reach 'Mr Hills Mill' below Bridgend Mill almost parallel with Nutshell Bridge. The mill here shows no sign of any of the usual Kemmett refinements and the view

from both bridge and canal bank indicate the navigation was abandoned at about this point. From here it is possible to see the original meandering course of the river and a straightened section probably attributable to the partners. This abrupt point of abandonment was probably the furthest the partners penetrated up the Frome although it is uncertain whether this section, the work at Bonds Mill and even perhaps the line to Churchend and Bristol Road were ever completed and used.

It is certain, however, that some of the lower sections nearer the Severn did operate for a time around 1760–61. The most detailed account of this comes from an article called Improvements and Savings on Inland Navigation, exemplified on the River Stroud written by Rev. Joseph Tucker in April 1760.[20] According to this Tucker considered Bridge's machine was 'simple in its construction, easy in operation, and cheap in point of expense'. As far as the navigation itself was concerned, the partners seem to have had some degree of success at least in the early stages. Tucker himself wrote after visiting the work that as 'far as they have hitherto proceeded, the success has answered their utmost wishes, and the river is made navigable, this second year of their undertaking, for miles, at the expense of one fourth part of what had always been thought necessary for such a work. They now carry goods at so cheap a rate to induce the ignorant to believe that they are the losers by their undertaking, and that at last they will be ruined by it. But they themselves are unanimously of another opinion, and scruple not to declare, that they shall be able to render the carriage still cheaper in proportion as they advance'.

The contrast between Tucker's cheerful report and the position of the partners only ten months later suggest the judgement of the Dean of Gloucester was on this occasion subordinated to his general enthusiasm for inland navigation. The report itself contains one clear inaccuracy. It was true the partners had been involved in the plans for over a year but it could hardly be the 'second year of their undertaking' if the Royal Assent was only twelve months old. One possible explanation for his enthusiasm could be that Tucker saw the cranes being demonstrated by Kemmett or Bridge rather than in general use when their faults later became only too apparent. If Kemmett was working at Fromebridge six months later, it seems likely Tucker visited the navigation at Whitminster. Tucker also neglected to mention that at least part of the evident success of the navigation and the cheapness which it had cost was due to the work Richard Owen Cambridge had done below the Bristol Road. Apart from erecting cranes and strengthening a bank or two, the partners needed only to tidy up the Cambridge work to find a ready-made navigation.

The euphoria of temporary success was soon dispelled as the inherent absurdity of the scheme became clear. The first hint of difficulties came in March 1761 when the partners made two attempts to call a meeting of commissioners 'on special Affairs'.[21] When the commissioners met at the George Inn, Stroud, on 8 April it was reported that although the partners 'have … made … considerable Progress therein, but by unforeseen Accidents and other legal Impediments …' they had been 'prevented from completing the … Undertaking within the [allotted] Time' which was due to expire on 29 September of that year.[22] Rather than abandon construction at this stage, when completion was not entirely despaired of, or attempt to find new undertakers to finish the work, the commissioners agreed to give the partners another six years to complete the navigation. In May the partners paid £119 to Giles Carter and Samuel Niblett for land at Framilode and promised to pay Joseph Everard of Gloucester £100 for land in the same parish.[23] The £100 was never paid and by August the partners had run out of capital and were unable to continue construction. At the meeting of commissioners on 28 August the partners, at their own request, were given powers to advertise the machines and works already completed and to dispose of their interest to anyone willing or able to complete the navigation. There were no replies.

Although it was shortage of capital which was the immediate cause of construction coming to a halt, it is unlikely that the navigation would ever have operated efficiently over the projected length

of ten miles. In the first place, goods would be severely damaged by repeated loading and unloading. This may not have been apparent when only one or two cranes were in action but might have become a serious problem if the navigation had ever extended above the Bristol Road. The cranes, too, would have been subjected to intensive wear and tear not only from what one observer called the 'injurious manner of working the cranes' but also from the need for larger volumes of raw materials which must have been greater than any machine navigation, moving a ton at a time, could manage.[24] The idea of using balancing cranes to enable two transfers of cargoes to be made simultaneously would be equally impractical unless the volume of imports and exports was comparable. There is also some evidence that the partners found their boats, capable of carrying up to ten tons at a time, were too large for the small River Frome.[25] Smaller tonnages, which might enable the boats to float properly would then perhaps be uneconomic. The most serious criticism, however, came from Ferdinand. Stratford replying to the aethereal writings of Joseph Tucker. Apart from alleging that the crane was not Bridge's invention at all but the idea of a Mr Padamore late of Bristol whose constructions could be seen working on the docks there every day, Stratford prophesied the most serious difficulty that would be encountered. The idea of moving goods in boxes, he declared, was 'frustrating the very intention of an artificial navigation which … is to convey in a cheap manner, goods and heavy, unweildy and unbalanceable commodities'. Stratford estimated it would take nine hours forty three minutes for a forty ton barge to travel from the Severn to Stroud and back again on a locked navigation. On a machine navigation, a barge carrying only ten tons would take twenty-eight hours and twenty-three minutes to cover a comparable distance, allowing half an hour for both loading and unloading at each change of level although at present they perform that work in twenty minutes only'. Allowing 1/6d (7½p) a day for each man's labour, the total labour costs of a forty ton barge would be 2/4d (11½p) or about 3/4d (¼ p) a ton. The ten too barge using cranes would cost £1 8s. 4d. (£1.41½p) in labour charges or around 2/10d (14p) a ton. A cost differential of this magnitude would ensure, according to Stratford, that a machine navigation was far from cheap and no match for the cost cutting lock navigations. The partners did eventually find their plans were 'unlikely to answer the Expence, as well from what was foreseen, a Want of Back Carriage, as the Costs of Banking and making Good the Damage of Leakage, they … deserted the Carrying the Navigation on any further, and left their Works in Ruins'.[26]

A few of the constructional details of the Kemmett navigation can be gleaned from later Parliamentary reports and other sources. Some millowners statements suggest the partners raised the height of mill dams to give a greater head of water perhaps to help cure the problems of insufficient depth for craft. This probably pleased the millowners although John Taylor, a local farmer, maintained that with the water being raised so high above the general land level water oozed out at the foot of the banks 'and made thirty or forty acre a morass'.[27] Other damage arose when Kemmett neglected to open the floodgates at times of high water. These difficulties at unspecified locations no doubt prompted the partners own admission that legal impediments and unforeseen accidents had dogged their work. Dallaway, too, implies that Kemmett's employees were not always the most careful users of the cranes. Whatever the cause and effects were, constructional and operational defects must have taken their toll of cash and confidence.

Nevertheless the evidence remains that the machine navigation did operate for a short period over a restricted length, that cargoes were carried at least on the lower reaches and that when abandoned construction was advanced 'for about half the Way' or somewhat over four miles from Framilode.[28] John Dimock, the Stonehouse clothier, thought in 1776 that the work had proceeded as far as Bonds Mill near Eastington although he did not elaborate whether this was the limit of the machines, the limit of Bridge's river work or the head of navigation.[29] Two of the crane machines were still visible at Churchend and Common Platt in 1777 although Yeoman reported the remaining machines were 'out of repair not being

used … and most of the ironwork is lost'.[30] All in all it seems probable that the navigation never operated successfully beyond Churchend and that the work at Bonds Mill and beyond was merely preparatory. It had been comparatively simple for the partners to build a navigation on the lower stretches of the Frome where the gradients were slight, the mills more widely spaced and where construction costs could be minimised by using the course of an earlier navigation. Most probably Joseph Tucker had seen the work at this preliminary stage and been carried away by the apparent simplicity of it all. Even allowing for the technical defects, it was quite a different matter for the partners to build a navigation where the gradients were steeper, the mills thicker on a restricted valley bottom and where they were breaking completely new ground.

Construction stopped during the late summer of 1761 although there is a hint that the partners may have continued trading on the lower reaches for a year or two.[31] By April 1763, however, the partners were more than ready to give notice that 'the joint Undertaking and Trade upon the Stroudwater River, leading from Framilode towards Wallbridge, which was carried on by Messrs Kemmett, Wynde and Pynock, was this Day dissolv'd'. The undertakers themselves were 'nearly ruined' and even though Thomas Bridge seems to have cut his losses earlier, John Kemmett complained that Arthur Wynde, who had disappeared abroad soon after the navigation collapsed, 'went off in my Debt four Hundred pounds & upwards & near the same sum with Mr Pynock'.[32] Kemmett himself seems to have been in dire straits for a time. His wife, Ann, unsuccessfully applied for the job of matron at Gloucester infirmary reminding her prospective employers that her husband had been a regular subscriber to the hospital charity 'till he fell under Misfortunes'.[33] At least two of the partners recovered some semblance at least of financial solvency for by October 1768 James Pynock was advertising for a sober man as a journeyman to himself now described as a grocer and linen draper.[34] By 1775 John Kemmett, in his letters to the new proprietors, suggests his position in Bristol society was not entirely impoverished. In fact the cordial relationship between the later proprietors and Kemmett on several occasions between 1774 and 1778 could imply they held him in high regard and thought him an innocent party to the earlier navigational debacle. *Sketchley's Directory*, too, confirms that John Kemmett and Co of 4 Princes Street on the corner of Excise Avenue in St Stephens parish were trading as iron merchants in the city of Bristol.[35]

Whatever its defects, the Kemmett navigation was not without benefit to the local community. As late as 1775, Purnell and Co, lessees of Framilode and Fromebridge Mills, were reported as using 'Mr Kemmett's … improvements of the river … and of reaping 'the benefits of the navigation to their own works' by carrying goods on the river between their mills.[36] Their later opposition to the 1774 Stroudwater scheme was based on the grounds that a new navigation would force them to pay tolls on their goods using the river. Thomas Lawrence, the millman at Whitminster, thought Kemmett's cut through Mr Stephen's land had been a great service to the mills by preventing the frequent floods which had often stopped the mills in earlier years. William Dutton a tenant farmer of Mr Stephens, thought Bennal's Mead was greatly improved by cutting off the meanders. Straightening the river had brought no loss or injury to Mr Stephens and actually given his landlord an extra acre and made the river lands much less liable to flood. Having known these lands for over thirty years, he had no hesitation in believing they were both better and more valuable since Mr Kemmett's cut.[37]

The last word, however, came from Fosbrooke, the Gloucestershire historian. Commenting on the details of Kemmett's scheme included in John Philip's Inland Navigation, Fosbrooke declared the author's censure of the partners was 'too mild to induce people … to consider … that the projectors and executors of such a scheme were great fools. I am only astonished' he continued, 'that their wives, persons often more interested in their husband's affairs than themselves, and never unwilling to advise, did not torment them out of it, before they had almost ruined themselves as they did'.[38]

Chapter Seven References

1 GJ 27 June 1758
2 JHC 28 398–99
3 Patent Office 1758/720
4 Patent Office 1750/673
5 JHC 28 425
6 Bigland, Ralph *Gloucestershire* 2 216 1792
7 GCRO D1181 uncatalogued deeds
8 *Annual Register* 3 142–44 1760
9 I am grateful to Charles Hadfield for this information quoting Don Navigation Minute Book General Meeting 10 August 1758 and Calder & Hebble Corn mittee Minute Book 15 November 1758
10 GJ 27 June 1758 GCRO D1180 Cl/1 Commissioners minutes 4 August 1758
11 GJ 15 April 1760
 'That done, and not to sleep inclin 'd,
 Some other deeds occur 'd to mind,
 For which the Gothamites are fam'd,
 As far as e'er the name is named;
 A few of which Ihere will tell,
 For all would to a volume swell.
 The first, I'llof their River treat,
 A work indeed stupendous great:
 For this they form'd and laid the plan,
 Where never water ever ran,
 And what was worse, or full as had,
 To pay for it no money had;
 So all this labour, all this pains,
 This River, dug through distant plains,
 Prov'd but a phantom in their brains,
 This project had they made succeed,
 Of Rivers sure they'd little need,
 For nothing is there to export,
 But those our wholesome Jaws transport;
 So that, in counting up the cost,
 They reckoned sure without their host.'

 '

 'Thus reader, it appears to me,
 And doubtless 'twill the same to thee ...
 Their schemes of Rivers and of locks
 Are one continued paradox.'
 Hyett Pamphlet 353 *The Razor Grinder's Dream* (Poem). These two short extracts from a longer poem ridiculing Stroud ('Gotham') and its pretensions to fame and greatness were probably written about 1775–76 by the author of the two Merlin poems and *Stroudwater Triumphant*. The financial references apply most logically to Kemmett, the constructional details to Dallaway's plan

for a separate canal. Perhaps the writer combines his views on all past construction attempts.

12 32 Geo 11 c 47 324–25, 329

13 JHC 28 398–99, 424–25, 442, 455, 466, 470–71
 JHL 29 446, 449, 465, 468, 480

14 I am most grateful for the assistance of Fred Rowbotham, Dudley Wilson and Lionel Walrond whose combinations of detailed local knowledge and perseverance helped me locate the course of the Kemmett navigation.
 GCL tithe maps for Fretberne and Saul, Eastington and Stonehouse

15 I am grateful to R. A. Lewis for this information. GCRO D1180 6/2 Copy of
 1776 Act, 1/1 Committee minutes 16 February 1775 and 8/1 land deeds refer to
 'Kemmett's Orchard'

16 I am grateful to Mr Martin for his permission to examine the deeds of Burnt House Fann, his assistance on the ground and many other favours of help GCRO 02078 lists 'Burnt House Farm' in December 1775 implying any accident predated this

17 GJ 30 September 1760

18 GCRO D149 P16 I am grateful for the repeated assistance of Stanley White of Fromebridge Mills for permission to examine his deeds, his exhaustive know ledge of the mill site which he kindly passed on to me and for his frequent unfailing courtesy when I arrived at inconvenient moments

19 GCRO D1180 10/l Map of River From Bristol Road to Eastington 1776

20 GJ 15 April 1760

21 GJ 17 March 1761, 31 March 1761

22 GCRO D1180 Cl/1 Commissioners minutes 8 April 1761

23 GCRO D1181 uncatalogued deeds

24 Annual Register 3 144–481760: GCRO D1180 5/1 Dallaway's Notes and Hints

25 GCRO D1180 5/1 Mr Dallaway's Notes and Hints, Reasons against the old Act of Parliament

26 GCRO D1180 5/2 *The Case of the Opposition* 1776

27 GCRO D1180 5/1 Mr Dallaway's Notes and Hints, Minutes of the Committee on the Stroudwater Bill 8 February 1776

28 GCRO D1180 5/1 Minutes of the Committee on the Stroudwater Bill

29 GCRO D1180 6/2 (Undated) Affidavit of John Dimock to support the motion for an injunction

30 GCRO D1180 1/1 Committee minutes 31 March 1777 'Common Platt' is indoubtedly a corruption of Chippenham Platt although the purpose of the crane at this point is a mystery unless it was dismantled from the navigation or was originally placed there awaiting fitment elsewhere

31 GJ 11 April 1763

32 GCRO D1181 uncatalogued deeds

33 GJ 8 July 1765. GJ 8 July 1765 refers to Ann Kemmett of Notcliffe GCL NZ19. l Gloucester hospital document In 1764 John Kemmett of Tewkesbury is listed as a regular subscriber to the hospital but by 1767 he is no longer subscribing

34 GJ 17 October 1768

35 GCRO D1181 uncatalogued deeds. No other directories, poll books etc. in Avon County Record Office mention Kemmett.
 An advertisement in *Felix Farley's Bristol Journal* 30 November 1771 could suggest Kemmett was established earlier in Bristol. 'Apprentice to an Ironmonger before Christmas next, and as he is to breakfast, dine and sup with his Master and Mistress, and handsome Gratuity will be expected. For further particulars apply to the printer.'

36 GCRO D1180 5/1 Dallaway, William *The case of the Stroudwater Navigation* 3: 6/2 Copy of 1775 Bill; 5/1 Mr Dallaway's Notes and Hints

37 GCRO D1180 5/1 Committee minutes 14 November 1775

38 Fosbrooke, T. D., *History of Gloucestershire* 169–73 Gloucester 1807

Chapter Eight
Stroudwater Revived

Although this third attempt to build a navigation to Stroud had ended in failure like the schemes of 1730 and 1755 before it, the pressure for local transport improvements continued to increase as the woollen industry grew in size over the next ten years and as its demand for larger and larger volumes of coal and other raw materials expanded. In 1764, for example, the *Gloucester Journal* reported the clothiers had 'so great a demand … for cloths for exportation that they can scarcely find hands sufficient to fabricate them in time'.[1] By 1775 William Dallaway might complain of workers half employed, of mills idle or turned to other use of the 'great Decay of the Coarse Trade' during a temporary downturn in trade, but he could still discern how much the industry had grown since the idea of a navigation had first been mooted.[2] Apart from twenty mills below Stroud, of which eleven were exclusively cloth mills, three flour mills, two iron mills, one a napping mill and three engaged in a variety of cloth, flour and paper production, there were over a hundred mills in the Frome valley east of the town most of which were engaged in woollen manufacture. In Stroud alone there were eighteen clothing mills and the consumption of raw materials used in the local woollen industry had nearly doubled over the last twenty years.[3] This 'Vast Increase of the Consumption of Coals and Dying Materials by the Increase of Dying and Use of Stoves', used to dry the wool and heat the water to dye the cloth, had made navigation even more essential than when the first Act had been passed.[4]

As demand grew, the difficulties of importing growing volumes of raw materials became apparent. Despite periodic complaints that a shortage of specialist labour, often fine spinners, was limiting further expansion of the woollen trade, frequent reports of a 'great scarcity of coals' – often only available at 90p or £1.00 a ton, a price considered little short of extortionate – suggest that recurring difficulties with fuel supply were acting as the main limiting factor on any further significant expansion of the industry.[5] Such problems as these kept the problem of transport improvements forefront in the minds of local clothiers and reminded them that a new form of transport would not only provide them with coal at much cheaper prices but enable them to penetrate new sources of supply by linking them to their nearest navigable waterway – the Severn.

There is every indication, however, that there were numerous, localised and small scale transport improvements in the Stroud area during the middle decades of the eighteenth century. There is growing evidence of turnpike activity and some attempts to run them on more businesslike lines.[6] By 1753 the trustees of the Stroud Stonehouse and Wheatenhurst turnpike were meeting quarterly instead of at irregular periods.[7] Benjamin Grazebrook might consider the upper part of the first turnpike, from Stroud to the Bristol Road, only 'tolerable' and the lower part 'very had' and Thomas Yeoman might suggest this turnpike was very had now, but at least it was better than the situation when he had surveyed the Frome in 1755 when there had been no turnpike road at all.[8] With some improvement in road conditions came an expansion of road carriers and waggon traffic now running for the first time to some sort of regular timetable.[9] Daniel Niblett of Painswick, Samuel Manning of Worcester, Samuel Tanner of Gloucester and Daniel Ballard as well as many others were running regular business services in the county.[10] Ballard built up a sufficiently large business to claim he constantly had waggons passing through Stroud on their journeys between Bristol and Gloucester.[11] Not all carriers were as successful as this. 'Poor Hopeful Jones', the carrier between

Stonehouse and Gloucester, had a family of five children who were 'shivering and shaking in the Wet and the Cold'; he was reluctantly obliged to make a 'Regulation in the Prices of his Carriage'.[12]

Twice weekly passenger coaches between Bristol and Gloucester returning the same day, were already common by the mid-1740s although some services were not available during the winter.[13] Ballard's Stroudwater Flying Coach, carrying both goods and passengers, ran from Stroud to Gloucester and back each Saturday.[14] Coach services to London were also being developed. By 1744 a coach left Gloucester three times a week during the summer months taking two days over the journey. By 1769 there are reports of a flying coach leaving the George Inn, Stroud, early in the morning, travelling via Oxford and arriving in London the same day.[15] Numerous reports of road widening suggest considerable increases in traffic although even then some carriers might try to shorten their route or avoid the tolls by travelling cross country to the consternation of Landowners.[16] Even so turnpike trusts were still recent enough to be the object of distrust and vandalism by those who feared they were a deliberate attempt to oppress the poor.[17] At least one local man, however, a Mr Thomas Crossley of Cirencester, considered there was sufficient potential to make it worth his while advertising his services as a surveyor and repairer of roads.[18]

There was a comparable picture on the navigable waterways of the Severn area and the further growth of traffic between Worcester, Gloucester, Bristol and other Severnside towns on the higher reaches of the river.[19] The regular passage of trows between Bristol and Gloucester was temporarily suspended when the Sheriff of Gloucester confiscated two trows belonging to John Owen and Josiah Cooke, and there was a good deal of inconvenience until John Perks of Gloucester and Thomas Hill of Worcester bought one of the trows and began trading in their stead.[20] The fifty-ton sloop *Brothers* was plying a regular trade from the Wye valley to Bristol, Francis Forres of Newbury was carrying regular loads to and from London via the Kennet Navigation as far as Newbury and thence overland by waggons to Bristol and John James the Gloucester wharfinger was offering a regular carriage of goods to Lechlade overland and then on to London by water.[21] Newnham vessel owners were moving goods from London to Gloucester Tewkesbury, Stourport Birmingham and Stroud using the coastal route around Lands End as well as some overland carriage.[22] When 'another large brig' was launched at Newnham to carry more goods on this route, it was asserted that the 'advantage … from a … regular communication with London by sea and so universally felt by all who trade in heavy commodities that freights are increasing every day'.[23] Some indications of the growth of local trade can be gleaned from Stroud markets and fairs. In 1728 it was announced there would be new and larger fairs held in Stroud.[24] By 1732 two great fairs were held in the town each year.[25] By 1743 there are reports of two great fairs and two great markets held annually although traders were still anxious all four should be held outside the winter months when local roads were at their worst.[26]

Welcome as these new and improved transport services were they did not solve the basic problems facing the Stroud clothiers. Through their involvement with many of these local turnpikes, clothiers helped improve the general quality of local roads and this probably mitigated the worst effects of poor transport facilities.[27] No improved road network, however, could change the basic relationship between the cost of land and water transport in eighteenth-century England. Road transport remained substantially more expensive and much less reliable than water transport for the carriage of bulk cargoes like coal which the clothiers still needed in larger amounts and competitive prices to meet the demands of their thriving woollen industry. Only improved water transport would enable the clothiers to penetrate new sources of supply, arrange regular and reliable deliveries and carry an essential raw material at a cheaper price.

The clothiers' continued interest in transport improvements to solve their basic dilemma was fostered by reports of the successful canal schemes of the late 1760s and early 1770s and by the regular details of profitable new navigations reported in the *Gloucester Journal*. During the winter of 1765–66

for example, the newspaper carried a full page article on 'The Duke of BRIDGEWATER's surprizing navigable CANAL near Manchester', following it shortly afterwards with plans of the proposed Trent and Mersey Canal estimated to cost £101,000 and a general outline of the benefits which accrued from inland navigations. The newspaper laid particular emphasis on the large savings in transport costs and on the growing trend of preferring new canal navigations instead of river improvements.[28] Details of the proposed Staffordshire & Worcestershire Canal which would link the midland coalfields to the Severn more effectively, plans for a canal from Birmingham to near Wolverhampton were all given prominence. [29] Perhaps the newspaper may have been dropping a broad hint when it suggested how 'Happy it would be for this nation, if men of fortune and influence instead of wasting their wealth and misapplying their talents in election squabbles and party broils would turn their thoughts to such national objects … which would best promote the interests of their country'.[30]

The gentlemen clothiers of Stroud were no strangers to the benefits a local navigation could bring them. They had after all made three attempts to build one already. The persistent news of successful and profitable schemes elsewhere often cutting transport costs dramatically must have attracted their attention and encouraged them to consider their own ideas for transport improvements on a similar line once again. This in retrospect was perhaps the main contribution the Bridgewater Canal made to the boom in canal construction in the late eighteenth century and why its completion is sometimes hailed inaccurately as the beginning of a so called canal age. The Bridgewater Canal was built on the reputation of many earlier navigational successes. Even the idea of an artificial waterway as used in the Cardyke, Fossdyke, Exeter Canal, Newry Canal, Canal du Midi and others were far from new. What was new was the way in which the Bridgewater Canal caught the public imagination as no other navigation had done before it. It helped to create a mood in which people in general and industrialists in particular became increasingly aware of the specific benefits inland navigation could bring to their locality.

These developments did not go unnoticed in the valley of the Frome. Waterways improvements elsewhere are constantly referred to in all the Stroudwater literature from around 1750. No doubt the gentlemen clothiers of Stroud noticed these new navigations in other parts of the country and overseas were on a much larger scale and required much heavier finance than their own modest hopes might entail. They were not interested in some grandiose waterway linking different parts of the country together with its associated paraphernalia of expensive tunnels or fashionable aquaducts. All they wanted was a short, eight-mile-long canal to link their mills to the nearest navigable waterway capable of supplying them with a cheap and reliable source of coal.

By August 1768 enough supporters of the Stroudwater scheme were sufficiently active once more to insert an advertisement in the *Gloucester Journal* asking the commissioners appointed under the two former acts to meet together at the George Inn on Friday 26 August 'in order to receive Proposals for carrying on the Navigation of the River'.[31] Although nothing more is heard of these proposals or their supporters and there is no evidence to suggest the commissioners ever met, it does indicate that the ideas for building a navigation were beginning to revive once more and that some people at least were prepared to give them serious consideration.

The authorisation of the Coventry, Droitwich and Forth & Clyde Canals in 1768, the Leeds & Liverpool Canal in 1770, the Chesterfield Canal in 1772 and the completion of the Severn-Trent link in the same year with the opening of the Staffordshire & Worcestershire Canal, to say nothing of the dozens of other schemes under active consideration, kept the issue well to the fore. Any encouraging news, such as that from the Sankey Navigation in Lancashire now carrying over 100,000 tons of cargo a year and paying handsome returns to its shareholders, was bound to be an encouragement to the clothiers' viewpoint. Repeated information such as this may have prompted a further advertisement in November 1771 when

the 'Hallers of Coals and the Consumers in and around Stroud' were asked to meet at the George Inn on 17 November when unspecified 'Affairs of Consequence' would be laid before them.[32] William Dallaway, one of the most active and influential supporters of the Stroudwater scheme, later admitted that the publicised expansion of canal navigations in other parts of the kingdom had been a factor encouraging the Stroud clothiers and their associates to take their ideas a stage further.[33]

Whether or not the affairs of consequence were ever laid before any interested parties, the gentlemen clothiers of Stroud had given the project sufficient serious attention by the spring of 1774 to prepare outline plans and call a meeting for 27 April at the George Inn to discuss proposals for making the river navigable by means of a new cut from the Severn at Framilode to Wallbridge near Stroud.[34] Meeting together in their roles as commissioners, the supporters appointed Peter Leversage, a prominent local businessman who founded Stroud Brewery and was heavily involved in turnpike trusts and their administration, as their clerk and resolved to call a general meeting of commissioners for 26 May when the outline proposals would be considered in greater detail. In addition the commissioners proposed to appoint some new commissioners to maintain and perpetuate their legal powers to build a navigation and also to swell their ranks with well-known and respected local supporters of the navigation.[35] Finally the commissioners decided to approach the directors of the Staffordshire & Worcestershire Canal Company. This newly completed canal, which would form a vital connecting link between the coalfields of Staffordshire and the Frome valley mills and which the supporters of the Stroudwater scheme hoped to use to tap these additional sources of coal supply, stood to make an extra gain in traffics, income and profits from the construction of a Stroudwater Navigation. It was understandable therefore, that the Stroudwater supporters should turn for advice and help to the directors of a successfully completed canal particularly since they hoped strong trading links would develop between themselves and the Staffordshire & Worcestershire Company.

From a legal point of view the meeting on 26 May proved somewhat of a disappointment. The numbers of commissioners had been severely depleted by deaths and illness over the years and only twelve legally appointed commissioners attended, one less than the minimum number required for a quorum. Even this figure included men whose recent appointment to the status of commissioners might be open to question. Nevertheless the attending supporters decided to press ahead with their plans especially since they had already published a list of proposed new commissioners in the *Gloucester Journal* and had previously suggested that the as yet unqualified commissioners might like to attend the meetings to add their support.[36] It was all slightly dubious legally but then the supporters considered themselves involved in more important matters than some of the finer subtleties of English law. It was fortunate for them that none of their opponents ever noticed or questioned the validity of appointing new commissioners without a quorum or of unqualified commissioners voting and acting as if they were already appointed. The list of new commissioners, included the usual sprinkling of county families; the Duke of Beaufort, the Right Honourable Lord Chedworth and the Right Reverend William Lord Bishop of Gloucester, who were probably appointed because of their status as major landowners, for the general air of probity their names brought to the decisions of the commissioners and for any favourable influence they could exert at county and national levels. The new list also included the usual mixture of established respectability such as John Hollings the Stroud mercer and well to do, up and coming, thrusting young entrepreneurs like Benjamin Grazebrook who was acting as unofficial clerk and treasurer to the Stroudwater supporters as early as 27 June 1774.[37] The most important decision of the. meeting, however, was taken in the presence of Joseph Lane and John Baker, the two representatives of the Staffordshire and Worcestershire Canal Company who had been instructed by the fellow directors 'to make themselves acquainted with the Business of the … Meeting and to suggest … what they shall think most conducive to the Interest of the said Stroudwater Company'.[38] It was agreed that Thomas Dadford, engineer to the elder company and whose father, Thomas

Dadford Senior, had been one of Brindley's assistants, and John Priddey, who had built the Droitwich Barge Canal as resident engineer under Brindley and acted as assistant clerk of works on the Oxford Canal, should survey a line for a possible Stroudwater Canal, suggest a suitable outline plan and receive eleven and fifteen guineas respectively for their pains.[39] Finally the commissioners agreed to insert two advertisements in the *Gloucester Journal* advising its readers that at the next meeting of commissioners on 21 July 'a subscription will be proposed for Defraying the Expence of Rendering the said River navigable upon a new plan Divided into Shares'.[40] Anyone wishing to encourage the scheme was asked to attend 'when an Estimate by Two able Surveyors would be laid before them'. For good measure notices were to be posted on the Market House in Stroud and on 'the most conspicuous and publick places' at Framilode and Wallbridge to spread the news as widely and speedily as possible. Anxious, perhaps, to secure the services of the two engineers the Stroudwater supporters sent eleven guineas back with the Staffordshire & Worcestershire representatives as an initial advance. A further four guineas was paid in October 1774 and a final payment of seven guineas – less than the originally agreed fee – in February 1776.[41]

At the meeting of commissioners on 21 July, Dadford and Priddey presented their outline plans and estimates confirming the now widely held view that the most practical course was co construct a separate canal rather than attempt to base a navigation on the existing River Frome. There were several specific advantage in adopting this suggestion. In the first place, as Cambridge knew and the Kemmett partners discovered only small craft drawing about two feet of water were practicable on the river. A canal navigation, on the other hand, could carry craft of three or four times the burthen of River Frome craft. Large Severn trows, carrying up to seventy tons each, could bring their cargoes to Wallbridge without unloading. With a river-navigation, trow cargoes would have to be unloaded into two or three lighters at Framilode. Each of these smaller vessels would then have to make several journey to convey a single trow load to Wallbridge. By the time this cargo finally arrived in Stroud repeated handling would make the goods expensive and probably leave them in an indifferent condition. Apart from their own disappointing experience with the Kemmett navigation which had demonstrated all too vividly the problems of transhipment, the Stroudwater supporters saw no point in building a navigation which would probably leave transport costs more or less unchanged. The idea of a river navigation had been useful enough in earlier years but, as William Dallaway declared, once the woollen industry had expanded and its calls on raw materials had increased 'the Demand of our Carriage is now become superior to such an insignificant Navigation'.[42] There were other reasons why a canal navigation was now preferred. A canal navigation would not be subject to the 'Malice and Wantonness of the Millmen and Millers, in drawing down Heads of Water, and hindering or molesting the passin of Vessels; which the Old River would be exposed to'.[43] Neither would a separate navigation be interrupted in times of flood or by shoals which, even if removed, would constantly reform, obstruct the navigation and be a continual drain on resources. Finally and perhaps most important of all, a canal navigation could provide the new transport facilities so hadly needed by the clothiers and at the same time overcome the largest single obstacle which had delayed the construction for so long. Only a canal navigation would prevent mudding the water and so prejudice the dyeing processes in the eleven or so cloth mills on the Frome below Stroud, avoid damage to mill property and minimise any loss of water to the mills by separating their water supply from that of the canal.

There is every indication that it was this prime factor which decided the opinion of the commissioners in favour of a canal navigation once Dadford and Priddey's plans were presented to them as 'after the manner of the most Improved Inland Navigation; whereby the Old River is as much as possible avoided, and the Interference with the Mills, which has always been an Obstacle, is very much prevented, as it communicates with the Old River but in Three Places'.[44] This alone, the commissioners thought, should allay the long standing opposition of the millowners and so remove the major obstacle to constructing the Stroudwater Canal.

The estimate which Dadford and Priddey had completed on 23 June and submitted to the Commissioners indicated a navigation could be built for a total of £16,451 1s 6d.[45] The full breakdown of the estimate included:

	£	%
Ninety-four feet of lockage	5,452.00	33.00
Cutting canal about seven miles, five furlongs at forty-two feet top width, six feet deep with a slope of four/three	5,236.00	32.00
Forty-five acres of land at £60 an acre	2,770.00	17.00
Twenty-one road and five foot-bridges	1,735.00	11.00
Temporary damages to lands and unforeseen accidents	550.00	3.50
Widening about seventy-four chains of the Frome section of the navigation	224.20	1.40
Three aquaducts and culverts for streams	180.00	1.10
Stop gates, wickets, stiles	95.37½	0.60
Extra cutting and banking	78.50	0.50
	£16,451.07½	

Although once again there were insufficient commissioners present to make the decisions legal, those present at the meeting decided to open a subscription of £20,000 to finance the navigation and cover any additional eventualities. The subscription was divided into two hundred £100 shares and articles were left with William Turner, landlord of the George Inn, Stroud, for anyone to inspect before committing their promise of financial support in writing. This time there was no shortage of subscribers to the fund. By early August it was reported that over £16,000 had been promised.[46] Within another fortnight the subscription was completely full and if one of the several satirical poems written about the navigation at this time is to be believed, a larger sum could have been raised without any difficulty.[47] At this stage shareholders pledged only their credit. When the promoters began construction, the company treasurer made periodic calls on the shareholders until their full £100 was paid up on each share.[48] This method of payment by instalments was widely used on many navigations and it proved its worth for the Stroudwater shareholders. According to the *Gloucester Journal* a shortage of cash was a persistent problem for local industrialists and a great inconvenience to the future development of trade.[49] At one point a group of clothiers, shopkeepers, farmers and tradesmen, led by such influential gentlemen clothiers as William Dallaway, Joseph Wathen, James Winchcombe, John Hollings and Thomas Baylis and supported by prominent tradesmen like Richard Aldridge, tried to remedy this shortage of coin by promoting the currency of Portuguese gold coins to help alleviate the situation.[50] One source hints that at least some supporters of the Stroudwater scheme may have found this coin shortage an embarrassment when they came to pay their calls and had to pledge their lands dwelling houses and presumably their mills as guarantees of their credit to borrow the money from a local banker.[51]

By the midsummer of 1774 the supporters had decided a number of important matters. In the first instance they had agreed to employ two experienced surveyors and engineers to produce an outline plan of the new navigation. Secondly, they had determined to construct a canal navigation rather than attempt to make the Frome navigable and incur the considerable wrath and opposition of some of the millowners below Stroud. Finally, whereas 'letting the River for a certain Sum' to undertakers who would build the navigation and then sell the completed waterway to the commissioners had been 'almost the general sense of the Proprietors' earlier in the year, it was now decided that they should raise the £20,000 themselves and employ an engineer to construct the navigation for them.[52] The idea of advertising for undertakers to build the navigation and then sell it to the commissioners had not gained

favour for long even though Mr W. Hawker suggested the undertakers should give good security and that the commissioners should employ a separate surveyor of their own to give constant attendance during the construction to make sure that undertakers completed the work to his satisfaction. Anthony Keck, too, suggested that to safeguard against faulty construction the undertakers should be responsible for all repairs during the first seven years.[53] But the commissioners' earlier experience with the Kemmett partners did not endear them to the idea of sub-letting the complete construction and it was, in any case, no longer the accepted method of building new waterways in the Midlands and north of England.

Although the supporters had little difficulty in raising sufficient promises of financial support, it soon became apparent that there were other problems which needed attention. The most serious of these was the re–emergence of an increasingly vocal opposition to any sort of Stroudwater scheme. The first evidence of this appeared in August 1774 when an advertisement called on 'Owners, Proprietors, and Occupiers of Such Mills, Lands and other Property … as are likely to be … injured, by the carrying into Execution the Plans proposed for making the River Stroud–Water navigable' to meet at the George Inn, Frocester, on 26 August 'to consider of proper Measures to be taken by them on that Business'.[54] The case of the opposition this time, however, went further than doubts about the damage to land and property. They were prepared to accept that the 1730 Act, which had given the then undertakers powers 'to make such New Cutts … for water … through the Lands … adjoining … as they shall think fit and proper for Navigation and [the] Passage of Boats' and that the 1759 act which gave powers 'for making navigable the River Stroudwater' both contained provisions which had not been repealed and therefore remained in force as long as the commissioners perpetuated their corporate existence. But the opponents claimed that these Acts had been passed specifically to make the river navigable and not to construct a canal navigation. In their view, the undertakers were laying plans for a type of navigation which they had not legal right to construct.

This was a point of some concern to the commissioners and supporters of the Stroudwater scheme and they decided to ask the opinions of Mr Gryffith Price, QC of Lincoln's Inn, and Mr J. Dunning. In the memorandum to their counsel the commissioners declared they had already agreed to carry out the scheme themselves 'if the powers of the first Act are now lawfully vested in them and they are enabled to do so'.[55] There were however, some differences of opinion among the commissioners themselves about the extent of their powers. Some commissioners considered that as the first Act made no order of the commissioners binding unless made 'at such meeting … as prescribed … in the Act and that such meetings had not been held regularly, they now had no powers to call any new meeting or do any Act whatsoever without the assistance of the Legislature'. Other commissioners thought that as the 1759 Act gave them powers to appoint new undertakers 'in case the river was not completed within the time stipulated and to convey the same to such persons so to be appointed to complete the navigation', they had every right to appoint both new commissioners and new undertakers to do this. 'No meetings were necessary in the interval of time', this group claimed, so it was 'absurd to suppose that at the expiration of the limited time, the Commissioners should be deprived of the power given in the last Act owing to their not keeping meetings which were totally unnecessary without business to do'. William Dallaway gave short shrift to anyone who doubted the continued powers of the commissioners. As be explained on a later date William Dallaway considered that 'The Act … Points out no Particular Method but leaves it discretional to the Undertakers and therefore … the Undertakers have … a Right to take the most Expedient'.[56] Dallaway was not one to consider the delicate subtleties of wards or brook any opposition and decided that the original Act 'did not intend a Canal Navigation because they were not then in use'. It was, he thought, 'Speaking as little to the purpose as a mere quibble on words. It intended new Cutts etc. wherever they were thought fit to be made; and it empowers the undertakers 'to do what they shall think convenient and to do other … things as the said Undertakers … shall think necessary for making and maintaining the same River,

streams, Cutts and Passages Navigable and Passable … or for the Improvement or Preservation thereof and therefore it justifies what is done and … what we intend to do'.

The commissioners therefore asked their advisers two questions.[57] Firstly, whether the commissioners, after neglecting to hold their meeting by adjournment, had the right to call a new or general meeting on 26 May 1774 to consider methods of making the river navigable by locks on the original plan to appoint new undertakers, and to convey the powers of the former Acts to them and whether such an appointment were valid. Secondly, if the appointments were valid did the new undertakers have sufficient powers under the first act to make the river navigable on the present plan they had accepted on 26 July and which had proposed building locks and constructing an almost entirely separate canal navigation.

On the first question there was some doubt about the true legal position of the commissioners. Offering his considered opinion on 26 July, Mr Dunning thought the commissioners could only act bindingly at a general meeting and that no such general meeting could be called unless it was an adjournment of an earlier general meeting. Since the commissioners had not adjourned from any previous general meeting during the period of the Kemmett navigation in the early 1760s, their general meeting of 26 May was not only invalid but the commissioners had no powers whatsoever to call any new general meeting, approve any plan or appoint any new undertakers. Mr Gryffith Price, on the other hand, was more optimistic. Submitting his opinion on 15 August, be expressed doubts on the legal validity of the election of new commissioners on 26 May 1774 since the general meeting was not held by adjournment from a previous meeting and was therefore invalid. Nevertheless, he was certain that the powers of the 1730 Act remained in force and that they were still vested in any thirteen of the commissioners who chose to act. If the commissioners cared to adjourn their next general meeting to one at a later date, this may convey validity to the new proposed undertakers. Even a moderately competent judge might feel the quality of this advice had all the stability of a Severn bore.

Opinion was also divided on the second question. Mr Dunning believed that even if the appointment of the new undertakers was valid, it would not authorise them to build a navigation on the present plan. Since the earlier Acts had specifically given powers to make the river navigable and the new plan proposed an artificial canal navigation with only a few short river links, he did not believe it could be built without further authority from Parliament. Mr Gryffith Price considered the powers of the 1730 Act did remain in force and were still vested in the hands of any thirteen commissioners. Whether chosen in the original Act or by the instrument of 3 September 1756 when new commissioners had been appointed, they could still appoint new undertakers to construct a navigation either by making cuts as the original Act had allowed or by any other method which in the words of the Act the commissioners might think fit and proper.

Even though the legal opinion was far from unanimous, the commissioners decided to prefer the later opinion of Mr Gryffith Price that a new navigation could be built on the lines of the new plan without further recourse to Parliament. They recommended to the subscribers, who in any case were chiefly composed of themselves and their associates, that they should form a body of undertakers and bind themselves by articles as counsel had suggested. The commissioners would then appoint these men as undertakers to build the navigation either on the plan proposed by Dadford and Priddey or some other plan they might prefer and approve.

A further lengthy list of new commissioners was appointed on 25 August and shortly afterwards the commissioners and subscribers to the fund of £20,000 set about turning themselves into a formally constituted body of undertakers which could be responsible for building the navigation.[58] After several further meetings of commissioners and subscribers on 27 October and 24 November, the subscribers met on 8 December to sign the articles and to settle plans for building a Stroudwater Canal.[59]

It may have been continued reports of opposition from some of the millowners below Stroud which encouraged the commissioners to invite Thomas Yeoman, the respected veteran engineer, to resurvey

the line in the autumn of 1774 and suggest ways of modifying the opposition.[60] Yeoman was an obvious choice for a second opinion since he had already been involved with the Stroudwater scheme in 1755 when John Dallaway had asked him to survey the River Frome. Yeoman was therefore familiar with the area, with the local problems of building a navigation and had moreover built up a formidable reputation during the intervening years.

Little is known of Yeoman's early life before 1742 when he reported in detail on Edward Cave's cotton mill in Northampton although there is some suggestion he may have been wheelwright and engineer to the Abbey Mills near Bromley before then.[61] During his stay in Northampton, however, Yeoman was primarily employed as a surveyor and as a mechanic for agricultural machinery. Although he describes himself as a 'millwright', Yeoman indicated the breadth of his talents and aptitudes by listing himself as a 'mechanical engineer to local industries – the cotton industry, the papermills, butchers, cornmerchants and farmers; as surveyor to local landlords; as weights and measures engineer for turnpikes, the municipality of Northampton' and others as well as 'water engineer for farms etc; as architect for mills; and as a philosophical instrument maker for surveyors and for gentlemen with scientific interests' as well as being a leading light of the Northampton Philosophical Society which met at his house in Gold Street, Northampton.[62] His abilities with water were demonstrated when he erected the machinery for the world's first water powered cotton mill which began operations in 1743 on the banks of the River Nene at Northampton. Apart from lecturing to the Philosophical Society on scientific subjects, Yeoman experimented with electricity in collaboration with other society members from December 1743 and held the post of president several times.[63] By the mid 1740s Yeoman had acquired the reputation as a skilled and versatile engineer involved in a variety of general engineering work.

By 1743, too, Yeoman had begun to extend his business away from the somewhat limited scope of Northampton for he mentions a journey into the west.'[64] The Birmingham newspaper *Aris's Gazette* reported in 1746 that Yeoman would shortly give lectures on electricity.[65] Yeoman had also been to London to collect more information about electricity and had already made electrical apparatus for sale. About the same time he installed a weighbridge designed by his friend John Wyatt. By 1757 Yeoman was involved in consulting the trustees of the Towcester to Weston Gate turnpike about their plans to widen and repair their road.[66] Other turnpike work occurred at intervals in his later career when he moved to London. On several of these turnpikes he installed his own improved version of John Wyatt's weighbridge to check on overweight coaches and carts and enable the turnpike trustees to collect the additional tolls. In addition Yeoman invented 'a Machine for cutting away … ant hills' which was erected by the Duke of Cumberland for use in Windsor Forest.[67]

It was the construction of ventilators and machines for cleaning corn, however, which were the earliest of Yeoman's activities to bring him widespread publicity and fame. From 1743 onwards he established a friendship with Rev. Dr Stephen Hales, F.R.S., the inventor of ventilators. Before long the manufacture of ventilators became an important part of his rapidly expanding interests and Yeoman fitted them in turn into Northampton General Hospital in 1748, Northampton Gaol in 1749 gaols in Shrewsbury, Maidstone, Bedford and Aylesbury and into St George's Hospital. Yeoman also began occasional work for the navy which led to his installing ventilators in their Haslar Hospital, the prison at Porchester and elsewhere in navy property which finally earned him a grateful letter of thanks from the Admiralty.[68] At unknown dates he fitted ventilators into both Houses of Parliament and into the Theatre Royal, Drury Lane. By 1749 Yeoman had fitted ventilators into a wide variety of ships including several for the Duke of Halifax whose patronage soon proved to be a major boost to his reputation. In August 1756 Yeoman was put in charge of ventilation arrangements aboard all His Majesty's ships and was appointed Chief Marine Superintendent of the navy.

Yeoman's increasingly widespread activities kept him away from Northampton more and more until by the mid-1750s he had moved permanently to London as a more suitable and accessible base. Before he left Northampton, however, Yeoman surveyed the Nene and estimated the cost of extending the navigation from Thrapston to Northampton in 1753. Yeoman also attended the Parliamentary proceedings for this Act three years later: This local experience on inland navigation proved to be only the first of many such projects. By 1758, when he had surveyed the Frome or John Dallaway and the River Ivel as well, he was generally described as a Surveyor and Civil Engineer'.[69] This work on the improvement of rivers gradually became more important as his career progressed and eventually developed into Yeoman's major work. In 1762 he surveyed the River Lea around Waltham Abbey in collaboration with Joseph Nickalls. In the same year and again in 1765 he surveyed the River Chelmer and gave evidence before the Parliamentary committee suggesting the proposed scheme would cost around £13,000.[70] By this stage it was reported that Yeoman had distinguished himself by conducting the works of several inland navigations'.[71] In 1765, too, yeoman surveyed the River Stour in Kent and outlined plans to drain the nearby marshes. During the same year he was also involved in improving the port of Sandwich. In 1766 Yeoman was proposing improvements to the drainage of the Level of Ancholme and assisted John Smeaton, the noted civil engineer, making a survey of the River Lea. A year later, in co-operation with other engineers, he produced the first of four reports on the embankment of the Thames.

During the late 1760s, Yeoman was engineer for the Stort Navigation, reported on the improvement of the Forth and Clyde Canal in association with Brindley and Golboume, made a survey of the Nene outfall below Wisbech and was called upon to testify on the Grand Trunk and Birmingham Canal schemes. By this stage in his career Yeoman had already been recognised as a leading engineer of the day. He had been elected a fellow of the Royal Society in 1764 and a further honour followed in 1771 when he became president of the Society of Civil Engineers, a clear indication of his status as an engineer of national standing. The 1770s, too, were a time of activity. He acted as consulting engineer to the Coventry Canal in 1769 and 1771, prepared estimates for the proposed Leeds and Selby Canal in 1773 and was consulted during the River Stour improvements between 1776 and 1778. By the time Yeoman was called upon to produce a plan and estimate for the Stroudwater Canal, he had extensive experience of inland navigations and was at the peak of his profession. Yeoman's national status was undoubtedly one of the main reasons the commissioners asked him to advise them further. Surely, they must have thought, any remaining opposition must be impressed with such an eminent consulting engineer on their side.

It is not known precisely when Thomas Yeoman began his new association with the Stroudwater commissioners and their newly appointed undertakers although on his own admission the relation ship began in 1774, when he surveyed the river again, and continued through 1775 when he surveyed the river a third time and gave evidence before Parliament on behalf of the undertakers.[72] Yeoman was certainly in correspondence with the undertakers during the winter of 1774–75 but it is probable this letter was only one of many and that the first new survey started sometime during the late autumn or early winter of 1774.[73] In any event Yeoman was certainly in the Stroud area on 2 January 1775 when the undertakers hired a chaise for him costing 15s 6d (77½p) from William Turner, the landlord of the George Inn. Seven days later they also paid a Bill of fare for £1 3s 6d (£1.18p) to Richard Hall suggesting Yeoman lodged at his New Inn at Framilode while he was surveying the line.[74]

Yeoman had several comments on the line, cost and proposed construction of the new navigation. In the first place, he commented very favourably on the comparative ease with which the new waterway could be built. The gentle rise from the Severn to Wallbridge was only a little over a hundred feet and there were no hill ranges, deep valleys or frequent water courses to cross. Yeoman thought it would

require no major aquaducts, no heavy lockage or long lock flights, no tunnels, deep cuttings or long embankments. It was a 'very practicable scheme' likely to be of great benefit to the neighbourhood. In fact Yeoman considered that 'the Ground through which the Canal will pass [was] the most favourable' he had ever seen in his life. No serious engineering problems were in any way forseeable. It was plainly and simply a matter of building a waterway across land which, from the physical point of view, lent itself admirably to canal construction and at a cost per mile which was cheap at anyone's price.[76] Secondly, Yeoman confirmed the view of Dadford and Priddey that a canal navigation almost exclusively separate from the Frome would be much more efficient than a navigation based on an improved river. It would avoid the serious deficiencies of a river navigation already outlined in detail by William Dallaway, and prevent as much interference with the mills west of Stroud as possible. In any case it was now Yeoman's considered opinion that a canal navigation could be built at half the cost of an improved river built on comparable lines and which in any event would still be liable to the serious impediments of shoals, floods and probable disputes with some millowners.[77]

Yeoman therefore proposed a canal navigation from Framilode to Wallbridge under eight and a quarter miles long compared with over ten miles for the existing turnpike.[78] Apart from using a short stretch of the river above the proposed Whitminster Lock, which was in any case later found unsatisfactory and replaced with a separate channel, and linking with three existing side-ponds, the navigation would be completely independent of the River Frome. It would be forty-two feet wide, six feet deep and be capable of taking Severn trows up to sixty-eight feet long, fifteen feet two inches wide, four feet draught and carrying a cargo of up to seventy tons.[79] Twelve locks would carry the canal a hundred and two feet down to the Severn.[80] Since 1755, when he had first surveyed the Frome, Yeoman believed that some sort of reservoir would be advisable to store water which ran to waste on Sundays when the mills were not working and any other surplus water which was available. He therefore proposed that two of the canal pounds should be deepened to Act as storage reservoirs. This would not only enable the navigation to operate effectively during the week when the mills were working without taking any of their water from the Frome but might even supply the mills with a larger volume of water because of more efficient conservation of water supplies. The top reservoir, supplied by Cuckolds Brook, was planned for the three quarters of a mile top pound from Dudbridge Top Lock to Wallbridge. This was eventually built three feet deeper than the rest of the canal and held an estimated extra ninety locks of water. Any surplus water from this pound flowed out of the canal into Mr Cooke's millpond and so back into the River Frome. The second reservoir, a little over a mile-and-a-half long, was planned for the pound between Ryeford Double Locks and Dudbridge Bottom Lock. This would be supplied from the overflow from Mr Turner's millpond – itself fed by the Dudbridge stream – and would be built about two feet deeper than the rest of the canal to hold an estimated seventy–four extra locks of water. In fact Yeoman thought a third of the water in the smaller reservoir would be more than ample for the navigation and that all the surplus water which would previously have run to waste could now be passed on to the mills as an additional supply.

Yeoman's final estimate for building the navigation came to £16,766.20 and was made up as follows :[81]

	£	%
Digging the canal at £526.40 a mile	4,211.20	25.10
Fifty-four acres of land at £60 an acre	3,240.00	19.30
Eleven locks at £400 each plus Framilode Lock at £700	5,100.00	30.50
Two principal road bridges at £100 each, twelve other road bridges at £60 each and five footbridges at £5 each	945.00	5.60

Aquaduct at Ebley Mill	150.00	0.90
Altering floodgates at Ebley Mill	100.00	0.60
Overshot at flood gates	50.00	0.30
Three culverts	100.00	0.60
Three stop gates	250.00	1.50
Sundry stiles	20.00	0.10
Wharfing and gravelling quay	150.00	0.90
Pumps, engines, barrows, planks	600.00	3.60
Temporary damages	1,600.00	9.60
Deep cutting, filling up hollows	250.00	1.50
	£16,766.20	

Although the final estimates of Dadford and Priddey and Thomas Yeoman are almost identical, the amounts each planned to spend on specific works tended to vary. Dadford and Priddey, for instance, estimated for only forty-five acres of land while Yeoman, possibly thinking it would be wiser for the company to by isolated pieces left in landowners' hands, budgeted for fifty-four acres. Allowing for te different methods of breaking the estimate down, however, the only significant difference is between Dadford and Priddey's plans to spend 11% on bridges and Yeoman's belief he could pare this to only 5.6%. Yeoman, planning for only nineteen bridges instead of the twenty-six Dadford and Priddey planned, evidently hoped to amalgamate some occupation bridges with certain road bridges and probably felt the five foot-bridges both sets of surveyors wanted could be built of wood or some other material cheaper than brick or stone.

The commissioners thought that Yeoman's name and his proposals to increase the water supply to the mills would chasten any remaining opposition. His role as to act as the consulting engineer to the Stroud water company rather than resident engineer, a job which was left to Dadford and Priddey. Yeoman may have been a regular visitor to the site during the period of early construction – there are periodic reports in the minutes of his being asked to come down to Stroud – but there is no record of any further payment to him after 14 March 1776 when he was paid £77.[82] In any event his health was beginning to fail and he died in 1781.

Meanwhile, at the meeting of commissioners on 29 December 1774 it was noted that the new survey which had lately been completed by 'able and experienced engineers' had proposed a plan for a navigation using locks by constructing a new cut 'in the nature of a canal'.[83] The commissioners had considered this plan, the report continues, 'and have agreed that, by means of a subscription among ourselves, to raise £20,000'. The commissioners therefore appointed a number of men from their own ranks as undertakers allowing them eight years in which to complete the navigation. From this point onwards the commissioners take a back seat apart from periodic meetings to adjudicate on disputes. It was now the undertakers who form the basis of a managing committee.

Who, then, were these nine men the commissioners had appointed as undertakers? By and large they were precisely the same local men he had been most prominent in using their positions as commissioners to press for the construction of a navigation. The most influential undertaker was William Dallaway, the wealthy and eminent Brimscombe clothier, county notable and long standing supporter of a Stroudwater scheme. Born in November 1721 William was the eldest son of John Dallaway who had initiated the proposals of 1755.[84] It seems likely that William Dallaway first became associated with the ideas for a waterway at about this time and no doubt became acquainted with Thomas Yeoman during his earliest visits to Stroud when he made his original surveys of the river. William Dallaway was one of the most

prosperous and powerful local clothiers. He was well known as a major exporter of cloth, especially to Hamburg – a trade he had developed and which he hoped to expand once a navigation was built.[85] Like most clothiers of this newer generation, Dallaway prefered to sell his cloth direct to continental markets rather than send it through middlemen at Blackwell Hall. This not only brought the clothiers a higher profit margin and contributed to the rapid expansion of their industry in Gloucestershire but broadened their horizons and made them aware of industrial and transport developments in other parts of Britain and the continent.[86] After the death of his father in 1764 Dallaway took over the management of the family clothing business and took an active part in the local government of the county. In 1766 he was appointed High Sheriff of Gloucestershire, a position one of the Stroudwater poems refers to when it calls him 'chief orator of the people'.[87] Over the years since the failure of the Kemmett scheme in the early 1760s, Dallaway had been the most active commissioner pressing for a navigation and in recognition of his work he was made chairman of the undertakers appointed to begin construction on 29 December 1774.[88] When he died aged fifty four on 7 March 1776 his death was widely and sincerely mourned as a serious loss to the neighbourhood. In his will Dallaway left extensive properties to his family and beneficiaries including his fulling mill, mill house, dye house, warehouse and his large private dwelling house at Brimscombe considered 'fit for the Reception of a substantial Clothier'.[89]

James Winchcombe, the Rodborough clothier and dyer, owned Ham Mills in Stroud.[90] His father, James Winchcombe the elder, had been a successful Stroud mercer who left a substantial estate to his son when he died in 1763.[91] James the younger prospered at his trade and soon began to move up the social scale and acquire the symbols of respectability. He bought his own pew in Stroud parish church from Fream Arundell, the Stoud clothier, for £14.92 In 1778 he became Deputy Lieutenant of the county and when he died in 1780 left his 'Messuages, Cottages, Mills, Lands, Tenements, Woods and hereditments in Stroud, Painswick, Rodborough and Minchinhampton' to his nephew Nathaniel son of the wealthy Nathaniel Winchcombe of Frampton Upon Severn; '£500 to his sister … the widow Mary Colbome; £500 to his sister Ann … the wife of John Colborne, then treasurer of the Stroudwater Navigation; £500 to his sister Elizabeth' the wife of John Hollings, himself a successful local mercer, influential shareholder in the Stroudwater company and a senior partner in the newly established Stroud bank; two houses and two dwelling houses cum shops to his grandson; his silver pint pot to his eldest son, John, as well as lands and tenements at Ruscombe, Slad, Standish, Moorfield and Haresfield. John Winchcombe rose rapidly to the status of gentleman himself and had no difficulty in raising a loan of £5,000 from William Lord Bishop of Gloucester, in July 1776. Finally, James Winchcombe left three houses to his son Richard.[93]

Captain George Hawker lived at the Grange in Painswick until he built the grandiose folly of Rodborough Fort, or 'Fort George' as the locals dubbed it, on Rodborough Hill in 1765 from the profits of his substantial clothing interests at Dudbridge and Stroud. Large ostentatious houses like this and other examples of conspicuous consumption were much favoured by some of the wealthier clothiers especially those whose main wealth had been made in trade rather than inherited from an existing gentry family. Such nouveau riche clothiers were more interested in buying the prerequisites of social advancement or sought visible symbols of their own rising respectability rather than acquiring such properties as serious investors in land and buildings. At his death in 1786 George Hawker left the bulk of his large estate and the lordship of the manor of Cowley which he had bought some years before to his son Joseph 'whom …' he declared, 'I have bred up'.[94]

The Grazebrook family had originally come from Stourbridge in Worcestershire and settled in the Bisley area near Stroud in the mid-seventeenth century.[95] Although Benjamin Grazebrook, born in 1731 the son of Benjamin Grazebrook the elder, is repeatedly listed as a plumber in many of the earlier

Stroudwater records, an outline of his career and experience suggests he was a talented and ambitious general contractor who saw in the Stroudwater scheme a local outlet for his drive and initiative as well as providing an ideal opportunity for his social and financial advancement. Fisher calls him 'an enterprising tradesman' of the town and recalls how Grazebrook built a large round reservoir at his own cost behind the gardens of the White Hart Inn at Stroud, filled it with water from Gainey's well and supplied piped water to the houses in the district prepared to pay the appropriate annual fee.[96] Grazebrook's general contracting experience, as well as the money he was prepared to invest in the project, were a considerable asset to the undertakers. He was appointed senior clerk in December 1774 with instructions to keep the books, attend all meetings of proprietors, be responsible for the day-to-day running of the company and to act as under-surveyor. Grazebrook's formal association with the Stroudwater supporters had begun earlier in 1774 when he was appointed a commissioner. This alone is a clear enough indication that by this stage the plumber of yesteryear was worth at least £50 a year or had a personal estate of £2,000; the minimum requirements for appointment. In fact there is some evidence that he was acting as clerk to the intended subscribers as early as June 1774.[97] With his flair for efficiency and organisation, Grazebrook gradually took on more and more of the supervisory duties of management and by 1778, when several other surveyors and engineers had failed to satisfy the Stroudwater directors, Grazebrook was appointed to take over all engineering responsibilities and to complete the navigation to Stroud. In addition to this Grazebrook established a prosperous canal carrying company trading between Stroud, Gloucester and Bristol as soon as the canal was partly open and managed to secure surprisingly low tolls from his fellow directors, became a partner in the Stroud Brewery established by Peter Leversage, joined the Stroud banking firm of Hollings, Dallaway & Co. in 1787, bought Rodborough Fort from James Dallaway in 1791 and became a long serving and influential member of the Stroudwater board of directors. There is some indication, however, that he was more admired for his undoubted skill as an engineer and businessman rather than for any more personable traits of character.[98] By 1797 it was customary to omit any references to his origins and refer to him as 'a gentleman of Stroud'.[99]

Joseph Wathen was a wealthy clothier with mills at Rooksmoor and Stroud. He lived at New House, Thrupp, which Rudder described as 'a very handsome building' and was generally considered to be 'one of the greatest clothiers in the county'. Apart from his activities as a Justice of the Peace, Joseph Wathen was a generous benefactor to religious foundations like the Stroud parish church and, with James Winchcombe, James Dallaway and John Hollings, founded Stroud Bank on 1 January 1779 with a total capital of £10,000.[100]

Thomas Baylis, another wealthy clothier, had erected a large and commodious dwelling house in 1766 close to his thriving clothing interests at New Mills. Born in July 1729 Baylis took an active interest in his business and running the adjoining estate. At least one of his grand concerts and balls was sufficiently memorable to reach the county newspaper.[101]

John Hollings had a great deal of experience in the retail trade. In 1763 he had taken over the shop and stocks of Anthony Pain, the Stroud shopkeeper, and advertised his 'new and handsome Assortment of MERCERY and LINEN and WOOLLEN DRAPERY GOODS'.[102] By 1779 he was prosperous enough to join with three other local men to form the Stroud Bank and bring at least £2,500 into the partnership.[103] In all probability this bank was merely a formalisation of the existing financial and credit arrangements in the town rather than a new innovation and that the four partners, all shareholders in the Stroudwater company, had used their earlier more informal banking structure to help locate and raise capital for building the navigation. Hollings withdrew from the banking partnership in 1798 and died a year later.[104]

Richard Aldridge was also a Stroud retailer who kept a shop in the centre of the town where be carried on the trades of soap boiling, malting, chandling and oil selling.[105] Of modest rather than substantial

means, Aldridge was nevertheless sufficiently well to do for his son, Richard, to go into banking in Bristol.

William Knight, the last named undertaker, was an important Painswick clothier who died in 1786.[106]

These chief undertakers and their supporters met together at the George Inn on 29 December 1774 to form themselves into a Company of Proprietors of the Stroudwater Navigation, to confirm their acceptance of their appointment as undertakers, to elect themselves as a committee of directors and to establish articles for the government of their company.[101] The articles, which had already been drafted and agreed to at a meeting on 8 December provided that the navigation should be built within eight years according to the terms of the two previous Acts although the commissioners could once again allow such further time as they might think fit. The £20,000 would be divided into two hundred equal £100 shares and would be raised gradually by a series of calls starting at not more than £5 a share for the first call and not more than £10 a share for each call thereafter. At least two months should be allowed between calls and a clear thirty days notice should be given of the first call by a letter to each subscriber and an advertisement in the *Gloucester Journal*. After the first call, subsequent calls were to use the same procedure but give sixty days notice of each call.

A committee of not more than thirteen and not less than nine directors should be chosen annually at the general meeting. A treasurer would also be chosen annually at the same time. The committee of directors would act as a managing committee during the period of construction and, once this was finished, assume the powers for running the navigation on a profitable basis. This committee, acting in either capacity, had powers to buy land and materials, employ workmen and conclude contracts and be able to direct the construction of the navigation. Any five members of the committee would constitute a quorum and the decisions they reached would be binding subject only to their being answerable to the general meeting of proprietors.

It was agreed there would be two general meetings each year held at the George Inn or any other suitable place. At this meeting the directors books, the accounts of the treasurer and other company details should be open to the inspection of any shareholder. One general meeting was to be held on the first Thursday in July and the second on the first Thursday in January. Each general meeting had the right to elect a new committee of directors and to remove any servant of the company if they chose to do so. Any proprietor was eligible to stand and serve as a committee. At general meetings the ownership of one share would count as one vote, of three shares two votes, of five shares three votes and of ten shares or more five votes. Apart from shares confiscated from their owners who neglected to pay their calls, no shares would be negotiable without the permission of the commissioners until the navigation was completed. Should the £20,000 be found insufficient to complete the navigation, the proprietors might either raise the additional money among them selves or raise it by credit on the company. Finally it was decided to appoint Richard Colborne as honorary treasurer, Benjamin Graze brook as senior clerk and Richard Hall, former steward to Lord Ducie, landlord of the New Inn at Framilode and owner of lands at Fretherne and Saul, as second clerk and under–surveyor at Framilode where he was to keep accounts of traffic entering the canal and the amounts of tonnages paid. Both clerks were to be given a salary of £50 a year to begin from 1 January 1775. Up to £112s 6d (£1.62½p) was to be allowed out of capital for the expenses of each committee meeting.

With all these administrative details now settled, the new Company of Proprietors of the Stroudwater Navigation and their servants were at last ready and able to start work on constructing their long planned and even longer needed waterway.

Chapter Eight References

1 GJ 12 May 1764
2 GCRO D1180 5/1 Dallaway, William, *The Case of the Stroudwater Navigation* Stroud 1775 1, 2: GCL 2257 JX14.21
3 Rudder712
4 GCRO D1180 5/12 Dallaway, William, *Resenes agenste the owld Acks*
5 GJ 3 January 1763, 12 March 1764 for example . See also Chapter Four references 38 and 39
6 GJ 1 August 1727, 26 December 1752, 26 June 1750, 15 January 1754, 22 April 1765, 16 May 1774 etc.
7 GJ 26 June 1753
8 GCRO D1180 5/1 Minutes taken before the Committee on the Stroudwater Navigation Bill 19 February 1776
9 GJ 12 June 1739, 24 January 1744
10 GJ 19 April 1773
11 GJ 22 February 1773
12 GJ 13 February 1775
13 GJ 2 April 1745, 22 April 1755, 8 May 1750 and 24 April 1744
14 GJ 8 August 1763
15 GJ 24 April 1744, 17 April 1769, 1 May 1769, 28 March 1774
16 GJ 30 January 1759, 13 February 1759
 GJ 2 March 1772 with complaints of coal horses crossing the lands of Richard Owen Cambridge between Saul and Whitminster Mills.
17 GJ 29 August 1727, 28 September 1731
18 GJ 31 December 1751
19 GJ 28 August 1739
20 GJ 28 March 1758
21 GJ 15 April 1771, 24 April 1774
22 GJ 7 September 1767
23 GJ 5 December 1768
24 GJ 23 April 1728
25 GJ 10 October 1732
26 GJ 5 April 1743
27 I am grateful to Christopher Chambers for evidence of this point
28 GJ 2 January 1766, 13 January 1766 These references only date the first record of both fairs and markets although they probably had a much earlier origin. The newspaper does not distinguish clearly between fairs and markets. The general point, though, is evident enough both fairs and markets were expanding locally.
29 GJ 2 December 1765, 13 January 1766
30 GJ 27 January 1766, 3 February 1766, 3 March 1766, 10 August 1767
31 GJ 8 August 1768, 15 August 1768, 22 August 1768
32 GJ 25 November 1771
33 GCRO D1180 5/1 Dallaway *The Case of the Stroudwater Navigation* 2: 5/3 Brief in support of the Stroudwater Navigation: 5/9 Petition to the Commons
34 GJ 2 May 1774, 27 June 1774 For detailed reports of all the commissioners' meetings see Cl/1

35 The suggested list of new commissioners, whose appointment was of doubtful legality without a quorum of commissioners attending, included:
Richard Aldridge Jnr., Ellis James, William Hopton, Edward Aldridge Jnr., William Knight, Samuel Heaven, John Arundell Jnr., Onesiphorous Paul Jnr., John Leversage, Daniel Chance Jnr., Edward Palling, Charles Phillips, Samuel Colbome, Richard Bird, Anthony Pain, Joseph Colbome, William Hall, Samuel Wallington

36 GJ 23 May 1774

37 GCRO D1180 2/17 Cash Book 2. It is Benjamin Grazebrook 's handwriting

38 PRO Staffordshire & Worcestershire Canal Co Committee minutes 19 May 1774

39 GCRO D1180 2/17 Account Book 27 June 1774, 23 July 1774

40 GJ 27 June 1774 GCRO D1180 Cl/1 Commissioners minutes 27 June 1774

41 GCRO D1180 2/17 Account Book 27 June 1774, 24 October 1774, 6 February 1776

42 GCRO D 1180 5/1 Dallaway, William, *The Case of the Stroud water Navigation* 3

43 GCRO D1180 5/1 Evidence before committee on Stroudwater Bill 22nd February 1776
Yeoman said navigations using rivers had problems with the mills 'perpetually hurting the navigation from the Nature of Working the Mill in drawing down the heads [of water] … and that often in spite.'

44 GCRO D1180 5/12 Dallaway, William, *Resenes agenste the owld Acks* 5/1 *The Case of the Stroudwater Navigation* 2,3

45 GCRO D1180 9/20 Estimate to make the River by Dadford and Priddey. Compared with the final cost, which is not comparable in detail because of different categories, land took 20% of expenditure and cutting 22.50%. The figures do not add up to 100% because of rounding.

46 GJ 8 August 1774

47 GJ 22 August 1774
GCRO Hyett Pamphlet 353 *The New Navigation*
'For twenty thousand pounds have been subscrib 'd, And if more's wanting, soon t'will be supply'd.'

48 GCRO D1180 2/69 List of Calls. The first call was in March 1775

49 GJ 9 September 1765, 23 September 1765, 14 0ctober 1765, 21 October 1765, 4 November 1765, 18 November 1765

50 GJ 8 November 1773

51 GCRO Hyett Pamphlet 353 *The Chronicles and Lamentations of Gotham* 'And the inhabitants assembled and said 'We will give our lands for gold, yea our dwelling places shall become sureties for the same'

52 GCRO D1180 9/25 'Proposells by Mr Hacker' The date of this is uncertain but the concepts suggested in it date it during the middle of 1774

53 GCRO D1180 9/25 'Proposells by Mr. Hacker'

54 GJ 15 August 1774

55 GCRO D1180 5/4 27 Commissioners Memorandum to Counsel

56 GCRO D1180 5/1 Mr Dallaway's Notes and Hints, *Resenes agenste the owld Acks*

57 GCRO D1180 6/1 Mr Prices opinion, Mr Dunning's opinion

58 GCRO D1180 Cl/l Commissioners minutes 25 August 1774

59 GJ 28 November 1774, 12 December 1774

60 GJ 12 September 1774

61 Robinson, Eric, *The Profession of Civil Engineering in the Eighteenth Century: A Portrait of Thomas Yeoman, FRS 1704(?)–1781* Annals of Science 18 4195– 215 Skempton, A. W. and Wright, E. C. *Early*

Members of the Smeatonian Society of Civil Engineers lecture read at the Science Museum, London, 10 November 1971

62 Northampton Mercury 27 April 1747

Thornton, J. H., *The Northarus Cotton Industry … an Eighteenth Century Episode* Jnl Northants Natural History Society and Field Club 33 242–59 1959

63 *Gentleman's Magazine* January 1764

64 BRL Wyatt Mss II 26 November 1743 Box Tew Mss Assay Office Library, Birmingham

65 Aris's Gazette 29 December 1746

66 Northants Record Office Map 1172 Plan of the enclosed estates of Hitch Young esq., deceased. Thos. Yeoman 1752 (surveyor?), YZ 4234e Attested copy of release of 10 October 1755, YZ 7310 Copy of indenture–marriage settlement (assignment) Ann Remington & William Langston to Thos. Yeoman. Remington & Thos Wilson, BH(K)582/3 copy of draft power of attorney 4 May 1759, Bouverie (Delapre) 322–26 plan of estate of late Bart . Clark (surveyor: Thos Yeoman), terrier of land in Hardingston e (surveyor: Thos Yeoman), survey & terrier (Brafield & Little Houghton) (surveyor: Thos Yeoman) Box X470 Towcester: Western Gate Turnpike, G(K) 2390 Surveyor's Club, London, list of members 1792–1937, Marriage licence bond 16 September 1738 Thos Yeoman & Mary Bennett

67 *Gentleman's Magazine* December 1746 639–40

68 PRO Admiralty Navy Board Out Letters 2188 452

69 Mortimer, J., *The Universal Directory* 1763

70 JHC 30 74118 April 6 Geo III

71 Mortimer, J., *The Universal Directory* 1763

72 JHC35 553

73 GCRO D1180 1/1 Committee Minutes 1 January 1775

74 GCRO D1180 2/17 Account Book 2 January 1775, 9 January 1775 A Bill for 26 November 1774 could be for an earlier visit or, more likely, refer to the commissioners meeting (Cl/1 24 November 1774) two days earlier

75 JHC35 553 GCRO D1180 5/1 Dallaway, William, *The Case of the Stroudwater Navigation* 3

76 Basingstoke (1778–94) cost £5,000 a mile Thames and Severn (1783–89) £7,333
Staffs and Worcs. (1766–72) £2,200 BCN (1768–72) £4,000
Coventry (1768–90) £2,800
Chesterfield 1771–77 £3,000
Stourbridge (1776–79) £5,500
Dudley 1776–79 £4,300
Erewash 1777–79 £1,750
Droitwich Barge 1768–71 £3,300 Trent and Mersey 1766–77 £3,200

77 JHC 35 469–70 1 December 1775

78 The precise length would be eight miles, three chains and forty–eight links

79 GCRO D1180 5/1 Dallaway, William, *The Case of the Stroudwater Navigation* 3

80 Later amended to thirteen by the construction of the Gloucester & Berkeley Canal and a new Junction Lock

81 GCRO D1180 9/20 'Estimate by Mr Yemen' The figures do not add up to 100% because of rounding

82 GCRO D1180 2/17 Account Book 14 March 1776 £77

83 GCRO D1180 1/1 Committee Minutes 29 December 1774: 8/1 Articles of Subscription

84 I am grateful to F. T. Hammond of Chalford for a good deal of this evidence BGAS 81208–10

85 GCRO Hyett Pamphlet 353 The Hamburg connection is mentioned in *A Prophecy of Merlin* and *The British Merlin* who refer to 'Hambro' and 'Hamburges' respectively and could refer either to the dead John Dallaway or William Dallaway if they were written after March 1776. *The Chronicles and Lamentations of Gotham* call William Dallaway 'Belshazzar'

86 GCRO Hyett Pamphlet 353 *The New Navigation* 140–49 and *The British Merlin*

87 GCRO Hyett Pamphlet 353 *The Chronicles and Lamentations of Gotham* 12– 19, 25, 33–36, 45 GNQ 3120

88 GCRO Hyett Pamphlet 353 *The New Navigation* 225–45

89 GJ 25 March 1776

90 GCRO 014913 In 0149 BIO he is asked 'to make as good colours as possible' 0149 940 D149 TI31 All Winchcombe family papers
 GJ 30 July 1764, 18 August 1766, 28 February 1774

91 GCRO D149 F198 Winchcombe family papers

92 GCRO D149 F24 Winchcombe family papers

93 GCRO D149 F32, D149 F198, D149 F33, D149 T931, D149 940 Winchcombe family papers

94 GCRO DC E88 17, GCL Wills 1786 116, ROL G4, D149 T36, DC E88 16 Hawker family papers

95 GCRO P147 IN 4/2 Grazebrook family papers D1180 3/1 10, 11, 51, 56 etc Register of Share Transfers

96 GCRO D1180 3/110, 11, 51, 56, etc, Register of Share Transfers
 Fisher, P. H., *Notes and Recollections of Stroud* 30 GJ 24 July 1769 refers to the inconvenience of the short water supply for Stroud being changed by Richard Capell forming a reservoir on his estate from whence water was conducted to the town. It seems likely Capell and Grazebrook were in partnership on this project with Grazebrook doing the contracting.

97 GCRO 2/17 Account Book 27 June 1774

98 GCRO Hyett Pamphlet 353 *The Razor Grinder's Dream* Refers to:
 'their famous Engineer
 Whose head with every wind did veer And which with maggots was as full As e'er was Don Quixote's skull'
 It could either refer to an allegedly senile Yeoman or be satirising Graze brook's relative inexperience.

99 GCRO TS 208 4/5 Grazebrook family papers

100 Rudder 712 GCRO D149 940 Wathen family papers William Dallaway, Fream Arundell, Thomas Baylis, Robert Ellis, Richard Aldridge and William Knight among others also contributed . James Dallaway was William's younger brother

101 See Chapter Three

102 GJ 7 February 1763

103 GCRO D149 T940 1 January 1779 Wathen family papers

104 Fisher 142

105 GJ 22 July 1776

106 GCRO Library G4

107 GCRO D1180 8/1 Articles of Subscription

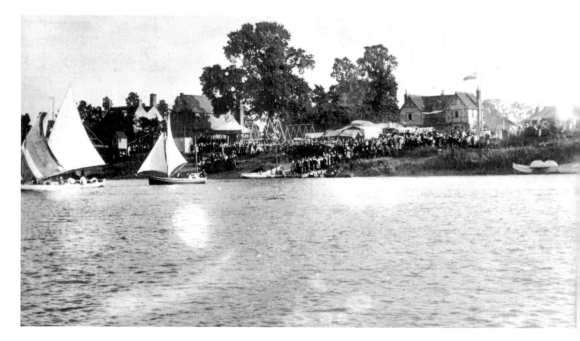

The start of the Framilode Regatta. The former public house, the Darrell Arms, in centre right. The canal basin is off the photograph to the left. Date uncertain, but probably 1920s.

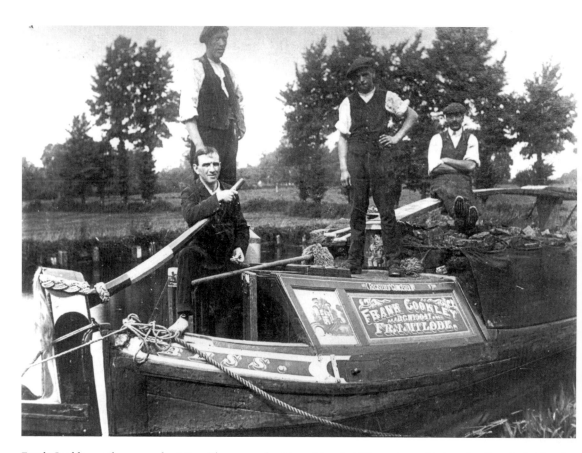

Frank Cookley on the narrow boat *Bess*. The narrow boat is registered at Gloucester and is based at Framilode. Dated *c.* 1920s.

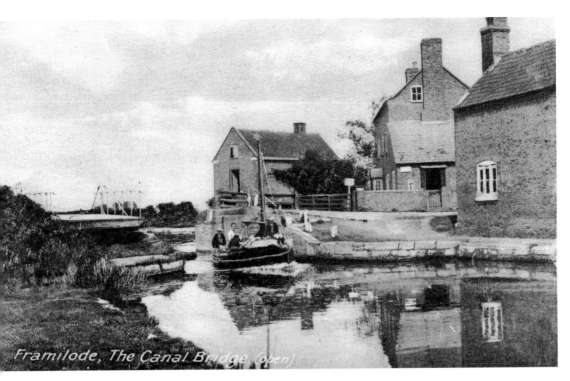

A view showing the warehouse, canal bridge and lockhouse at Framilode. The craft may be a pleasure boat. Dated c. 1910.

The Ship Inn and Burnt House Farm at Framilode.

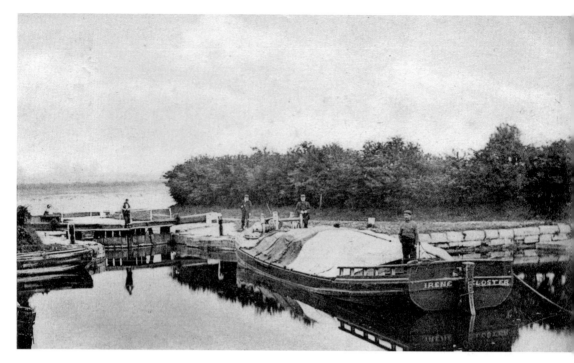

Framilode basin showing the trow *Irene* of 'Gloster' ready to pass the lock. Note the substantial coping stones to the right, *c.* 1900.

Canal coming up from Framilode Basin, 2012.

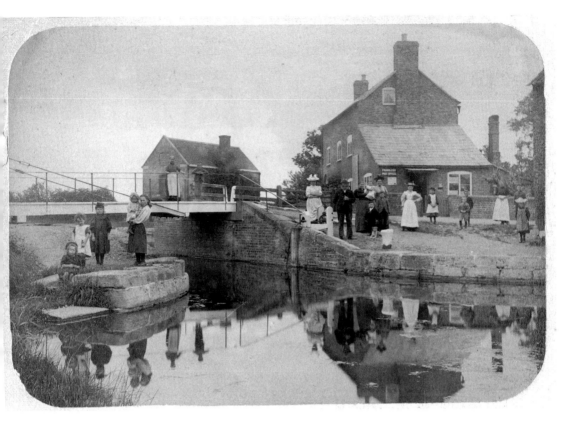

Framilode Swing Bridge showing warehouse, lockhouse, post office and a mix of local residents and visitors. Notice the chain and spindle lying flat in the centre of the picture. These would pull up a gate in the canal bed to avoid floods backing up over the basin from the Severn. Dated *c.* 1910.

The white house is by the swingbridge on the Saul to Framilode road. The River Frome is on the right. Dated early 1970s.

The former swingbridge at Stonehouse. The world famous (and useless) plastic bridge has replaced this. Dated early 1970s

Whitminster Reach, east of Walk Bridge, Whitminster, and looking towards Whitminster Lock. Dated early 1970s.

Whitminster Lock had new lock gates fitted in 1996 but is till out on a limb as the rest of the canal here awaits restoration and linking with the national canal network

Westfield Bridge from the east.
Dated early 1970s.

Westfield Bridge from the lock.
Dated early 1970s

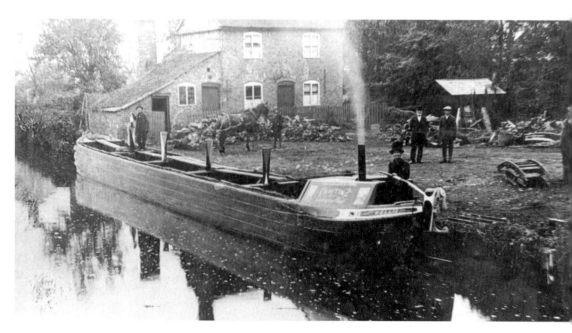

Captain and Mrs Chandler on narrow boat *Nellie* at Eastington Canal Wharf. The boat was owned by Mr Zacharia Whiting (with the beard), the village coal merchant. He is standing on the wharf with a friend. *Nellie* made the journey to and from Staffordshire via the Berkeley Canal, the River Severn and the Staffordshire & Worcesrershire Canal carrying best quality staff house coal. Notice the horse on the wharf. *Nellie* was 'a de-luxe joey boat'. Dated 1910s.

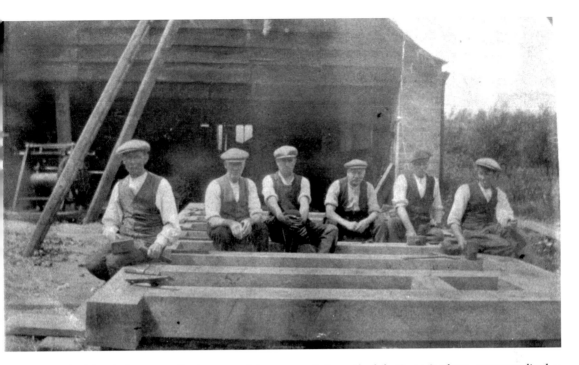

The men are building lock gates at Eastington maintenance yard. From the left, Harry Stephens, carpenter, lived at Brimscombe, Frank Smith, blacksmith, employed occasionally; Geoffrey Brinkworth, general worker; John White, lockkeeper; John Whiting, mason, lived at Tunnel Cottages in Daneway; Gordon Harrison, carpenter, John Whiting's son-in-law, lived at Sapperton.

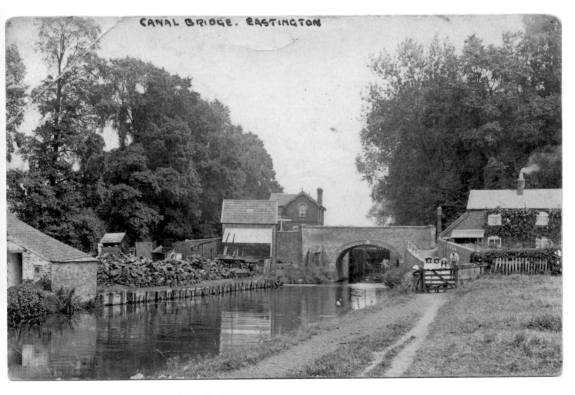

Coal Wharf, Eastington, Eastington Wharf *c.* 1910.

Blunder Lock, Eastington, so named after the lock was built on the wrong level. Dated early 1970s.

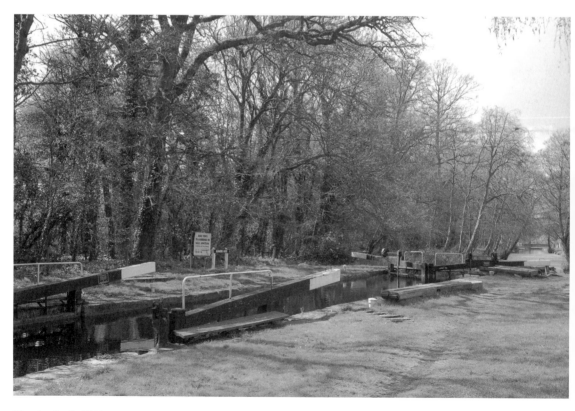

Blunder Lock, 2012.

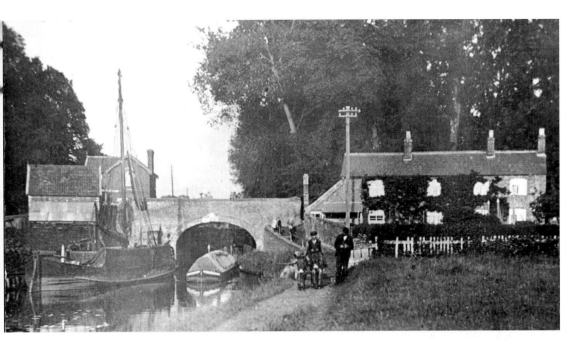

This original bridge – Pike Bridge – carried the turnpike road over the canal for 135 years before it was found too narrow for motor age traffic. The houses on the right were demolished and the Cotswold Canals Trust depot is on the site. Notice the trow, and the animals pulling the Fellows, Morton & Clayton horse boat. Pike Lockhouse is in the middle left. Dated *c.* 1910.

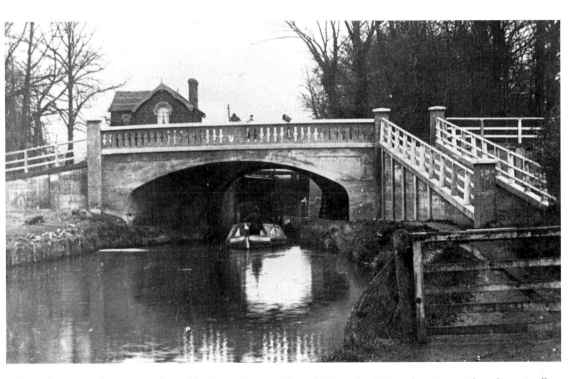

Pike Bridge replaced the original canal bridge and existed from 1924 to the 1970s when it was taken down to allow extensive alterations to be made for the construction of a roundabout and subsidiary roads. Its modern replacement is similar. Notice the kissing gate and boat. Dated *c.* 1928.

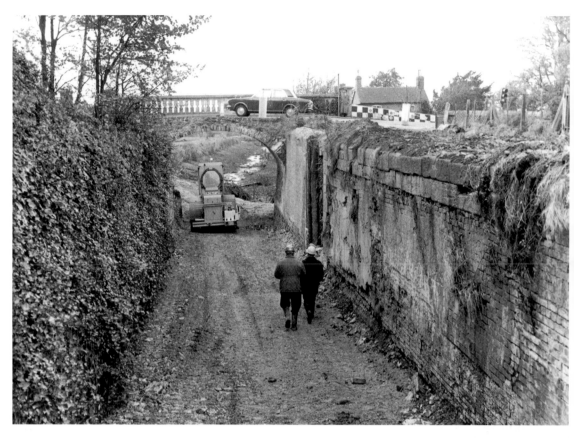

Pike lock is shown here, drained, on 11 November 1970. Notice the substantial stone capping and deterioration below water level. At this point the towpath changes side.

Pike Lock, 2012.

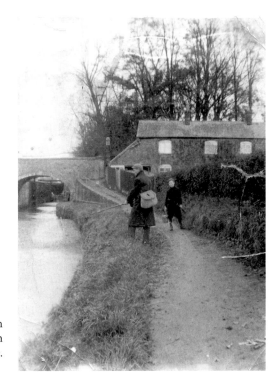

This is the original pre-1924 road Pike Bridge. The fisherman is George Bennett, a well-known local angler. He was a cloth designer at Bonds Mill and lived at Avenue Terrace, Stonehouse. The lad is his son. Dated 1912.

Alice Brinkworth (left) and Alice White with Harold Brinkworth, aged four at Pike Lock. Notice the leaking Blunder lock gates in the distance. Dated 1928.

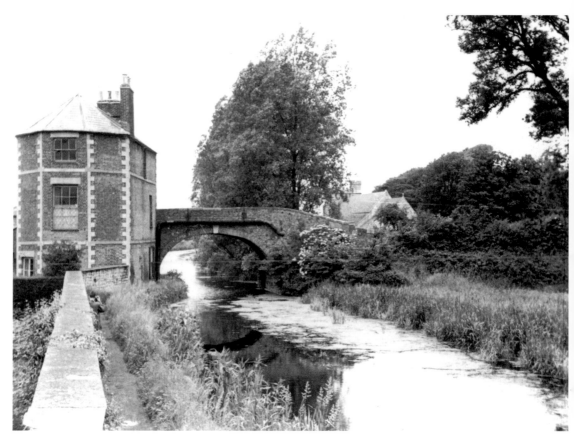

Nutshell Cottage and House. A note on the back of the photograph says the house was originally a warehouse. Dated *c.* 1920s.

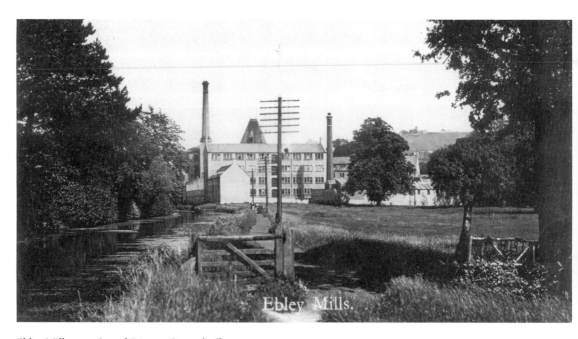

Ebley Mills, now Stroud District Council offices, *c.* 1920s

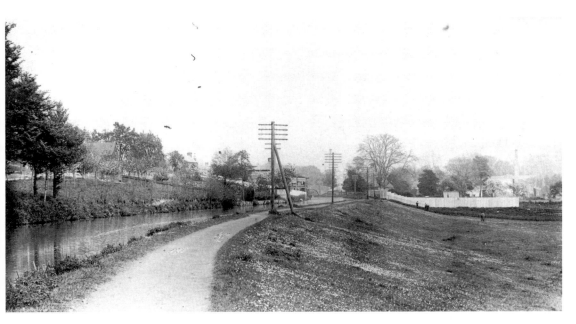

Looking towards Oil Mills Bridge. Hooper's Saw Mills on the left. Oil Mills are on the right. Dated *c.* 1920s.

Circular weir at Ebley. This pattern was copied from the Staffordshire & Worcestershire Canal. Dated early 1970s.

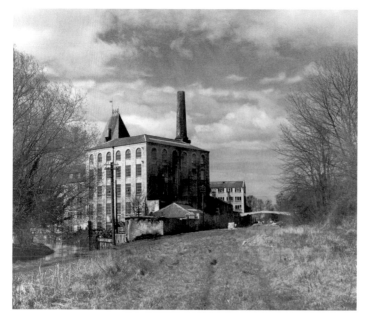

Infilled canal at Ebley Mills. River Frome is on the left. Dated early 1970s.

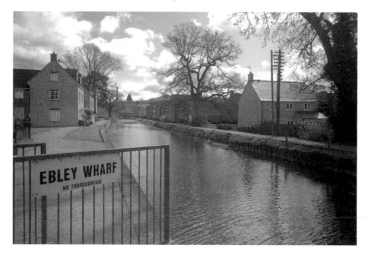

Ebley Wharf, 2012.

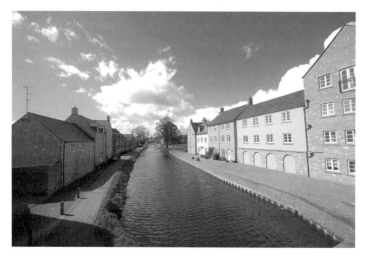

Part of the regeneration of the canal has involved building many new houses along the route, such as here at Ebley Wharf.

Chapter Nine
'A Great Concourse of Spectators'

The early months of 1775 were a busy time for the new company of proprietors and especially for those active shareholders who had elected themselves on to the committee of directors responsible for supervising construction. Since the directors knew the 1730 Act remained law and assumed its provisions gave them powers to build a canal navigation separate from the River Frome, they lost no time in making outline plans for work to begin. Benjamin Grazebrook and Richard Hall staked the line out from Framilode to the Bristol Road by the middle of February measuring the lands required from each owner and assessing the rental value. While this was being done some of the directors came to inspect the work to consider the general quality of the land the canal would cross in an attempt to work out a formula for paying compensation to landowners.[1] Richard Hall meanwhile began negotiating with Robert Dobyns Yate for the purpose of his land at Framilode.[2] Advertisements in the *Gloucester Journal* requested estimates for delivering rough hewn Ashler stone for building the two lower locks, oak timber for lock gates, green elm for flooring the locks and announced the directors were ready 'to treat with an Person ... who will undertake for Digging and Banking from Framilode to the [Bristol] Road'.[3] Edward Hinton, the brickmaker, received a guinea for testing clay along the lower line and selecting a spot most suitable for exercising his craft.[4] Lock sizes were provisionally settled at seventy foot by sixteen foot, two inches and it was agreed to make the canal wide enough above Framilode Lock for vessels to turn.[5] The committee also accepted Yeoman's suggestion for employing Samuel Jones of Boston as resident engineer at £1 11s 6d (£1.58) a week providing this included all his expenses incurred on company business. Jones was asked to come to Stroud as soon as possible and to contact the directors and engineers of the Staffordshire & Worcestershire Canal Company for general consultation and advice. The Stroudwater directors and Samuel Jones, however, found their relations strained almost at once and by 16 February the committee had resolved to discharge him but pay him twelve guineas for his trouble. There is no evidence to illuminate the cause of this disagreement but if later experience is anything to go by it probably centred on the amount of discretion Jones was allowed. The Stroudwater directors, successful and self-made businessmen, were used to having their own way in their own businesses and probably had their own opinions about costs and construction. Almost certainly they sought to involve themselves intimately with the day to day management of building a canal. Samuel Jones a respected engineer in his own right, may have found this a frustrating experience and an unnecessary insult to his abilities. In any event, this was only the first of many disagreements between the committee and their engineers.

The directors met at Framilode at 9 a.m. on 2 February to consult Mr Wakefield, a trow owner, watch the tide coming up the Severn and decide precisely where the first lock should be built. Wakefield considered the earlier idea of dropping the canal into the Severn near the New Inn was impractical as the river was either full of sand or had dangerous rock projections at that point. In his opinion the only suitable site within a mile of Framilode either upstream or downstream was at Kemmmett's Orchard. Wakefield's opinion was confirmed by fifteen other trow owners who submitted their written opinions to the directors before their meeting on 16 February.[6] These experienced boatmen confirmed they had

never been troubled with sandy obstructions near Kemmett's Orchard, probably because of scouring from the nearby exit of the Frome, and that in their opinion this was the only place with a good six feet depth of water close to the bank at even the lowest Severn tides. This reinforced the view of the directors that they had chosen the best site for the first lock, especially when they beard the soil there would be suitable for holding a lock chamber.

In the meantime advertisements in the *Gloucester Journal* had brought in a spate of replies from would–be suppliers and contractors attracted by reports of the £20,000 pledged for construction and anxious to be involved in this major local project. William Hearne of Gloucester and William Land offered to cut the canal from Framilode towards the Bristol Road. Mr Price, the Gloucester timber merchant, and several others submitted proposals for supplying oak timber. Edward Heels offered to burn lime for the company at 6s 8d (33p) a ton and John Vaughan of Courtfields, who had already supplied stone for the newly built Bristol Bridge, offered his stone at ls 6d (7½p) a ton at his quarry, 4s 6d (22½p) a ton delivered to Brockware by the bargeman William Hawkins or 8s 0d (40p) a ton delivered to Framilode.[7] This itself is a clear indication of the extent to which the price of heavy goods such as stone and coal was determined by the additional cost of carriage.

The directors proceeded to conclude a series of contracts for the supply of materials, for the excavation of a lock chamber and for the cutting, digging and puddling of the canal.[8] Unlike a modern government department inviting tenders or the construction of major works such as motorways, the committee of directors did not appoint an individual or corporate body of individuals with powers to purchase all materials needed, to delegate work to more specialised sub-contractors and to have complete responsibility for the construction. Instead, they appointed a resident engineer and surveyor as a direct employee who was subordinate to them but who nevertheless, like the committee, was also responsible for seeing that the navigation was built soundly and effectively. In addition the committee itself invited separate tenders for building each individual bridge and each individual lock, for the construction of each individual section of canal and for the supply of each individual load of stone, wood, bricks, lime and the like. The committee itself then appointed individual contractors or suppliers for each specific task in hand or material requirement. The contractors and suppliers were therefore directly bound to the committee of directors and not to the resident engineer and surveyor who was nevertheless still supposed to be responsible for the quality and accuracy of the contracted work and materials supplied. This standard arrangement for most eighteenth century canal construction proved to be a far from ideal arrangement for the Stroudwater directors and their engineers.

In the first place, because it was so intimately involved in the day to day running of the company, the committee was prompted to interfere in many minor matters of administration and construction rather than concerning itself with the broader aspects of company policy and leaving the detailed decisions to their paid employees who were in most cases better qualified to give expert judgement. In April 1775, for instance, the directors ordered more wheelbarrows to be made, told their mason Thomas Bartlett to leave off digging stone but to prepare that he had already dug and made several other trivial suggestions which more properly belonged to the province of their resident engineer. This persistent involvement in the duties of the engineer, no doubt aggravated by the previous business experience of the directors who were 'Master of the whole Manufacture from first to last', led to a great deal of friction between the committee and their chief engineer and surveyor and was almost certainly the main reason why the company employed such a gallery of engineers before the canal was finally completed.[9]

In the second place, the directors' detailed involvement led to a general confusion of responsibilities. It was had enough for an engineer to try and keep track of the dozens of contracts the committee agreed and of the various contractors, workmen and suppliers some of whom were not primarily concerned with

the quality of their workmanship. It is hardly surprising that final costs were more than double the original estimate, that sections of the waterway had to be completely rebuilt and that one lock was built on the wrong level if an engineer was trying to do all this and a committee of up to thirteen directors was busying itself with viewing the works, issuing instructions to all and sundry, perhaps without consulting either their engineer or each other and who were all trying to keep a watchful eye on the motley host of suppliers and contractors.

These activities kept the committee of directors active. They usually met formally at 5 p.m. on every second Thursday at the George Inn to decide on matters of policy to review the state of construction and to issue a series of instructions and decisions to their subordinates. It was not unusual however, for the directors to meet more frequently if the need arose. A few of these meetings were held at the New Inn at Framilode where Richard Hall lived. At either venue the committee usually dined well at company expense; an extravagance they regretted in later years when money for completing the navigation was particularly short.[10] Forthcoming work on behalf of the company was shared out between committee members at these meetings. During the spring of 1775, for example, William Dallaway negotiated with Richard Owen Cambridge to buy five acres of his land; Thomas Baylis was offering to buy Kemmett's Orchard at Framilode for the lock site and for making bricks if the soil was found suitable; John Hollings was in contact with. Mr Parry about Robert Dobyns-Yate 's land; and Timothy Lewis, who often acted as chairman at committee meetings, was negotiating with a Mr Coulson.[11]

The committee concluded a series of agreements with a variety of suppliers and contractors for the supply of goods and services. One of their first actions was to appoint John Priddey as resident engineer and surveyor in place of Samuel Jones who had already discharged. Priddey was appointed at a salary of £100 a year on 23 February with instructions to complete the whole navigation and to ensure he spent at least a quarter of his time on supervising construction – or more if special circumstances required it – and not to take on more work than he could handle as some other engineers were liable to do. [12] The committee also asked John Gleave of Willoughby, Northamptonshire, for his terms for supervising puddling and banking and specifically requested proof of his abilities from a former employer. John Gleave arrived in Stroud shortly afterwards to take up his position, went into partnership with Robert Perry, the former surveyor of the Staffordshire & Worcestershire Canal, and was soon submitting proposals for cutting Framilode Lock and the section of canal to Bristol Road.[13] The directors also engaged the mason Thomas Bartlett and sent him out to search for suitable stone at Gatcombe and Tintern. Bartlett finally found the quality of stone he required at Guns Mills where he bought three hundred tons at 1s 6d (7½p) a ton at the quarry. This stone was expensive to work but its hard texture made it ideal for lock chambers. Mr Benett of Coleford in the Forest of Dean agreed to supply oak timber for Framilode Lock gates.[14] Thomas Barnard was to supply fifty thousand bricks landing them at Kemmett's Orchard at a maximum price of 19s 6d (97½p) a thousand.[15] Griffith Cooper of Little Deane would provide nails for the whole navigation at 4d (1½p) a pound.[16] Samuel Farmer and Samuel King supplied additional timber requirements.[17] John Priddey meanwhile was ordering wheelbarrows from Edward Keen, planks for barrow ways, special spades and buying deals from William Evans and Co of Bristol, sending pattern tools from Droitwich, marking out the site of Framilode Lock and giving instructions to John Gleave and Robert Perry who were in charge of the cutters.[18] Richard Hall, was to supervise hauling two forty ton loads of stone a day from the quarry to the waterside for a trial period of fourteen days, supply a hundred tons of Aberthaw stone for burning lime at 5s 8d (28p) a ton, land the stone and timber at Kemmett's Orchard charging only 5s 0d (25p) a ton transport for wood and 2s 0d (10p) a ton .transport for stone as well as to visit Hereford on 8 April to complete the purchase of the Dobyns-Yate property. Further supplies of stone came from Hampton quarry and from the Forest of Dean. Six labourers were employed in the orchard to dig clay for bricks at 6s 0d (30p) a thousand and

Thomas Davis contracted to provide an additional supply.[19]

Construction began on the Framilode Lock site before the middle of February when men employed by Perry and Gleaves were already excavating the lock chamber.[20] The directors had agreed to build the lock on a 'Timber Frome agreeable to Mr Jones Modell', but there was some indecision about lock sizes. William Symonds, a trow owner, thought the largest vessels on the Severn measured about sixty feet long, seventeen-feet, six-inches beam and five-feet, six-inches draught and carried between fifty and eighty–five tons. The committee were anxious to build locks to this size at first until it was pointed out that larger vessels would be unable to use the canal unless it was built to larger dimensions at a considerably greater cost. The directors therefore decided to reduce the lock width to fifteen-feet, two-inches and finally agreed on a standard lock size of seventy-four feet long in April 1775.

All these purchases and contracts needed money to pay for them so on 19 January the first call was announced of £5 on each share. This was to be paid by 7 March to John Colborne, attorney of Stroud and the new treasurer of the company, replacing Richard Colborne who had retired. John Colborne was the grandson of John Colborne Senior, the Stroud mercer who died in 1723, and the son of Joseph Colborne, a local clothier and gentleman. John Colborne, born in 1729, became a respected Stroud lawyer who like many in his profession at the time adopted the role of banker in channelling funds from estates in his trusteeship to many prominent local people who needed capital for industrial expansion or other purposes.[21] The directors announced, too, that share certificates would be distributed to proprietors on 7 March.[22] Two further calls of £10 on each share were called on 6 April for 5 June and on 7 June for 11 August. These three calls raised a total of £5,000 – a quarter of the capital – to finance the first months of construction.[23] Although all calls would normally be paid direct to John Colborne in full, there is ample evidence that some were paid to William Dallaway and Benjamin Grazebrook as well. It was also common for shareholders to pay their calls in instalments. John Cambridge, for instance, paid £7 18s 0d (£7.90) to John Colborne and the balance to Dallaway and Grazebrook at a later date.[24]

Who were the shareholders in the Stroudwater Navigation? Where did they live and what occupations did they follow? Two main factors stand out for consideration.[25] Firstly about 78% of the shares were held by proprietors living in Stroud or in neighbouring towns and villages within a radius of ten miles. By far the greatest proportion of the total, 51.5%, was held by residents of Stroud itself with Dudbridge (6%), Painswick (5%), Minchinhampton (4.5%), Chalford (2.5%) and other nearby villages with smaller totals. The remaining 22% of shares were held by residents of London (9.5%), Bristol (4%), Cirencester (2.5%) with individual holdings as far away as Reading and Surrey.

Secondly, about 70% of the shares were held by individuals connected with the woollen textile trade or by local gentlemen of substance many of whom had originally made their money in the woollen industry. These were the men who believed their interests were being damaged by poor transport facilities and who were ready to join with other local individuals in a similar position to remedy the situation. Clothiers and members of their families held 31% of the shares, gentlemen 20%, dyers 8%, woolstaplers 6.5%, lacemen 4% and mercers 1%. The remaining shares were held by chemists (3.5%), the plumber/contractor Benjamin Grazebrook (3%), ministers (2.5%), spinsters (2.5%), the tallow chandler Richard Aldridge (2%) and a whole variety of minor shareholders including maltsters, yeomen, innholders, merchants, bakers, widows, a distiller, an iron manufacturer, a surgeon, a tailor, a carrier, an architect, a land surveyor, a wine merchant, a banker and a 'Doctor of Physick' not to mention two in the hands of the nobility. Individuals such as William Dallaway, George Hawker, Joseph Wathen, James Winchcombe, Thomas Baylis, John Hollings, Richard Hawker, John Butt, Thomas White, John Colborne, Durley Wintle, John Gardner, John Allaway were all prominent shareholders. Anthony Keck, the architect responsible for the construction of Ryeford Locks, John Priddey, the Stroudwater

engineer, John Kemmett, a partner in the ill-fated machine navigation of 1759 and now a Bristol iron manufacturer, and Richard Hall, the Framilode land surveyor now junior clerk and under surveyor to the Stroudwater directors all held single shares. Even those shareholders who did not live in the Stroud area invariably had some connection with the locality, often with the woollen industry, a local family or both. Daniel Clutterbuck, the Bradford-on-Avon gentleman, was related to the local Clutterbuck family; Samuel Peach, minister at East Sheen in Surrey, had relatives in the Peach clothing family of Stroud; Samuel Walbank, a London wine merchant, was related to Abraham Walbank, the Chalford Gentleman who was himself a shareholder; John Billingsley of Shepton Mallett was a well-known industrialist with clothing connections with the Stroud area – he was later connected with the Somerset canals; Thomas Gibson and Thomas Bradbury Winter, both London lacemen, and Richard Coney and John Wilson, the London druggists, all had links with the Stroud woollen industry and like other more distant shareholders had no doubt learnt of the Stroudwater project in this way.

By far the greater part of the capital, however, came from local industrial interests in the immediate vicinity of Stroud. It was these local clothiers and their commercial associates who stood to gain most from a navigation. A fall in the cost of moving raw materials to their mills would give them a substantial cost advantage and enable their industry to meet the long term growth in demand. Any returns from dividends – welcome though these would be – were probably of secondary importance.

Several changes made raising finance easier by 1775. There was, for example, the optimism generated by the opening of successful canals in other parts of England. There was no doubt about the benefits these new navigations brought to the areas they served. Yeoman, too, had outlined a scheme to solve the serious problem of water supply which had been the main rallying point of the opposition in earlier years and himself admitted the reservoirs were specifically intended to overcome this problem. When he had first proposed a reservoir in 1755 it 'was then looked upon by the Generality of … Mill-Holders to be a sufficient Remedy to supply the loss' and only a few millowners had persisted in opposing the Dallaway scheme.[26] Raising the £20,000 was also facilitated by the recent growth of local banking and credit services which had accompanied the general expansion of the woollen trade.

Areas like Stroud which had industrialised in advance of the country as a whole were particularly favourable to the early growth of banking services. Although the first bank was not formally established in Stroud until 1779, it seems likely this was more of a centralisation of pre-existing financial arrangements rather than a complete innovation. Stroud already contained the three main groups of individuals whose presence was conducive to the early growth of banking: industrialists, financial intermediaries, and remitters of funds. As far as industrialists were concerned, they were strongly attracted to banking by the need to develop some local form of payment to circumvent the perpetual shortages of coin, by the need to extend their sources of credit as their industry expanded and by the need for more and better currency.[27] A local bank could support the issue of Bills or tokens as payment for goods and services and would enable them to create a stable currency of paper money or Bills. Successful businessmen like John Hollings, James Dallaway and later Benjamin Grazebrook also saw banking as profitable outlet for their profits and as a useful second string to their other business interests. The legal profession formed the second largest source of bankers. They acted as agents for rural savings and were able to channel investment into areas or industries which stood to produce an acceptable return. Richard and John Colborne, both local attorneys, often had estates and capital passing through their hands. Some estates were held in trust and had capital to invest. John Colborne was certainly acting in a banking capacity as early as the late 1760s and he was by no means the only lawyer in the town.[28] By this stage, therefore, the Colbornes had either become sources of finance themselves or were at least acting as a clearing house for information where money could be borrowed and lent. Both Colbornes held the post of treasurer to the proprietors at various times and no doubt used their contacts and reputation

to help raise the finance needed. The third main source of bankers originated from the wholesale and retail trades and from their connections with credit and supply. Richard Aldridge, son of the Stroud tallow chandler of the same name, went into banking in Bristol with some considerable degree of success.[29]

When the Stroud Bank was established in 1779, banking services in the town were now centralised in one specific building and run by a group of wealthy respected individuals who had bound themselves with their personal resources. In the years before the bank was established, however, it seems likely that banking services had been associated with individuals rather than groups and that it had developed and expanded with the local woollen industry. While there had only been a handful of bankers in country towns before 1750 there is plenty of evidence for their rapid growth after this date. Usually banking was developed as an adjunct to other businesses at first and the degree of occupational specialisation was limited. Generally speaking after 1750 men who had developed subordinate banking services tended to concentrate more and more of their energies on their financial interests and less and less on their industrial concerns. Some evidence for this process operating in Stroud can be gleaned from family histories. John Hollings, for example, retired from his mercering trade and used the capital he had accumulated to establish himself as one of the founders of the Stroud Bank. James Dallaway, another partner, gravitated gradually from the family woollen interests into the banking profession. Benjamin Grazebrook, too, later joined the partnership and left the management of his other industrial interests to his sons.

The country banks, or their earlier more informal predecessors, could raise finance from their partners, from the public or other sections of the money market. The partners brought their capital, their credit worthiness and their general reputation with them. These were essential if a bank was to create confidence and become a financial success. If such conditions were not created or their reputation was more illusory than real, a banker's private assets could be called upon to settle his banking debts until the Joint Stock Act of 1858. Bankers like Hollings and Dallaway and others like the Colbornes connected with the local financial scene were able to assist navigations like the Stroudwater by supporting the promotion by subscribing to the capital, and by helping to raise loans in times of financial stress. The Stroudwater scheme already had the support of other respected individuals, like the credit worthy bankers of John Hollings and James Dallaway or John Colborne, the eminent local attorney, who gave an added air of probity and respectability to the plans and helped to oil the general wheels of investment. Dallaway and Hollings, who held two shares each, were able to encourage investment in the scheme through their extensive range of personal and financial contacts. John Colborne already had an excellent grasp of legal affairs and his experience as an executor and estate agent for wills and local properties had given him plenty of experience of collecting and remitting monies associated with those interests. His appointment as treasurer to the Stroudwater company, with the tasks of holding the cash balances and managing the accounts, could only encourage the confidence of investors.

Once John Colborne had made the first call on the shares, the company had enough money to start construction in earnest. Although the work went ahead without any major hindrances at this stage, the directors soon found a series of organisational problems which hampered the speed of advance and which cast some doubt on the honesty and efficiency of some of the contractors and workmen. Since John Priddey was on site for only about a quarter of his time, there was confusion on occasions when he was not immediately available for consultation or when there were doubts about what his precise instructions had been. To avoid these difficulties it was decided that Priddey should leave detailed written instructions in a book which could easily be referred to during his absences. The two clerks would then be responsible for seeing that his instructions were properly carried out. Suggestions of theft, dishonesty and incompetent workmanship were not entirely absent during this period of construction either. To minimise these problems it was decided to keep a book containing written copies of all agreements signed by contractors and suppliers and to check the tools belonging to the company against a special tool book every two months. Hall and Grazebrook were

asked to be on site three days a week each, to remain on the construction sites constantly during working hours, to weigh and measure everything delivered to the site and to check that those men being paid a daily rate were actually on site during the day and not working elsewhere by calling out a register of their names twice a day. The clerks were also given specific powers to discharge anyone disobeying company orders and to pay all workmen every Saturday night in cash making sure not to pay anyone 'working in Gross' and claiming more than the work they had done or the materials they had supplied.

Cutting and banking now proceeded apace with the company advertising for 'All Persons ... desirous of being employed in the digging by the Yard or Banking ... to apply at the work at Framilode' in April and instructing Priddey to engage carpenters and masons for building Framilode Lock chamber and gates and for a foreman to supervise them all.[30] Construction started officially on Tuesday 30 May. On that day, the *Gloucester Journal* reported, 'the first stone was laid of the first lock ... by William Dallaway, Esq; [and named} ... Framilode Lock. Besides a great concourse of other spectators, there was present the major part of the chief proprietors in the Navigation; and many also of the neighbouring gentlemen honoured the meeting, and attended the usual ceremonies. Some coins of the present year were put under the stone, after which the gentlemen all dined together, at Mr Hall's at Framilode, under an awning erected for that purpose. After dinner suitable healths were drunk, particularly the Mayor and Aldermen of Gloucester for the time being, as standing Commissioners appointed by the Act of Parliament ... The whole was conducted with great decency, accompanied with cheerful shouts, and other acclamations of real joy, expressive of the satisfaction that was felt by those present, upon seeing so necessary a work, so long wished for, thus begun; and in so promising a way of being speedily completed (unless retarded by the malignant spirit of opposition). A work of utmost utility to the clothing party of this county; 'and which will be a great relief to the poor in the article of firing; and likewise an ease to the neighbouring estates in the saving of the roads'.[31] The extract similarly predicts that coals, then only available at £1 1s 6d (£1.08) a ton at the cheapest in Stroud, would be sold for only 13s 3d (66p) a tone once the navigation was completed.[32] It refers, too, to the way in which the Stroudwater would keep the visionary project of uniting Severn and Thames before the public eye. At the ceremony, carpenters, masons and other labourers working on the canal were given a cash bonus and encouraged to join in the general merrymaking.

With the final expenses for the celebration amounting to £13 3s 0d (£13.15), it seemed an auspicious enough start towards constructing the Stroudwater Canal Navigation.[33]

Chapter Nine References

1 GCRO D1180 1/1 Committee Minutes 6 January 1775
2 GCRO D1180 1/1 Committee Minutes 19 January 1775
3 GJ 9 January 1775, 16 January 1775, 23 January 1775, 30 January 1775, 6 February 1775, 13 February 1775, 20 February 1775, 27 February 1775
4 GCRO D1180 2/17 Account Book 20 January 1775
5 GCRO D1180 1/1 Committee Minutes 19 January 1775
6 GCRO D1180 1/1 Committee Minutes 19 January 1775, 16 February 1775 William Symonds had used the Severn for fifteen years between Bristol and Brosley.
 6/2 Copy of Bill, Brief for the Plaintiffs. The other trow owners included Thomas Bowen, John Doughty, Thomas Humphries, Jones Lloyd, Samuel Loyde, Richard Loyde, William Loyd of Bridnorth, John Oakes, Edward Owen, John Phillips, Luke Pool, William Pool, Francis Richards, John Richards, Edward Rousell and William Symonds

7 GCRO D1180 1/1 Committee Minutes 19 January 1775, 2 February 1775

8 GCRO D1180 1/1 Committee Minutes 6 May 1775

9 Tucker, Josiah *Instructions to Travellers* 37 Gloucester 175S

10 GCRO D1180 2/17 Account Book 19 May 1775 for eleven Bills of fare totalling £18 11s 0d (£18.55) from William Turner of the George Inn; 2/17 28 March 1775 £6 10s 6d (£6.52½) 24 May 1775 £3 4s 6d (£3.22½) 21 June 1775 £2 2s 7d (£2.13)

11 GCRO D1180 1/1 Committee Minutes 19 January 1775, 2 February 1775, 16 February 1775, 23 February 1775, 9 March 1775

12 GCRO D1180 1/1 Committeee Minutes 4 May 1775 Priddey was paid £21 15s 0d (£21.75) for his survey prior to engagement.

13 GCRO D1180 9/20 'Proposals by Messrs Parey and Gleaves for Cutting'

14 GCRO D1180 2/17 Account Book 13 May 1775. It cost £60

15 GCRO D1180 2/17 Account Book 7 April 1775. He was paid £48 18s 6d (£48.92½) for bricks

16 GCRO D1180 1/1 Committee Minutes 24 May 1775

17 GCRO D1180 2/17 Account Book 10 May 1775 Samuel King was paid £34 10s 6d (£34.52½); GCRO D1180 1/1 Committee Minutes 24 May 1775 Samuel Farmer paid in cash

18 GCRO D1180 2/17 Account Book barrows 24 June 1775 cost £17 16s 0d (£17.SO); 1/1 Committeee Minutes deals 9March1775 cost £39 8s 6d (£39.42½); 1/1 23 February 1775, 23 March 1775

19 GCRO D1180 2/17 Account Book 27 May 1775 Thomas Davis was paid £10 for bricks

20 GCRO D1180 6/2 Legal paper detailing work started: the trow owners comment on 16 February 1775 on the lock site 'now being built at Framilode'

21 GCRO D149 T377, D149 927 Two documents mentioning Colborne family

22 GCRO D1180 1/ 1 Committee Minutes 19 January 1775; 2/69 List of Calls GJ 23 January 1775

23 GJ 10 April 1775, 12 June 1775
 GCRO D1180 2/69 List of Calls. The first call in fact raised less than £2,000 because of some dilatory payments perhaps stemming from uncertainties

24 GCRO D1180 2/69 List of Calls. John Cambridge paid £7 12s 0d (£7.60) on 7 March 1775 and £2 2s Od (£2.10) at an unspecified date

25 There are several shareholder lists whose composition varies slightly according to the date. Figures here are taken from GCRO D1180 3/1, the earliest list, not the later 3/6 or 3/20.

26 GCRO D1180 5/1 Minutes before the Committee on the Stroudwater Bill 19 February 1776

27 Pressnell, L. S., *Country Banking in the Industrial Revolution* Oxford 1956

28 For many references of attorneys selling houses see GJ 3 July 1759, 27 May 1760, 10 June, 10 March 1761, 25 April 1763, 17 October 1763, 1 February 1768, 9 May 1768, 27 June 1768, 19 September 1768, 17 October 1768, 10 April 1769, 29 May 1769, 30 September 1771, 9 March 1772, 20 February 1775, 5 June 1775, 3 July 1775, 22 July 1775 and many others

29 Cave, C. H., *A History of Banking in Bristol* Bristol 1899

30 GJ 10 April 1775; GCRO D1180 1/1 Committee Minutes 6 April 1775

31 Felix Farley's Bristol Journal 3 June 1775; Bristol Journal 3 June 1775, GJ 5 June 1775 Similar wording for all the reports suggests a circular letter sent out by the directors. Dallaway's wife had died three months earlier (GJ 13 March 1775) and his health ebbed quickly after that. This was one of the last services he performed for the company before he died in 1776.

32 GJ 12 October 1772 John Longney was selling best Forest of Dean coal at Framilode for 12s 0d (60p) a ton

33 GCRO D1180 2/17 30 May 1775 The meal cost £3 4s 6d (£3.22½) and other expenses £9 18s 6d (£9.92½).

Chapter Ten
'The Battle of Carter's Close'

These public reports that directors, navvies and inhabitants 'rejoiced with exceeding great joy' at Framilode masked private fears that the position of the new company was far from certain. The 'malignant spirit of opposition' referred to only obliquely amid the general festivities had already made its presence felt by the time William Dallaway laid the first stone on the lockside declaring 'God prosper this our undertaking.'[1] As early as September 1774 the opponents of the Stroudwater scheme gave a clear warning that they intended to try and prevent a navigation being constructed.[2] When it became obvious proprietors were beginning to formulate detailed plans and estimates and that they intended to proceed with construction, certain landowners and millowners on the Frome west of Stroud met at the George Inn, Frocester, on 30 January 1775 bringing with them 'the Names of such Persons as have already committed Trespasses on any of their Lands of Authority from the Commissioners at Stroud'.[3] This group of opponents had already established a subscription fund among themselves and made no secret of their intention to spend it in opposing the navigation.

They considered their most effective line of attack was to challenge the legal validity of the powers the company were already exercising. In their enthusiasm for getting work under way the directors were not liable to err on the side of caution. They had already appointed some new commissioners in doubtful circumstances and ignored one legal opinion questioning their powers. The committee now assumed that the powers given to the undertakers by the 1730 Act had been transferred to them (which was true) that construction could take place under these powers (which was equally true) and that these powers included the right to build a canal navigation (which they manifestly did not). The 1730 Act contained sufficient powers for the undertakers to make such new cuts as they thought advisable in building a river navigation. It had not contained and did not contain any powers to allow undertakers to build an artificial waterway almost wholly separate from the River Frome. In any event the 1730 Act had been specifically passed to make the Frome navigable. There was never any intention to authorise any other type of navigation. This confusion, the opponents felt, would prove fertile ground for frustrating the ambitions of the Stroudwater supporters.

The two main groups of opponents comprised landowners and millowners with interest lying between Framilode and Wallbridge. Neither were wholly distinct and separate groups since several millowners, like John and William Purnell, manufacturers of tin plate at Framilode and wire at Fromebridge, owned adjacent lands which would be crossed by the navigation. On the other hand landowners such as George Augustus Selwyn, MP for Gloucester, held the part ownership of excellent farmlands at Ebley through his links with the corporation of Gloucester and also had interests in one of the oldest and largest corn and cloth mills nearby. Many of those who opposed the canal from the landowners' point of view also signed petitions in their parallel roles as individuals with mill interests and joined the opposition in both capacities. There is also doubt about the authenticity of a few signatures on the landowners' petition.[4] Some were joint occupiers of lands rather than tenants in their own right and others held only a remote Reversionary interest in local lands. Landowners opposing the navigation included Samuel

Apperley of Stonehouse, Benjamin and George Harris, John Curefield, Thomas Evans, Thomas Bridge, Hannah White, John Ford of Alkerton, Thomas Hitch, Richard Martin of Hardwick, Samuel Beard of Stonehouse, Joseph Faithorne of Dursley, Samuel Chance, Thomas Chambers of Minchinhampton, John Hugh Smith of Ashton near Bristol, Thomas and John Asbell, the Reverend John Pettat, MA, who stood to lose part of his church graveyard at Stonehouse in the canal bed, Thomas Turner of Ebley, John Andrews of Ryeford, John Ford, John Purnell Senior, John Purnell Junior, William Purnell, George Augustus Selwyn, Ambrose Redall the Stonehouse yeoman, Halliday Phillips of Ryeford, Ingram Ball, Mary Ball of Gloucester, the Reverend John Davis and Nathaniel Davis of Eastington, William Coaley of Eastington (possibly the same man as Purnells' Framilode agent) and Samuel Beard. Finally the list of opponents included the names of the four Stephens of Ebley, two Nathaniels, a Richard and a Robert, who held lands and ran a large mill there, and John and Ellis James. Ellis James was a 'substantial tenant' who tenanted a large estate at Eastington for £120 a year including a farm, summer house, grist mill, fulling mill and over a hundred acres of ground. In addition he had been involved in a banking and milling partnership with Bryan Smith but when this was dissolved in 1773 he had continued to operate a flour mill at Eastington.[5]

William Dallaway outlined some of the landowners' objections when he wrote some were 'tenacious of their lands, and averse to their being cut through; others object that the lands adjoining the Canal will be injured by the Water ouzing … through its Banks'.[6] There was more to it than this however. Certainly one of the most vociferous arguments advanced by the landowners was that 120 acres of valuable land would be lost.[7] According to John Taylor, a local farmer who rented lands slightly away from the projected line, land locally was generally considered to be 'rich and good'.[8] 'Great Quantities of very Rich Meadow and pasture and arable lands of very considerable Value' would be lost if construction went ahead.[9] Meadows and fields for pasture, the predominant local land use, might be worth an annual rent of between £1.50 and £3 an acre. Arable land was less valuable and usually fetched an annual rent of between £1 and £1.50 an acre although this could rise to £3 an acre if the land was especially fertile. Rudder himself admitted that lands around Stroud and district were let 'at a high rate' by county standards.[10] Landowners also feared the canal would divide some single land units into one or more smaller units which would make it more difficult to farm and worth less on the land market. This was combined with the fear that since the new canal would be built at a higher level than the old river it would be subject to leakage from the banks and seepage into the neighbouring fields. This, too, would produce a general deterioration of land values resulting from the construction of the waterway.[11] All in all the complainants were 'very apprehensive … that the Damage … will Greatly exceed the Value of the Land which will be actually Cut and destroyed'.[12] John Dimock, the Stonehouse clothier who had attended several of the opponents' meetings, confirmed that total damage could be more serious than just the loss of certain valuable lands for the canal bed.[13]

The most serious complaint of the landowners was that the purchase prices offered for their lands were inadequate. If lands were divided and fell in value as a result, prices based only on the value of land actually taken for the canal could leave landowners at a financial disadvantage. Although it is difficult to judge this complaint with any degree of accuracy because of a general shortage of comparable land prices, it is possible the earliest view in company circles was that the purchase price should only be based on the value of land taken and not include any additional side effects – unfortunate or otherwise – resulting from the new use of land. However, there is strong evidence to suggest that the committee did not take this limited view. If the exasperated opinion of a frustrated William Dallaway is to be believed, the committee were flexible about both the amount of land they bought and the price they paid for it.

Not only, Dallaway proclaimed, had they decided to build a canal navigation to avoid interference with the mills and made special provision for a canal reservoir on the Wallbridge level to prevent any interruption of normal water supplies to the mills but they had:

'gone out of their Way, at additional Expence, in order to avoid cutting through the Middle of Lands, and have brought the Canal to the Borders and Hedge Rows, and to near Roads, wherever it was possible. They have also agreed for and purchased whole Pieces of Land at the Owner's Request, when they have been divided by the Line. They have never refused to take any … small Pieces that were cut off. And they have given more than the real Value for the Lands they wanted. They have endeavoured also to obtain a Reconciliation with the Opposition, but in Vain.'[14]

Even allowing for some exaggeration resulting from his chronic ill humour at finding the Stroudwater scheme held up for the fourth time, the attitude of the senior and most influential member of the committee was far from irresponsible.

At the same time landowners' complaints could contain greater validity if the directors were proposing to base purchase prices on existing rents which might have been fixed several years before and which might not therefore reflect their true current value. Landowners, however, make no complaints on this score which, in any event, would hardly tally with the directors' attempts to maintain good relations with landowners. To some extent the directors had little choice but to work in concert with local landowners and to show at least some deference to complaints of inadequate prices and unfair treatment whether this was real or imaginary. Although none of the two previous Stroudwater Acts contain any immediate powers of compulsory purchase they did provide that if company and landowner were unable to agree, arbitration should pass to the commissioners. Since the verdict of a full meeting of commissioners, which in any case included a fair sprinkling of landowners, could perhaps not always be relied upon and since speed was sometimes essential if construction was not to be interrupted, the company might choose to pay a higher price rather than allow the decision to go to appeal.[15] Whatever the provisions of the Acts, therefore, the company was to some degree dependent on the goodwill of landowners in agreeing to sell at a fair and equitable price. It seems unlikely that men so sensitive to their personal interests as the millowners would fail to appreciate their position was rather stronger than it appeared at first sight. In these circumstances it is understandable they should use this position to make the company raise their bid especially if the landowner had genuine doubts about the effects of a navigation.

In all probability, and even allowing for some validity in their complaints, the opposition of some landowners west of Stroud was probably designed primarily to encourage the company to offer more generous purchase prices for their lands. There were, though, two sides to the landowners' arguments. If it was true that cutting lands in two would reduce the value of remaining lands, it was equally true a navigation would increase the value of some other canal-side land especially if wharves, warehouses and other ancillary facilities were required. On this question of benefits arising from the navigation, the tongues of the landowners brought forth only a monumental silence.

Apart from some landowners, the other main source of opposition came from some owners and occupiers of mills situated between Framilode and Wallbridge.[16] It included a number of millowners who also opposed the canal in their role as landowners, such as George Augustus Selwyn, Joseph Faithorne, John James and the three Pumells, as well as others such as Richard Clutterbuck, Daniel Chance of Dudbridge, Henry Reddall, Thomas Pride, a second John James, Elizabeth Wilding, Ambrose Reddall, Joseph Clutterbuck, Daniel Partridge, Thomas Turner of Ebley, Bryan Smith, Halliday Smith, Nathaniel Smith, Thomas Haycock, John Beard, William Hill, John Harmer and John Warmer. This list

too is not entirely above suspicion. For a start it appears to include several names who neither owned nor occupied mills west of Stroud and were probably therefore mill employees encouraged to sign by their employer. Others like Elizabeth Wilding and possibly Daniel Partridge were not even connected with mills which were adjacent to the new navigation.

The millowners held two main objections to the waterway. In the first instance, the opposition of the Purnells was based on their continued use of the improvements Kemmett had made to the river after 1759. The Purnells were still using part of this earlier navigation to carry coals and iron from Severnside to their mills at Framilode and Fromebridge without paying any tolls. A new navigation would not only interfere with this channel, especially at Whitminster, but force the Purnells to pay tonnages on their goods using the new canal.[17] But the main objection of the body of millowners was once again 'That the mills be injured by being robbed of their Water, and the Manufacture suffer in Consequence'.[18] Most of the twenty mills in the valley west of Stroud were engaged in cloth production but there were also 'Corn, Iron and Tinplate' as well as 'a new manufacture of Brass Wire … now setting up'.[19] In a number of instances mill premises were subdivided and several industries such as cloth, flour and paper were all operating under one roof. All in all the opponents claimed the mills below Stroud employed 5000 people directly and indirectly and that their mills alone contained forty-two pairs of stocks, sixteen gig mills, seven napping mills all employed in the woollen manufacture; sixteen pairs of millstones used in grinding corn; an iron wire mill, a steel wire mill, six pairs of rolls for rolling iron, a slitting mill and a rounding hammer for braziers' roads used in the 'Manufacture of iron, all of which are wrought by wheels turned by the Water of the … River'.[20] These industries were experiencing an encouraging boom in trade around this time. John Dimock claimed that these mills now had more trade than they had had for twenty or thirty years and William Coley, clerk to the Purnells, indicated that they had a 'great and flourishing trade' with more orders than they could possibly execute.[21]

According to the millowners, there was 'a great scarcity and want of water' during the summer months which periodically interrupted production at the mills and on occasions left them completely idle.[22] One estimate suggested the shortage was so serious that there was not enough water to keep the mills occupied for more than two thirds of the time in the summer and two other estimates suggest a general summer shortage which might last with varying degrees of intensity for three to six months.[23] A navigation, the millowners claimed, could only aggravate this already deteriorating situation. In any case the accuracy and justness of their claim had already been recognised by undertakers on two previous occasions. The 1730 Act had been 'so attentive to the Interests of the Millowners' that it planned to suspend navigation for two months in the summer unless the millowners gave it their consent to operate. Similarly the 1759 Act, the millowners claimed, had also recognised their dilemma and had 'expressely forbidden' the construction of locks.[24]

The fears the millowners voiced were genuine enough. There was a serious water problem which led to periodic interruptions of water supplies dislocating both power generation and industrial production. The Stroudwater committee had tried to head off this opposition by proposing to build two large reservoirs on the canal to store water normally running to waste on Sundays, use part of it for working the navigation and convey the surplus to the millowners. When the time came for the company to challenge these predictions, however, they found the millowners were wrong in assuming there was insufficient water in the Frome to cope with both the demands of the mills and the new navigation. Members of the committee were particularly careful to take detailed measurements of the size and capacity of each of the millponds and to calculate exactly how much water normally ran to waste from each of them. These experiments soon showed that the real problem was inadequate management of the existing available water resources rather than a simple shortage of water. There was no concerted

attempt among the millowners to conserve, manage and share the water supplies at all let alone attempt to approach the problem with any degree of rationality. As a result the millowners were often squabbling among themselves about individual water rights, bickering about the validity of allegedly ancient privileges of supply handed down from some previous owner or tenant, occasionally contesting law suits and even periodically relieving the monotony of argument by tipping each other angrily into the disputed waters of some local millpond.

The measurements conducted by Benjamin and Joseph Grazebrook, John Gleave, Thomas and John Baylis, John Harwood, Richard Hall and others showed just how ridiculous all this was.[25] Readings at Whitminster millpond – perhaps the only mill where Stroudwater directors and employers could feel entirely safe from the risk of an unscheduled ducking – showed on successive Sundays between 27 August and 15 October 1775 waste water running from nineteen to thirty-inches deep through a seven-inch gap in the millpond gates. Even on 4 June, the driest part of the whole summer, water ran sixteen inches deep through the gates. On 24 September surplus water at Cooke's Mill could have filled 322 locks in a day. At Lodgemore the millpond was emptied on 1 October and filled again in only ten minutes; equivalent to twenty full locks in that time or nearly 3,000 locks a day according to Baylis' calculations. A week later some committee members conducted a similar experiment on six mills near Wallbridge. The seven millponds filled in two hours, twenty-six minutes; enough to fill over 1500 locks a day. At Ebley the millpond filled with sufficient water for twenty-five locks in twentytwo minutes or over 1600 locks a day. On 29 October Mr Chance's millpond filled in eighteen minutes; equivalent to over 3500 locks a day, and a week later the same millpond filled in only twelve minutes or over 5000 lockfuls a day. Considering the navigation was only expected to use around twenty locks of water a week, the evidence clearly disproved the millowners' claim that the volume of water was inadequate for both a navigation and water power. It is clear the general evidence points to inadequate conservation of a plentiful water supply as the main cause of periodic deficiencies rather than to a shortage of water as such.

Perhaps other unspoken fears and resentments fuelled the opposition of some landowners and millowners below Stroud. Both parties could have benefited from the prevailing view that 'Corn … in the County of Gloucester (and more so in the manufacturing Part) is dearer than in any other part of England'.[26] Existing corn imports from Herefordshire and elsewhere fetched a high price in Stroud partly because of the distance and cost of land carriage. A navigation would cut transport costs, reduce the price of imported corn and perhaps threaten to undercut a prosperous and secure local market millowners and landowners had carved out for themselves. Jealousy or rivalry between different classes of clothiers or between successful clothiers and other local industrialists who resented their domination of the locality could have been a contributing factor. Some hint of this appears in The Case of the Opposition, where the opponents claimed millowners above Stroud were encouraging the scheme since they had nothing to lose if mills on the Frome below Stroud were prevented from working since 'it must bring [only profit] … to the Mills above [the town]'. 'To be sure', the opponents added sarcastically, that too 'would be for the Public Good'.[27]

Whatever the truth of the matter was it is important to recall that not all landowners and millowners below Stroud opposed the Stroudwater scheme and those who did formed only a small minority in their own land and milling circles in the neighbourhood as a whole. Dallaway thought only about a sixth of the local millowners were against the scheme and the general evidence confirms a group of around this size.

It is uncertain when the proprietors of the navigation first became aware of the serious intentions of their opponents. John Jepson, the company solicitor, claimed he heard about the opposition at the first meeting at Stroud in 1774 but Joseph Grazebrook believed they had not conceived any opposition when construction began in mid February 1775 and that it was only some six to eight weeks later that he heard

rumblings for the first time.[28] Evidence from the opponents themselves, however, was more specific. 'The Present Undertakers', they stated, 'began work, despite full notice from the land and millowners … [beforehand that what] they intended was illegal and not within the powers of either of the former acts'.[29] Since the opponents had not been reticent in advertising their views and the proprietors had themselves taken advice on their legal position, it seems likely the proprietors were aware of the opposition not later than the autumn of 1774 but that they dismissed it at this stage. It was only at a later date, perhaps six or eight weeks after work began, that they were forced to recognise its strength and validity.

During the spring of 1775 the opponents determined to use part of their subscription fund to take legal opinions about the true position of the undertakers and especially their powers for building a canal navigation under acts for making the river navigable. Their counsel was no clearer than those of the proprietors but collected his fee nevertheless and recommended the question should be put to the courts for an authoritative answer. On 19 April, therefore, the opponents met again in the George Inn at Frocester 'in order to give their Solicitor proper Authority to pursue the Directions of Counsel, for bringing the pretended Powers of the Commissioners at Stroud and their Undertakers to a legal Decision'.[30] By this stage however, the Stroudwater directors, still confident they had at least some legal backing for their actions, had inadvertently given their opponents a perfect case to argue.

On 18 March Mr Parry, agent to Robert Dobyns-Yate, had written to Richard Hall with the news that his employer had agreed to sell a piece of permanent pasture at Framilode called Carter's Close 'on being paid a fair price for the land'.[31] Richard Hall went to Hereford to discuss these final details with Dobyns-Yate and on 8 April the two men agreed terms for that part of the close the company needed – immediately east of the Framilode Lock site – on terms comparable to those paid to other compensated landlords. Arkell, the tenant of Carter's Close, agreed to terms similar to those offered to other displaced tenants. During the discussions on the transfer of ownership Dobyns-Yate gave permission for the cutters to enter the close. John Gleave and his gang of cutters therefore started work on constructing the canal bed in the close on 4 April and by 19 April had dug and bottomed it through most of the site apart from eight to twelve yards at the end closest to the lock site. At this stage upwards of a hundred men were employed in building the canal including about twenty-seven labourers 'digging, cutting and wheeling earth' in the close itself. John Priddey and Robert Perry were supervising the cutting and acting as overseers of the men.

On 19 April the Purnells sent William Coaley, their agent at Fromebridge iron mills in Whitminster parish, with a message to the cutters in Carter's Close ordering them to suspend work immediately. Since neither the Purnells nor Coaley suggested any reason for the demand it was decided to ignore the message and continue excavating the lock chamber and cutting the canal through Caner's Close. The Purnells, after all, were well known as virulent critics of the navigation and it was only to be expected they might try any trick to inconvenience the committee and their workmen by holding up construction for a day or two on some wholly spurious pretext. In any case both Dobyns-Yate and Arkell had given permission for work to proceed and no one saw any reason to dispute the rights they had given the directors.

William Coaley returned to the close two days later and saw the cutters still at work. Once again he ordered them to stop work at once and erected two notices forbidding any further construction without the express authority of John Purnell. Work then stopped while John Priddey, Richard Hall and Benjamin Grazebrook asked Coaley the reasons for his interference. Coaley replied he was only acting under instructions from John Purnell who had told him to stop the work. Coaley then left the close noticing before he did so that Grazebrook had put the men back to work and told them to continue cutting.

It is not certain when the committee first became aware that Purnell had issued his instructions on the grounds that he alone was the true tenant of Carter's Close and that he – not Dobyns-Yate – had sublet the close to Arkell. Since the committee had entered, trespassed and damaged his land without securing his permission beforehand, he felt every justification in suing them for substantial damages and at the same time challenging the whole validity of the powers which the company sought to exercise. Whenever it was the committee learnt of the news (and the evidence suggests it was later than 21 April), it is clear no one believed the story of his tenantship at first. When it became clear that Purnell did own the lease and that in these circumstances he had every right to suspend construction, the fury and bitterness of the committee knew no bounds. If a 'Business of such consequence and Importance', it said, 'is to be stopped at the humour and Caprice of every individual … through Petulance or from a spirit of opposition … all works of general utility must cease and these natural Improvements which are the Glory of every Country can be no more unless Private Convenience gives way to public welfare'.[32]

At first the general opinion was that Purnell had bought Carter's Close secretly in a deliberate attempt to 'stop … the undertaking which if finished would subject them to the payment of tonnage on all their goods or that the undertakers might come to a beneficial composition with them for the tonnage'. No amount of worthy rhetoric, however, could conceal that Framilode Mill and Carter's Close had been leased to John Purnell, ironmaster of Frampton, and William Purnell, gentleman, in August 1767 and that both were within their rights in objecting to the trespass.[33] Although it is possible the Purnells had only just remembered the lease and realised how it could further their opposition to the Stroudwater scheme, the evidence strongly suggests the directors walked into a secretly planned and carefully laid trap arranged by the objectors with at least the tacit support, if not connivance, of both Dobyns-Yate and Arkell. Landlord, tenant and sub-tenant would each be aware of the lease. None of them mentioned its existence to the directors. Dobyns-Yate or Arkell may even have told the directors a deliberate falsehood about their legal relationship with the certain knowledge the committee would find out when it was all too late. It was not the first time the Yate family had figured among Stroudwater opponents. In 1729 Walter Yate, then owner of Framilode Mill, had petitioned Parliament against the Stroudwater Bill maintaining 'his ancient mills on the river' would be 'very much damaged and destroyed' if the Bill went through.[34] The mill later passed to the Dobyns family, distant kinsmen of the Yate family, who added the former owner's name to theirs as part of the covenant.[35] In any event, Joseph Grazebrook later confirmed that Purnell had allowed the cutters to dig through most of the close before he had questioned their right to proceed.[36]

Fearing a suspension of work would hold up construction, lead to a dispersal of the navvies and leave Framilode Lock open to the strong erosive powers of the Severn tides, the committee tried to reach a compromise with their opponents which would allow them to carry on with the work. At first they tried to reach agreement with the Purnells alone by suggesting the lessees should construct a cut to their works from the towing path side of the canal near Framilode Mill. If the Purnells paid for this themselves, the company would undertake to ask the forthcoming general meeting of proprietors in October to approve a scheme by which the Purnells paid only 1p a ton on goods passing Framilode Lock. The committee believed the general meeting would accept this proposal but it was understood this concession was only to be used to carry coal, goods and merchandise to their mills at Framilode only and not to any other part of the navigation. To ensure the Purnells kept this provison, they were to agree to pay a £100 fine if it were broken.[37]

The rejection of this proposal prompted the committee to retain the Gloucester solicitors, Lane and Jepson, in early May to prepare themselves for any 'Litigations concerning … carrying the Act of Parliament … into execution' and to ask for a further legal opinion of the powers of the 1730 Act from Mr Dunning. Since the reports and threats of action had become so widely known, the directors

told John Jepson to suggest to the opponents that if they had any doubts about the previous Acts their validity should be tried on a 'feigned issue' at the approaching Gloucester Assizes.[38] Meeting on 19 May on this 'particular Business', the opponents declined to accept this course of action and determined to press ahead with their full challenge to the powers of the company.[39]

Even at this stage the company continued to press forward with their work on the new navigation. John Priddey and Robert Perry arranged for the rest of the land in Carter's Close to be cut through sometime after this at their own discretion as they had not received any official orders from the committee of directors. Work also continued on the Framilode Lock site with the first stone being laid by a defiant William Dallaway on 30 May. In early June the committee were still ordering more cutting to be done, although they intended to terminate this within a fortnight, and were asking Priddey to tell Edward Hinton to make as many bricks as possible.[40] As late as 10 July Thomas Bartlett, a contractor and mason engaged on building Framilode Lock, was still advertising for 'a Number of STONE MASONS', which were 'WANTED immediately' at Framilode.[41] At about this time Framilode legend reports a farcical situation developing with the company cutters earnestly digging out the canal by day and Purnell's men desperately filling it in again under cover of night. Frequent violent skirmishes are reported to have occurred to try and secure mastery of the close.[42] In the lurid nomenclature of the time this was called 'The Battle of Carter's Close'.

There were several meetings between the committee and their opponents during this period in an attempt to reach some sort of agreement. At one such meeting held at Yate on 21 July at the special request of the opponents, Benjamin Grazebrook, John Priddey, Richard Hall, Robert Perry, John Colborne, Wilham Dallaway and Thomas Baylis – the entire crew of Stroudwater heavyweights – represented the interests of the company. Once again the main point of discussion centred on whether or not the company had any rights to make a cut through Carter's Close under powers granted by the 1730 Act. The company remained convinced, at least publicly, that their powers were valid and offered to pay the sum of £20 as an indication of good faith. If the powers of the company were not proved the money would remain in the hands of the opponents.[43] By this stage, however, consistently had relations had soured even this simple gamble. When the company tried unsuccessfully to reclaim the money later on some unknown pretext, the £20 itself became a new bone of contention. According to the company, the opponents had been 'contriving and fraudulently intending craftily and subtilly publickJy to deceive and defraud … them by refusing to return the £20 when they were asked to repay it. Perhaps the sight of their £20 being added gleefully to the opponents' fighting fund was the final straw for a harassed and irate company of directors.

In the meantime the company carried on with the canal construction and were evidently determined to do so until a court of law decided against them. Their opponents were just as determined to stop the work until the company had proved their rights to proceed. To put a stop to the cutting and digging once and for all, therefore, the opponents, headed by the Purnells, applied to the Court of Exchequer in Westminster for 'an Injunction to stop Proceedings on the Canal' until the matter could be tried at the local assizes. Applying for the injunction John Dimock said it was essential to prevent the Stroudwater company from continuing their work and further injuring the lands at Framilode before the merits of their authority could be determined especially since he understood the company intended to continue construction unless they were restrained. On 3 July Masham, solicitor to the opponents, informed the directors and their employees that they should appear before the Court of Exchequer 'to answer us containing certain Articles then and there on our behalf to be objected against you'.[44] By this stage, too, the plaintiffs were claiming £500 damages for damages to their lands. On 14 July an injunction was granted to John Dimock and William Coaley preventing the Stroudwater company from making

any further cuts in Carter's Close until a jury had adjudicated on their powers. Work stopped at once although the hearing continued until 22 July.

Giving evidence at Chancery Lane on 21 July the two company clerks Richard Hall and Benjamin Grazebrook explained the case for the company and promised no more cutting would be done until the issue was properly resolved.45 The proprietors, Hall and Grazebrook explained, thought a wholly artificial navigation which did not use river water and parts of the river would not be 'conformable with the express terms of the Act'. On the other hand a navigation using cuts which did connect with the river at various points would come within these terms. In any case the company certainly had powers to make cuts since the 1730 Act had envisaged them to bypass mills or avoid tortuous river stretches. It was true, they admitted, that they had not taken the steps prescribed in the Act for ascertaining the value of damages the cutting had done and they had certainly trespassed on land they did not own. But the company had done all this by accident because it had assumed, erroneously as it turned out, that it had already bought Carter's Close and that therefore this procedure was unnecessary. Nevertheless they confessed they were wrong on this point, if only technically, and they would agree to pay whatever damages a jury assessed. The two clerks maintained that they had in fact already filed such a Bill with the Court of Exchequer stating this view and, since filing it, had suggested to their opponents that a feigned issue should be used to try their legal powers.

Grazebrook and Hall also pointed out that it was essential to take the navigation through Carter's Close for several reasons. In the first place it was imperative to build a lock somewhere between Framilode Mill and the Severn because of the large range of river tides and because the fall of water from the mills to the Severn was so great that no vessel could come up the canal without a lock. If the lock was built too close to Framilode Mills it would prevent them from operating effectively by 'backing water on the wheels'. This would deprive the mills of water power and remove the energy needed for manufacture.46 Secondly, if the cut were brought nearer to the stream which ran from Framilode Mills it would be necessary to pull down a building valued at £80 as well as two houses and a garden belonging to Mr Purnell. Even if this course were desirable, the company had no powers to do this. The 1730 Act had specifically prohibited the undertakers from cutting through any house, mill or garden standing on or before 25 March 1730. All these four properties came within this group. Thirdly, the site already chosen for the lock chamber and the canal exit to the Severn was the only place where boats could enter the navigation at all states of the tide. There were no comparable sites for a mile above or below the chosen site. This opinion had already been suggested by several trow owners earlier in the year and it was confirmed by Robert Whitworth, the London surveyor and later engineer to the Thames & Severn Canal, when he gave evidence at Chancery Lane.47 Whitworth had already examined the canal works and lock site and it was his opinion too that apart from the site where the lock was being built, the rest of the shore was flat, rocky, shallow and quite unsuited for any type of waterway exit. Even if it proved possible to build an outlet through these inhospitable shores … and that was by no means certain … it would still be most expensive. Whitworth confirmed that using the old river would be impractical since this would still need a lock which would certainly damage Framilode. Mills and might conceivably lead to their abandonment. There was another point too. The only drain in Saul taking surplus water from land floods and unusually high tides emptied into the Severn near Framilode Mills. If the river was made navigable and if a lock were built on the Frome at Framilode this drain would have to be stopped up. The two clerks felt this would undoubtedly cause severe flooding in Saul parish. Finally, Hall and Grazebrook maintained, the greatest merit of the present lock site at Framilode was that it carefully avoided any injury to the mills or even the slightest detrimental side effect. Indeed, they both submitted, the whole undertaking had been specifically designed with this in mind. All in all the company felt it

would be impossible to build a navigation without using cuts and on any other line than the one planned through Carter's Close. The only alternatives would delay canal traffic when the mills were operating and probably damage the mills themselves into the bargain.

The evidence from the plaintiffs repeated all of their earlier complaints. The only new point to emerge was that it was John Dimock who had told his solicitor to contest the authority of any person cutting through the lands of those who opposed the scheme. The solicitor had already advised them that the Stroudwater company had no powers to leave the channel of the Frome except where new cuts were essential to straighten the route.

The court reached a decision on 22 July. It ordered, with the consent of both parties' counsel, that they should proceed to test the powers of the company under Judge Ingram before a special jury at the next Gloucester Assizes on the feigned issue which the plaintiffs themselves had rejected at an earlier date, namely 'whether [or not] the defendants have or had any rights under the several previous Acts of Parliament to make cuts through Carter's Close. If the verdict went in favour of the company the injunction would be dissolved without further delay. In the meantime Grazebrook suggested to Purnell that the company would offer to pay any damages assessed by the Gloucester jury if Purnell agreed to drop the separate trespass action against them. Purnell agreed and the company for their part undertook not to trespass in the close. Until the issue was decided neither the undertakers nor any of their workmen would cut any more of the intended line at Framilode or elsewhere.

The question therefore came before the jury at the Gloucester Assizes on 5 August 1775 when it was decided that the company had exceeded the powers contained in the 1730 Act and that it had no powers to build a navigation whatsoever unless it was on the original plan of making the river navigable with cuts. It as a bitter blow to the company directors who had spent so much time, effort and money to get construction under way.[48] According to William Dallaway, they had 'nearly finished the Lower Lock, which is the most expensive and important, as it opens to the Severn, and is exposed to the Tides. They have proceeded in the New Canal about One Mile and a Quarter; but the Work is not all completed so far. They have more lands purchased, and Sundry Materials provided. Several Calls, amounting to Five thousand Pounds, have been made upon the Subscribers'.[49] From this income over £4,000 had already been spent buying lands and constructing the works including about £300 to £400 on general materials. When Robert Perry and John Gleave submitted their Bill for construction, they stated more precisely that cutting had been completed from Lyeham to near the comer of Mr King's Orchard. Cutting in Carter's Close, Burnt House Ground, Pents Hill Orchard, Partridge's little ground, Pool Field, Pool Wall and part of Lyeham remained unfinished.[50] Canal basins in Pents Hill Orchard, Partridge's ground, Pool Field, Pool Wall and Lyeham required further attention as well. So far they had cut a canal 1732 feet long with a width varying from eight-feet, six-inches to fourteen-feet and a depth varying from a foot to three-feet, two-and-a-half inches.[51]

At two hastily convened general meetings it was agreed to call an extraordinary general meeting of proprietors on 24 August 'on special Purposes' to consider applying to Parliament for an amendment to the original Act which would allow the directors to continue with the present plan for a canal navigation.[52] In the meantime Timothy Lewis – Stroudwater shareholder and son of Lord Bathurst was to supervise another survey of the river to be laid before Parliament as evidence. Thomas Yeoman was asked to come down again to re-survey the line so he could speak authoritatively on their behalf before the Parliamentary committees and each proprietor should lobby as many members of both houses as possible – especially the local members who would be asked to support the Bill by lists containing the names of as many holders as possible.[53] In particular Joseph Wathen was to use his influence with Charles Garth and James Sutton, the members for Devizes; Charles Pendruddocke and Ambrose Goddard, the

members for Wiltshire; Sir Edward Bainton Rolt and Samuel Marsh, the members for Chippenham; John Dunning and Isaac Barre, the members for Calne; and with Lord Shelborne and Mr Morrice.[54] Nathaniel Peach would contact Edmund Burke and the other members for Bristol; Joseph Martin, a member for Tewkesbury; Samuel Blackwell and James Whitshed, the members for Cirencester; and Sir William Guise, one of the members for Gloucestershire.[55] William Dallaway and Joseph Wathen would both visit the Duke of Beaufort to ask for his support and contact Sir William Codrington, the other member for Tewkesbury; George Augustus Selwyn and Charles Barrow, the members for Gloucester; and Edward Southwell, the other member for Gloucestershire.[56]

The general meetings also resolved to finish as much of Framilode Lock as possible since there was a danger it would be damaged by the powerful Severn tides and winter frosts. Cuts already begun should be left in a state to prevent any deterioration during the winter. Accurate and detailed accounts for all work done, land and materials bought should be laid before the special general meeting. When work on the lock was finished and the rest of the canal was left in a safe enough condition, the workmen could be dismissed and all construction stopped.

The special general meeting of commissioners and shareholders was held as planned on 24 August at the George Inn. There were only two courses of action open to the proprietors. They could either abandon the works entirely, lose the money they had already invested in it and admit their fourth attempt to build a navigation to Stroud was a failure like the plans of 1730, 1755 and 1759 before it; or they could apply to Parliament for new powers to enable them to complete the waterway on the improved lines their engineers had recommended. There was no doubt in their minds that a separate canal navigation was the only solution which would supply the improved transport facilities now so desperately needed and at the same time minimise any inconvenience to the millowners. The detailed canvassing and general sounding of opinion which had gone on in the few days before the meeting left little room for indecision. With one accord they unanimously passed two resolutions empowering the existing directors to apply to Parliament either for an amendment to their original Act or for a completely new Act altogether if the directors considered this were preferable.

By early September it was decided to submit a completely new Bill to Parliament and Mr Lane was instructed to prepare a rough draft which was read through and approved at the committee on 5 October. By 25 September all outstanding accounts were settled and the books were available to any shareholder who wished to view them.[57] William Dallaway and Thomas Yeoman were cooperating in drawing up a 'Declarative Appeal' to outline the advantages of a navigation, to detail the present position of the shareholders and to galvanise support for the new application to Parliament. The final draft of this comprehensive document now retitled *The Case of the Stroudwater Navigation,* was approved on 23 October and circulated to all shareholders.

Meanwhile the committee asked John Priddey to return to Stroud immediately to supervise the completion of Framilode Lock before winter set in. Both clerks were advised to buy any materials such as stone which was still needed for this work and Richard Hall visited the Forest of Dean to negotiate a contract for supplying and delivering suitable stone for that purpose. When the committee examined Mr Lewis, bricklayer and mason, on 7 November he could report that the work at Framilode was now fully completed and that it was safe enough to withstand whatever weather the winter might bring. With the canal pegged out to near Whitminster and the canal partially cut for nearly 600 yards, the committee ordered all the remaining workmen to be dismissed. Work on constructing the Stroudwater Navigation now came to a complete halt once again.

Chapter Ten References

1 GCRO Hyett Pamphlet 353 *The Chronicles, and the Lamentations of Gotham* lines 25–28. In this and other poems the wisdom of Stroud inhabitants is unflatteringly compared with that of the wise men of Gotham who reputedly imprisoned a cuckoo believing it would keep the spring in all the year round 'Then came forth Belshazzar and laid the foundations thereof, and behold he put his hand to the trowel, and his right hand to the workman's hammer, and in the presence of all the people, cried with a loud voice *God prosper this our undertaking*
And when the people saw what was done, behold they shouted with a mighty shout, and the voice thereof was heard after.
And the rulers and chief people gave money to the carpenters, and to the masons, and such as laboured at the work, and hade them eat, drink and be merry; and they kept the feast many days.
And the people of Gotham rejoiced with exceeding great joy, for they said,
It will now be unto us even as our elders said.

2 GJ 12 September 1774

3 GJ 23 January 1775

4 GCRO D1180 5/3 Petition from Owners and Occupiers of Messuages, Lands and Tenements near or adjoining the river, dated 5 February 1776: 6/2, a detailed account of all the proceedings from which most of the information for this chapter is culled: GJ 12November1769

5 GJ 16 September 1771, 22 February 1773, 18 April 1774

6 GCL JX 14.21 Dallaway, William The Case of the Stroudwater Navigation 3 dated October 1775

7 GCRO D1180 5/3 Millowners' petition

8 JHC 35 528 8 February 1776. See also evidence of Chambers on the same date

9 GCRO D1180 6/2 'Mr Coaley's Affidavit'

10 Rudder 712

11 GCRO D1180 5/1 Minutes of the Committee before the Stroudwater Navigation Bill 8 February 1776 the evidence of John Bestwick surveyor, and Daniel Jenner, servant to the Steward of the City of Gloucester who were part owner of a corn and cloth mill at Ebley and nearby valuable lands

12 GCRO D1180 6/2 'Mr Coaley's Affidavit'

13 GCRO D1180 6/2 Affidavit of John Dimock made to support the motion for an injunction

14 GCRO D1180 5/1 Dallaway, William, *The Case of The Stroudwater Navigation* 2

15 See the chapters on land purchase

16 GCRO D1180 5/3 Petition from Owners and Occupiers … CA15 the 17'16 Lewis plan lists eighteen mills west of Stroud including Mr James' mill at Dudbridge Mr Clutterbuck's and Mr Phillips' mills at Ryeford, Mr Price's mill and Mr Beard's mill at Stonehouse, Mr Clutterbuck 's mill at Eastington and Mrs Wildey 's (Wilding's probably) at Framilode

17 GCRO D1180 5/1Dallaway, William, *The Case of the Stroudwater Navigation* 3: CRO D2115 There is no evidence of how, if at all, they passed Whitminster Mill although it is possible the Purnell boats traded only up to Framilode Mill.

18 GCRO D1180 5/2 *The Case of the Opposition*

19 GCRO D1180 5/2 2: JHC 35 553 12 February in evidence of Daniel Chance

20 GCRO D1180 5/3 Millowners petition the five thousand would probably include outworkers both full and part time

21 JHC 35 553 12 February 1776

22 GCRO D1180 5/2 *The Case of the Opposition* 2: JHC35 528 8 February 1776 evidence of Daniel Chance

23 GCRO D1180 5/2 *The Case of the Opposition* 2: 5/3 Mlllowners' petition: JHC 35 553 12 February 1n6 evidence of Daniel Chance

24 GCRO D11805/3 Millowners' petition The Act had not expressly forbidden the use of locks but had merely given authority for a navigation without locks

25 GCRO D1180 5/1 Dallaway, William, *The Case of the Stroudwater Navigation* 3, 4: 5/1 'Mr Baylis Calculations' A tabele shewing the Expance of water running [through] a three inch square hole, 'waste water at Mr Cambridge's Mill', A Calculation of the time all the mill pond forcing from Wallbridge to Severn', Calculations of waste water at Mr Cookes by Ben Grazebrook' and others: JHC35 469–70 evidence of Thomas Yeoman

26 GCRO D1180 5/1 *The Case of the Stroudwater Navigation* 1

27 GCRO D1180 5/2 *The Case of the Opposition*: See also Chronicles … reference 30 below

28 GJ 12 September 1774 suggests Jepson 's view was more accurate

29 GCRO D1180 5/2 *The Case of the Opposition* 3

30 GJ 17 April 1775 GCRO Hyett Pamphlet 353. *The Chronicles, and the Lamentations of Gotham* 19–30
 'But behold there dwelt in the land men of wicked and malignant spirit, who assembled together and said, Gotham is waxen proud, they have taken to themselves the inheritance of our fathers, and destroyed the work of thelr hands, they have brought destruction in the land, and destroyed the fruits of the earth
 And there was a great stir among the people, for they thought to hinder them from their work'

31 GCRO D1180 1/1 Committee Minutes 6 April 1775: 6/2letter18March1775

32 GCRO D1180 6/2 Brief for Plaintiffs

33 GCL R.135.1 lease of Mrs Wilding to Messrs Purnell and Faithome

34 JHC 21 509, GCL SO 751103 Dobyns-Yate lease

35 GCRO D619, CRO photocopy 175–80 Document listing Dobyns Yate geology

36 GCRO D11805/1 The Petition to the House of Commons for making the River Navigable. It includes the proprietors' names. Also Report of the Committee on the Stroudwater Navigation

37 GCRO D1180 6/2 'Terms proposed by the committee to Mr Purnell' the evidence for this period is undated but logically the offer would fit between Purnell's first attempt to stop the navigation on 19 April and the company's offer to try the Act on a feigned issue in early May

38 GCRO D1180 1/1 Committee minutes 3 May 1775, 10 May 1775

39 GJ 15 May 1775

40 GCRO D1180 1/1 Committee minutes 5 June 1775, 21 June 1775

41 GCRO D1180 1/1 Committee minutes 6 April 1775: GJ 10 July 1775

42 I am grateful to Oliver Silvey and others for this information which in no way contradicts the written evidence.

43 GCRO D1180 6/2 Handwritten draft of brief for plaintiffs the use of 'Benjamin, Richard, Robert and Thomas' suggests a friendly group of men acting in concert

44 GCRO D1180 6/2 Copy of application for injunction, Notice of Motion for Injunction 5 July 1776. The defendants were Benjamin Grazebrook, Richard Hall, John Priddey, Robert Perry, John Colborne, Gent., William Dallaway Esq., Thomas Baylis Esq. The plaintiff were William Purnell Esq, John Purnell, Gent., Joseph Faithome, Nathamel Stephens Esq., Ellis James, Ambrose Reddall Esq and Mary Ball.

45 Their journey on 20 July and that of Jepson cost £9 12s 0d (£9.60)

46 GCRO D1180 6/2 Brief for Plaintiffs

47 GCRO D1180 6/2 Statement of Mr Whitworth's Evidence: 2/17 He also gave evidence at Gloucester 29 July and 4 August. It cost £11 7s 0d (£11.35) to fetch Mr Whitworth and £11 11s 0d (£11.55) for his journey to London
2/17 Account Book Whitworth and Edward Wakefield view at Framilode on 5 August 1775 costing 7s 10d (39p)
2/17 Account Book General Assizes expenses £3 10s 6d (£3.52½)

48 GCRO D1180 5/1 Dallaway, William, *The Case of the Stroudwater Navigation*
2:6/2 The Case of the Opposition:
GJ 7 August 1775
JHC 35 461, 469–70

49 GCRO D1180 5/1 Dallaway, William, *The Case of the Stroudwater Navigation* 2

50 They had probably staked out as far as Whitminster but only cut from Carter's Close to somewhere near the present Junction Lock

51 GCRO D1180 2/72 'Cutting Acct. as alter'd by Mr Priddey'

52 GCRO D1180 1/1 Committee minutes 7 August 1775, 10 August 1775: GJ 14 August 1775, 21 August 1775

53 Voting freeholders, of course

54 There were probably clothing and business connections: James Sutton was the son of a clothier; Charles Penruddocke was considered a moderate member; Ambrose Goddard was a landowner and merchant; Samuel Marsh was the son of a Blackwell Hall factor; John Dunning was a lawyer, later Chancellor of the Duchy of Lancaster and author of the well-known dictum on 6 April 1780 'that the authority of the Crown has increased, is increasing and ought to be diminished', Isaac Barre was the son of a Hugenot refugee; the 'Mr Morrice' referred to is probably Humphrey Morice, MP for Launceston, Cornwall, although there is no known connection between him and Wathen.

55 Joseph Martin was a member of the family banking house; Samuel Blackwell had an established position in Gloucestershire society and was a wealthy landowner; James Whitshed married a daughter of Lord Bathurst.

56 Charles Barrow was a well-liked local MP, George Augustus Selwyn was a wealthy dilettante known for his gambling, extravagant life style, his greatly admired wit, and incidentally, his barbs on the unguarded follies of Gloucestershire clothiers.

57 GJ 25 September 1775 Bills ordered to be paid included: £696 15s 2d (£696.76) to Robert Perry and John Gleave, £70 12s 8d (£70.63) to John Colborne for law charge August 1774 to May 1775; £85 to Griffith Cooper for hauling stone. Another Bill of £88 for hauling stone; £6 1s 2d (£6.06) to William Coales for iron work; £1 14s 0d (£1.70) to John Kemmet and Co for iron; £8 9s 0d (£8.45) to Mr Underwood; £17 18s 2d (£17.91) for nails; £120 3s 10d (£120.19) to Richard George for deals; £36 to Griffith Cooper for stone hauling ;£2 9s 10d (£2.49) to Charles Ginderby; £27 19s 10d (£27.99) to Edward Keene; £33 2s 8d (£33.13) to Mr Underwood ; £5 17s 8d (£35.88) to Edward Keene; and five Bills for stone hauling; £13 0s 8d (£13.03) to James Green, £8 3s 2d (£8.16) to Peregrine Martin. £7 3s 2d (£7.16) to William Pope, £5 16s 0d (£5.80) to William Tippins and £5 9s 2d (£5.46) to John Hoare.

Chapter Eleven
Parliamentary Procedures

William Dallaway was anxious to press ahead with the new Bill. It was unnecessary, he declared, to await replies from all landowners before their petition requesting leave to introduce a Bill was laid before the House.[1] All they needed was a copy of the Bill, a signed estimate of the construction cost from Thomas Yeoman and a list of shareholders with the amount of money each promised to subscribe. It was imperative too that any shareholders still owing money from the third call should pay up at once or they could not legally be described as subscribers. If these matters were neglected or if action were delayed any longer, they might never get their Bill to Westminster.

The immediate task facing the directors was to share out these Parliamentary preparations. John Jepson, the company solicitor, had already drafted an outline Bill which was approved and circulated to all shareholders who were asked to sign it before it was presented to Parliament. John Colborne listed the subscribers and the number of shares each had purchased. John Priddey was asked to return to Stroud from Droitwich and cooperate with Thomas Yeoman in producing a new estimate of the probable cost of construction.[2] Joseph Grazebrook and John Jepson contacted the owners and occupiers of lands the intended canal would cross, asked their opinion of the line and drew up a list of those who approved, disapproved or were disinterested in the proposals.[3] Landowners who favoured construction and whose lands had been cut through already without damage were encouraged to sign a certificate for use as Parliamentary evidence.[4] This certificate, dated 11 January 1776, disclosed that the signatories, 'being Owners and Occupiers of Lands which have been lately cut through … do hereby declare … that the said Cut has been an Improvement and real Service to such of our said Lands that adjoin the Canal' especially by protecting them from the worst of the winter floods and tides.[5] It was signed by Mrs Ann Morse of Cam and Joseph Champion her tenant at Saul; Thomas Carter and William Saunders, tenants of Richard Owen Cambridge at Saul and Framilode respectively; Richard Hall, the company second clerk, and Elizabeth Partridge, both landowners at Framilode; John Saunders, the Fretheme landowner; Benjamin Watkins, a landowner in Saul; and a Joseph Sinderby who was probably a tenant farmer. Benjamin Grazebrook visited shareholders who had still not paid their third call, reminded them that they risked losing their shares if they did not pay calls within the allotted time and urged them to repay their debts as soon as possible. In fact Grazebrook was singularly unsuccessful in persuading errant shareholders to bring their calls up to date. Of the twenty-four who still owed calls on a tot of fifty shares only one, Mrs Jane Sheppard, paid her calls in full before the end of the year. The rest preferred to wait until the Parliamentary position was clarified. After all it was better to make sure first that the new navigation would be authorised rather than risk throwing good money after bad. Nevertheless Grazebrook found all the shareholders willing to sign a petition of proprietors asking Parliament for leave to introduce a Bill.[6]

There were other duties to complete before the petition and the Bill went up to Westminster. Joseph Wathen and Richard Capel presented the petition of county freeholders to the Members of Parliament for Gloucestershire and urged them to use their influence in favour of the Bill. Mr Knight, Richard

Arundell and Thomas White were asked to use their extensive business connections to bring in petitions from Malmesbury and other woollen manufacturing areas of Gloucestershire and Wiltshire.[7] All committee members were urged to write to all their friends requesting them to support the several petitions circulating in favour of the Stroudwater Bill. John Hollings and Joseph Wathen went to Bristol to ask the Lord Mayor and the master of the Society of Merchant Venturers to submit petitions in favour of the Bill from their respective corporations. Both obliged though it is probable their interest was marginal.[8]

By 14 November it was decided that Durley Wintle John Hollings, Francis Knight, Joseph Wathen, Richard Aldridge, Dr Jones and Richard Arundell should remain in Stroud during the passage of the Bill and act as a resident committee of correspondence keeping in touch with the other directors in London.[9] William Dallaway, Thomas Baylis, James Winchcombe and Timothy Lewis were to set out for London on Monday 24 November accompanied by Benjamin Grazebrook, the senior clerk, and his son Joseph. Grazebrook took £150 with him to London to cover all expenses including accommodation for both directors and witnesses and any other Parliamentary disbursements. Grazebrook and his son were both allowed 5s 0d, (25p) a day for their own expenses during their attendance in London.[10] This entire Stroudwater group went up to town to present the petition to Parliament, to request leave to introduce a Bill, to marshal witnesses speaking in their favour, to give evidence themselves before the various Parliamentary committees and generally to lobby support for the Bill and to promote its successful passage through the legislature.

The directors presented their petition on Thursday 27 November 1775. This confirmed that the method of constructing the river navigation which had been authorised by the 1730 Act would present several serious difficulties for traffic using the navigation. They were therefore seeking to introduce a Bill giving them powers to build an artificial canal navigation instead.[11] Before granting such permission, the committee examining the Stroudwater petition first examined a number of witnesses to make certain the petitioners had complied with the standing orders of Parliament. These standing orders applied to all navigation Bills. The committee also sought to establish whether or not the petitioners had a *prima facie* case for introducing a Bill into Parliament.[12] The Parliamentary Committee which met to consider the petition, and which sat on Thursday 27 November, Friday 28 November and Monday 1 December, therefore set about examining Joseph Grazebrook, John Jepson, Thomas Yeoman, Richard and John Capel, Richard Owen Cambridge and a number of other witnesses.

Joseph Grazebrook showed the Parliamentary committee a plan of the intended navigation, which they examined, and then gave them an outline history of the Stroudwater scheme. Grazebrook mentioned that over £5,000 had been raised from the shareholders by calls totalling £25 on each share and the greatest part of this – well over £4,000 – had already been spent in buying lands, supplying materials to the contractors and paying for the construction of part of the waterway. Although construction had continued after the directors had received the initial warning from Purnell, Grazebrook explained, this had only been done because the directors thought the terms of the 1730 Act entitled them to build a navigation on the lines they had intended.

John Jepson produced the articles for raising £20,000 in two hundred £100 shares which the proprietors had signed on 8 December 1774 and the agreement of commissioners dated 29 December 1774 to appoint new undertakers. Thomas Yeoman, giving evidence on 1 December, confirmed that the work of building the navigation had already begun and that 'Framilode Lock … is nearly finished, and … about a Mile of canal has been cut'.[13] Yeoman made one particularly significant comment about the way in which the Stroudwater supporters had thought about their scheme when the idea of reviving the project had gathered momentum in 1774. According to his evidence, the new supporters had originally intended to base the

navigation on the existing River Frome and that it was only sometime later, when they re-read the Act and found it included powers to make cuts, that they had decided to build a canal navigation instead.[14]

Richard Capel thought a new navigation would be of great benefit to the woollen industry and John Capel stressed how it would facilitate coal imports to Stroud especially as 'within his memory ... half the woods in that neighbourhood have been destroyed, which has rendered fuel much dearer.'[15] Richard Owen Cambridge, who owned more land along the intended line than anyone else, declared himself strongly in favour of the waterway especially since it was a canal navigation which would not prejudice the mills as a river navigation certainly would.

On 1 December 1775 the Parliamentary committee agreed the Stroudwater Bill could go forward.[16] The same day Edward South well, MP for Gloucester, Samuel Blackwell and Thomas Whitshed, the members for Cirencester, Sir William Guise, MP for Gloucestershire and Edmund Burke, the highly respected member for the city of Bristol, were given permission to introduce the Bill into the House of Commons.[17] Edmund Burke brought the Bill in on Monday 8 December where it was given an unopposed first reading before the members rose for the winter recess.[18] The directors who had been in London now returned to Stroud for Christmas to prepare for the next stages of the Parliamentary procedures and to consult with the corresponding committee they had left behind them.

This corresponding committee had not been inactive while their colleagues were away in London. They had busied themselves in collecting evidence to use in the forthcoming committee stages of the Bill particularly the crucial details of water supplied to the Frome valley mills. It seemed certain that the millowners' allegations that a navigation would compete for already depleted water supplies would form the basis of the evidence the opposition would submit to Parliament. It was therefore essential that the corresponding committee should continue the attempts to separate aquatic fact from aquatic fiction in the many widespread and often contradictory claims about water supply. With a series of favourable water measurements already in their possession from earlier in the autumn, the corresponding committee had continued inspecting local watercourses and millponds for themselves and convened a series of meetings to interview local millmen.[19] Most of these millmen had an intimate knowledge of the local water supply conditions and it was feasible that some might be suitable for giving evidence before the Parliamentary committees. If this were true, then it would clearly be advantageous to the Stroudwater cause to select the most articulate and favourable millmen they could find, The corresponding committee had already held a number of these meetings before their colleagues returned from London. Now the full committee continued to pursue the enquiry and held three further meetings in December.

William Beard told the committee he had previously worked at Mr Hill's Mill, Bridgend Mill and Sandford Mill but that for the last twenty or thirty years he had been employed as millman at Ebley Oil Mill.[20] In all his seventy years he had rarely known a millpond take more than two hours to fill and he had never known water to be so scarce that the flashboards on the weir were left down on Sundays to store a head of water for the following day.

John Lawrence had worked as a millman at Eastington Mill for six years before he had moved to Whitminster Mill eight years ago. He confirmed that it was normal custom to raise the flashboards every Sunday to allow waste water to flow away. In his experience too there was always waste water on Sundays which the mills did not use.[21] Even in the driest summers he had seen the whole of Cuckold's Brook, which normally emptied itself into Mr Chance's millpond, diverted over Mr Chance's meadow to improve the quality of the pasture. On top of this it was more than possible that a new navigation could be a considerable service to the mills. Mr Kemmett's cut had run through Mr Stephen's land and had certainly been a great help to the mills by helping to drain the valley more effectively and so preventing those floods which had held up production at the mills in earlier years.

William Mayo had spent most of his sixty-five years working in the mills including the past twenty-four years at Lodgemore Mill.[22] Here he had been millman for the last seventeen years with full responsibility for ensuring there was always an adequate water supply for the mill. Once again he confirmed that the millponds, or 'pens' as they were often called, did not take long to fill and that there was always water running to waste from Lodgemore millpond every Sunday. If the water supply at Lodgemore was adequate that below the mill was even more so since the Frome received two additional tributaries of the Woodchester Water and the Cuckold 's Brook just there to augment its supply.

The committee also examined a number of other workmen and millmen including Stephen Ducke of Mr Cooke's Mill, John Beard of Frombridge Mill, John Hall of Ebley Mill, Samuel Webb of Ebley Oil Mill, Amara Harris of Elliott's Mill, John Clissold of Mr Hill's Mill, Mr Mullard of Whitminster Mill, Thomas Mayo of Hawker's Mill and Mr Daniel Chance's millman. Their evidence confirmed the general impression that water did regularly run to waste on Sundays when the mills were idle and that under normal circumstances there was no shortage of water supplies for the mills.

The committee then turned their attention to other considerations. They interviewed John Gleave who had been in charge of the cutters. Gleave told them that the final cost of Framilode Lock would be about £1,500 and that only about another £100 would finish the lock completely.[23] Gleave confirmed that in his opinion it had been imperative to continue working on Framilode Lock after the proprietors had been served with an injunction on 22 July 1775 or the lock would have been destroyed by the coming equinoctial tides. The opposition might seek to prove that the company had deliberately and illegally ignored the injunction. So Gleave was asked to prepare himself to give evidence to the contrary before Parliament particularly impressing upon them that the work was absolutely necessary to prevent the lock being damaged by the tides and not, as had been suggested to impress Parliament with the amount of money already expended in the hope it would persuade them of the need for further powers.[24]

William Dutton, a tenant farmer of Nathaniel Stephens at Eastington, confirmed there had been a considerable improvement in the safety and value of the Frome valley lands after Kemmett had built his machine navigation.[25] Dutton had known these lands for more than thirty years and he had no hesitation in saying that the Kemmett improvements had not only severely reduced the risk of flooding by draining the valley lands more effectively, and so improving the position of the mills, but that it had also straightened many of the meanders of the river and created additional land as a result. Mr Stephens, for example, had gained an additional acre and a similar situation had occurred in Bennal's Mead. On hearing this the committee suggested that Benjamin Grazebrook should accompany William Dutton on a visit to Eastington Mead to see this evidence for himself and report on its possible relevance for use in Parliament. Grazebrook was also asked to visit Mr Stephens with John Kemmett, now re-established as an ironmaster in Bristol and cooperating with the Stroudwater company on a number of occasions, to ask for a plan of the land which Kemmett had cut. If Dutton's evidence were true, the company might also claim that a new navigation could have a comparable effect and improve the position of both lands and mills still further.

Samuel Simmonds, the Gloucester trow owner, told the committee there were usually periods of low water on the Severn at least once every summer and when the main navigation was in this condition it was impossible for any barge or trow to navigate down stream from Shrewsbury, Bridgenorth, Bewdley and Stourport to either Gloucester or Framilode. During the summer of 1775, for example, no coal had been brought down the Severn to Framilode for about two months because of the low water. Trow owners regularly expected the trade to Framilode might be interrupted for anything from one to three months during the average summer.[26] When Edward Owen, a barge owner from Brosely in Shropshire who owned several vessels and was a considerable trader in coals, attended the committee meeting on

18 January he confirmed this evidence and told the directors that it was not uncommon for no vessels to come down the Severn for up to twenty weeks at a time. He could even recollect a period of six months when very little traffic had moved because of exceptionally low water.[27] In the drier summer period therefore, when clashes of interest between the company and the millowners might otherwise have been expected to occur, it was possible there would be no conflicting claims on water supplies at all if Severn traffic was suspended. If river levels were low and there was no way of Severn traffic reaching Framilode as a result, then the Stroudwater navigation itself could hardly be used. In these circumstances the dissenting millowners could not genuinely complain that the navigation was taking water from the Frome.

The committee had already asked Benjamin Grazebrook to arrange for Simmonds or some other intelligent barge owner to present this evidence on the state of the Severn navigation in summer and the resulting claims on Frome water before the committee of the House of Commons. Edward Owen, however, had both the knowledge and the status of an important trader to commend him and the committee therefore decided to ask him to attend at Westminster on Thursday 30 January and be ready to give evidence if required.[28] Other witnesses would include Thomas Yeoman to confirm his estimate, indicate the advantages of a canal over a river navigation prove the projected reservoirs would give the mills both a more regular and more plentiful supply of water, and verify that the houses below the canal level would not be damaged by floods or leakages. Mr Cambridge and Mr Capel would tell the Parliamentary committee how important coal was to the local economy. Mr Cook would supply details about the water supply to the mills and Benjamin Grazebrook should provide the definitive evidence about the volume of water which normally ran to waste on Sundays in the dry season. William Dutton, John Gleave, Thomas Lawrence, William Beard, William May and William Clissold also agreed to give evidence in London.[29]

Postponing the general meeting of commissioners which had been scheduled for 4 January, it was decided that the same corresponding committee should remain behind to deal with any matters which might arise but that John Colborne and Thomas White should be added to their ranks. Joseph Wathen, who had previously been a member, was now to accompany the other directors to the capital. Apart from William Dallaway, who had returned to Westminster before the directors meeting of 4 January, the remaining members of James Winchcombe, Timothy Lewis, Thomas Baylis, Joseph Wathen and Dr Capel planned to return to London together by coach sometime after 18 January.[30]

It was unfortunate that the Stroudwater company were soon to lose one of their ablest and most active exponents. William Dallaway had fallen ill on his return to London and the state of his health perhaps aggravated by the recent death of his wife, gave some immediate cause for concern. Writing from London on 5 January he apologised for his 'feeble hand … and for his grievous loss of memory … and made it clear to the other directors he considered himself a 'Sick and Dying Man'.[31] Nevertheless he was determined to remain as involved in the Stroudwater project as his failing health would allow. First of all he reminded the other directors that the second reading of the Bill would be within ten days of Parliament reassembling and that the sooner they fixed the date the better it would be. They were all to make sure that the petitions in favour of the Bill were submitted before the motion for allowing a second reading was called, to check all the witnesses had arrived safely, to write to all the MP's they had contacts with to tell them the date of the second reading and also to tell the Lord Chancellor that if the threats of the opposition were believed they might need the support of his friends. At the same time Dallaway was sufficiently confident of a successful outcome to the Parliamentary proceedings to outline some general suggestions for the opening ceremony of the canal which might start with a short discourse on the general advantages of inland navigations. Dallaway's understanding of the basic effects a navigation would have

on Stroud are summed up briefly in his hints for the opening. 'When the Carriage of Goods is rendered much cheaper,' he wrote, 'than it was before there is not only an increase of all articles formerly brought to that Place … [and] an Increase of all the Articles there … manufactured; but also … many articles [are brought] which were never thought of before and could never have been interchanged [but] … for the … Reduction of the price of Carriage'. Dallaway considered Joseph Grazebrook, was an 'exceedingly capable' young man and strongly recommended that once they had got the new Act the committee should employ him 'not as a clerk … but to attend and Direct Work People and to see that they do right on the Cannal'. There were harsher words for some members of the committee. In particular Dallaway was annoyed Joseph Wathen and James Winchcombe had put off their journey to London for a while on account of their private interests to which 'they [have] discovered so strong an attachment … that I fear you will get little from them for the Publick Good'. Dallaway does not elaborate whether these private interests were unexpected business commitments or some subtle commercial pressures to encourage them to modify their support for the Stroudwater Bill. There was no such uncertainty about Dallaway's view of these interests, however, once he had declared himself 'highly disgusted with it'. Even though his health continued to deteriorate over the next two months, Dallaway was able to hear the new Act had passed both Houses of Parliament shortly before he died in March 1776.[33]

The opposition which Dallaway referred to in his instructions to the committee indicated that the opponents of the Bill had not abandoned their position after their successful encounter at the Gloucester Assizes the previous August. Before 18 September 1775 they had been aware that the proprietors intended to apply for a new Act of Parliament to supplement their powers of construction. Since then the opponents had met monthly at their usual venue in Frocester to keep the matter under review.[34] They met there once again on Wednesday 3 January 1776 'in order to sign Petitions … to prevent [the] Bill … from passing into a Law'.[35] There were four petitions against the Stroudwater Bill.[36] The petition from the corporation of Gloucester, who feared some damage to their financial interests in land and in corn and cloth mills at Ebley and who were especially conscious that a Stroudwater navigation would usurp their overland coal trade from Gloucester docks to the Frome valley, disguised the true nature of their opposition by alluding to other difficulties.[37] Since the nearest custom house to Framilode was at Gloucester, they maintained the canal 'will be an inlet to many illicit practices and open a Source for many Frauds and Abuses in His Majesty's Revenue, necessarily increase the Number of Revenue Officers and in its Consequences be prejudicial to the Fair Trades by its particular convenient situation for Smuggling.' The Stroudwater company thought this petition quite 'frivolous' pointing out that the nearest custom house was at Berkeley not Gloucester and refers to the objections in the most disparaging terms. Two other petitions came from the Owners and Occupiers of Mills between Wallbridge and Framilode', which was dated 1 February 1776 and from the 'Owners and Occupiers of Messuages, lands, and Tenements near or adjoining the river between Framilode and Wallbridge', which was dated 5 February. The final petition entitled 'The Case of The Opposition to the Bill for Making a Navigable Canal from the River Severn to Wallbridge', was especially scathing about the Stroudwater claim that the mills would be better supplied with water once the two reservoirs were built. 'How' it demanded angrily, 'is any Addition to be made [to the volume of water] unless from the Clouds of their Understanding … for it appears … to be saying that the same water, already insufficient for one purpose, when applied to two will become sufficient'. In any event, there was no waste water during the dry summer months so any idea of using any Sunday waste water would hardly solve the problem.

The Society of Merchant Venturers of Bristol had dated their favourable petition on 8 December and submitted it to Parliament claiming the Bill would be 'very beneficial to the Trade and Commerce of this City'.[38] The petition of the undertakers themselves had already been submitted on 27 November

before the first reading had begun. In the new year petitions favouring the Bill followed from the local communities of Bisley, Dursley, Painswick, Cirencester, Cricklade and Malmesbury.[39]

On 8 January 1776 the Stroudwater company issued their 'Brief in Support of the Stroudwater Bill' in which they dealt at length with the millowners claims that a new navigation would damage the water supply to the mills. Were it well founded, the company stated, this objection would certainly deserve serious consideration. But it was not well founded and the time of short water was usually inconsiderable. Believing that the best method of defence was attack the company sought to lay the blame for any shortage of water supply squarely on the shoulders of the millowners. 'However the Opposition may complain of the want of water in the summer', it said, 'several of the Millowners at the driest times in the most dry seasons often turn the water over their meadows for three or four days together … so that it will water their land'.[40] 'Recent experiments', it continued, 'done with great Accuracy, show that the millponds fill in a very short time by the Common Stream; some in ten minutes, to fifteen, twenty or forty minutes … and all the millponds from Wallbridge to [the] Severn might in a general way be filled in six hours and in dry or short seasons in twelve hours. So that any scarcity of water, which some of the Millowners may dread or complain of, must … be owing to their Neglect by suffering the water to run to waste. Hence it may with Justice be suspected this is only a pretence to evade cutting through their lands; they make a handle of this objection to conceal their want of public spirit and their unwillingness to part with their property (though at or above its full value) for the general good of the County. But the principal Reply … is that the Mills below Wallbridge, in consequence of the navigation, will have more water than ever they had for working days and consequently be benefited'.

It was certainly true that Benjamin Grazebrook's calculations, which had been made in the driest season, suggested it was the management of water supplies rather than the total volume which was at fault. It was equally true that on Mr Baylis' calculations, and allowing six barges up a week and six down the navigation, would not use more than twelve locks of water a week before allowances for leakage. Even allowing eight locks full for running waste water the volume of water the navigation could use would be very small compared with the total volume of water used by the mills. Nevertheless, the Stroudwater company were wise to give the question of water supply their greatest attention and to consider it would form the principal plank of the opposition case.

By early February most of the witnesses the Stroudwater company had gathered together to give evidence on its behalf had arrived in London and were installed at the Queens Head Tavern. The Bills for this accommodation were paid by the company; suppers alone for 'Mr Mayo and Co' costing a total of £27 16s 1d (£27.81).[41] The directors were accommodated in other nearby quarters but their Bills too were paid by the company.[42]

The second reading of the Stroudwater Bill began on Thursday 8 February 1776 when the 'order on the Stroud Water Navigation Bill was read, and Mr Townsend rose, observed that one of the council (Mr Kenyon) had unfortunately slipped and hurt himself so as not to be able to attend any business since, and that the other gentleman (Mr Bearcroft) was so closely engaged in his attendance on the Select Committees, as not to have time to make himself master of his briefs; be therefore proposed to put off the second reading for a few days longer. This proposition was opposed by Mr Burke, and Sir George Yonge, and the question being put, whether the order should be gone into or postponed, it was carried by a majority of sixty-seven to twenty-six, that the council now be called'.[43] Mr Bearcroft was counsel for the landowners, Mr Morgan for the millowners, Mr Selwyn for the Corporation of Gloucester and Mr Lee for the company of proprietors.[44] Mr Bearcroft, Mr Selwyn and one other (probably Mr Morgan) were heard first against the Bill and then a number of witnesses were examined to establish the leading facts of the case.

According to these witnesses these facts included 'the injury that would be done to the landlords, thro whose lands the cut was proposed to be made; The destruction of the mills on the river for want of water, by which 9,000 persons would be thrown out of employment; and the great injury the woollen manufacture would suffer if those mills were obliged to stand still for want of water.'[45] The witnesses included John Merrit, John Taylor, Mr Chambers, John Bestwick and Daniel Chance. John Merrit, a local surveyor: told the assembled Members of Parliament that he had measured the amount of land which would be needed for the projected navigation. He estimated the canal would take about eight acres a mile and that the towing path suitable only for towage by men would take about six acres a mile making a total of roughly a hundred and twenty acres. John Taylor, a local farmer, was sceptical whether the banks of the navigation would hold water safely. Water had seeped out from the base of some of the banks on Kemmett's navigation, he said, and had created a morass in adjoining fields. Taylor thought the plan for the new navigation would have even worse results since more of it would be above the prevailing level of the land. After all, the soils in the Frome valley were known to be gravelly and therefore especially liable to leakage. Nevertheless Taylor admitted under cross examination that at least part of the damage from Kemmett's navigation arose from keeping water levels so high and from the partners' failure to open the floodgates when needed. Taylor also admitted there was little risk of leakage from the newly constructed part of the Stroudwater navigation since it contained only small amounts of water at present. Both John Bestwick, a local surveyor, and Mr Chambers, a local landowner, repeated general leakage fears from the canal and felt the resulting damage to neighbouring fields could more than outweigh the compensation for lands actually taken for the canal bed and towpath. In these circumstances even generous compensation could leave them in a worse financial position. Daniel Chance, a millowner on the Frome itself, voiced the well-known fears of water shortages if the river supplied both mills and navigation.

The proceedings were interrupted by the opposition at this point. The *Gloucester Journal* reports that 'While the examination was going on a Member rose and observed that there was no House, on which the Speaker counted the Members, and only 35 being present, the House suddenly rose.'[46] But by this stage the Bill's supporters were not unduly troubled by the general prospects. Edmund Burke, writing to Richard Champton on 8 February, offered the opinion that 'They rather delay than destroy us.'[47]

The second reading resumed on Monday 12 February when Daniel Chance told the Parliamentary committee that about 5,000 were employed in the local woollen trade and that the mills might lie idle for from three to six months at a time when water was short.[48] John Dymock admitted the mills had more trade at that time than they had for twenty or thirty years but insisted the existing water shortages would be aggravated if a navigation were built. He maintained water taken from the Frome on Sundays to fill the canal reservoirs was the same water which normally turned the mills on the following day. William Foley, clerk to the Purnells, and Daniel Jenner, servant to the steward of the city of Gloucester, confirmed these periodic water shortages and the generally flourishing state of the cloth trade. Joseph Clowes, the canal engineer, admitted that it was not yet possible to make banks completely water tight but suggested a considerable amount of water could be saved if a larger number of low rise locks were built instead of a smaller number of high rise chambers.

Thomas Yeoman thought a navigation would be a great benefit to the neighbourhood and that it would be an exceptionally easy canal to build. 'The Ground thro' which the Canal will pass', he declared, was 'the most favourable I ever saw in my life.'[49] Yeoman nevertheless admitted the navigation could have damaged the interests of the millowners if it had not included plans for building reservoirs to conserve and distribute water which normally ran to waste on Sundays. Yeoman claimed he had been in the Stroud area in all sorts of weathers and had always seen plenty of water running to waste on Sundays

when the mills were not working. On 8 October 1775, for example, the amount of water running to waste at Richard Cook's Mill was equivalent to 255 locks full of water. According to his calculations, and those of Mr Baylis and Mr Grazebrook would confirm it, three locks of water a day would be ample to supply the navigation.[50] In any case Yeoman already had personal experience of constructing navigations where there were just as many mills as there were on the Frome. The River Nene in Northamptonshire, for example, had been made navigable under his own supervision and management. Yeoman considered the mills on the Frome would certainly have a more reliable water supply if the reservoirs were built and if the existing water resources were properly conserved and managed rather than being allowed to run to waste every Sunday as they did at present. If the canal were built carefully there as no reason at all why the adjoining fields should be in the least bit boggy. Thomas Yeoman was near the end of a long and celebrated career in engineering and it was understandable if the house gave considerable credence to the opinions of an established national authority on navigations.

Finally Joseph Grazebrook gave the members details of the series of experiments which his father had done with the assistance of Mr Baylis and others. These proved conclusively that the fears of the millowners were groundless and that storing the water which normally ran to waste on a Sunday would improve the general water supply to the mills. The experiments also disproved the complaint that if Sunday waste water were collected in the reservoirs each week there would be no water in the Frome the following day and that consequently the mills would always be deprived of water on a Monday. The experiments done on Sunday 8 October 1775 showed that Frome water took only two hours twenty-seven minutes to flow from Lodgemore near Stroud to the Severn. As far as the volume of waste water was concerned, Joseph Grazebrook told the house that right at the height of the dry season on Sunday 27 August 1775 six-and-a-half million cubic feet of water had run to waste on that day alone; a surplus sufficient to fill 700 locks full of water. With such conclusive factual evidence as this no one could claim a mere three locks of water a day from this more than generous supply could damage the interests of the millowners. It was equally clear to the Parliamentary committee that it was the management of water supplies rather than the total volume of water which was at fault. Later on 12 February the matter was put to a vote and, with Mr Southwell and Sir William Guise acting as tellers in favour of the Ayers, the Bill passed its second reading by a majority of fifty-two to eleven.

The third reading of the Bill began on Monday 19 February when Thomas Yeoman was recalled and questioned about the Kemmett navigation. Yeoman told the house he had no idea of the present value of the machines but that he had seen them during his surveys for the new navigation. All of them were out of repair, no longer in use and most of their ironwork had been lost. The hearing continued on Thursday 22 February and Friday 23 February when Yeoman was recalled to give evidence once again. Yeoman confirmed the canal had been begun according to his survey and that one of the first objectives had been to join the canal from Framilode to Mr Cambridge's millpond at Whitminster. He was certain the technique of using puddled clay to line the banks would make the navigation watertight and repeated that the mills would certainly benefit from his suggestions for conserving that part of the water supply which had previously run to waste. This saved Sunday water alone would be more than sufficient for the needs of the navigation and that the company would pass on this large surplus to the mills during the following week. Yeoman effectively synthesised the case the company sought to present to the house: they could not increase the volume of water in the Frome but they could increase the amount of water available for use if they introduced their planned proposals for water conservation. These could work to the mutual benefit of both navigation and millowners.

Another petition against the Bill was presented and read to the house with John Stocks acting as agent for the petitioners.[51] John Jepson, the company solicitor, was the next to be examined. He produced

accounts to show that about £4,000 had already been spent on the works before construction had finally been suspended. When Benjamin Grazebrook came before the committee he told them the existing costs of carrying dyers' materials overland from Gloucester to Stroud was around £1 a ton.[52] Compared with this the company were planning tolls of 2s 6d (12½p) a ton on coal and 3s 6d (17½p) a ton on other goods. Since several carriers had already offered to carry goods along the navigation for 3d (1p) a ton, this meant the final costs including both tolls and freight charges would be around 2s 10d (14p) or 3s 10d (19p) a ton according to the type of goods carried. Grazebrook himself had often employed waggons and found the lowest price for carriage over short distances was between 8d (3p) and 1s 0d (5p) a ton so that he confidently expected the carriage costs from Wallbridge basin to Stroud would cost an additional 1s 0d (5p) a ton at the most. This would bring the final carriage costs from Framilode to Stroud to between 3s 9d (19p) and 4s 9d (24p) a ton. At the present time, Grazebrook maintained, a 'great many people kept Teams [of Horses] for Coals' but some of these were engaged on other work at time. In his opinion about 10,000 tons of coal and other goods would be brought to Stroud every year once the canal was completed.

Edward Owen, the Shropshire coal trader, told the house he could deliver Shropshire coals to Framilode for 11s 0d (55p) a ton and coals from Staffordshire for 12s 0d (60p) a ton.[53] Excluding tolls, the additional charge for carriage to Wallbridge would be 3d (1p) a ton extra. There was, however, always a danger this supply would be interrupted during the summer months when it was sometimes impossible to navigate to either Gloucester or Framilode. During the previous summer, for instance, he had been detained about ten weeks because of low water on the Severn.

It is not certain how many other witnesses were called to give evidence before the house since the Stroudwater records list several witnesses brought to London who were not eventually listed in the Parliamentary records.[54] In all probability some of these were examined briefly but provided no additional important information thought worth recording. William Beard and William Mayo, however, were certainly paid 10s 6d (52½p) each on 23 Feb for being witnesses and a further £1 11s 6d (£1.57½) each on 20 April for their attendance in London.[55] In addition Edward Owen was paid two guineas (£2.10) and Thomas Lawrence, William May, William Beard and William Clissold two guineas (£2.10) each early in March for similar services.

When the third reading came to a vote the opposition sought to defeat the Bill on the grounds that it had failed to comply with a standing order of the House but this was rejected and the Bill passed its third reading on 8 March 1776.[56] The Bill then passed to the House of Lords where five peers in committee examined it over the period 11 to 13 March.[57] The passage through the Lords was uneventful and the Bill was approved without amendment. It received the Royal Assent a few days later on 25 March 1776.[58]

Chapter Eleven References

1 GCRO D1180 5/1 A letter by W. Dallaway 23 October 1775
2 GCRO D1180 1/1 Committee Minutes 5 October 1775, 23 October 1775
3 GCRO D1180 8/2 A list of Proprietors … and their Assents and Dissents thereto
4 GCRO D1180 5/1 Certificate of the Landowners showing no Injury
5 they mean 'adjoin '
6 GCRO D1180 2/69 Treasurer's Accounts relating to calls on shares, booklet listing third calls
7 GCRO D1180 1/1 Committee minutes 21 December 1775
8 GCRO D1180 1/1 Committee Minutes 7 December 1775, 2/17 Cash Book 1775–79. This may be the Bill for £14 19s 10d (£14.99) on 28 December 1775

9 GCRO D1180 1/1 Committee minutes 14 November 1775. The minutes on 18 January 1776 add John Colbourne and Thomas White but omit Joseph Wathen

10 GCRO D1180 1/1 Committee minutes 14 November 1775

11 GCRO D1180 5/3 Brief in Support of the Stroudwater Navigation Bill 1, JHC 55 461.
The Parliamentary Committee on the Stroudwater. Navigation Petitions (27 November 1775) included:–Edward Southwell,. Sir William Guise, Messrs. Cust, Buller, Scawon, Pettitt, Olivier, Allen, Martm, Paulet, de Grey, Luttrell, Adair, Hayley, Hartley, Howard, Montagu, Marsharn, Dunning, Whitmore, Littleton and Edmonstone, George Augustus Selwyn, Edmund Burke, the Lord Mayor of London, Sir J. Wrottesley, Sir G. Robinson'. Mr Comptrolle and the members for the counties of Glouc., Worcs., Warwicks ., Oxon., Wilts., Berks., Somerset, Hereford, Dorset, Devon, Cornwall and the principality of Wales (Sir George Young, Mr Cater, Mr Harris, Mr Wished, Mr Blackwole, Mr Burk, Sir William Mayne and Mr Goddard)

12 These were dated 25 April 1774

13 JHC 35 396–70.

14 GCRO D1180 5/1 William Dallaway's Notes upon the Act for making the Stroudwater Navigable

15 JHC 35 469–70

16 GCRO D1180 5/3 Brief in Support of the Stroudwater Navigation Bill 1

17 JHC 35 469

18 JHC 35 483

19 GCRO D1180 2/17 Cash Book 1775–79. On 5 November 1775 Daniel Chances millman was paid 2s 6d (12½p) probably for showing them around

20 GCRO D1180 1/1 Committee minutes 11 January 1776, 5/3 Brief in Support of the Stroudwater Navigation Bill 9, 5/1 Copy of evidence taken at meetings 14 November 1775 to 28 December 1775

21 GCRO D1180 1/1 Committee minutes 11 January 1776, 5/3 Brief in Support of the Stroudwater Navigation Bill

22 GCRO D11801/1 Committee minutes 11 January 1776, 5/3 Brief in Support of the Stroudwater Navigation Bill 8

23 GCRO D1180 9/20 Proposals by Messrs. Perry, Gleave for cutting, dated 1 April 1775. Yeoman's original estimate was £700

24 GCRO D1180 1/1 Committee minutes 4 January 1776, 11 January 1776, 5/3 Brief in Support of the Stroudwater Navigation Bill

25 GCRO D1180 1/1 Committee minutes 4 January 1776, 11 January 1776

26 GCRO D1180 1/1 Committee minutes 28 December 1775, 5 January 1776, 11 January 1776

27 GCRO D1180 1/1 Committee minutes 18 January 1776

28 GCRO D1180 1/1 Committee minutes 18 January 1776

29 GCRO D1180 1/1 Committee minutes 4 January 1776, 5/3 Brief in Support of the Stroudwater Navigation Bill

30 GCRO D1180 1/1 Committee minutes 18 January 1776

31 GCRO D1180 5/1 5 January 1776 Mr Dallaway's Memorandum for Rule of Conduct in London

32 GCRO D1180 5/1 25 January 1776 Mr Dallaway's letter to the committee

33 GCL Wills 0873 T83, GCRO CA19 *The New Navigation or Scroudwater Triumphant 225–33*

34 GJ 18 September 1775, 16 October 1775, 20 November 1775, 18 December 1775

35 GJ 1 January 1776

36 GCRO D1180 5/1 Copies of individual petitions, 5/2 The Case of the Oppo sition, 5/3 Brief in Support of the Stroudwater Navigation Bill 2, JHC 35 512–13

37 GCRO Hyett Pamphlet 353 *The Chronicles and Lamentions of Gotham*, CA19 *The New Navigation or Stroudwater Triumphant*, GCL MR 5.2(2)

A Prophecy of Merlin, The British Merlin, Sabrina Speaks
 With ire Gloster regards thy enprise, and complains:
 Her snarls, her empty anger nothing gains:
 Ere long her ravish'd coal she will bemoan,
 And sulph 'rous kitchens cold and empty groan.
The Tucker's Tale or Stroudwater Navigable
 From each neighbouring town they hither will hie,
 And Glo'ster foresaken, At Stroud they will buy.
A Prophecy of Merlin
 Glo'ster, meantime, with envy growls;
 And so disturb'd she is with ire,
 Her very floods seem all on fire.
 Well may she growl! she'll soon deplore,
 That smoaking chimnies smoak no more;
 That kitchens, erst which stunk aloud,
 Transfer their grateful stench to Stroud.
 Thou'lt bear away her comfort sole,
 Alas! consisting in her coal.
 Hence let her rage with heat supply her
 To roast and boil, instead of fire.
The British Merlin
 Meanwhile foresaken Glo'ster shall complain,
 Grin like a dog, and menace, but in vain;
 In vain regret the dire reverse of fate,
 And mourn her past neglect, but mourn too late;
 In vain her ravish'd coals shall she deplore;
 Her freezing pots and spits shall turn no more.
The bitterness between Gloucester and Stroud in the eighteenth century could be also a reflection of Gloucester's relative stagnation and its envy at the relative prosperity and industrial growth of Stroud.

38 GCRO D1180 5/1 Copy of petition from the Society of Merchant Venturers, Bristol, JHC 35 481
39 GCRO D1180 5/1 Copies of petitions from the six towns and villages, JHC 35 461, 502–3,512–3
40 GCRO D1180 5/3 Brief in Support of the Stroudwater Navigation Bill
41 GCRO D1180 5/1 Three lists of Bills delivered, 5/3 Brief in Support of the Stroudwater Navigation Bill
42 GCRO D1180 2/17 Cash Book 1775–79 Mr Capel's lodging £2 8s 0d (£2.40),Mr Baylis' lodging £36s 6d (£3.32½), Mr Lewis' lodging £5 8s 0d (£5.40) all paid 14 February 1776, 5/1 three lists of Bills delivered 16 February to 25 March 1776 Bills of £46 5s 2d (£46.26), 25 February to 4 March 1776 Bill totalling £68 7s 4d (£68.37) for meals and wine
43 GJ 12 February 1776. This dates the second reading as beginning on 9 February which conflicts with GCRO D1180 5/1 Minutes on second reading of the Stroudwater Canal Bill 8 February 1776
44 GCRO D1180 5/1 Various Minutes on the Second Reading, JHC 35 528
45 GJ 12 February 1776

46 GJ 12 February 1776

47 Guttridge, G. H., *The Correspondence of Edmund Burke* 3 247

48 JHC 35 553 The committee on the second reading on 12 February 1776 included Sir William Guise, Sir George Young, Sir G. Whitworth, Lord Bulkeley, Messrs Southwell, Gleves, Gilbert, Townsend, Bootle, Montagu, Bwll, Lygon, Barrow, Grenville, Skepwith, Pownell, J Townsend, Ord, Baron, Whitworth, J. Grenville, Tuffnell, Lascelles, Brett, Lyttleton, G. A. Selwyn, Foley, Dodd, Hunt, Howard, Fielder, Straham and the members for the counties of Gloucester, Wilts., Somerset, Devon, Dorset, Cornwall, Worcester Salop., Southampton and the principality of Wales. In this list some members names are mentioned twice and spellings differed slightly from 27 November 1775

49 JHC 35 553

50 GCRO D1180 5/1 Mr Baylis' calculations

51 There is no evidence to suggest which petition this was

52 GCRO D1180 5/1 Minutes on Stroudwater Navigation Bill 19–23 February 1776. Evidence here is reported as given by Benjamin Grazebrook Junior but it is unclear whether this refers to a son of Benjamin Grazebrook, the senior clerk; or to Benjamin Grazebrook the senior clerk himself whose own father had the same name. Even though this father (born 1680) was unlikely to be still alive, the evidence most logically refers to the senior clerk himself who at some earlier date had adopted the use of 'Junior' to distinguish himself from his father.

53 GCRO D1180 1/1 Committee minutes 18 January 1776, 5/3 Brief in Support of the Stroudwater Navigation Bill 10. Edward Owen contradicts himself in both these references. In 5/3 he said he could deliver coal to Framilode for 11s 6d (57½p) a ton not 11s 0d (55p) and 12s 0d (60p) and in 1/1 he said coal at Wallbridge would be 6d (2½p) a ton dearer than coal at Framilode not 2d (1p) dearer. This additional cost excluded the toll.

54 GCRO D1180 1/1 Committee minutes 11 April 1776 Joseph Pierce and Ben Fennell were paid for 'attendance in London' and 'for evidence in London' without appearing in the Parliamentary records, 2/17 Cash Book 1775–7923
February to 20 April Wm Beard and Wm Mayo paid total of £8 8s 0d (£8.80); 2/17 5 March to 27 April Wm Clissold for attendance in London, a total of £3 13s 6d (£3.67½); 2/17 3 March to 4 July paid total of seven guineas for attendance in London; 2/17 Ben Fennell 5 March to 6 May paid total of £3 13s 6d (£3.67½) for the same; 2/17 26 February to 17 April paid total of six guineas for wages in London: 2/17 3 March to 2 May Thomas Lawrence and Joseph Pierce paid total of £4 14s 6d (£4.72½) for attendance; 2/17 20 April Robert Lawrence paid £1 11s 6d (£1.57½) for attendance in London: 2/17 2 February to 4 March Edward Owen paid two guineas: 2/17 3 March Joseph Pierce paid two guineas: 1/1 4 July 1776 William Dutton paid two guineas extra for expenses and attendance: 1/1 2 May 1776 Joseph Pierce and Thomas Lawrence paid an extra £1 1s 0d (£1.05) 'in consequence of their illness when in London'

55 GCRO D1180 2/17 Cash Book 1775–79. Dates as in text

56 JHC 35 630, JHL 34 582–3, JHC 35 641, GJ 11 March 1776

57 House of Lords Committee Book 21 289–91

58 JHL 34 589–91, JHC 35 679

Chapter Twelve
The New Act

The news that the Stroudwater Bill had passed its final reading in the House of Lords and was confidently expected to become law as soon as the king could give his Royal Assent was received with satisfaction in the expectant neighbourhood of Stroud. Contemporary accounts of the local reaction come from a new rash of satirical poems written in the mock heroic style with the usual references to classical tradition and mythology. They were primarily intended to ridicule the 'conscious worth' of the clothiers and the pretensions of their township rather than to provide an accurate account of the clothiers' return to Stroud shortly before the Royal Assent was given. The elements of absurdity and caricature are therefore particularly marked and both poems should be taken with liberal pinches of salt.

Nevertheless these new satirical poems, as well as those of an earlier date, should not be dismissed as mere elaborated frivolity. They can be informative sources on some of the gentlemen clothiers' personal relationships and on other matters concerning the canal itself. They can, for example, give valuable insight into locally held opinions of some prominent promoters and shareholders. On several occasions the poems hint that although the more important local promoters might be respected as successful businessmen or capable local government administrators, the population at large could often be amused by their concern for status, ceremony and rank. This in turn probably reflected the short genealogical history of most gentlemen clothier families, their generally modest social origins and their intention of using their new found wealth to acquire a respectable social position sufficient to put them at least on nodding terms with the more exalted Gloucestershire county families when they met them taking the waters, at the Cheltenham races or riding in the country.

On the very day on which the King used the traditional form of Norman French to signify his assent to the Bill, the *Gloucester Journal* announced a new poem in two cantos, 'Addressed to the Proprietors on their Success in obtaining a new Act to compleat the Canal', had just been published and was available from Mrs Bond, the Stroud bookseller, for 4d (1½p).[1] This poem, called 'The New Navigation; or Stroudwater Triumphant', gives an impression of the promoters' return to Stroud with crowds jostling and cheering church bells pealing, flags waving, music playing and the ground itself shaking from the salute of the cannon as the promoters walked triumphantly through the narrow streets of the town.[2] The poem compares their reception with the victorious return of Roman generals to the Capitol after long and successful wars on behalf of their empire. Surely, the poem suggests mockingly, the grateful inhabitants of Stroud will erect some mighty brass monument to proclaim the greatness and heroism of the conquering clothiers to all ages yet to come.[3]

Shortly afterwards on 6 May the *Gloucester Journal* announced another poem, written on quarto, was being published that day for 1/– (5p). It was called 'A Prophecy of Merlin' after a supposed prediction by the legendary magician of King Arthur's court and was a 'Heroic Poem' concerned with 'the wonderful success of a Project now on Foot, to make the River from the Severn to Stroud … navigable'.[4] This poem, itself closely modelled on 'The New Navigation or Stroudwater Triumphant', was advertised as a translation and adaptation of an earlier poem called 'The British Merlin' which had been written in Latin

about 1730 by the Reverend William Deighton BA, then Rector of Eastington, to satirise the proposals for a navigation in that year.[5] This earlier poem, which includes lines used in both later poems almost word for word, seems to be the origin of most of the Roman references, the 'conscious worth' of the promoters' procession and the general rejoicings in Stroud. It therefore throws considerable doubt on the contemporary accuracy of the texts of both later poems. It seems certain the local inhabitants would be well pleased that the promoters had returned with a new Act of Parliament. If later reports of the extensive rejoicings at the opening of the canal are accurate it is even probable the promoters would be greeted on their successful return. But whether this general contentment took the form of great processions and official public festivities is certainly open to question.

There was no such doubt, however, about the terms of the Act which the promoters had been granted by the legislature.[6] The Act stated that under the powers of the two previous Acts the commissioners had appointed William Dallaway, William Knight, George Hawker, Joseph Wathen, Richard Aldridge, James Winchcombe, Thomas Baylis, John Hollings and Benjamin Grazebrook as new undertakers on 29 December 1774 and that the commissioners had conveyed to them all the remains of the 1759 navigation with full powers to begin construction. The undertakers had begun construction but discovered the powers conveyed under the terms of the 1730 Act only authorised them to make the river navigable with artificial cuts and not to construct a separate canal navigation which they had already begun. Since a river navigation on the lines of the earlier plans would be difficult to construct, liable to constant interruptions from flooding and in any case be inadequate for present needs, it had finally been decided to apply for a new Act to provide the powers necessary for such a separate navigation. The powers of the 1730 Act remained in force except where they were specifically repealed by the new Act or where the powers were strengthened by additional clauses.

The company had already anticipated the administrative arrangements of the new Act in the reconstitution of the proprietors in 1774–1775 which itself followed the same general scheme as that outlined in the two previous Acts. It confirmed that these promoters or shareholders should be united in 'One Body Politic and Corporate, by the Name of the Company of Proprietors of the Stroudwater Navigation', for 'making, compleating and maintaining the said Navigation' with full powers to negotiate for and purchase any land needed for the construction provided this did not involve carrying the canal through any house, mill or garden which had been standing or in use on 25 March 1730. The proprietors were also empowered to appoint a committee of directors, not more than thirteen or fewer than nine in number, to carry the main responsibility for supervising the construction, maintaining the completed canal and carrying on the general business of the company. This committee of directors, which had a quorum of five, was to meet at least once a month until the navigation was completed and thereafter as often as the directors thought fit. In fact in addition to the frequent informal consultations between individual directors the committee often met three or four times a month during the period of construction and in times of special difficulty might meet two or three times a week. The committee of directors were instructed to prepare a report of the company activities for each general meeting of proprietors which should include details of the progress of construction, the volume of traffic in the preceding half year, the financial position of the company and the dividend which would be declared. The general meeting had the right to reject the directors' report, replace any directors who had died, now resided outside the county or who had failed to attend the committee for three calendar months and to appoint a completely new committee of directors as and when they thought fit.

The Act stipulated that the first general meeting of shareholders should be held at the George Inn, Stroud, on the second Thursday after the Bill became law when the first new committee of directors should be elected. Any subsequent general meeting could be held anywhere within the town at the

discretion of the committee of directors. Since it was some years before the company could afford to build their own headquarters at Wallbridge, they usually held all general meetings and most committee meetings at the George Inn. Two of these general meetings should be held each year and at one of these the proprietors should elect a new committee, a clerk and a treasurer who would all bold office for one year unless the proprietors decided to replace them at an earlier date. The treasurer, who was allowed his expenses, could pay the larger Bills provided they had been approved by the committee beforehand. The treasurer's accounts, which would be open to examination at each general meeting, would then be approved by the general body of proprietors at the meeting. The clerk, whose expenses were not mentioned in the Act but were subsequently allowed by the committee, was entrusted with sufficient cash to pay any small Bills and petty expenses and then account to the committee for his expenditure. The committee itself was allowed expenses of up to £1 12s 6d (£1.62½) for each meeting which would be equally divided between all the directors present.

The Act also appointed four hundred and fifteen commissioners with responsibilities for 'settling, determining and adjudicating on all questions, matters and differences which may arise between the Company … and any other persons', for ensuring the proprietors discharged their functions in a proper manner and for ascertaining that landowners were fairly compensated for land taken in the navigation and for any damage caused by the construction. In the last resort the proprietors were fully responsible to the commissioners whose decision was final and binding on both sides. However, the Act included a provision that if ever the commissioners were unable to reach a verdict or if there was a general dissatisfaction with the decision of the commissioners a special jury could be appointed by the justices of the peace and summoned to reach a decision. The commissioners could perpetuate their corporate existence by appointing new commissioners at any properly convened meeting of their number. This meeting should have a quorum of seven commissioners present who had been given at least fourteen days written notice of the meeting and who had been reminded by an advertisement in the *Gloucester Journal* at least ten days before they met. The Act required that any commissioner must have a personal estate of at least £3,000 or a yearly income of at least £100 to qualify for election. These qualifications, which were higher than those in the 1730 and 1759 Acts, not only ensured that each commissioner had a substantial personal stake in the good order of the county but limited the choice of people who could be considered for appointment. Only a small proportion of Gloucestershire residents had the wealth or substance to even qualify for the position of commissioner of the Stroudwater Canal. If ever the body of commissioners became defunct, failed to act or if ever there was a shortage of active commissioners to nominate new members, then the justices of the peace were empowered to nominate such new commissioners as they might think fit who could then, provided they qualified on financial grounds, revive and execute the functions of their office.

This most recent list of commissioners included a number of men who had already acted in that capacity under the terms of the earlier acts as well as a substantial majority of new names. It contained such names as Richard Owen Cambridge, the Whitminster landlord now resident in Twickenham; Thomas Baylis and William Dallaway, the wealthy local clothiers and prominent Stroudwater shareholders; the Reverend Josiah Tucker, Dean of Gloucester and an ardent chronicler of the successful early months of the ill-fated Kemmett navigation; Anthony Keck, the Kings Stanley architect later responsible for some undistinguished lock construction at Ryeford; Sir Onesiphorus Paul, the Woodchester clothier, noted philanthropist and sometime visitor to Bath; the ubiquitous Benjamin Grazebrook, and many others with some connection with the navigation.[7] At the same time the full list of new commissioners included a much more representative cross section of well-to-do Gloucestershire society, most of whom had no direct connection with Stroud, the woollen industry or the projected navigation. This balanced selection

of aristocrats, landowners, industrialists, Members of Parliament, clergymen, merchants, clothiers and the usual sprinkling of other local respectability was appointed to ensure that any disputant received a fair and sympathetic hearing for his complaints against the Stroudwater company. There is plenty of evidence in the records of the commissioners meetings that they were far from being a tool of the committee of directors.[8] On several occasions the directors increased their initial offer for lands rather than risk an appeal to the more uncertain opinion of the commissioners. The more usual procedure was for the company to strive for an amicable agreement with the owners of lands needed for the navigation and only to appeal to the arbitrating powers of the commissioners in the last resort. If a decision went against the company it would have to pay not only the costs of convening the meeting of commissioners but also pay the new and probably higher price which had been agreed by the meeting.

The new Act also contained a number of specific provisions about the construction, the way in which the navigation should be built and financed, and the movement of traffic. The company was authorised to raise £20,000 by dividing the share capital into two hundred equal shares of £100 each. This sum would be raised by a series of calls on the proprietors as construction proceeded. These calls, which must be separated by at least sixty days, would be advertised in a Gloucestershire newspaper, usually the *Gloucester Journal*, and give at least sixty days notice of the expected date of payment. Any shareholder who failed to pay his call before the appointed time could forfeit £5 for each of the shares he owned. If the call and additional penalty were still not paid after a further two months, the company could deprive the indebted shareholder of his shares and resell them. If any shares were forfeited in this way the full details should be laid before a general meeting of proprietors within six months of the date of forfeiture. In fact the company were most unwilling to exercise these powers unless they were seriously inconvenienced by a persistent defaulter. The more usual method of dealing with the occasional reluctant shareholder was to send the clerk or some prominent member of the board of directors to see him, reminded him of the expected profits on completion and urge him not to lose all the money he had already invested in the project. Executors of former shareholders, however, were specifically excluded from this provision and were allowed to retain their shares and pay the back calls as soon as they could conveniently do so after the death of the original proprietor. No shares were negotiable until the navigation was completed, no person could sell his share until all the calls were paid up to date and no new shareholder could vote at a general meeting unless he had held his shares for at least six months. Decisions were ratified at general meetings by a simple majority of votes cast: one share entitled a proprietor to cast one vote, three shares carried two votes, five shares three votes and ten to fifteen shares carried five votes. No proprietor could own more than fifteen shares in the navigation or his holding could be confiscated and any shareholder could vote by proxy for up to three other shares.

The Act also provided a safeguard in case the £20,000 raised by the issue of shares proved insufficient to complete the navigation. If these circumstances arose the company could raise a further £10,000 either by further calls on the existing shareholders or by mortgaging the navigation. But if the company chose to raise a mortgage, the mortgagees should be given a proportionate share in any profits and the mortgage interest, which should be paid half yearly, should always be paid before any dividends were declared from the remaining profits.

The Act gave the company powers to build a canal navigation of eight-and-a-quarter miles long wholly separate from the River Frome apart from two short stretches where the canal crossed Richard Owen Cambridge's millpond at Whitminster and the millpond at Ebley; both parts of the Frome watercourse. The canal was also planned to cross an important tributary of the Frome, the Painswick Water, where it formed part of the Lodgemore millpond. The detailed clauses on construction included a number of pro visions to safeguard the interests of the landowners. This suggests that either the company was

particularly anxious to minimise the opposition of some contentious landowners by agreeing to certain restraints on construction or that these same landowners were able to exert sufficient influence to ensure that the draft of the original Bill met at least some of their basic objections. The company, for example, were not allowed to deviate more than sixty yards from the line shown on the approved plan or convey the cut through the lands of any owner not listed in the associated book of reference unless the newly affected landowner gave his written consent and at least nine commissioners gave their approval at a specially convened meeting. The total width of land taken for construction, inclusive of towpath and fences, could not exceed thirty yards except where provisions were made for vessels to turn, or to pass each other or at the sites of cuttings and embankments where the total width should not exceed 120 yards. The company were also instructed to buy any small patch of land which was cut off from the rest of an owner's lands by construction. When the company bought these pieces of land their usual practice was to try and resell them to the adjoining landowners and to use the sale to help offset the costs of buying lands. In addition to this the company was made responsible for building drains to keep the adjoining lands free from water although they could still not build these drains, or indeed any other part of the canal, across any highway or footpath unless they provided usable temporary crossings to carry the right of way without interruption while construction proceeded and permanent bridges or culverts were built. Equally the Act provided that the towing path should be separated from the adjoining lands by either fencing or ditching to prevent cattle from straying along the canal banks. All these bridges, fences and ditches, as well as any other parts of the construction, should be built by the company and kept in good repair at their expense. If any of this work was neglected the owners and occupiers of lands could undertake the repairs themselves and reclaim the full cost from the company. Similarly any cattle cut off from their usual watering places should be supplied with proper substitutes by the company which was responsible for keeping them supplied with water. Finally landowners were given the right to fish in the canal and to move manure on the navigation without tolls. There were, however, some restraints on the rights of landowners and tenants. If ever the owners and occupiers of adjoining lands found any of the bridges, gates or other ancillary facilities built for them by the company had become inadequate for their needs, they could only improve or replace them at their own expense and were specifically instructed to make certain that when they undertook any of these improvements the navigation was not interrupted for a longer time than necessary. Company agents and workmen could enter any of the lands listed in the book of reference at any time to check or clarify the 'divers levels and surveys' which had already been taken provided the company was responsible for any damage their agents caused.

To keep the navigation supplied with water the company could take water from the River Frome, from any springs discovered in the bed of the canal during construction or from any other water course which flowed within a hundred yards of the canal. In order to keep the level constant, millowners on the Frome were obliged to open or shut any of the floodgates at the request of the company provided they had been given at least twenty four hours notice. The company could also use water from the Frome to scour or clean the canal anytime between 5 November and 25 May when water supplies were usually plentiful. However, the company was instructed to make certain that this scouring did not hinder any working of the mills nor leave them short of water before they began the operation. If ever the mills were stopped by these scouring attempts or by the need to maintain a constant level, the company should pay 2s 0d (10p) an hour compensation to the millowners for the first twelve hours and 3s 0d (15p) an hour thereafter.

Finally the Act included a number of clauses governing the behaviour of traffic on the canal. Some of these were specifically designed to conserve water supplies and reduce any potential inconvenience to the millowners. They included provisions that when two boats arrived at a lock simultaneously the lock should go to the boat with the lock in its favour; that unless a boat was returning empty or there

was plenty of excess water available no vessel carrying less than twenty tons should pass locks without the written consent of the proprietors; that boatmen should close all gates and paddles securely to cut down on leakage; and that any wilful waste of water would lead to a fine of up to £5 for each offence. The tolls, unmentioned in this new Act, remained the same as those already listed by the 1730 Act, 2s 6d (12½p) for coal and 3s 6d (17½p) a ton for general goods carried the full length of the canal and a proportionate charge for any shorter distance. Each vessel entering the canal should have its name and that of its steersman clearly painted on its outside and the master should provide the toll collector with an accurate written account of the cargo he was carrying which would list the weight and nature of the cargo as well as its origin and destination. The toll should then be paid before the vessel continued on its journey. If there was any difference of opinion between the master of the vessel and the toll collector on the weight of the cargo, the toll collector could halt and weigh the cargo. If the weighed cargo was heavier than the declared amount the master was required to pay both the additional tolls and the cost of the gauging. On the other hand, if the cargo weighed less than the declared amount the toll collector was obliged to pay the cost of gauging and recover it from the company. To simplify toll collection, fifty feet of round timber, fifty feet of fir, deal, beech, baulk, poplar and other woods and forty feet of square oak, ash and elm timber should be calculated as one ton. Floating timber and boats so loaded as to obstruct the passage were liable to a £10 fine. Gravel or rubbish thrown in the canal could lead to a fine of not less than £5. Boats lying at a wharf for less than twelve hours need not pay wharfage dues but in no circumstances could boats remain at a wharf more than six days. Each boat obstructing the navigation or sunk in the channel would pay a fine of 10s 0d (50p) for each hour the canal was obstructed. Each person obstructing the navigation would forfeit the same sum for each hour the obstruction continued as the company were obliged to pay the millowners in cases of water shortage. In the event of non-payment of tolls or fines the company could seize and sell vessels to defray their losses.

In conclusion the Act listed a few final safeguards to cover two remaining eventualities. If the canal was not built within five years or fell into disuse within that time the land on which the navigation was built would revert to the original landowners who need not pay more than the sum the proprietors had paid them to gain the title. If the canal was not constructed within fifteen years of the Act, the company would need to regain the permission of landowners before they could enter and survey the lands.

Now the new Act was law the company could turn its attention to restarting construction. One of their first tasks was to order materials, recruit labour and begin negotiations for the purchase of lands.

Chapter Twelve References

1 GJ 25 March 1776 The poem cost four old pence
2 Occasionally referred to as *Stroud Triumphant*
3 GCRO CA19 *The New Navigation or Stroudwater Triumphant* Canto II 13–15
4 GCL MR 5.2(2) *A Prophecy of Merlin*
5 GCRO Hyett Pamphelt 353 *A Prophecy of Merlin.*
6 GCRO D1180 5/3 Act 16 Geo II Cap 21
7 This was the William Dallaway who had just died. His son, William Dallaway Jnr, was also included.
8 GCRO D1180 C1/1 Commissioners' minutes especially 26 May 1774 to 1 May 1777

Chapter Thirteen
The Purchase of Lands

The confidence of the Acting directors rose as the new Bill continued its steady passage through the House of Commons and by the time it passed the third reading in March 1776 the committee was already planning,a general resumption of work.[1] As soon as the Bill passed its fourth and final reading in the Lords and received the Royal Assent the directors wrote to shareholders with the good news, informed them of a forthcoming general meeting of proprietors at the George Inn at 10 am on Thursday 4 April, and advertised in the *Gloucester Journal* urging all shareholders to attend in person or use their proxy 'for the Purpose of nominating a Committee, Treasurer and Clerks' to implement the general provisions of the Act and manage the company in the coming year. If the company still owed anyone money from the previous period of construction he was asked to send an account to Benjamin Grazebrook in Stroud at least a day before the meeting so it could be considered before the full body of proprietors and the accounts of the company brought up to date.

The new Act gave powers to the Stroudwater shareholders to form themselves into a company of proprietors and to delegate their authority to an elected committee of directors with general responsibility for managing the company. The shareholders could also appoint a treasurer to receive tolls and handle the accounts and a clerk to deal with the day to day running of the company. The main purpose of the general meeting on 4 April, therefore, was to conform to the administrative provisions of the new Act by turning the existing de facto company established at the meeting in December 1774 into a de jure body which could legally fulfil the powers Parliament had given it. The general meeting set about this task at once. The shareholders turned themselves into a company of proprietors and re-elected John Colborne, the Stroud solicitor, as treasurer thanking him for his outstanding services during the previous hectic but finally successful year. The election of a solicitor to the post of treasurer followed the usual practice of most river navigations, turnpike trusts and canal companies. If a respected local solicitor like John Colborne were elected to a key post in a fledgling company like the Stroudwater he could bring a number of valuable assets with him. In the first place he could use his extensive industrial, commercial and social contacts in the local community to help locate any sources of available capital and urge its investment in the projected improvement. This was hardly a serious advantage for the Stroudwater company, however, since the gentlemen and clothiers of Stroud had already demonstrated their capacity to raise the estimated £20,000 needed for construction with comparatively little effort. The other usual advantages of a solicitor were more directly relevant. A reliable and competent solicitor could bring his considerable administrative and accounting experience to bear on the management of company affairs and hope to ensure that at least one side of the business was properly and sensibly run. Perhaps most important of all, a respected local solicitor could bring his name and reputation to a new company and help to create a general feeling of confidence in the aims and abilities of the directors. This in turn would help to consolidate the strong local support for the Stroudwater scheme and possibly encourage a number of waverers or sceptics to support the plan. Finally, the reputation of a treasurer may well have been instrumental in raising the additional cash when the company found itself in financial difficulties.

Joseph Grazebrook, who had already been assisting the company informally for some considerable time, replaced his father as clerk to the company. Benjamin Grazebrook had probably decided to concentrate his energies on his expanding business interests which were soon to include a canal carrying company on the new navigation. He therefore stood down from the influential but time consuming post of company clerk and was elected to serve on the committee of directors instead where his knowledge of company affairs and general business acumen made him a valued and well respected member of the board. On more than one occasion in the years to come it was his drive, his skill, his ambition and his flair for business organisation which rescued the company from serious financial or constructional difficulties and it was to Benjamin Grazebrook that the directors turned with a request to supervise the completion of the navigation after repeated troubles and disagreements with contractors and civil engineers had brought the company to the verge of despair.

Fream Arundell, the Stroud clothier, and Anthony Keck, the architect from Kings Stanley, were also re-elected to the committee in place of the wealthy William Dallaway and the successful Stroud tallow chandler Richard Aldridge Snr, who had both died, and Captain George Hawker, a member of the respected family of Dudbridge dyers who had already sold part of his holding to Samuel Skey, the Bewdley chemist, and was soon to dispose of the remainder to Christopher Chambers, the London banker, and Thomas Cooper, the Woodchester clothier. All the other directors were re-elected to serve on the committee for a further term.

This new committee of directors still mirrored the predominance of local clothing interests in the ownership and management of the company. Eleven of the thirteen directors came from Stroud or the immediate neighbourhood and at least half the directors were directly involved in the woollen industry. Several others, now listed as 'Esquire' or 'Gentleman' in the company records, were either connected with ancillary trades or professions or had made their money in the woollen industry and chosen to retire from any active involvement with the trade to live the leisured life of a country gentleman instead.

Several hours after the general meeting had finished, and the directors had eaten their usual lunch in the hotel at the company's expense, the newly elected committee met to consider their general state of preparation. The directors were anxious to get work under way as soon as possible and for this it was essential to reach agreement with landowners along the line of the intended route. The committee were faced with two main options on the purchase of lands. They could either complete the purchase of each piece of land before they entered it to begin construction or they could ask landowners to allow them to enter their lands before an acceptable settlement had been reached. This second course of action recommended itself to the committee of directors for a number of reasons. In the first place it meant that provided landowners gave their consent contractors could enter lands as soon as they wanted and not be delayed by disputes of differences over the value of lands needed for the canal. This was undoubtedly the main reason for the decision the directors took in the spring of 1776 when the company still had plenty of resources to call on and when their immediate concern was to get construction started as soon as possible.

The second reason, probably given less weight at the time, eventually proved crucial in keeping the company solvent when confidence rather than cash was in short supply. If the directors negotiated with landowners on this basis, the company need not pay for some of the land it wanted 'until the navigation was completed, the contractors paid off and tolls were providing a useful supplement to company income. In the short term this meant that all the assets of the company could be applied to the Actual construction of the waterway itself and not be divided between two separate and demanding calls on resources. In the long term it meant the company could spread the total cost of the canal over a period substantially longer than the years of construction and that they could pay for some of the land out of operating profits rather than from the capital raised by the original issue of shares. These factors may not have been an important influence on the

initial decision of the directors taken in the confident days of April 1776 when the company had no inkling of the financial troubles ahead and when the directors were more than happy to settle in full with any amenable landowners. But by November 1777, when the company had completed less than half the canal, had already exceeded their own estimate of £20,000 and was finding it increasingly difficult to make ends meet, it had assumed a much greater significance. Only two of the landowners contacted after November 1777 were paid in full before August 1779 and one of those, a certain Mr Loyde, had sold only a small piece of land at the bottom of his garden for a total of £1 14s 3d (£1.71½).[2] In these disturbing financial conditions the company could not afford any capital expenditure which was not essential to the construction of the canal itself and if landowners could be persuaded to allow contractors to enter their lands before a definitive purchase price had been agreed with the company then the directors were only too pleased to agree.

Finally this course of action simplified the details of land purchase for both company and landowner. There is plenty of evidence in the company records to show that the precise lines of the intended navigation was not always fixed until construction was under way and that even when built the line might be varied for one reason or another.[3] The company therefore suggested to landowners that it would be advisable for them to wait until the canal was completed before they were paid in full. The exact amount of land taken from each landowner could then be measured and the final purchase price agreed. This line of thought, however, was not seriously advanced until the financial position of the company was beginning to give some cause for concern and it is possible that the directors saw it as a useful delaying device rather than as a serious argument in its own right.

Some landowners, however, still insisted on payment and when they did they could stretch the company's increasingly slender resources to the point of embarrassment. In July 1778 Benjamin Grazebrook was asked to pay the balance owing to Ellis James 'as soon as the Treasurer had cash' and in October 1780 the company did not even have the hundred pounds to make up the sum to pay for Mr Phillips' land and Joseph Grazebrook had to borrow it from the Stroud bank.[4]

The basis of company policy at the meetings of directors in the hopeful spring days of 1776, however, had not yet reached this stage of desperation. On 11 April the committee asked their new clerk and John Jepson to visit landowners at the lower end of the canal immediately to negotiate both for permission to enter and for the Actual purchase of lands.[5] This was not the first time directors had negotiated to buy land for the navigation. In January 1775, less than a month after the company had been reformed at the George Inn under the terms of the previous Acts and several months before John Purnell challenged the validity of their actions, directors were negotiating with Richard Owen Cambridge for his lands between Framilode and Lockham Bridge. Richard Owen Cambridge, a prominent Stroudwater shareholder and erstwhile owner of 'his own private navigation', was one of the largest landowners in the district and a well-known supporter of the Stroudwater scheme.[6] The company probably believed an early settlement with a major landowner like Cambridge would encourage other landowners to do the same. It is possible, too, Richard Owen Cambridge's local standing helped to minimise any latent opposition to the navigation west of the Bristol Road. Even John Purnell, who stuck out for a high price for his lands at Framilode, was no exception to the general rule that west of the Bristol Road landowners either assented to the sale or did not oppose it. Richard Owen Cambridge was only too pleased to assist the company and by 2 February 1775 had agreed to accept a price based on their rental value for thirty-two years. Similarly James Clutterbuck had reached an outline agreement with the company by early in March.[7]

In the spring and early summer of 1775, when the company had started to build a navigation under the terms of the 1730 Act and before John Purnell had emphasised the illegality of their actions, the directors had begun to negotiate with a number of landowners whose land lay mostly west of Bristol Road. Within a few months the company had reached agreement with Richard Aldridge, Elizabeth Partridge, Richard

Hall, John Saunders, James and Samuel Farmer, Benjamin Watkins, Mrs Ann Morse, Phillipa Grove and Elizabeth Heathcote, Richard Martin, Dudley Baxter and probably several others.[8] Negotiations with most of these landowners still continued, with varying degrees of success, even after Purnell had questioned the validity of the company. At first the directors believed they had the law on their side and saw no point in suspending the discussions. Even later, when a legal opinion confirmed the company had no right to build a canal navigation without a new Act, the directors sought to conclude agreements with Richard Martin, Mrs Ann Morse, Benjamin Watkins, John Saunders and Richard Hall.[9] In early July 1775, however, all negotiations were suspended while the directors prepared their case for the forthcoming trial at Gloucester Assizes and, immediately after the decision in August, then concentrated their attention on drafting a new Bill for submission to Parliament. Apart from Mr Eycott approving the intended line through his estate in November 1775 declaring he was satisfied there would be no injury to his mill and the company reaching an agreement with James Clutterbuck and the then living husband of Elizabeth Partridge in January 1776, there are no further records of negotiations with any landowner until the following April when the new Act had become law and the company of proprietors was a legally constituted body.[10]

Negotiations after April 1776 fall into two broad categories. First of all there were discussions to complete with those landowners who had already been contacted in 1775. Some of these landowners, like Richard Aldridge, Elizabeth Partridge, Richard Hall, Benjamin Watkins and Mrs Ann Morse, had already been paid in full.[11] In the case of several others, such as Phillipa Grove and Elizabeth Heathcote and Richard Owen Cambridge, negotiations had reached an advanced stage before the trial at Gloucester and it was only a matter of weeks before a final agreement was reached.[12] Within this first category there was a third group of landowners; those whose agreement took a further few years. Richard Martin, for example, was not paid in full until September 1777, Henry Eycott until May 1778, Samuel Walbank until November 1779, John Webb until April 1780, Dudley Baxter until May 1780 and John Saunders until April 1782. Some of this delay resulted from doubts or disputes about the quality and quantity of land the company had taken for the canal. The remainder was probably occasioned by the decision to postpone payments for land as long as possible.[13]

The second main category included those landowners who had not been contacted at an earlier date.[14] At the meeting on 11 April 1776, however, the committee had asked Joseph Grazebrook and John Jepson to start negotiations with all landowners at the Framilode end of the canal and mentioned at least three landowners by name; Lord Middleton and Alexander Colston who held land jointly in the Fromebridge Mills area on both sides of the Bristol Road, and John Purnell previously tenant of the lands at Framilode which had been the subject of the Gloucester trial but who had now bough the lands from Robert Dobyns-Yate.[15] It is probable the committee also suggested immediate negotiations with the Rev. Henry Davis who held land at Saul since within a month he was paid £112 in full for land.[16] Details of negotiations with Lord Middleton, Alexander Colston and John Purnell, however, are more substantial than those for the Rev. Henry Davis.

The company told Lord Middleton and Alexander Colston that the proprietors needed about four-and-a-half acres of land and asked if they could negotiate with his lordship's steward, William Lowe. At first Lord Middleton was emphatic: he declared himself not only against a Stroudwater navigation in particular because it could cut through his lands but also against all such canal navigations in general.[17] By 14 May, however, William Lowe and Richard Bigland, acting for Mrs Sophia Colston, had agreed the company 'may enter upon and begin cutting such land in the parish of Wheatenhurst … as may be wanting for the use of the said Navigation making such Satisfaction for the same as is made to other Proprietors of Lands adjoining in proportion to its quality'.[18] By 20 May, only a few days later, John Purnell had been paid in full for his land and a further important land purchase was completed.

In early August, when construction of the new navigation was already underway, the committee asked three of their number; Richard Bigland, James Winchcombe and Benjamin Grazebrook, to

write to the landowners as far as Chippenham Platt and try to settle the value of these lands as soon as possible. [19] These landowners included the Rev. Prosser, James Clutterbuck, John Hugh Smith and Ann Hort, John Ford, Edmund Phillips, Nathaniel Stephens and the Rev. Robert Stephens. For the moment the lands of Ellis James, also at Chippenham Platt, were left alone probably because of his well-known opposition to the canal. As far as the Rev. Prosser and John Ford are concerned the company records are seriously deficient. The records state that the Rev. Prosser held land at Fretherne glebe although he himself admitted he did not own the freehold but held it in trust for another gentleman, possibly Robert Dobyns-Yate or his brother. The only remaining information records that Rev. Prosser adopted a neutral stance over the sale of this land. Personally he favoured the canal and if the land were his own he would have no difficulty in giving his consent. As it was he was certainly not against it 'if Mr Yate and his brother are not'.[20] There are no records of either the sale of this land or that of John Ford of Alkerton, who told the company his view would be deter mined by that of Mr Stephens, or of the price paid for them.[21] It is possible, however, both were included in the company purchases from John Purnell and Nathaniel Stephens respectively.

The records are equally unhelpful for James Clutterbuck. Although the company had contacted James Clutterbuck in March 1775 for his land in Pool Field and he had been paid £6 on account in January 1776, it was not until May 1777 that the records mention further negotiations for his lands at Whitminster and Saul.[22] By this stage, however, the company had reached final agreement with him. It seems probable therefore that negotiations had restarted during August 1776 or shortly afterwards .The records of negotiations with the remaining landowners are more comprehensive. Joseph Wathen, James Winchcombe and Benjamin Grazebrook visited the Rev. Robert Stephens in August 1776. Although he expressed some dissent about the sale, Stephens had been offered and accepted a £100 deposit within a week of the visit.[23] Nathaniel Stephens, who also dissented from the sale, is poorly documented.[24] As the largest landowner in the Chippenham Platt area, he undoubtedly would have been contacted in the autumn of 1776. The first accounts of any negotiations with him, however, are not found until September 1777 when the company were consulting their solicitors to consider employing counsel to advise them on the legal position of Mr Stephens' land. The implication here is that negotiations had begun much earlier but failed to make any serious headway. By 11 December 1777, however, Stephens too had been paid £100 on account. John Hugh Smith and Ann Hort, joint owners of a piece of pasture, were contacted in October 1776 when Benjamin Grazebrook called to see their agent John Harvey. An amicable agreement was concluded in December and both partners were paid in full at the end of January 1777.[25] Edmund Phillips, first contacted in November 1776, also settled within a few months.[26]

In February 1777 the committee decided to apply to owners of land as far as Bridgend Mills at Stonehouse Cross and shortly afterwards members of the board approached Samuel Beard, Rev. John Pettat, Ellis James and the widow Mrs Ball about the sale of their lands.[27] The negotiations with Samuel Beard were soon concluded. Beard, who owned two strips of land lying across the intended line near Bonds Mill, arranged to exchange them with Mrs Ball for an equivalent acreage from her lands further away from the canal. No separate agreement between Beard and the company was therefore concluded.[28]

Eventually the company needed permission from the Bishop of Gloucester to take the canal through church property at Stonehouse but for the moment an outline agreement with the Rev. John Pettat was sufficient. Discussions with Pettat were completed towards the end of July when the company met him at Stonehouse to settle the precise line through part of his churchyard.[29]

Mrs Ball and her neighbour Ellis James, however, proved more obdurate. Mary Ball owned lands at Stonehouse and Ellis James had lands at Eastington and a mill at Chippenham Platt. Both were opposed to the canal and were far from helpful to company negotiators. Although both parties agreed to sell their

lands within a matter of weeks and each received a deposit of £100 on account, their disputes with the company over trespassing, damage to crops and leakage dragged on until the early 1780's.[30]

Despite these difficulties, the company achieved their basic aim in the area between Chippenham Platt and Stonehouse Cross. There might still be disagreements and disputes over the amounts and values of land needed for the canal and about certain additional compensation but all landowners had agreed in principle to sell their land to the company and allow the contractors to start work as and when they wanted. By the late summer of 1777, therefore, the company began to turn their attention to owners who held land east of Stonehouse Cross in the general direction of Wallbridge.[31] In early August, for example, Benjamin Grazebrook was planning to visit the Rev. Robert Sandford of Chelsfield in Kent to explain the route of the canal and seek his consent for the sale of land held by Hollowday Phillips for his lifetime but in which Sandford held a Reversionary interest.[32] The committee soon reported agreement with Hollowday Phillips and within a week were negotiating with John Andrews who owned land between Ryeford and Ebley.[33] By early September the committee were concluding agreements with Daniel Smith and Gabriel Harris who both received the customary deposit on account.[34] At the same time Benjamin Grazebrook was preparing to ascertain the rental value of Ambrose Reddall's orchard near the turnpike in Haywardsfield at Stonehouse and to negotiate for its purchase.[35]

On 1 October 1777 the committee asked their clerk to apply to all the remaining owners of lands as far as Wallbridge and by the end of the year the company were negotiating with William Knight, Richard Pettat, Richard Stephens, Mrs Christian Ellis, George Augustus Selwyn and the Corporation of Gloucester, John Mosley, Mrs Ann James, the trustees of Richard Cook, Daniel Chance, Henry Wyatt and possibly Nathaniel Beard.[36] By the end of 1777, therefore, the company was negotiating with most of the landowners as far as Wallbridge with the exceptions of Samuel Peach, Samuel Remington, John Butcher, Mr Playne and Mr Loyde.[37] Since there is no record of any sale price paid to Lord Middleton and Alexander Colston and an agreement with Peach's executors nine years later granted them compensation in lieu of a bridge at Bristol Road, it seems likely Peach bought his property off the two previous owners before final negotiations were completed with the company. This is supported by other evidence confirming that Peach, who was not listed as a landowner along the canal, had a tenant at Bristol Road named Mrs Hannah White who had previously been a tenant of Lord Middleton and Alexander Colston at the same place.[38] Samuel Remington, who owned land at Ebley, was probably contacted sometime during 1778 although a final agreement was not signed with him until June 1779. John Butcher, who owned an orchard at Cainscross, was probably contacted at about the same time although his first entry, dated September 1779 in the commissioners' records, suggests earlier negotiations had foundered and Butcher had appealed to the ultimate authority of the commissioners hoping to receive a higher price for his land. The only other exceptions to landowners contacted before January 1778 were Mr Playne, Mr Loyde and Richard Owen Cambridge. Both Mr Playne and Mr Loyde were also unlisted on the original documents as landowners but the company approached them later on when it wanted small additional pieces of land to widen the towpath or alter the line of the Frome slightly. The company also contacted Richard Owen Cambridge again in May 1779 when they decided to vary the line at Whitminster because navigation across the millpond had proved unsatisfactory.[39]

By and large most of the landowners along the intended line favoured the canal and presented no serious obstacles to the company. They were usually more than willing to sell land at a fair price with a minimum of fuss no doubt welcoming the improved access a navigation would bring, lower transport costs and a probable rise in the value of their land. Even the opposition of some landowners was perhaps more apparent than real. Alexander Colston, who was listed as dissenting to the sale, told the company he would readily give his consent if the land was all his own and not shared with Lord Middleton. George Augustus Selwyn, MP for Gloucester and joint owner of land at Ebley with Gloucester Corporation,

apologised for not consenting to the sale but explained that as the corporation intended to petition against the new Bill and expected him to present to the Commons be had little alternative. If it were his own property, he admitted, he would have 'very little difficulty' in assenting to the sale.

There were, however, a number of landowners who declared their opposition to the canal on a variety of grounds. Some, like Ellis James and Richard and Nathaniel Stephens of Ebley Mill, signed the petition against the Bill fearing a loss of water supplies to their mills. Even though the Bill had now become law and the company had powers to buy land compulsorily, these landowners were not always amenable to negotiation and were not averse to thwarting the company if they could.

The most significant fact about the opposition from this group of landowners, however, was how much of it melted away within a year or two of the new Bill becoming law. Ellis James, Dudley Baxter, Richard and Nathaniel Stephens, Mrs Ball and others might involve the company in legal proceedings or take their case to the commissioners of the navigation but most of those landowners listed as dissenting to the navigation accepted the terms of the company with remarkably little delay. The Corporation of Gloucester gave Mr Harris powers to negotiate with the company on their behalf within a few weeks of being contacted by company representatives in October 1777 and had agreed final terms by May 1778.[40] Lord Middleton had expressed his views on the proposed navigation in a most forthright manner but his steward had agreed terms by May 1776 with an almost indecent haste. Ambrose Reddall took barely three weeks to reach agreement and within a week of a visit from Benjamin Grazebrook, John Andrews was ready to settle. The Rev. John Pettat was contacted in June 1777 and had settled the line of the canal through the churchyard within a month. Mrs Ball agreed terms within fourteen days and Ellis James within a month. Dudley Baxter, Rev. Robert Sandford and John Ford all settled speedily with the company. Gabriel Harris, who declared himself opposed to the canal as well, was not approached before 11 Sep tember 1777 when the committee asked Joseph Grazebrook to apply for his land. By the next day Harris had not only agreed to negotiate but received a deposit of four guineas on account and agreed to sell a small area of arable land in Haywardsfield at the equivalent of £35 an acre.

There could be several reasons why the opponents of the canal finally modified or withdrew their opposition. Some of the landed millowners might have seen from construction at the Framilode end that the canal did not cause the disruption they had predicted. Perhaps after all there was no noticeable interruption with their water supplies either. Indeed if the previous experience of Richard Owen Cambridge is anything to go on, water control could have been improved and the dangers of flooding reduced. Equally it is clear from the earliest traffic records that virtually all the goods carried on the canal comprised either coal or building materials and that the millowners possible but unspoken fear of cheap wheat flooding into the Frome valley and undercutting their prices failed to materialise. It is possible that some millowners realised the advantages of cheap transport once it was brought to their doorstep and, now that coal was being moved into the valley at substantially cheaper prices, several may have pondered the use of coal as a source of power rather than relying on the uncertain vagaries of water power. Still others, who may not have recognised any particular advantage for themselves, may have come to share the private opinion of George Augustus Selwyn that he could not really object to 'a public good for a little private injury'. Perhaps some millowners appreciated that however much the commissioners, acting as the court of final appeal, could alter the value of purchase prices they had no powers to interfere with the Actual purchase of land. Under the terms of the new Act these amounted, in effect to the powers of compulsory purchase. Although there is no evidence on these viewpoints of the millowners one way or another, the complete absence of serious complaints once construction was under way could speak volumes for a change of heart.

The most likely reason for the apparent change of mind could be that the company offered prices for land which were somewhat above the existing market value. It is difficult to ascertain whether the prices the company paid for land are an accurate reflection of their contemporary market value or whether

these prices were deliberately inflated to encourage landowners to come to agreement or to allow the company to enter their lands to begin construction. Since most landowners agreed to sell their land without delay, it seems probable the directors invariably offered at least market value for lands and usually 'more than the real Value of the Lands they wanted'.[41]

It is possible, however, that some of the opposition centred on the method of assessing the value of lands. Although in later years the company often paid a lump sum for each acre, in the earlier years it frequently offered to buy land at between thirty and thirty–five times the current rental value. In many cases rents on these lands had been fixed several years or even decades earlier. Since land prices at this time were tending to drift upwards as a result of inflation, a growing demand from an increasingly numerous and more prosperous population and the impact of the American War, then any price the company offered based on the existing rental value might not be a true reflection of the contemporary rental value. It is hard to believe, however, with the company claiming it had 'gone out of their Way' to meet the objections of the dissenting landowners, that this represented a serious problem.[42]

The precise picture of land purchase prices is also complicated by a number of factors which either blur the real value of the lands or make the Actual stated purchase price subject to several qualifications. These additional factors included the purchase of land surplus to requirements, hidden selling and leasing, payments or services in lieu, exchanges of land, damages, tenants' compensation, compensation for loss of crops, trees and other assets, Reversionary rights, taxes and tithes, legal costs, interests, rents and problems of timing. All the quoted costs of land purchase, therefore, are subject to error and it is impossible to tell to what extent these complicating factors are mutually exclusive or cancel each other out by working in opposite directions.

One major factor in assessing the value of lands was the company policy of buying more land than it actually needed for the line of the navigation itself. Both estimates of land bought from Daniel Chance show that less than one-third of the land purchased was used in the canal. At Dedmarlin, for example, the company bought one-and-three-quarter acres but only needed less than half an acre for the canal.[43] However, the company did reach agreement with Chance that the purchase price could be reduced if they later returned pieces of his land which were surplus to requirements. From John Mosley the company bought not only the land 'now made use of in the Canal' but also 'the strip lying between the said canal and the old river'.[44] Ellis James sold the whole of the land between the canal and the turnpike road.[45] The company bought an additional quarter acre of land from Hollowday Phillips which lay between the canal and his millpond.[46] Dudley Baxter, at one time a noted opponent of the canal, may have been sweetened by the offer to purchase all his land which would be cut off by the canal.[47] The company also bought additional land from Mrs Ball at Stonehouse so it could be added to Rev. John Pettat's churchyard and so finalise agreement with him.[48] Similar types of agreement were reached with John Butcher, Henry Stephens, Richard Clutterbuck, John Hugh Smith and others.[49] All in all there is plenty of evidence from about a dozen landowners that the company bought land in excess of its actual needs. This was in line with the policy declared in 1775 that it would try to ease the position of landowners whose holdings were divided or isolated by the canal. The total costs of land purchase, therefore, must exceed the cost of lands on which the canal was built. Even though the company paid over the odds for land and bought more land than it required, these total costs of land purchase must be included in any accurate assessments of the cost of construction and not the Actual value of land the company bought or that part of the land purchases it used on the canal. These total costs, accurate or not, inflated or not, represent the sum which the company needed to expend in order to get agreement from all landowners and they – like all the other complicating factors – are a real cost in the total construction Bill.

Land purchase prices are also complicated by sales and repurchases from these surplus lands owned by the company. John Lawrence, Samuel Remington, Ambrose Reddall, William Knight and several other landowners and tenants either bought back pieces of their own land or other surplus lands adjacent to

their own holdings.[50] The response of other landowners, however, was not among the most helpful. Joseph Grazebrook wrote to Dudley Baxter in April 1779 advising him the company had a piece of land next to his estate at Eastington and enquiring if he would be interested in it. After a further letter from young Grazebrook, Baxter replied two months later in the most unequivocal terms: he would neither exchange any of his land nor purchase any parcel of land adjacent to his estate.[51] By their very existence these re-purchases and sales confuse the pattern of land prices but their effect is even more far reaching than this. Sometimes landowners paid cash for their purchases and sometimes they were allowed these small pieces of surplus lands in lieu of part of the purchase price for those lands they had sold to the company. It is also uncertain, for example, whether the prices the company asked or allowed for these lands were an accurate assessment of their true value or whether the company sold them at under market values to retain the goodwill of landowners. In view of the large amount of surplus land the company is known to have bought, it seems equally uncertain whether the total known repurchasers are an accurate reflection of the total volume of company resales. In addition to this the sums paid or allowed for these sales and repurchases are imperfectly recorded since most of the company receipts are either missing or destroyed. Even though this incomplete picture is far from accurate, the known sums paid to or allowed by the company should be deducted from the total Bill for land because they represent a subtraction from the total company purchases of land.

A further complication was created by the complex system of land tenure which prevailed on several holdings in the line of the intended route. Some of the land the company needed was not owned in full by the occupying landowner but held as a freehold only during his lifetime. At his death it would pass to another owner under the terms of a reversionary covenant. If the company wished to purchase the full freehold of the land, therefore, it needed to reach agreement with both the existing and the future landowners. This included consent to the sale from both parties, an agreed price for the land paid to the existing owner and compensation to the future owner for the loss of his reversionary rights. Only three known cases of reversionary rights are listed in the company records and each of these poorly documented. Mrs Phelps of Dursley held the reversionary rights on Mrs Ann James' land near Cainscross and the Grazebrooks needed all their tact and powers of persuasion to encourage her to release them.[52] Nathaniel Winchcombe held Reversionary rights on Edmund Phillips' lands at Chippenham Platt but he at least proved more amenable.[53] The situation on Hollowday Phillips' land at Ryeford was more complicated. Mary Brown a spinster from Clifton in Bristol, held reversionary rights on his land and readily agreed to forego these in exchange for compensation.[54] However, Rev. Robert Sandford of Chelsfield in Kent held Reversionary rights on the death of Miss Brown and the company were obliged to negotiate with him as well. Both Miss Brown and Rev. Sandford agreed to allow the company to take down the end and corners of Ryeford Mill and dyehouse if this proved necessary providing the company made good any buildings taken down and paid both parties whatever sum the commissioners decided would compensate for their losses as soon as the exact amount of land required was known and an accurate measurement could be laid before them. Although the records show clearly that the company promised to pay this compensation, the accounts omit any known reference to compensation for the loss of Reversionary rights, less they were included in the compensation paid to the occupier himself in each case. Mrs Phelps provides the only possible clue which itself is far from certain. In February 1780 Joseph Grazebrook visited Mrs Phelps and Mrs James to pay for lands the company had bought.[55] But the record of a payment of £28 18s 5d (£28.92) to Mrs Phelps six days later does not indicate whether this was paid to Mrs Phelps for the loss of her Reversionary rights, to Mrs Phelps on behalf of Mrs James for the sale of her land or for any possible combination of these two factors.[56] Since the cost of compensation paid for these Reversionary rights also represents an essential expenditure of the company was to acquire the full freehold, these costs, if known, should be added to

the total Bill for land purchase.

The exchange of land between owners to simplify sales to the company and to consolidate holdings is equally poorly documented. Samuel Beard, for example, was not paid for his lands near Eycott's Mill but exchanged his lands with Mrs Ball who gave him a comparable piece of land in lieu.[57] The value of his lands, therefore, is included in the total price paid to Mrs Ball. John Webb exchanged some of his land at Wallbridge with other landowners although the amount and value are not listed.[58] John Andrews accepted some of the surplus land the company had bought from Rev. John Pettat in part payment for the sale of his own lands.[59] John Merrett measured 'Sundry Pieces of Land to be exchanged … between Richard Owen Cambridge and some other landowner.[60] At least two landowners were unwilling to sell their land until exchanges of land had been arranged. Edmund Phillips refused to conclude any agreement until he discussed a possible exchange with Henry Stephens.[61] Similarly, although the company had already taken part of Stonehouse churchyard for the canal, Rev. John Pettat refused to reach any final agreement until the company provided him with an equivalent piece of land. Joseph Wathen and John Hollings, two of the most respected directors, were therefore sent to visit Christopher Gardner, Mrs Ball's agent, to buy that part of her orchard suitable for enlarging the churchyard.[62] When Mrs Ball refused to cooperate, Joseph Grazebrook offered Pettat a £10 deposit for the churchyard land until an equivalent piece could be found and exchanged for his loss. Pettat at first refused this but, after two more months of discussion, finally agreed to accept £18 7s 0d (£18.35) in full for the land.

Apart from the case of John Andrews listed above, there is at least one additional example of the directors making settlements in lieu in order to reach agreements with landowners. In April 1783, three years before the final price for his land was agreed, the company offered Samuel Peach £40 in lieu of a bridge he had been promised adjacent to the Bristol Road. At first each asked for an annual payment of £3 a year instead but after his death, one of his executors, Thomas Cooper, accepted the £40 as part of a general final agreement on the value of Peach's land.[63] Both these types of expenditure – payments in lieu and purchase of land for exchanges – represent additional charges the company had to incur to conclude agreements with landowners and they too should be added to the total Bill for land.

Since the company often paid for land some time after they had entered it and began construction, it was usual to come to some sort of interim financial agreement. If a final purchase price was already agreed and the company decided to delay payment for the time being, then they would usually pay interest on the outstanding capital sum until the purchase was completed. Alternately, if a final purchase price remained under negotiation until the total area of lands taken was known, the company usually paid rent for the use of the land from the date of entry to the date of settlement.

The payment of interest was simple enough. Each year the company paid interest, usually at 5%, on the agreed purchase price to each appropriate landowner. George Augustus Selwyn and the Corporation of Gloucester received a total of £49 4s 5d (£49.22) for the interest on their lands at Ebley from Lady Day 1780 to January 1784.[64] Mrs Ball, who had already been paid in part for her lands at Stonehouse, was paid £19 5s 0d (£19.25) in September 1780 as interest on her outstanding balance due since the summer of 1777.[65] Dudley Baxter was paid £8 16s 0d (£8.80) for interest charges, Henry Wyatt £4 5s 0d (£4.25) and Thomas Cooper a total of £105 17s 10d (£105.89) in the spring of 1786 for seven-and-a-half year's interest on the late Samuel Peach's land.[66] Mrs Phillips, widow of Hollowday Phillips, was paid a total of £59 1s 3d (£59.06) in August 1780 for the interest due on her late husband's land. This sum, however, also included an unspecified amount for damages which they had allegedly sustained during construction. In May 1782 Mrs Phillips was paid a further two guineas interest for ten weeks lapse from the time of settlement to the date the deed was finally executed and payment made.[67] The executors of the late John Mosley's will received interest of £6 11s 6d (£6.57½) every year from April 1781 until September 1794 when his land purchase price was paid. This made a total of £94 18s 9d (£94.94) over the full period.[68] Finally

Darnel Chance, always anxious to squeeze the last possible penny out of the company, submitted about half a dozen different claims for interest on his outstanding balance on several occasions. Chance may have preferred the company to continue their interest payments rather than pay the purchase price they had agreed since in October 1780 the company solicitors, Lane and Jepson, wrote to Chance reminding him that 'unless he furnish them with the Abstract … of the Title to the Lands and Premises agreed upon … within one month, … they are determined not to pay … any interest for the purchase money from that time.'[69] Two months later when Chance enquired if the company would pay for an abstract of his title deeds the reply was even more definite. 'We will not', thundered the committee, 'nor will we pay any more interest.'[70] Eventually Chance seems to have been allowed £25 6s 8d (£25.33) as interest on his outstanding account although in view of the numerous claims, counter claims and contradictions in the records of his Bills, this figure is far from certain.[71]

Since all of these known interest payments, totalling £368 17s 9d (£368.89) are confirmed to only eight of the forty odd landowners involved in land sales to the company, it is possible they do not include paid but unrecorded transactions of interest concluded with other landowners. If such unrecorded sums were paid, they would probably be included in the final settlement terms agreed with landowners. Although this would inflate the true figures for the Actual purchase of land and deflate the true figures for interest, it would not invalidate the eventual figures for total land purchase costs. Omission in one quarter would be balanced by their hidden inclusion elsewhere.

The payment of rents is more complex since it includes three Dudley Baxter was paid £8 16s 0d (£8.80) for interest charges, different types of cash transfers. Firstly it includes rents paid by the Henry Wyatt £4 5s 0d (£4.25) and Thomas Cooper a total of £105 7s 10d (£105.89) in the spring of 1786 for seven-and-a-half year's company to landowners for the use of their lands during the period of construction, sometimes because a final purchase price had still to be agreed, sometimes in lieu of interest, sometimes for making bricks and sometimes to store stone and building materials on a lockside or other site. Secondly it includes payments to certain tenants as compensation for their loss or for the surrender of their lease. Although these payments to tenants, like the payments of interest or rents to landowners, should be included in the final sum for land purchase costs they are more properly included in tenants' compensation. The payment of rents also included a third type of cash transfer which is not included as part of total land purchase costs. These were payments from tenants to the company for surplus lands which were rented off by the company clerk on the precise instructions of the committee of directors.[62]

As far as payments to landowners were concerned, rental transactions were confined to only four or five known landowners. Here again it is possible they may not represent the total amount of rent paid out to landowners. It is equally arguable that some rental payments should be included in the costs of actual construction since they represent land rented to ease the tasks of building rather than land bought for the canal itself or to sweeten the feelings of landowners. In view of the restricted nature of such payments, however, and their small totals, all rental payments to landowners are included within the total costs of land purchase. These payments included twelve guineas to Richard Cook for twelve months rent on the lower meadow from 25 March 1777 £3 15s 0d (£3.75) to James Clutterbuck for a year's rent of all his land at Whitminster to Lady Day 1777, plus a further £8 7s 6d (£8.37½) for five years 'rent of land at £1 10s 0d (£1.50) an acre a year, 3s 6d (17½p) to Daniel Chance for rent of land at Dudbridge lockside at 1s 0d (5p) a year from Michaelmas 1779 to Lady Day 1783 and £11 5s 0d (£11.25) to John Saunders for three years' rent of three acres in Meddalls field for making bricks at £1.5s 0d (£1.25) an acre a year.[73] The only other listed rental payment to a landowner was the sum paid to John and Samuel Webb in April 1780.[74] In January 1777 the company agreed to purchase two parcels of pasture at Wallbridge, then owned by John Webb and his son Samuel of The Hill in Painswick but then tenanted to Henry Cooke, William Taylor, Edward Power

and Nathaniel Watts.[75] The Webbs agreed to transfer their land to the company before 25 March 1778, when it was estimated construction would be nearing Wallbridge, and in return the company would pay a deposit of £100 plus a rent of £18 9s 0d (£18.45) a year from the date of entry until the final balance of £573 10s 0d (£573.50) was paid. In reality, therefore, the company payment of £29 11s 0d (£29.60) in April 1780 was in lieu of interest which they would otherwise have paid but since it is included under 'rents' in the company records it is here included within that general category.

Three further complications in land purchase price include general compensation paid to tenants for loss of rights, compensation to landlords or tenants for the loss of crops, trees and other tangible assets and finally compensation for general damages. These three groups are far from mutually exclusive but each represents an additional cost resulting from the conditions of land purchases which the company adopted.

As far as general compensation paid to tenants is concerned, it is uncertain whether or not it was company policy to reach some settlement with them for the loss of their leases. In view of the small number of tenants who received compensation of this type by the company paying an allowance for their rent, it may have been usual not to compensate tenants at all except in certain unspecified circumstances. Alternatively it could indicate that most tenants' compensation was calculated when the purchase price of land was being assessed and that it was therefore included in the final sum paid to each landowner. Equally it could indicate that the company only needed to pay tenants' compensation when land was leased for a longer period and that since most tenants rented their land on an annual basis it was simple enough for most landowners to dispossess them at the end of their yearly tenancy. What little evidence there is suggests most general compensation for the loss of tenancy was included within payments for damages. On 30 December 1777, for example, Joseph Grazebrook reported that one of Lord Middleton's tenants, Mrs Hannah White, had been paid £29 18s 0d (£29.90) in full for all damages caused by construction of the banks, canal and coal wharf at Bristol Road.[76] A detailed breakdown of these damages, however, shows it included a, £6 2s 6d (£6.12½) for the rent of nearly one-and-a-half acres of land taken in the canal and towing path for two years at two guineas an acre a year. In all probability, therefore, the promised rent paid to John Arkell in June 1780 and the two years rent for Samuel Peach's land paid to the tenant, William King, is calculated in the general accounts of damages paid to tenants.[77]

Compensation for the loss of tangible assets such as crops, trees, stables, houses and the like is rather more fully documented. The 1776 act had specifically prohibited the removal of any properties along the intended line unless the company acquired the consent of the owner beforehand and paid the appropriate compensation. Two main difficulties arise from this policy: firstly, should the replacement of these premises or the cost of compensation be included in the eventual costs of land purchase or as part of the Actual construction and, secondly, how reliable are the sums mentioned for compensation and how many of the agreed terms were finally paid? Both questions revolve around the basic problem of inadequate information. John Hugh Smith and Ann Hort, for example, were concerned about the loss of a watering place for their cattle and insisted on their replacement rights laid down in the Act.[78] While the construction of this new watering place should probably be included in the eventual cost of land purchase since it, too, represents a cost the company needed to incur to secure the agreement of landowners, there is no way of costing this piece of construction or separating it in the general Bills of contractors. It therefore remains unaccounted for in the final totals of land purchase prices. A similar situation exists for the case of Edmund Phillips. In the autumn of 1777 Edmund Phillips agreed to allow the company to take off as much of the north end of his mill as necessary and to remove his house which lay in the line of the canal provided they erected a comparable house in a place he appointed. Both Macy Brown and Rev. Robert Sandford, who held Reversionary rights on the land agreed to the removal of these premises and to accept compensation for the loss of their interest in them.[79] Although there is some record that

the company did remove some or all of these premises, there is no record of any rebuilding nor of any compensation paid to either Mary Brown or Rev. Robert Sandford. A sum of £58 6s 3d (£58.31) was paid to Holloway Phillips 'for land at Ryeford and full consideration … [for his] Lands, Mill, Racks, Stove and all his other premises at Ryeford as a consequence of completing the navigation' but apart from £7 15s 0d (£1.75) of this being allowed for the net cost of pulling down and replacing the stove, it is uncertain how much of the remainder was attributable to compensation for his mill, racks and other tangible assets and whether any part of it included payments which would be transferred to Mary Brown or Rev. Robert Sandford. Whether or not the company did make 'good such buildings so … taken down' is equally open to question though if they did these additional costs, also more properly included within the eventual costs of land purchase, are interred in oblivion somewhere in the general costs of construction.[80]

The same problem can arise even when compensation for the loss of tangible assets is included in the records but included incompletely. The company, for example, agreed to buy Mrs Wilding's house at Framilode for £60 in May 1776 since it stood on land, recently bought by Richard Aldridge, which was directly in line with the projected route.[81] There is no account of this sum ever being paid, however, unless it is included in the amounts paid to Richard Aldridge.[82] In contrast, the position is decidedly clearer for the purchase of young Richard Cook's stable and coachhouse which stood in a comparable position to the canal near Lodgemore Mill. The promised sum of £50 was paid to his trustees, Henry Cook and John Hawker, in February 1778 and the transaction is recorded in several of the account and minute books.[83]

It was also usual for the company to pay compensation for crops and timber standing on land needed for the canal over and above the Actual purchase price paid for the land itself. The first mention of this is in March 1775 when William King, acting for Richard Owen Cambridge, agreed to sell timber on the estate for £39 10s 0d (£39.50). There is plenty of evidence to suggest this sort of agreement was common to at least several other landowners. Only a few days after the agreement with William King, for example, James Farmer agreed to sell his land at Framilode for the equivalent of' thirty-five years purchase of the annual rental value plus the value of timber standing on it.[84] Later on during the land negotiations Mrs Ann Morse was paid two guineas for supplying elm timber as part of the purchase price she received and Edmund Phillips received £1 17s 5d (£11.37) for nearly eight tons of timber valued at £1 10s 0d (£1.50) a ton.[85] When Samuel Remington bought part of Barn Orchard, which the company had purchased from Thomas Ellis in October 1778, the company deducted 16s 0d (80p) from his Bill for a crop of grass.[86] Dudley Baxter's claim for the loss of an oak tree got as far as the company solicitors before it was dropped in favour of a readjusted interest settlement.[87] As usual it was Daniel Chance, one of the canniest and most obdurate of landowners, who provided the most numerous and detailed claims for losses of tangible assets. Chance claimed £3 14s 0d (£3.70) for the loss of timber standing on lands he had sold to the company, £6 for six apple trees destroyed during construction and a heady selection of other minor claims.[88] The company thought the damages Chance had done on land he had already sold to them, especially cutting down timber, more than compensated for any loss of apple trees. Eventually the company agreed to pay for his damages and standing timber subject to certain conditions and finally seems to have allowed the £3 14s 0d (£3.70) for timber loss and the further £6 as damages.

Payments for damages, general compensation to tenants and landlords, and specific compensation for the loss of tangible assets are not only virtually impossible to disentangle from each other on several occasions but sometimes even straddle the division between constructional building materials and land purchase costs. Some landowners may have chosen not to be compensated for the loss of assets as such but sold the timber direct to the company for building materials on the canal. There is a distinct possibility that this may have been the case with Daniel Chance and with certain other landowners notably Richard Martin.[89] In these cases the timber sold represents both a constructional cost and a

land purchase cost. More confusing still, only part of the timber supplied in these circumstances may have come from land the company had bought and the remainder from other nearby acreages held by the same landowner. In this case part of the sale would represent a constructional cost and a land purchase cost and part a constructional cost exclusively. Shortage of evidence in land sales, the balance of probabilities and the need for some semblance of financial simplicity suggest these payments should be included wholly within the orbit of constructional costs rather than elsewhere.

The same sort of general problem arises with assessments of damages. Some damages, and probably other types of compensation as well, may have been intended as inducements to encourage landowners to agree to terms for the sale of their land. This purpose may well have applied when damages were paid to landowners simultaneously with or shortly before a final purchase settlement. In these cases damages paid should be included in the eventual costs of land purchase since they, too, represent an additional cost the company had to incur in order to reach agreement with some of the landowners. On the other hand there is some evidence to suggest that a substantial part of damages, especially those paid to land users, represented more genuine claims on company resources resulting directly from the effects of construction.

In the absence of more detailed information it is often little more than guesswork to decide which damages are ancillary to land purchase costs and which fall into the general category of constructional costs. Broadly speaking, however, damages paid to landowners can be seen as an integral part of land purchase costs and damages paid to tenants or others represents compensation for disturbance during construction. This convenient division between damages paid to the owners of land and damages paid to the occupiers of land can therefore form a line which as far as the evidence goes appears to be generally accurate. Nevertheless it remains a clearly arbitrary division subject to error and a number of qualifications. The two categories of owners of land and occupiers of land, for example, were not always distinct. Richard Aldridge, Samuel Beard, John Butcher, Daniel Chance, Christian Ellis, Henry Eycott, John Ford, Richard Hall, Gabriel Harris, Ellis James, Richard Martin, John Mosley, Hollowday Phillips, Ambrose Reddall and probably several others were all both owners and occupiers of the land they sold to the company. Some payments, such as the £34 10s 9d (£34.54) paid to Rev. Robert Stephens in December 1777 for damages 'done to all tenants', the £2 2s 0d (£2.10) paid to Mrs Ewin for damages to trees destroyed on Mr Reddall's land in which she had a life interest, the £1 1s 0d (£1.05) paid to Rev. Henry Davis for damages caused by flooding his land called Little Oldbury near Chippenham Platt, the £9 17s 0d (£9.85) paid to Richard Stephens of Ebley for leakage, damage to an elm tree and for earth and soil thrown on his land, and finally the additional £21 paid to Richard Martin in October 1778 caused by brickmaking and the construction of banks on his land, all fall within the above definition of land purchase costs although they clearly belong to the general sum of damages resulting from construction.[90]

In several cases the damages paid to landlords went unrecorded. In October 1783 Richard Owen Cambridge complained of damages probably caused by leakage from the canal. Although Thomas Baylis and Benjamin Grazebrook met Mr Organ, then Cambridge's agent, two months later there is no mention of any sums involved.[91] Joseph Grazebrook visited Henry Cook and John Hawker, trustees to the young Richard Cook, in January 1780 to conclude the purchase of his land and agree on the attendant damages but here again there is no mention of any transaction including damages in the later records.[92] John Jepson, the company solicitor, offered William Knight unspecified damages in April 1782 which Knight rejected. There is no further evidence of any later negotiations or payments to William Knight.[93]

In several other cases payments for damages are inextricably bound up with other payments to landowners. In September 1777 for example, Richard Martin was paid £7 16s 3d (£7.81) for 'rent and damages', John Saunders and Mrs Ann Morse received £14 17s 0d (£14.85) in April 1782 for 'land and damages', apart from £4 13s 5d (£4.67) to John Purnell for land and damages, £74 9s 6d (£74.9½) to

Christian Ellis in September 1779 for land and damages as well as £80 9s 0d (£80.45) in July 1778 to Henry Stephens for the same.[94] In each of these cases there is no distinction made between the amount paid for damages and the amount paid for rent or land. Regardless of whether these combined payments are included in the basic land purchase costs or, as in this analysis, wholly within damages, the effect on the final figure for eventual land purchase costs is the same.

Damages paid to landowners included a galaxy of smaller sums like a £1 to Hollowday Phillips and a total of £3 2s 0d (£3.10) to William Halliday for damages to their lands and racks at Rackhill, £4 to Mrs Ann James, £4 11s 6d (£4.57½) to John Saunders 'for sundry damages … a total of £5 15s 0d (£5.75) to executors of John Mosley and £14 10s 0d (£14.50) to James Clutterbuck for damages in Walk Round and Pool Field.[95] Other damages included larger sums paid to Daniel Chance, Mary Ball and Ellis James. Daniel Chance received a total of £23 13s 0d (£23.65) for damages in Lower Huntley, in two orchards and the moor at Dudbridge, and to the banks of Dedmarlin.[96] Mary Ball was awarded £44 5s 9d (44.29) for 'damages done to herbage in Vineyard Orchard, Evelands and Lady Orchard', for the use of her lands at brickyards and for 'hounding out the cows from our land'.[97] Ellis James held a running battle with the company for over five years about his own damages. By April 1779, when it was clear neither Ellis James nor the company could agree on damage assessments, Benjamin Grazebrook suggested James appointed an arbitrator to work with one appointed by the company. Ellis James, however, refused to cooperate and Grazebrook's first choice of John Smith was unable to oblige so the company chose Richard Hall and John Taylor to assess the damages regardless of the opinion of Ellis James. These men assessed total damages at £52 3s 6d (£52.17½) which included compensation for crops lost during construction, damages caused by interrupting the flow of water and diverting it over his lands, general trespassing and dumping bricks and earth on his land. Ellis James considered this offer totally inadequate and a series of commissioners' meetings in August and early September failed to reach any agreement satisfactory to both sides even though damages were now assessed at £57 9s 0d (£57.45).[98] By December 1781 Ellis James was complaining once again to Benjamin Grazebrook about repeated damages to his lands and asking for a new meeting of commissioners to assess them. Grazebrook agreed provided James signed a £100 bond to the company to cover legal costs if he lost the case. Once this was signed a meeting of commissioners was called for Thursday 30 May 1782 when James asserted he had been 'and still is greatly injured' by the proprietors covering a great quantity of his land at Eastington with gravel and clay, by leakage through the canal banks onto his lands and for 'sundry Quantities of Land that have from time to time Colted into the said Canal and entirely lost and sunk therein'.[99]

Unable to reach a verdict, the commissioners took the unprecedented step, permitted in the 1776 act, of asking the sheriff of Gloucestershire to provide twenty-four freeholders to act as jurors at the Golden Cross, dwelling house of Samuel Clutterbuck at Cainscross, at 8 a.m. on Thursday 13 June and to consider the merits of the case. When the freeholders met, however, the company challenged eighteen of their number for unspecified reasons leaving too few to act in their intended capacity. Subsequently it was agreed John Skinner Stock and John Wilkins Jepson, acting for Ellis James and the company respectively, should visit the sheriff again and select a further twenty four names from the freeholders book. Each side agreed not to challenge more than twelve of the names put forward. The newly selected freeholders were then asked to meet at the George Inn on Thursday 4 July.[100] At the appointed date and place, therefore, twenty four freeholders assembled of which twelve were sworn in as jurymen. After viewing the land at Eastington and listening to the evidence, they awarded Ellis James a total of £98 3s 0d (£98.15) which included the previous damages awarded by the commissioners in 1779 and which the company agreed to pay forthwith.[101]

Most of the legal affairs of the company were handled by the company solicitors, Lane and Jepson of Gloucester, although there are also recorded payments of £4 8s 3d (£4.41) to Mr Vizard in connection

with the transfer of Rev. Robert Stephens' land, a total of £135 2s 8d (£135.13) to John Skinner Stock in November 1776 'for law expenses' and two sums of £23 17s 6d (£23.87½) and £24 6s 0d (£24.30) to John Colborne in April 1776 and April 1779 respectively.[102] These probably represent selling landowners' legal costs which the company may have been obliged to pay and, in the case of John Colborne, general administrative costs at least in part. The main problem with legal costs, however, is that there is no way of separating legal costs resulting from land purchase and legal costs originating from any other work. Mr Vizard's Bill alone is unambiguous and probably represents the only land transfer not completed by the company solicitors, undoubtedly on the insistence of the landowner involved in the sale. John Colborne was paid a total of £48 3s 6d (£48.17½) for unspecified services which may well have been for a variety of legal and/or general expenses but which certainly included payment for the purchase of an iron trunk probably for keeping the company seal or vital documents in safe keeping.[103] There is some suggestion Stock's Bill included £47 11s 9d (£47.59) for real or imagined damages John Purnell had sustained in Carters Close in April 1775 and that the balance of £87 10s 9d (£87.54) included Stock's expenses for representing Purnell at Gloucester Assizes and later at Westminster.[104]

This problem of separating legal costs resulting from land purchase and legal costs resulting from other sources is highlighted by the example of the company solicitors where the omission of certain known expenses and the absence of a detailed breakdown of legal costs makes it impossible to allocate them on other than an arbitrary basis. The costs of employing Bearcroft, Kenyon and Cooper as counsel during the passage of the 1776 act, for example, are not separately accounted for in any of the company records and are therefore presumably included in the Bills submitted by Lane and Jepson between February and October 1776.[105] Leaving aside this total of £300, which in any event probably represents the total legal costs of getting the new Act through Parliament, Lane and Jepson were paid a total of £489 11s 3d (£489.56) between May 1777 and April 1785.[106] Since many of the land purchases were not completed until the early eighties it is probable a large part of these payments to the company solicitors represented legal work involved in land conveyance. This supposition, however, is subject to at least two qualifications. In the first place it is by no means certain that the company always insisted on proper legal conveyancing to accompany the transfer of ownership. In June 1778, for instance, the committee instructed that no more conveyances should be made for land and that purchase price receipts would be acceptable instead.[107] Soaring costs of construction and an embarrassing short age of cash may have prompted this move which, in any event, seems to have been of a temporary nature. In January 1780 the company clerk was instructed to execute a deed of conveyance to Samuel Remington and in December of the same year Joseph Grazebrook was asked to get particulars of the pieces of land purchased by the company and to instruct Lane and Jepson to prepare conveyances for them all.[108] Secondly, at least four payments made in this period are clearly connected with other legal services and should therefore be deducted from the total. These include £11 8s 0d (£11.40) paid to Lane and Jepson in May 1779 for the purchase of land from Samuel Walbank, the £66 13s 0d (£66.65) paid in July 1780 for costs proceeding against Daniel Ballard, £70 for costs proceeding against Anthony Keck paid in July 1782 and £21 10s 6d (£21.52½) paid in April 1785 for the purchase of additional land from Rev. Yates which leaves a net balance of £319 19s 6d (£319.97½).[109] As the company solicitors were not exclusively concerned with land conveyance this is probably an over estimate of legal costs originating from that source. In the absence of more detailed information, however, it is only estimate we have.

One further complication to the picture of land purchase costs is the question of poor rates, land tax, highway tax and church tithes. In the early years of land purchase the company usually offered to buy land for the equivalent of the current rental for a given number of years. In these early days this would usually be for thirty or thirty two years and the company invariably added an additional three years rental

on to cover the costs of taxes and tithes. In later years the company consolidated this practise and offered either thirty five years value of the current rental, leaving vendor to pay taxes and tithes, or a lump sum per acre also usually free of rates and taxes. In both cases therefore, in one obvious and one hidden, the company are including the costs of various rates and taxes as part of their total land purchase costs. These, too, therefore should be included in the total land Bill.[110] Poor rates totalled £16 11s 4d (£16.57) to fourteen tenants between 20 June 1776 and 13 August 1783.[111] Land tax and highway tax came to £7 13s 8d (£7.68) and tithes to £29 19s 3d (£29½).[112] The final problem complicating land purchase prices, and the whole costs of construction as well, is the question of timing. How can prices paid for land at one time be compared with other land prices paid at another time when the value of money was different? At what point in the canal history does construction end and maintenance or improvement begin? Two practical examples will illustrate this dilemma. The value of money has rarely remained constant for any length of time since the middle ages and the last quarter of the eighteenth century was no exception to the general pattern of price fluctuations. Helped first by the American War of Independence and then by the lengthy wars with France, the rise in prices was paralleled by a fall in the value of money. Just as £100 today is worth less than £100 in 1970, so the £131 12s 0d (£131.60) paid to the trustees of John Mosley in September 1794 for the sale of his land at Dudbridge and Stonehouse was worth less than when it had been accepted in exchange for his land used in the canal about fifteen years before. This whole problem of changing values in the purchasing power of money complicates every single one of the tens of thousands of transactions and payments made during the canal construction. Unless one base date was chosen during construction, and every single transaction recorded was adjusted to that date to allow for changes in the value of money, it would never be possible to get an accurate estimate at that date let alone convert it to a modern price equivalent.

The second example concerns the land purchase and building costs of erecting a number of lock–houses and warehouses along the line of the canal. These ancillary premises were essential to the efficient operation of the waterway and should therefore be included in the total costs of construction. The detailed position, however, as considerably more complicated than this. The original estimate for building the canal was exceeded even before it was half completed and, anxious not to stretch its increasingly slender resources to breaking point, the company deferred some of these capital building projects until the first priority of a cut to Wallbridge had been reached and the canal could be opened for the whole of its length. Expenditure on land for these premises, therefore, and their actual cost of construction are both genuine costs of canal construction delayed until the early 1780s when tolls were providing a major supplement to company income and constructional improvements like these could be financed from company revenue. Once again an arbitrary line is the only method of dividing constructional and improvement costs with any semblance of order. Since it is clear from the company records that construction of the waterway itself was not completed until a year or two after the canal was opened, all buildings started before the end of 1781 are included within the total costs of canal construction and any buildings started after then within the general orbit of maintenance and improvement.

Chapter Thirteen References

There are a number of documents in which all or most landowners are mentioned. These 'Miscellaneous Documents' are listed at the end of the Chapter Thirteen references.

1 GCRO D1180 1/1 Committee minutes especially the Committee of correspondence minutes January to April 1776
2 GCRO D1180 1/1 Committee minutes 1 July 1779 8 July 1779, 15 July 1779, 2/18 Cash Book 1779–88

12 July 1779

3 GCRO D1180 1/1 Committee minutes 24 July 1777 13 May 1779, 5/1 William Dallaway, *The Case of the Stroudwater Navigation* 2. From Westfield Lock the canal climbs up a spur of land through Court Orchard (or Dock) Lock. [Turn] Pike Lock Lower Nassfield (or Blunder) Lock and Upper Nassfield Lock near Newtown rather than following the line of the River Frome more closely. This route was probably adopted to skin rather than penetrate Ellis James' lands at Eastington Park by keeping the canal close to the turnpike road.

4 GCRO D1180 1/1 Committee minutes 4 July 1778, October 1780

5 GCRO D1180 1/1 Committee minutes 11 April 1776

6 GCRO D1180 1/1 Committee minutes 2 February 1775, 29 March 1775, 24 May 1775

7 GCRO D1180 1/1 Committee minutes 9 March 1775

8 GCRO D1180 8/2 a small collection of miscellaneous documents, bits of paper listing odd pieces of information on land purchase Committee minutes Richard Aldridge GCRO D1180 8/2 Reference to a Plan of the Intended Canal, Richard Aldridge 'Letter Richard Aldridge 25 October 1782 re Mr Selwyn's lands', Richard Aldridge's letter to Joseph Grazebrook 25 October 1782, 1/1 Committee minutes 24 May 1775, D1181 uncatalogued deeds of the Hawker and Clutterbuck families 9 May 1775, 20 May 1775, 27 May 1775 Elizabeth Partridge GCRO D1180 1/1 Committee minutes 29 March 1775, 11 January 1776 2/17 Cash Book 1775–79 23 May 1776, 24 May 1776, 8/2 Miscellaneous documents, Plan of the Intended Canal. Richard Hall GCRO D1180 1/1 Committee minutes 9 March 1775, 5 July 1775, 2/1 General Account 1776–94 27 December 1777, 2/17 Cash Book 1775–79 27 December 1777, 8/2 Plan of the Intended Canal Miscellaneous documents under 8/2 Richard Hall 'Proprietors of Lands in the line of the River'. John Saunders GCRO D1180 1/1 Committee minutes 29 March 1775, 2/10 Ledger 1775–1802 15 April 1782, 2/17 Cash Book 1775–79 24 June 1775, 2/18 Cash Book 1779–88 24 May 1775, 8/2 Cash Book 1775–79 24 June 1775, 2/ 18 Cash Book 1779–88 24 May 1775, 8/2 Plan of the Intended Canal. Miscellaneous documents, Proprietors of Lands in the Line of the River, James and Samuel Fanner GCRO D1180 8/2 Plan of the Intended Canal Miscellaneous documents, Proprietors of Lands in the Line of the River Benjamin Watkins GCRO D1180 1/1 Committee minutes 21 June 1775 8/2 Miscellaneous documents, Agreement for land 29 March 1775, Proprietor of Lands in the Line of the River Mrs Ann Morse GCRO D1180 1/1 Committee minutes 29 March 1175, 2/10 ledger 1775–1802 24 June 1775, 8/2 Miscellaneous documents. Agreement for land 29 Match 1775, Mrs Ann Morse 'Proprietors of Lands in the Line of the River'. Phillipa Grove and Elizabeth Heathcote GCRO D1180 1/1 Committee minutes 9 March 1775, 24 May 1775, 23 May 1776, 8/2 Miscellaneous documents including Mr John Bradford's letter giving his consent to cut through lands 17 November 1775 Richard Martin GCRO D1180 1/1 Committee minutes 29 March 1775, 21 June 1775, 2/1 General Account 1776–94 15 September 1777, 20 September 1777, 2/10 Ledger 1775 – 1802 15 February 1777, 20 September 1777, 8/2 Damage on the Lands of Mr Richard Martin occasioned by the Banks of the River and making Bricks 9 January 1778 measured by John Merrett, Agreement for land 29 March 1775, Proprietors of Lands in the Line of the River Dudley Baxter GCRO D1180 1/1 Committee minutes 3 October 1776, 15 October 1776, 24 October 1776, 7 November 1776, 21 November 1776, 12 December 1776, 8 April 1779, 22 April 1779, 6 May 1779, 13 May 1779, 3 June 1779, 17 June 1779, 25 June 1779, 2 September 1779, 16 September 1779, 4 January 1780 2/10 Ledger 1775–1802 29 November 1776, 25 July 1780 8/2 Several pieces of meadow or pasture purchased from Dudley Baxter, Miscellaneous documents, Lands in the Parish of Eastington taken in the Canal and Towpath, All the several pieces lately purchased from Dudley Baxter

9 GCRO D1180 1/1 Committee minutes 21 June 1775, 24June1775, 9 March 1775, 5 July 1775 2/17 Cash Book 1775–79 24 June 1775

10 GCRO D1180 2/10 Ledger 1775–1802 15 January 1776 James Clutterbuck paid £6 on account, 5/1 Mr Eycott's Authority to apply for the Bill 18 November 1775

11 There is some doubt about exactly when some of these people were paid. Several, like Benjamin Watkins, Elizabeth Partridge and Richard Aldridge agreed terms to sell but do not appear anywhere in the accounts

12 GCRO D1180 1/1 Committee minutes 9 May 1776, 23 May 1776

13 GCRO D1180 Henry Eycott 1/1 Committee minutes 7 May 1778, 2/1 General Account 1776–94 7 May 1778, 2/17 Cash Book 1775–79 7 May 1778 5/1 Mr Eycott's Authority to apply for the Bill 18 November1775 8/2 Miscellaneous documents. Samuel Walbank 1/1 Committee minutes 9 May 1775, 2/18 Cash Book 1779–88 20 November 1779, 8/2 Misciellaneous documents, Proprietors of Lands in the Line of the River

14 This, however, is not certain. The records are incomplete and rarely detail informal contacts which could have occurred without being listed

15 QCRO D1180 1/1 Committee minutes 11 April 1776

16 Rev. Henry Davis GCRO D1180 1/1 Committee minutes 25 September 1777, 21 September 1779, 2/1 General Account 1776–94 12 June 1776, 10 December 1m, 2/17 Cash Book 1775–79 12 June 1776, 10 December 1777 – he was paid a further £15 5s 0d (£15.25) in December 1777 on top of the earlier £112, 8/2 Miscellaneous documents

17 GCRO D1180 8/2 The Measurement of the Canal and towing path belonging to the Right Hon Lord Middleton and Mrs Colston measured 27 May 1777 by John Merrett

18 Lord Middleton and Alexander Colston GCRO D1180 1/1 Committee minutes 11 April 1776, 18 April 1776, 16 May 1776, 23 May 1776, 1 May 1777. 15 May 1777, 29 May 1777, 4 December 1777, 11 December 1777, 18 December 1777 29 December 1777, 8/2 Measure of Lord Middleton's land by Mr Lingard 13 May 1777, Measurement of the Canal and towing path belonging to the Right Hon Lord Middleton 27 May 1777, 30 December 1777 Lord Middleton's and Mr Colston's agreement for lands 14 May 1776, Proprietors of Lands in the Line of the River John Purnell GCRO D1180 1/1 Committeee minutes 11 April 1776, 18 April 1776, 25 April 1776, 2 May 1776, 9 May 1776, 16 May 1776, 11 January 1776, 29 March 1775, 20 April 1775, 10 February 1783, Cl/1 Commissioners minutes 9 May 1776, 2/1 General Account 1776–94 20 May 1776, 6 February 1783, 2/17 Cash Book 1775–79 20 May 1776, 6 February 1783, 2/ 18 Cash Book 1779–88 27 April 1785, 8/2 Proprietors of Lands in the Line of the River

19 GCRO D1180 1/1 Committee minutes 9 August 1776. This minutes mentions 'Grazebrook' not 'Benjamin Grazebrook' but it would probably refer to three committee members and their new clerk. In any case as a director Benjamin Grazebrook would have a higher status than his son and was already schooled in the subtleties of land purchase – not least through the difficult negotiations with John Purnell

20 Rev. Mr Prosser GCRO D1180 2/18 Cash Book 1779–88 27 April 1785

21 John Ford GCRO D1180 8/2 Miscellaneous documents

22 James Clutterbuck GCRO D1180 1/1 Committee minutes 9 March 1775, 29 May 1775, 26 June 1777, 10 July 1777, 24 July 1777, 11 October 1781, 17 February 1780, 8/2 A Plan of the Ridges in Pool Field, Particulars of the Ridges in Pool Field, Survey of Mr Clutterbuck's lands, Account of the Measure of Mr Clutterbuck's land 22 June 1776, Proprietors of Lands in the Line of the River, DI49 E65 Amount of Richard Clutterbuck's land at Eastington taken for canal

23 Rev. Robert Stephens GCRO D1180 1/1 Committee minutes 22 August 1776, 29 August 1776, 2/10

Ledger 1775–1802 8 December 1777, 2/17 Cash Book 1775–79 29 August 1776, 11 December1777, 8 July 1778, 8/2 Miscellaneous documents

24 Nathaniel Stephens GCRO D1180 1/1 Committee minutes 25 September 1777, 1 October 1777, 16 October 1777, 30 October 1777, 12 November 1777, 20 November 1777, 27 November 1777, 4 December 1777, 11 December 1777, 7 May 1778, 11 May 1778, 21 May 1778, 26 May 1778, 9 June 1778, 2/1 General Account 1776–94 11 December 1777, 9 July 1778 Henry Stephens paid total of £180 9*s* 0*d* (£180.45) for land and damages, 2/17 Cash Book 1775–79 11 December 1777, 9 July 1778, 8/2 Lands in the Parish of Eastington taken in the Canal and Towpath (Henry Stephens)

25 John Hugh Smith and Ann Hort GCRO D1180 2/1 General Account 1776–94 29 January 1777, 2/17 Cash Book 1775–79 29 January 1777, 8/2 Lands in the Parish of Eastington taken in the Canal and Towpath, Miscellaneous documents Bristol Record Office A/C No 1424(c) The Woolnough Papers – letters between John Hugh Smith, John Harvey and Benjamin Grazebrook 12 October 1776 to 6 February 1777

26 Edmund Phillips GCRO D1180 1/1 Committee minutes 7 November 1776, 21 August 1777, 28 August 1777, 11 September 1777, 18 September 1777, 4 December 1777, 11 December 1777, 18 December 1777, 2/1 General Account 1776–94 3 April 1778, 2/17 Cash Book 1775–79 3 April 1778, 8/2 Measure of Mr Edmund Phillips' land by Mr Davies and Mr Merrett 9 November 1777, Lands in the Parish of Eastington taken in the Canal and Towpath, Agreement with Mr Phillips to enter on his lands 21 August 1777, Agreement with the Rev. Robert Sandford for the reversion of land 27 October 1777, Miss Brown's Assent to the Variation of the Line at Ryeford 26 December 1777, D149 E7 Valuation by Joseph Grazebrook of land of Edmund Phillips taken for the canal 26 August 1777

27 GCRO D1180 1/1 Committee minutes 20 February 1776

28 Samuel Beard GCRO D1180 8/2 Miscellaneous documents

29 Rev. John Pettat GCRO D1180 1/1 Committee minutes 26 June 1777, 9 July 1777, 24 July 1777, 26 February 1778, 5 March 1778, 16 March 1778, 26 March 1778, 6 April 1778, 9 April 1778, 16 April 1778, 22 April 1778, 30 April 1778, 7 May 1778, 11 May 1778, 21 May 1778, 26 May 1778, 9 June 1778, 18 June 1778, 25 June 1778, 9 July 1778, 13 August 1778, 8 October 1778, 12 October 1778, 2/17 Cash Book 1775–79 9 July 1778, 13 August 1778, 8/2 Agreement with the Rev. Mr Pettat for tithes 8 October 1778

30 Mary Ball GCRO D1180 1/1 Committee minutes 6 March 1777, 20 March 1777, 11 September 1777, 18 September 1777, 16 October 1777, 30 October 1777, 9 June 1778, 18 June 1778, 25 June 1778, 29 June 1778, 30 July 1778, 1 October 1778, 8 October 1778, 22 October 1778, 5 November1778, 12 November 1778 26 November 1778, 10 December 1778, 18 November 1779, 2 December 1779, 28 August 1780, 25 September 1780, 5 October 1780, 24 October 1780, 2/1 General Account 1776–94 21 October 1780, 8 March 1777, 23 May 1777, 17 June 1777, 2/10 Ledger 1775–1802 21 October 1780, 8 March 1777, 23 May 1777, 17 June 1777, 2/17 Cash Book 1775–79 8 March 1777, 23 May, 1777, 17 June 1777, 2/18 Cash Book 1779–88 21 October 1780, 8/2 Mr Gardiner's measure of Land and Damages for Mrs Ball 4 July 1778, Measurement of Mr Clark's Temporary Trespass in Madam Ball 's Estate 26 September 1777, Mr Gardiner's Memorandum of Lands and Damages at Stonehouse Ocean, Ellis James GCRO D1180 1/1 Committee minutes 6 March 1777, 20 March 1777, 31 March 1777, 9 July 1778, 27 August 1778, 10 September 1778, 8 April 1779 22 April 1779, Cl/2 Commissioners' minutes 9 September 1779 4 July 1782, 2/10 Ledger 1775–1802. 31 March 1777 10 November 1777, 2 September 1778, 2/17 Cash book 1775–79 31 March 1777, 10 November 1777, 2 September 1778, 6/3 Bundle of papers relating to Ellis James' and Mary Ball's dispute 2 October 1777, 4 July 1782, 8/2

Lands in the Parish of Eastington taken in the canal and lowing path

31 GCRO D1180 1/1 Committee minutes 7 August 1777, 21 August 1777, 18 September 1777

32 Hollowday Phillips GCRO D1180 1/1 Committee minutes 7 August 1777, 21 August 1777, 27 November 1777, 4 December 1777, 11 December 1777, 18 December 1777, 29 December 1777, 8 January 1778, 17 June 1779, 25 June 1779, 26 July 1779, 5 August 1779, 28 October 1779, 18 November 1779, 2 December 1779, 16 December 1779, 30 December 1779, 4 January 1780, 20 January 1780, 3 February 1780, 17 February 1780, 25 April 1780, 5 May 1780, 25 May 1780, 28 August 1780, 7 September 1780, 25 September 1780, 5 October 1780, 24 October 1780, 16 November 1780, 16 May 1782, Cl/2 Commissioners' minutes 9 September 1779, 2/1 General Account 1779–94 18 May 1782, 29 August 1780, 13 November 1780, 2/10 Ledger 1775–1802 Copy of the Commissioners' order relative to Mr Phillips' lands 9 September 1779, 29 August 1780, 2/18 Cash Book 1779–88 18 May 1782, 13 November 1780 8/2 Memorandum 21 August 1777 Company of Proprietors of the Stroudwater Navigation and Hollowday Phillips, Measure of Mr Phillips' damage, valuation of old materials in Mr Phillips' stove, Estimate of Putting Down and rebuilding Mr Phillips' stove, measure of Mr Halliday Phillips' land 11 October 1779, Agreement with Thomas Pettat Esq on behalf of Mr Phillips 5 May 1780, Particulars of Mr Phillips' land 9 September 1779–8 May 1780

33 John Andrews GCRO D1180 1/1 Committee minutes 28 August 1777, 4 September 1777, 30 October 1777, 5 November 1777, 12 November 1777, 27 November 1777, 4 December 1777, 11 December 1777, 18 December 1777, 7 May 1778, Cl/2 Commissioners' minutes 6 November 1777, 2/1 General Account 1776–94 15 December 1777, 2/17 Cash Book 1775–79 15 December 1777 18/2 Miscellaneous documents

34 Daniel Smith GCRO D1180 1/1 Committee minutes 11 September 1777, 1/2 Committee minutes 4 June 1787, 5 December 1791, 2/1 General Account 1776–94 9 September 1777, 4 May 1792, 2/10 Ledger 1775–1802 9 September 1777, 4 May 1792, 2/17 Cash Book 1775–79 9 September 1777, 4 May 1792, 8/2 Miscellaneous documents Gabriel Harris GCRO D1180 1/1 Committee minutes 11 September 1777, 15 September 1777, 2/1 General Account 1776–94 12 September 1777, 26 February 1782, 2/10 Ledger1775–1802 12 September 1777, 26 February 17S2 2/17 Cash Book 1775–79 12 September 1777, 26 February 1782, 2/15 Cash Book 1779–88 12 September 1777, 26 February–1782, 8/2 Miscellaneous documents

35 Ambrose Reddall GCRO D1180 1/1 Committee minutes 27 November 1777, 4 December 1777, 11 December 1777, 15 December 1777, 29 December 1777, 8 January 1778, 15 January 1778, 22 January 1778, 29 January 1778, 5 February 1778, 12 February 1778, 19 February 1778, 26 February 1778, 5 March 1778, Cl/2 Commissioners' minutes 6 November 1777, 2/1 General Account 1776–94 15 December 1777, 2/17 Cash Book 1775–79 15 December 1777, 5/2 Mr Reddall's agreement 5 November 1777, Lands of Ambrose Reddall 15 December 1777

36 William Knight GCRO D1180 1/1 Committee minutes 1 October 1777, 16 October 1777, 30 October 1777, 7 September 1750, 14 December 1780, 5 April 1752, 1/2 Committee minutes 5 January 1784, 19 February 1784, 8 April 1784, 24 July 1784, 3 February 1785, 24 April 1785, 15 December 1785, 21 February 1786, 10 April 1786, 15 May 1786, 5 August 1786, 10 October 1786, 16 November 1786, 7 May 1787, 4 June 1787, 8/2 Miscellaneous documents Richard Pettat GCRO D1180 1/1 Committee minutes 16 October 1777, 30 October 1777, 5 November 1777, 12 November 1777, 20 November 1777, 27 November 1777, 4 December 1777, 11 December 1777, 18 December 1777, 29 December 1777, 8 January 1778, 2/1 General Account 1776–94 8 January 1778, 2/17 Cash Book 1775–79 8 January 1778, 8/2 Agreement with Mr Richard Pettat for Lands 4 November 1777 Richard Stephens GCRO D1180 1/1 Committee minutes 30 October 1777, Cl/2 Commissioners' minutes 6 November 1777, 2/1 General Account 1776–94 14 October 1778, 2/10 Ledger 1775–1802 February 1779, 2/17 Cash Book 1775–79

14 November 1778, 8/2 Miscellaneous documents Christian Ellis GCRO D1180 1/1 Committee minutes 16 October 1777, 5 November 1778, 12 November 1778, 21 January 1779, 2S January 1779, 4 February 1779, 6 May 1779, 16 September 1779, 2/1 General Account 1776–94 14 October 1777, 30 January 1779, 18 September 1779, 21 February 178O, 2/10 Ledger 1775–1802 14 October 1777, 30 January 1779, 24 October 1778, 2/17 Cash Book 1775–79 14 October 1777, 30 January 1779, 2/18 Cash Book 1779–88 18 September 1779, 21 February 1780, 8/2 Miscellaneous documents George Augustus Selwyn and the Corporation of Gloucester: GCRO D1180 1/1 Committee minutes 5 November 1777, 27 November 1777, 4 December 1777, 15 January 1778, 22 January 1778, 29 January 1778, 16 April 1778, 22 April 1778, 30 April 1778, 9 June 1778, 5 April 1781, 26 April 1781, 26 February 1782, 1/2 Committee minutes 8 January 1784, 19 February 1784, 2/1 General Account 1776–94 27 February 1782, 7 August 1783, 9 January 1784, 2/18 Cash Book 1779–88 27 February 1782, 7 August 1783, 9 January 1784, 8/2 Miscellaneous documents John Mosley GCRO D1180 1/2 Committee minutes 20 November 1783, 18 December 1783, 31 May 1784, 10 April 1787, 16 January 1794, 27 February 1794, 7 April 1794, 21 May 1794, Cl/2 Commissioners' minutes 6 November 1777, 7 May 1787, 2/1 General Account 1776–94 6 April 1781, 2 May 1782, 2 June 1783, 31 March 1784, 31 March 1785, 6 April 1786, 3 May 1787, 4 April 1788, 26 March 1789, 7 April 1790, 4 April 1791, 27 March 1792, 8 April 1793, 3 April 1794, 3 September 1794, 2/18 Cash Book 1779–88 6 April 1781, 2 May 1782, 2 June 1783, 31 March 1784, 31 March 1785, 6 April 1786, 3 May 1787, 4 April 1788, 26 March 17S9, 7 April 1790, 4 April 1791, 27 March 1792, 8 April 1793, 3 April 1794, 3 September 1794, 8/2 Particulars of Land taken from the Estate of John Mosley deceased, A Brief Account of the Situation and original owners of the Land Bought off the Executors of the late John Mosley by the Proprietors, Measure of Land belonging to the Executors of John Mosley, Particulars of Mr Mosley's Land to be conveyed to the Company, PRO Gloucester Quarter Sessions Q/RD 1/1 – 9 Mrs Ann James GCRO D1180 1/1 Committee minutes 16 October 1777, 30 October 1777, 4 December 1777, 11 December 1777, 3 February 1780, 13 September 1781, Cl/2 Commissioners' minutes 20 October 1777, 6 November 1777, 9 February 1780, 2/10 Ledger 1775–1802 20 October 1777, 9 February 1780, 26 September 1781, 2/17 Cash Book 1775–79 20 October 1777, 2/18 Cash Book 1779–88 9 February 1780, 8/2 Miscellaneous documents Richard Cook GCRO D1180 1/1 Committee minutes 16 October 1777, 30 October 1777, 4 December 1777, 11 December 1777, 18 December 1777, 29 December 1777, 8 January 1778, 15 January 1778, 22 January 1778, 29 January 1778, 5 February 1778, 17 February 1780, 2/1 General Account 1776–94 17 February 1780, 2/10 Ledger 1775–1802 17 February 1780, 8/2 Miscellaneous documents Daniel Chance GCRO D1180 1/1 Committee minutes 30 October 1777, 16 March 1778, 26 March 1778, 6 April 1778, 9 April 1778, 16 April 1778, 22 April 1778, 30 April 1778, 7 May 1778, 11 May 1778, 16 September 1779, 17 February 1780, 2 March 1780, 30 March 1780, 22 June 1780, 11 July 1780, 17 August 1780, 28 August 1780, 7 September 1780, 25 September 1780, 5 October 1780, 24 October 1780, 16 November 1780, 14 December 1780, 26 August 1783, Cl/2 Commissioners' minutes 6 November 1777, 2/1 General Account 8 January 1780, 26 August 1783, 2/10 Ledger 1775–1802 11 May 1778, February 1779, 1 November 1779, 8 January 1780, 26 August 1783, 2/17 Cash Book 1775–79 11 May 1778, 8/2 Particulars of Lands to be conveyed by Mr Chance's land, Daniel Chance account of lands, prices and damages, land of Mr D. Chance taken for the Purpose of the Navigation Measured by John Merrett, Measure of Mr Chance's lands, Account of Mr Chance's land, the Proprietors of the Stroudwater Navigation to Daniel Chance, date unreadable, Company of Proprietors of the Stroudwater Navigation; their Account with Daniel Chance of Dudbridge, Copy of Agreement with Mr D. Chance for Lands 30 April 1778, Messrs Daniel and William Chance accounts of land and prices 11 May 1778–4 November 1780. The Company to Mr Chance for Interest 11 May 1778–4

November 1780, The Proprietors of the Stroudwater Navigation with Daniel Chance 11 May 1778 – 5 November 1780, 10 October 1778 – 22 May 1779 wood bought off Daniel Chance, Mr Daniel Chance's Promise to pay the Extra Expense 13 January 1779, Letter to Daniel Chance from Lane and Jepson 4 October 1780, Letter Daniel and William Chance to Stroudwater Navigation Company 29 March 17S3. Henry Wyatt GCRO D1180 1/1 Committee minutes 16 October 1777, 30 October 1777, 4 December 1777, 18 December 1777, 29 December 1777, 8 January 1778, 15 January 1778, 22 January 1778, 29 January 1778, 5 February 1778, 12 February 1778, 17 February 1780, 2 March 1780, Cl/2 Commissioners' minutes 6 November 1777, 2/1 General Account 1776–94 3 December 1782, 2/10 Ledger 1775–1802 20 October 1777, 3 December 1782, 8/2 Miscellaneous documents Nathaniel Beard GCRO D1180 8/2 Miscellaneous documents

37 Samuel Peach GCRO D1180 1/1 Committee minutes 26 March 1778, 29 June 1778, 1/2 Committee minutes 15 May 1786, 6 June 1786, 5 October 1786, 2/1 General Account 1776–94 2 June 1786, 2/18 Cash Book 1779–88 2 June 1786, 8/2 Measure of Mr Peach's lands, Measurement of the estate of the late Mr Peach Samuel Remington GCRO D1180 1/1 Committee minutes 14 October 1779, 20 January 1780, 2/10 Ledger 1775–1802 3 June 1779, 7 July 1779, 8/2 Copy of Deed Company of Proprietors to the Stroudwater Navigation 14 October 1779 to Mr Samuel Remington
John Butcher GCRO D1180 1/1 Committee minutes 28 October 1779, 24 May 1781, 21 June 1781, Cl/2 Commissioners' minutes 9 September 1779, 2/1
General Account 1776–94 6 June 1781, 2/18 Cash Book 1779–88 6 June 1781, 8/2 Miscellaneous documents
Mr Playne GCRO D1180 1/1 Committee minutes 10 June 1779, 17 June 1779, 2/10 Ledger 1775–1802 16 August 1779 to 23 August 1779, 2/18 Cash Book 1779–88 31 August 1779
Mr Loyde GCRO D1180 1/1 Committee minutes 1 July 1779, 8 July 1770, 15 July 1779, 2/18 Cash Book 1779–88 12 July 1779

38 Bristol Record Office AC/WO 1424(c) The Woolnough Papers Letters between John Hugh Smith, John Harvey and Benjamin Grazebrook 12 October 1776 to 6 February 1777, GCRO D1180 1/1 Committee minutes 4 December 1777, 5 July 1781, 1/2 Committee minutes 15 May 1786, 8/2 William King – account of Mr Peach's rent, Mr Powell's damages, acreages and prices 25 January 1779, Proprietors of the Stroudwater Navigation to the estate of the late Samuel Peach

39 Richard Owen Cambridge GCRO D1180 1/1 Committee minutes 2 February 1775, 29 March 1775, 24 May 1775, 11 April 1776, 18 April 1776, 25 April 1776, 2 May 1776, 9 May 1776, 8 January 1778, 15 January 1778, 22 January 1778, 29 January 1778, 19 February 1778, 26 February 1778, 5 March 1778 –30 April 1778, 7 May 1778, 11 May 1778, 21 May1778, 26 May 1778, 9 June 1778 – 13 August 1778, 27 August 1778, 13 May 1779, 27 May 1779, 2/10 Ledger 1775 – 1802 30 March 1780, 14 April 1780, 3 June 1780, 27 October 1781, 2/17 Cash Book 1775 – 79 11 August 1775, 28 December 1775, 8/2 Measure of Sundry land to be exchanged with Mr Cambridge 5 February 1778, Proprietors of Lands in the Line of the River.

40 GCRO D1180 1/1 Committee minutes 5 December 1777

41 GCRO D1180 5/1 William Dallaway, *The Case of the Stroudwater Navigation* 2

42 GCRO D1180 5/l William Dallaway, *The Case of the Stroudwater Navigation* 2

43 GCRO D1180S/2 Daniel Chanre records (see reference 36)

44 GCRO D1180S/2 John Mosley records (see reference 36)

45 GCRO D1180 6/3 Measure of Mr James Lands by Hall and Keene 2 September 1778

46 GCRO D1180 8/2 Hollowday Phillips records (see reference 32)

47 GCRO D1180 1/1 Committee minutes 15 October 1776

48 GCRO D1180 1/1 Committee minutes 5 March 1778, 8/2 Rev. John Pettat and Mary Ball records

(see references 29 and 30 respectively)

49 GCRO D1180 1/1 Committee minutes 4 December 1777, 28 October 1779, 8/2 John Hugh Smith records (see reference 25) John Butcher (see reference 37), D149 E65 Account of Richard Clutterbuck's land at Eastington taken for canal

50 GCRO D1180 1/1 Committee minutes, 11 April 1780, 1/2 Committee minutes 21 February 1786, 8/2 Miscellaneous documents and records of individual land owners (see above)

51 GCRO D1180 1/1 Committee minutes 8 April 1779, 6 May 1779, 3 June 1779

52 GCRO D1180 1/1 Committee minutes 16 October 1777, 30 October1777

53 GCRO D1180 1/1 Committeee minutes 18 December 1777, 8/2 Edmund Phillips records (see reference 26)

54 GCRO D1180 1/1 Committee minutes 27 November 1777, 4 December 1777, 11 December 1777, 18 December 1777, 29 December 1777, 8 January 1778, 8/2 Miss Brown's assent to the variation of the line at Ryeford 26 December 1777

55 GCRO D1180 1/1 Committee minutes 3 February 1780, 8/2 Agreement with Rev. Mr John Sandford for the reversion of lands

56 GCRO D1180 2/1 General Account 1776–94 9 February 1780, 2/10 Ledger 1775–1802 9 February 1780, 2/18 Cash Book 1779–88 9 February 1780

57 GCRO D1180 9/20 Mrs Ball's document

58 GCRO D1180 1/1 Committee minutes 22 April 1778

59 GCRO D1180 1/1 Committee minutes 5 November 1777 – 4 December 1777

60 GCRO D1180 8/2 'Sundry Pieces of Land to be exchanged' 5 February 1778

61 GCRO D1180 1/1 Committee minutes 18 September 1777

62 GCRO D1180 1/1 Committee minutes 26 February 1778 –13 August 1778

63 GCRO D1180 1/2 Committee minutes 15 May 1786, 8/2 Proprietors of the Stroudwater Navigation to the estate of the late Samuel Peach 13 April 1786

64 GCRO D1180 1/1 Committee minutes 26 February 1782, 2/1 General Account 1776–94 27 February 1782, 7 August 1783, 1 January 1784, 2/18 Cash Book 1779–88 January 1784

65 GCRO D1180 2/10 Ledger 1775–1802

66 GCRO D1180 2/1 General Account 1776–94 3 December 1782, 2/10 Ledger 1775–1802, 2/18 Cash Book 1779–88 2 June 1786, 8/2 records of various landowners (see reference 8 for Dudley Baxter, 36 for Henry Wyatt and Samuel Peach) 13 April 1784

67 GCRO D1180 1/1 Committee minutes 5 May 1780, 16 May 1782, 2/1 General Account 1776–94 29 August 1780, 18 May 1782, 2/10 Ledger 1775–1802 29 August 1780, 18 May 1782.

68 GCRO D1180 2/1 General Account 1776–94, 2/18 Cash Book 1779–88

69 GCRO D1180 8/2 Letter to Daniel Chanre from Lane and Jepson 4 October 1780

70 GCRO D1180 1/1 Committee minutes 14 December 1780

71 GCRO D1180 2/10 Ledger 1775–1802 26 August 1783

72 GCRO D1180 1/1 Committee minutes 9 January 1777

73 GCRO D1180 1/1 Committee minutes 29 May 1777, 2/10 Ledger 1775–1802 15 January 1776, 2/18 Cash Book 1779–88 24 May 1775, 8/2 Daniel and William Chance's letter to the Company 29 Mach 1783

74 GCRO D1180 2/1 General Account 1776–94 3 April 1780

75 GCRO D1180 8/2 Articles between Samuel Webb and Benjamin Grazebrook 7 January 1777, Deed from Mr Webb to the Company

76 GCRO D1180 1/1 Committeee minutes 4 December 1777, 11 December 1777, 18 December 1777, 29 December 1777

77 GCRO D1180 1/1 Committee minutes 25 May 1780, 8 June 1780, 8/2 Agreement for land by Messrs King, 29 March 1774, Assessment to William King 21 August 1778

78 Bristol Record Office AC/WO 14 24(c) The Woolnough papers Letters between John Hugh Smith, John Harvey and Benjamin Grazebrook 12 October 1776 to 6 February 1777

79 GCRO D1180 1/1 Committee minutes 27 October 1777, 26 December 1777, 8/2 Estimate of Putting Down and rebuilding Mr Phillips' stove, value of the materials in Mr Phillips's stove

80 GCRO D1180 2/1 General Account 1776–94 5 May 1780

81 GCRO D1180 1/1 Committee minutes 2 May 1776, 9 May 1776

82 GCRO D1180 1/1 Committee minutes 9 May 1776 – 27 May 1776

83 GCRO D1180 1/1 Committee minutes 29 January 1778, 5 February 1778, 2/1 General Account 1776–94 5 February 1778, 2/17 Cash Book 1775 – 79 5 February 1778

84 GCRO D1180 1/1 Committee minutes 24 May 1775 The Cambridge sum was probably included in the total Bill of £420 7*s* 6*d* (£420.37½) paid for this first purchase of land from Cambridge in 1775/76 although it is possible it could be included in some of the damages paid to his agent and tenant, William King. Conceivably, therefore, it could be double counted in the estimates of eventual land costs

85 GCRO D1180 1/1 Committee minutes 21 August 1777, 26 August 1777, 11 December 1777, 2/10 Ledger 1775–1802, 24 June 1775, 2/17 Cash Book 1775–79, 3 April 1778, D 149 E7 Valuation by Joseph Grazebrook of land of Edmund Phillips taken for the canal 26 August 1777

86 GCRO D1180 8/2 Copy of Deed Company of Proprietors to the Stroudwater Navigation 14 October 1779 to Samuel Remington

87 GCRO D1180 1/1 Committee minutes 20 January 1780

88 GCRO D1180 2/10 Ledger 1775–1802 11 May 1778, February 1779, 1 November 1779, 8 January 1780, 26 August 1783, 8/2 Messrs Daniel and William Chance accounts of lands and prices 11 May 1778, 21 October 1779, 7 November 1779, 22 June 1780

89 GCRO D1180 2/1 General Account 1776–94 24 May 1777, 1 July 1778, 2/17 Cash Book 1775–79 24 May 1777, 1 July 1778, John Mosley 2/10 Ledger 1775–1802 3 January 1779 6 April 1781

90 GCRO D1180 1/1 Committee minutes 21 September 1779, 13 August 1778, 27 August 1778, 10 September 1778, 22 September 1778, 1 October 1778, 8 October 1778, 22 October 1778, 1/2 Committee minutes 28 February 1788, Cl/2 Commissioners' minutes 21 September 1779, 9 September 1779, one reference calls him Rev. William Davis, 2/1 General Account 1776–94 7 March 1788, 21 September 1779, 9 October 1778, 2/17 Cash Book 1775–79 9 October 1778, 7 March 1788, 2/18 Cash Book 1779–88 21 September 1779

91 GCRO D1180 1/2 Committee minutes 14 October 1783, 20 November 1783, 18 December 1783

92 GCRO D11801/ 1 Committee minutes 20 January 1780, 3 February 1780

93 GCRO D1180 1/1 Committee minutes 8 April 1782

94 GCRO D1180 1/1 Committee minutes 10 February 1783, 2/1 General Account 1776–94, 2/10 Ledger 1775–1802 15 April 1782, 20 September 1777 (Bill submitted 25 March 1777), 2/17 Cash Book 1775–79 9 July 1778, 6 February 1783, 2/18 Cash Book 1775–88 18 September 1779

95 GCRO D1180 1/1 Committee minutes 3 February 1780, 13 September 1781, Cl/2 Commissioners minutes 9 September 1779, 9 September 1781, 2/1 General Account 1776–94 9 July 1778, 2/10 Ledger 1775–1802 13 September 1781, 2/ 17 Cash Book 1775–79 9 July 1778, 2/ 18 Cash Book 1779–88 24 May 1775, 9 July 1778, 6 April 1781, 2 May 1781

96 GCRO D1180 2/10 Ledger 1775–1802 11 May 1778, 22 June 1780, 8/2 Messrs Daniel and William Chance accounts of land and prices 11 May 1778, 22 June 1780

97 GCRO D1180 1/1 Committee minutes 28 August 1780, 25 September 1780, 5 October 1780, 24 October 1780, 2/10 Ledger 1775–1802 8 March 1777, 23 May 1777, 17 June 1777, 21 October 1780, 8/2 Mr Gardiner's measure of Land and Damages for Mrs Ball 4 July 1778, Measure of Mr Clark's Temporary Trespass in Madam Ball's Estate 26 September 1777, Mr Gardiner 's Memorandum of Lands and Damages at Stonehouse Ocean

98 GCRO D1180 1/1 Committee minutes 8 April 1779, 22 April 1779, 30 September 1779. This last reference states Ellis' Bill was paid though this could refer to the legal expenses, 6/3 Survey of the Banks of the Stroudwater Navigation on the lands of Mr James 28 April 1779, Letters from Mr Ellis James 7 December 1781, 3 July 1782, 1/2 Committee minutes 31 May 1784, Cl/2 Commissioners' minutes 4 July 1782 as well as 2/1 General Account 1776–94 10 April 1784 and 2/18 Cash Book 1779–88 10 April 1784

99 GCRO D1180 Cl/2 Commissioners' minutes 30 May 1782

100 Perhaps malice or a jury too partial to Ellis James could be the reason for the company challenge

101 GCRO D1180 Cl/2 Commissioners' minutes 4 July 1782, 6/3 Request to the Sheriff 30 May 1782, The Names of the Jurors at the Golden Cross 13 June 1782, Company's challenge of jurymen 13 June 1782, Second request to the Sheriff 30 June 1782, Names of Jurors at the George Inn 4 July 1782, Report of inquisition at George Inn 4 July 1782, Draft of Commissioners' order 4 July 1782

102 GCRO D1180 1/1 Committee minutes 11 April 1776, 9 August 1776, 2/1 General Account 1776–94 6 April 1776, 9 April 1779, 11 November 1776, 2/10 Ledger 1775–1802 8 December 1777, 2/17 Cash Book 1775–79 6April 1776, 11 November 1776, 9 April 1779

103 GCRO D1180 1/1 Committee minutes 8 April 1779

104 GCRO D1180 1/1 Committee minutes 11 April 1776

105 GCRO D1180 2/1 General Account 1776–94 28 October 1776, 2/17 Cash Book 1775–79 7 February 1776, 5 March 1776, 28 October 1776

106 GCRO D1180 1/1 Committee minutes 11 April 1776 says their Bill for 'sundry attendances' is £469 3s 0d (£469.15) but there is no record of this sum being paid, 20 March 1777, 6 March 1777, 8 April 1779, 14 October 1783, 8 January 1784, 19 February 1784, 8 April 1784, 31 May 1784, 17 August 1784, 2/1 General Account 1776–94 9 May 1777, 28 October 1776, 28 July 1777, 2/10 Ledger 1775 – 1802 12 May 1779, 2/17 Cash Book 1775–79 9 May 1777, 28 July 1777, 12 May 1779, 20 May 1779, 25 July 1780, 10 June 1782, 10 June 1784, 27 April 1785

107 GCRO D1180 1/1 Committee minutes 18 June 1778

108 GCRO D1180 1/1 Committee minutes 20 January 1780, 4 December 1780

109 GCRO D1180 2/17 Cash Book 1775–79 20 May 1779, 25 July 1780, 10 June 1782, 27 April 1785

110 GCRO D1180 1/1 Committee minutes 23 February 1775 thirty years plus three years for taxes e.g. 1/1 16 October 1777 Christian Ellis thirty-five years free of taxes for lawn, thirty-two years subject to taxes for orchard

111 GCRO D1180 2/1 General Account 1776–94 Edward Warner 20 June 1776 to 26 January 1778, 2/17 Cash Book 1775–79 Thomas Evans 23 November 1776–20 November 1777, Thomas Miles 11 July 1778 to 2 January1779, Thomas Pearce 6 March 1778 to 15 October 1779, 2/1 General Account 1776–94 William Jennings 2 September 1779 to 20 February 1782 and 2/18 Cash Book 1779–88 2 September 1779 to 20 February 1782, 2/1 General Account 1776–94 William Wetmore 21 August 1782 and 2/18 Cash Book 1779–88 21 August 1782, 2/1 General Account 1776–94 Samuel Webb 8 August 1780 and 2/17 Cash Book 1775–79 8 August 1780, 2/1 General Account 1776–94 William Palling 18 April 1783 and 2/18 Cash Book 1779–88 18 April 1783, 2/1 General Account 1776–94 Samuel Lawrence 16 August 1782 to 27 December 1782 and 2/18 Cash Book 1779–88 16 August 1782 to 27 December 1782, 2/1 General Account 1776–94 John Keene 1 February 1782 to 14 October 1782 and 2/17 Cash Book

1775–791 February 1782 to 14 October 1782, 2/1 General Account 1776–94 Mr Horlick 13 August 1783 and 2/18 Cash Book 1779–88 13 August 1783, 2/1 General Account 1776–94 William Evans and Co 7 March 1779, 4 October 1779 and 2/18 Cash Book 1779–88 7 March 1779 and 4 October 1779, 2/1 General Account 1776–94 John Carefield 3 August 1781, 26 August 1781, 29 March 1782 and 2/18 Cash Book 1779–88 3 August 1781, 26 August 1781, 29 March 1782, 2/18 Cash Book 1779–88 Mr Hardwick 16 February 1781

112 GCRO D1180 2/17 Cash Book 1775–79 Esau Palmer 15 June 1776 to 3 July 1776, 2/17 Cash Book 1775–79 Daniel Gainey 27 May 1778 to 8 June 1778, 2/1 General Account 1776–94 William Jennings 2 September 1779 and 2/18 Cash Book 1779–88 2 September 1779, 2/1 General Account 1776–94 Samuel Webb 17 September 1777 to 26 July 1779 and 2/17 Cash Book 1775–79 17 September 1777 to 26 July 1779, 2/1 General Account 1776–94 William Butcher 4 December 1781, 13 June 1783 and 2/18 Cash Book 1779–88 4 December 1781, and 13 June 1783, 1/1 General Account 1776–94 William Wetmore 4 December 1782 and 2/18 Cash Book 1779–88 4 December 1782, 2/1 General Account 1776–94 Samuel Webb 17 September 1777, 26 July 1779, 21 August 1780, 28 July 1781, 21 August 1782 and 2/17 Cash Book 1775–79 17 September 1777, 26 July 1779, 21 August 1780, 28 July 1781, 21 August 1782, 2/1 General Account 1776–94 Mr Turner 27 February 1782, 7 August 1783, and 2/18 Cash Book 1779–88 27 February 1782 and 7 August 1783, 2/1 General Account 1776–94 Edward Parker 10 January 1782, 1 May 1782, 4 January 1783 and 2/18 Cash Book 1779–88 10 January 1782, 1 May 1782 and 4 January 1783, 2/1 General Account 1776–94 Samuel Lawrence 1 September 1780, 25 May 1781 and 2/18 Cash Book 1779–88 1 September 1780 and 25 May 1781, 2/1 General Account 1776–94 John Wilkins 8 June 1776 to 24 November 1779, 2/17 Cash Book 1775–79 William Clark 30 April 1776 to 24 December 1777, 2/17 Cash Book 1775–79 Rev. John Pettat 6 October 1779, 2/1 General Account 1776–94 Rev. William Davis 5 June 1777–5 July 1781 and 2/17 Cash Book 1775–79 5 June 1777–5 July 1781, 2/10 Ledger 1775–1802 William King 1779

List of miscellaneous documents in GCRO D1180 8/2 in which most landowners are mentioned

1 A list of proprietors and owners of lands
2 Particulars of land purchased by the company out of the Canal – a list of tenants and rent per annum
3 Schedule of lands to be taken into the canals intended to be made to complete the Navigation from Stroud to Framilode
4 The Measure of the titheable land in each respective Parish [measured by] John Merrett September 1779. This mentions Kemmett's Orchard
5 Assenting [Landowners], Dissenting and Neuter
6 Particulars of ridges in Pool Field [Saul] 1781
7 Measure of the Island at Eastington by John Merrett, December 5 1777
8 List of Proprietors of Lands and Occupiers with their contents, etc
9 Schedule of lands to be taken into the canal (booklet)
10 A List of Proprietors whose Lands are to be taken for the Navigation
11 Schedule of Lands giving owners, occupiers and amounts of land and money involved
12 Account of the Measurements of the Canal and Towing Path and other Lands 30 September 1777

The Purchase of Lands (Cont.)

Given all these factors complicating any accurate assessment of the true costs of land purchase, how much did the proprietors pay in total for the land they needed to build the canal? What sort of acreages were involved? How much did they pay an acre? To what extent did they distinguish between land of different quality or put to different uses? Were the proprietors more generous to landowners opposing the canal? Here again a shortage of detailed information makes any assessment subject to wide margins of error.

Although the company records include the names of all landowners who negotiated with the proprietors, there are occasional confusions over the Actual ownership of land or no indication of how much some landowners received for their sale. In March 1775, for example, Robert Dobyns-Yate agreed to sell Carters Close at Framilode 'at usual terms' and about three weeks later Richard Hall and Benjamin Grazebrook were asked to visit his agent the following day to pay for the land. [1] At this point John Purnell stepped in with his claim to the land and challenged the right of the company to build a canal navigation under the terms of the 1730 Act. The same land is next mentioned in January 1776 when John Jepson visited Dobyns-Yate 'to buy the land now cut through for the use of the navigation'. When Carters Close is referred to again in April 1776, John Purnell appears to be completing the purchase from Dobyns-Yate. [2] Similar deficiencies occur concerning land purchases from Rev. Prosser, Phillipa Grove and Elizabeth Heathcote, John Ford and Nathaniel Beard.

Rev. Prosser was approached by the company sometime during 1775 or 1776 when he told the proprietors he did not own the land at Whitminster himself but held it in trust for a gentleman. This gentleman is not named nor is there any known payment to him for the land held by Rev. Prosser. [3] Between March and May 1775 Richard Hall was negotiating with Richard Davis, steward to Phillipa Grove and Elizabeth Heathcote, for part of the lands belonging to Frampton Manor. Negotiations were completed on 24 May when the committee agreed to pay thirty five times the annual rental value of the lands. There is however no record of any payment to the 'Lady of the Manor of Frampton' unless this is included in an undated payment of £17 10s 0d (£17.50) to Richard Clutterbuck 'for land cut off … in Frampton Mead'. Equally there are no records of any payments to John Ford of Alkerton or Nathaniel Beard of Fromehall Mill who both owned land along the projected line. [4]

As far as acreages are concerned, the information is not so much scanty as contradictory. Occasionally the acreages listed do not tally with the price paid to the landowner. Richard Aldridge, for example, bought under an acre of land at Framilode on behalf of the company but paid a total of up to £376 15s 0d (£376.75) for it. [5] However, it is possible this may involve double counting, the £60 compensation paid to Mrs Wilding for her house and perhaps some of the missing payments to other landowners. John Andrews, too, is supposed to have sold nearly an acre to the company but was paid £200 19s 0d (£200.95) for the sale. However, a suggestion that Andrews sold additional land to the company, who then exchanged it with Richard Pettat for some of the land he lost, may be the cause of this discrepancy. [6] Occasionally, too, when acreages are mentioned in connection with a purchase from one specific landowner they are contradicted by a different acreage mentioned elsewhere for the same vendor. Mary Ball is listed as selling nearly seven acres at one point and only five-and-a-half acres at another. [7] James Clutterbuck assented to sell under half an acre in March 1775 but was finally paid for

over an acre-and-a-half in January 1776.[8] Rev. Henry Davis is reported to have sold a little over an eighth of an acre at one date and over a quarter of an acre at another.[9] The same pattern of contradictory amounts of land bought can be found right through the records of land purchase. It is possible that where this occurs the smaller original figure represents the amount of land needed from each owner for the canal itself whereas the larger figure represents the total amount needed to secure agreement with the landowner.

Since many land sales are not listed in acreages at all any estimate of the total acreages the company bought is little more than guesswork. However, since both Yeoman and Dadford estimated average land costs at £60 an acre and total land purchase costs excluding complicating factors were about £5,600, the company may have bought a total acreage of around ninety acres.[10] Taking the largest acreages mentioned for each landowner and omitting those owners where no acreages were listed, a total of about seventy-five acres is reached. In all probability therefore the total bought acreage lies somewhere between these two figures with the likelihood the ninety acres is the more accurate estimate.

The company certainly paid different prices for land put to different uses. During 1775–6, for example, the company seem to have adopted a standard policy of paying £20 an acre for arable land and around £59 10s 0d (£59.50) an acre for pasture. Originally Richard Hall had been instructed to settle for land 'as cheaply and speedily as possible' allowing thirty-three years purchase of the annual rental value. However, there is a hint of collusion between owners of arable strips in Pool Field, Saul, since John Saunders, Mrs Ann Morse, Samuel Walbank and Benjamin Watkins all asked for £20 an acre and Richard Hall himself agreed to accept the same rate for his own land. Richard Hall was therefore instructed to pay .£20 an acre for the land in Pool Field if necessary but to try and settle it as near as possible to thirty-three years purchase of the annual rental value to avoid further heavy claims. This apparently standard price of £20 an acre was therefore paid to James Clutterbuck, Mrs Ann Morse, John Saunders, Samuel Walbank, Benjamin Watkins and Richard Hall.[11] Since the landowners themselves asked for this sum there is no reason to assume that £20 an acre was a particularly low price for land in Pool Field. It was in any case low lying poorly drained land and its continued division into strips could suggest it was not the most sought after arable land in the neighbourhood. John Saunders and Richard Owen Cambridge, however, were both paid £35 an acre for some arable land in Pool Field presumably because this land was better drained or better quality.

By far the greater part of the land the company bought was pasture and during 1775 and early 1776 the price stabilised at around £59 10s 0d (£59.50) an acre. This was the sum paid to John Saunders and Mrs Ann Morse for part of Meddalls Meadow, to Rev. Henry Davis for part of Saul Glebe, to Richard Owen Cambridge, to John Hugh Smith and Ann Hort of Bristol for land in Eastington parish, to Richard Martin for land at Lockham Bridge and to Elizabeth Partidge for part of Partridge's Ground. James Clutterbuck, however, got a slightly higher price for his lands at Whitminster in January 1776 when he agreed to settle at £60 an acre for his lands there. Once again it is difficult to assess how far £59 10s 0d (£59.50) an acre was a fair reflection of the true value of pasture land although its higher price certainly measures its greater potential and probably better quality than land in Pool Field.

Most of these negotiations with landowners were conducted in a friendly and cordial manner. The Woolnough papers, for example, give a detailed account of the negotiations between Benjamin Grazebrook, acting for the company, John Hugh Smith himself and John Harvey, his agent at Eastington.[12] On 12 October 1776 John Hugh Smith wrote to Harvey that 'a Mr Grazebrook of the Stroudwater Navigation' had called to get his consent for the company to enter a piece of land he owned jointly with Mrs Ann Hort. John Hugh Smith had not given his immediate consent but asked to see a copy of the Act of Parliament and a plan of the intended canal. Benjamin Grazebrook had promised to send these to him and in the meantime suggested that John Harvey and Mrs Hort's agent should view the land concerned. John Hugh Smith therefore asked Harvey to let him know how much the yearly value

of such a piece would be, how much land would be cut off on the other side of the canal, how far the distance would be to reach it when the canal were built and how many years purchase price the company had given for land they had already purchased. Nine days later, on 21 October, Benjamin Grazebrook wrote to John Hugh Smith enclosing a copy of the Act and a plan of the navigation with the intended line marked out. The company hoped, Grazebrook told him, that John Hugh Smith would instruct his steward to meet him and negotiate as soon as possible 'as wee want to enter on it immediately'. Unless Grazebrook heard from him soon, the company would have to stop the works which would be 'a great disadvantage'.

Replying on 5 November John Hugh Smith confirmed he had received the enclosures safely and told Grazebrook that as soon as he heard the value of his land from Harvey be hoped to convey it 'without giving unnecessary trouble'. On 10 December John Hugh Smith asked Harvey to meet Mrs Hort's agent, decide on the acreage of land required, assess its annual value, which he thought would be about £2 as it was a good piece of land which will be divided, and agree with the company on the same number of years purchase as other neighbouring landowners have done. Both Mrs Hort and himself would allow the land to be cut through as soon as they received the purchase price but not before. John Harvey wrote back on 22 December reporting he had met the commissioners with Mrs Hort's agent the previous day and the company had agreed to pay for half an acre of land even though he had measured it and found it slightly less than this.[13] The yearly value had been agreed at £1 13s 0d (£1.65) an acre and thirty–five times this value would be paid. This was the same period as agreed to by other landowners including Robert Stephens even though the Stephens' land was better quality. The company had agreed to pay for the land within a week and Benjamin Grazebrook sent if off to John Hugh Smith the following day.

A few of the negotiations with landowners, however, did not follow this more usual placid and gentlemanly course. Like Ellis James, Daniel Chance, Richard and Nathaniel Stephens, John Purnell of Framilode and Fromebridge Mills was not the most accommodating of landowners. Purnell had already made the company abandon their fourth attempt to build a navigation to Stroud in 1774–5, involved them in an expensive law suit at Gloucester Assizes which he had won and forced the company to apply for a new Act of Parliament. Purnell now determined to use his strategic occupancy of Carters Close at Framilode to extort the best possible price from the company. Meeting on 11 April 1776, shortly after the new Act had received the Royal Assent, the committee of directors asked Joseph Grazebrook and John Jepson to visit Purnell at his Dursley home the following day and offer him thirty five years at £1 10s 0d (£1.50) an acre a year for his land. However the committee placed a maximum limit of £39 on this offer for the three quarters of an acre the company needed. This was equivalent to £52 10s 0d (£52.50) an acre for the land at Carters Close. Purnell prevaricated refusing to agree on a price on the grounds he was uncertain whether the conveyance of lands from Joho Yate, executor of Robert Dobyns Yate, had been completed. In any event Purnell felt certain a game of cat and mouse would oblige the company to raise their offer. Anxious to reach agreement with Purnell and conscious that their previous dealing with him had embittered mutual relations, the committee tactfully requested two other company representatives to meet Purnell and propose further terms. Accordingly therefore, Benjamin Grazebrook and Richard Bigland met Purnell a few days later when be agreed to meet members of the committee at Carters Close on Tuesday 30 April to settle the value of his lands. When a further selection of the committee, this time William Knight, Robert Ellis, John Hollings and Benjamin Grazebrook, met Purnell at Framilode on the appointed day he made his demands quite clear. Purnell wanted thirty-five years purchase price based on an annual rental value of £2, equivalent to £70 an acre. Once again no agreement was reached.

At the committee meeting on 2 May Joseph Grazebrook was asked to meet Purnell once more, offer him £60 an acre and tell him that unless he agreed the company would apply to the commissioners to arbitrate a price. Grazebrook was also asked to offer Purnell £40 on account and to request the commissioners to meet at Thomas Cullis' New Inn at Framilode on Tuesday 21 May. Early in May,

therefore Joseph Grazebrook revisited Purnell who called the company's bluff. Purnell refused to accept the £40 on account declaring he would rather leave it to the discretion of the jury than reduce his price. Although the commissioners met on 9 May to advertise the meeting to value Purnell's land and to qualify themselves to reach a decision, there were not enough present to provide a quorum. Rather than occasion any further delay by trying to convene a quorate meeting of commissioners, the committee decided Joseph Grazebrook should visit Purnell at once and offer him his now amended asking price of £52 10s 0d (£52.50) 'since (the] lands … are directly wanted to proceed with the work.'[14] Purnell received the equivalent of £66 13s 4d (£66.67) an acre for his land, the highest price the company had ever paid. His successful war of nerves seems to have pushed aside company policy of paying standard prices for arable land and standard prices for pasture land regardless of any differences in quality. A few months later, in December 1776, John Harvey specifically mentions the company offered John Hugh Smith and Ann Hort the same price as they had offered Robert Stephens even though their neighbour's land was better quality. This was the last known time the company paid a standard price for land of different quality.

From the middle of 1776 onwards the company adopted a policy of paying for land according to its actual quality and value. At the same time the company began to replace the idea of paying thirty five times the annual rental value and offer a lump sum instead. Occasionally, too, prices now varied not according to the value of land needed for the canal but according to the amount of opposition the landowner showed to a sale. In November 1776, for example, Dudley Baxter was paid £25 an acre for his arable land near Chippenham Platt, a 25% rise on the amount paid for land in Pool Field.[15] In the autumn of 1777 Gabriel Harris, Daniel Smith, Ann James and Ambrose Reddall were all paid £35 an acre for their arable land. By contrast the Stephens family of Ebley, some of the strongest opponents of the canal scheme, were paid £43 15s 0d (£43.75) for their arable land. Even the influential Richard Owen Cambridge received only £35 an acre for his arable land in May 1779 when the company bought extra land for an improved cut at Whitminster.

Prices for pasture varied even more. Dudley Baxter and Rev. Robert Stephens were paid £50 and £70 an acre respectively in the autumn of 1776 although Ellis James accepted the earlier norm of £59 10s 0d (£59.50) an acre for land at Chippenham Platt. In November 1777 Ann James accepted £52 10s 0d (£52.50) an acre for pasture at Fromehall, Henry Wyatt £52 10s 0d (£52.50) and £70 an acre for pasture near Dudbridge, John Mosley £52 10s 0d (£52.50), £60 and £70 an acre for various pastures, Richard Stephens £60 and £70 an acre for meadows at Stonehouse, and John Andrews £87 10s 0d (£87.50) an acre for pasture at Cainscross. When the company required additional land at Stonehouse from John Andrews this sum was raised to £95 an acre. In April 1778 George Augustus Selwyn and the corporation of Gloucester accepted £87 10s 0d (£87.50) an acre for the whole of Weir Meadow and parts of Mill Meadow and Dyehouse Meadow at Ebley.[16] At the same time Daniel Chance, another active opponent of the canal, received £70 and £105 an acre for various meadow lands phis an unprece dented £193 10s 0d (£193.50) an acre for 'a piece of meadow called Lower Huntley tenanted to John Hawker.'[17]

Prices paid for orchard and garden land were even higher. Christian Ellis, for example, was paid £80 an acre for orchard land and £87 10s 0d (£87.50) an acre for part of his garden. Hollowday Phillips and Samuel Remington both received £87 10s 0d (£87.50) an acre for their orchards although John Butcher and Richard Stephens were all paid the higher price of £105 an acre. Ambrose Reddall received the same price for his orchards at Ewens Lands, Upper Rack Close and Gabs Leaze although George Augustus Selwyn and the corporation of Gloucester were offered £122 10s 0d (£122.50) for the whole of Little Harry's Acre. Both Mr Playne and Mr Loyde were each paid the equivalent of £100 an acre for the loss of small pieces of land at the end of their gardens. Daniel Chance got equally good terms, he was paid £70 an acre for Home Orchard, Aldershill Orchard and the meadow land called the Moors and £188 13s 5d (£188.67) an acre for Cairnshill Orchard.

The problem with all these acreage prices is that there is no way of knowing whether the rise in land

costs reflected a general price rise encouraged by the American war or other circumstances, whether the company moved into better drained or more valuable land areas as its purchases spread up the Frome valley towards Stroud, whether it stemmed from the vocal opposition of the Purnells, the Stephens and their associates or from any combination of these and other factors. In any event by the time the company had bought all the land they needed for the canal and paid additional costs of interest, damages, Reversionary rights and the like they had expended a sum of at least £7,267 0s 10d (£7,267.04) compared with Yeoman's estimate of £4,211 4s 0d (£4,211.20).[18]

The company, however, did not wait to complete the purchase of all these lands before it began to build the canal. The committee of directors, meeting early in April 1776 immediately after the Royal Assent was given to their new Act, turned their attention not only to questions of land purchase but to questions of materials, surveyors, contractors, labour and other general matters of construction as well. This was the time for them to prepare themselves for a new start on their navigation to Stroud.

Chapter Fourteen References

1 GCRO D1180 1/1 Committee minutes 29 March 1775, 20 April 1775
2 GCRO D1180 1/1 Committee minutes 11 January 1776, 11 April 1776
3 GCRO D1180 8/2 Miscellaneous documents and the Measure of Rev. Mr Sullins land by Lockham Bridge 1776 and 1778, 2/18 Cash Book 1779–88 27 April 1785
4 GCRO D1180 1/1 Committee minutes 9 March 1775, 23 May 1775, 24 May 1775, 3/2 17 November 1775, 8/2 John Bradford for the Ladies of Frampton Manor, Proprietors of Lands in the Line of the River, D149 E65 Account of Richard Clutterbuck's land in Eastington taken for the canal
5 GCRO D1180 1/1 Committee minutes 24 May 1775, 8/2 Miscellaneous documents, D1181 uncatalogued deeds of the Hawker and Clutterbuck families 9 May 1775, 20 May 1775, 27 May 1775
6 GCRO D1180 2/1 General Account 1776–94 15 December 1777, 8/2 Documents relating to John Andrews Chapter 13 reference 33
7 GCRO D1180 2/10 Ledger 1775–1802 8 March 1777, 23 May 1777, 17 June 1777, 21 October 1780, 8/2 Mr Gardiner's measure of Land and Damages for Mrs Ball 4 July 1778, Mr Gardiner's Memorandum of Lands and Damages in Stonehouse Ocean
8 GCRO D1180 1/1 Committee minutes 9 March 1775, 2/10 Ledger 1775–1802 15 January 1776
9 GCRO D1180 8/2 Agreement for land by Rev. Davies [and others] 29 March 1774, Lands in the Parish of Eastington taken in the Canal and Towpath
10 GCRO D1180 9/20 Estimate to make the River by Thos. Yeoman, Mr Dadford and Priddey 23 June 1774, Estimate by Mr Yeoman dated 1774
11 GCRO D1180 1/1 Committee minutes 9 March 1775, 29 March 1775
12 Bristol Record Office AC/WO 14 24(c) The Woolnough papers Letters between John Hugh Smith, John Harvey and Benjamin Grazebrook 12 October 1776 to 6 February 1777
13 Harvey means members of the committee of directors not the commissioners of the navigation who would only be involved in a case of dispute. Most likely this is Harvey's error but Benjamin Grazebrook in particular might not be averse to pulling rank if this served his purpose.
14 GCRO D1180 1/1 Committee minutes 11 April 1776–23 May 1776
15 GCRO D1180 2/10 Ledger 1775–1802 29 November 1776–25 July 1780
16 GCRO D1180 8/2 Miscellaneous documents
17 GCRO D1180 8/2 Copy of agreement with Mr D. Chance for Lands 30 April 1778
18 See Appendix

Prow of a derelict Severn trow on a field near Ryeford. Dated early 1970s.

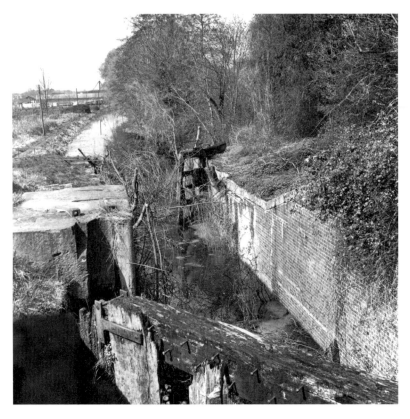

Ryeford Double Locks. Dated early 1970s.

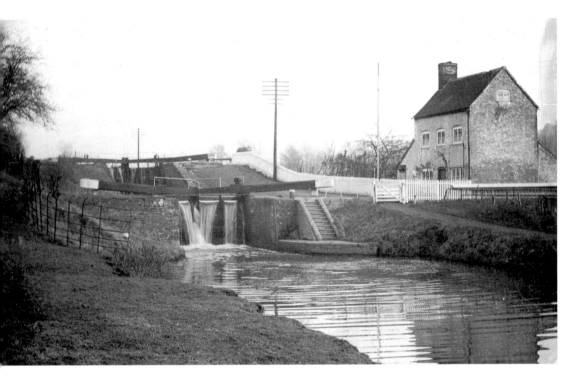

Ryeford Double Locks and house. Dated 1920s?

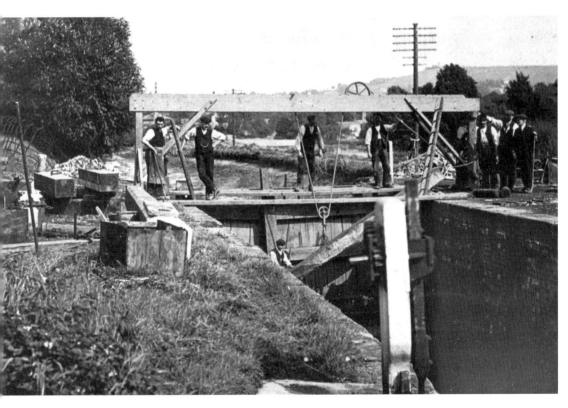

Repairs to Ryeford Double Locks, 1907. The double board, bolted girder could be taken apart and moved. John Whiting is first left. Harry Stephens in in the lock. Other people are unknown.

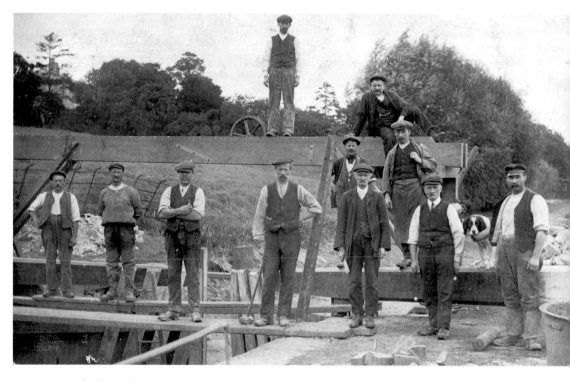

Repairs to Ryeford Double Locks 1907. The workers have not been identified.

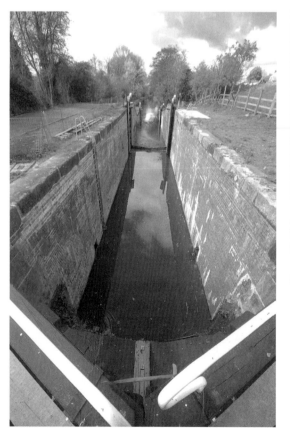

Above: Ryeford Locks
Ryeford Bridge Locks,
2012.

Left: Ryeford Lock.

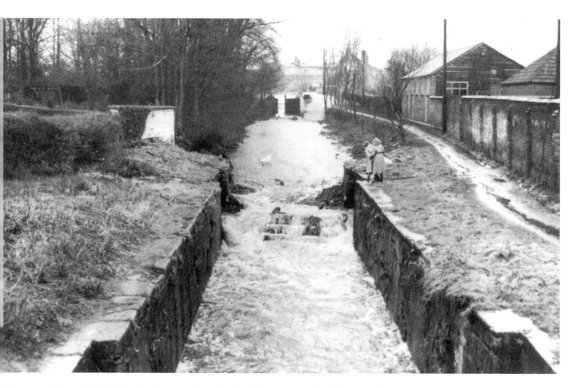

Upper and Lower Dudbridge Locks. Just above this lock the men in the far distance found that the trap where the Ruscombe Stream went under the canal and into the Frome was in perfect order. Dated 28 December 1956. In the earlier view, two men stand on the lock gate at Dudbridge, on probably a clerk from the Canal offices and the other the lockkeeper

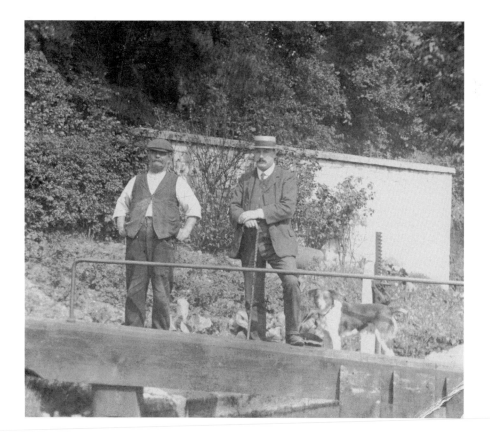

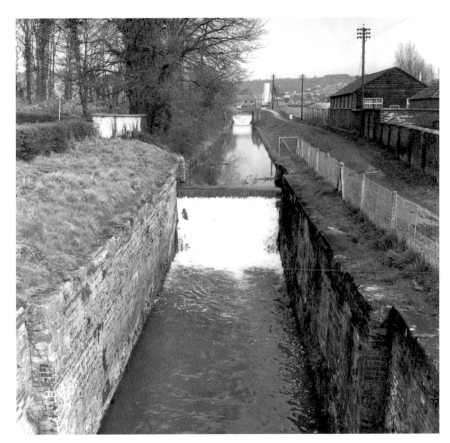

Dudbridge Locks. Dated early 1970s.

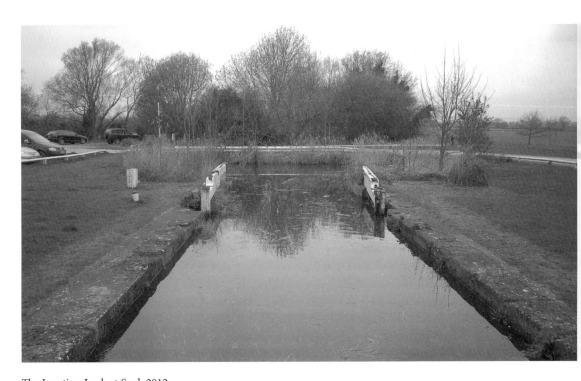

The Junction Lock at Saul, 2012.

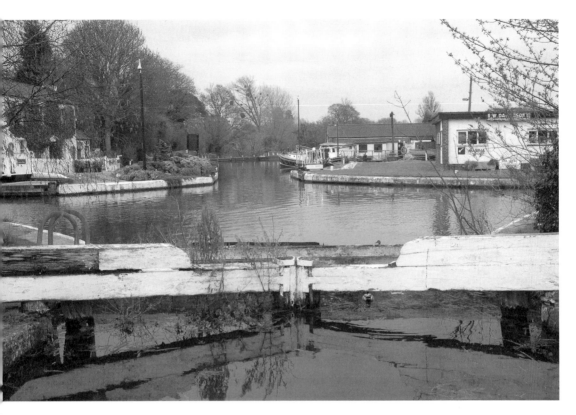

The Junction Lock at Saul, 2012.

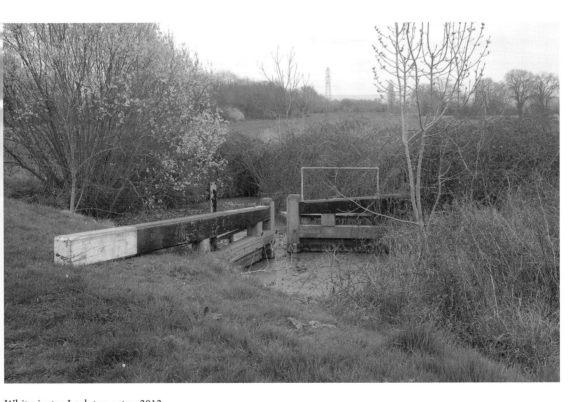

Whitminster Lock top gates, 2012.

Gloucester and Berkeley
boundary stone near Junction
Lock. Dated early 1970s.

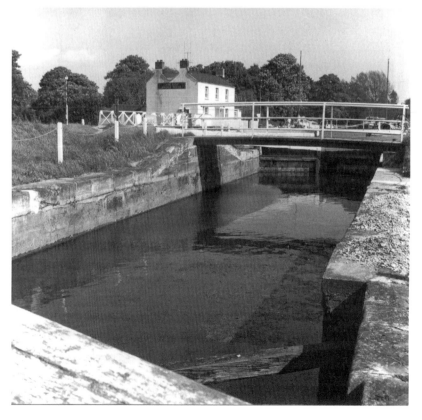

Gloucester & Sharpness Canal
Junction Lock
Junction Lock, where the
Gloucester & Berkeley Canal
(going from left to right)
crossed the Stroudwater
(straight ahead). This lock
now owned by the Canal and
River Trust was built in the
mid 1820s when the Berkeley
Canal was constructed.
Junction House visible in
the background. Dated early
1970s.

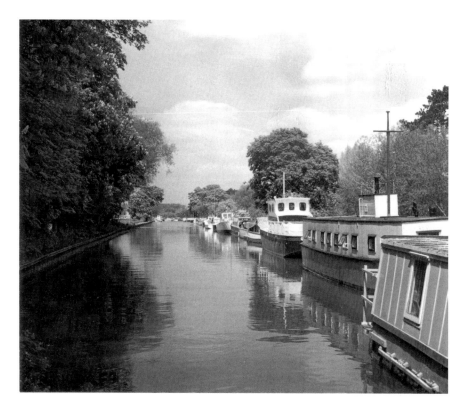

Stroudwater Moorings on the Stroudwater Canal east of the junction. The new marina now goes off at the middle left. Dated early 1970s.

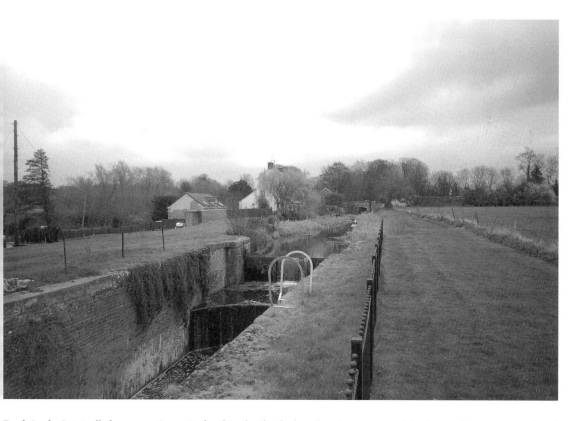

Dock Lock. Originally known as Court Orchard Lock. The dock and maintenance yard for the canal company was based here (2012).

The weir below Court Orchard Lock. Westfield Bridge is not far away.

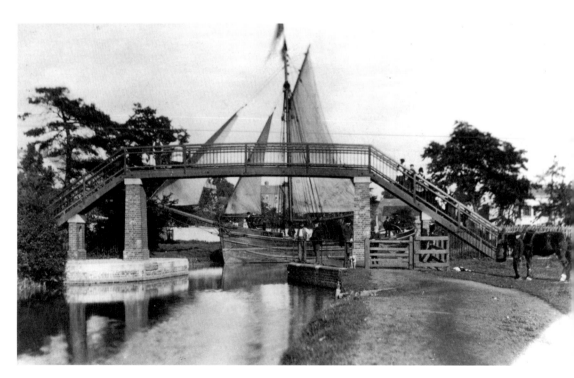

This posed photograph shows the trow *Gertrude* and the horse attached to the boat at Hilly Orchard Bridge. It was against company regulations to travel on the canal with sails fully rigged. Dated c. 1907.

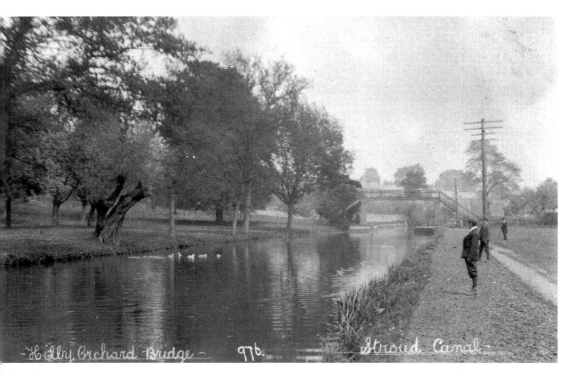

Hilly Orchard Bridge. Dated 1910.

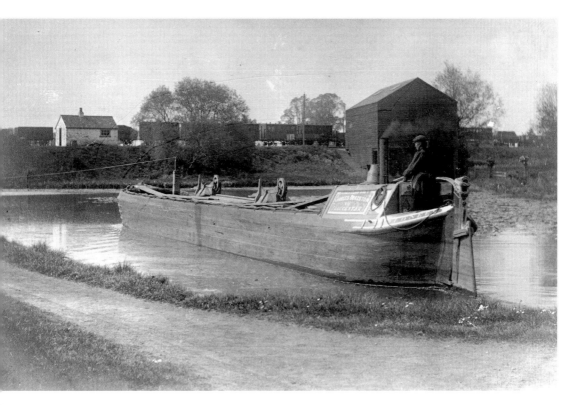

Charles Brayston on *Pioneer* at Stonehouse Basin. Notice the wheelbarrows for loading and unloading, the tow rope to a donkey or a horse on the towpath, railway wagons on the main line and the ubiquitous Buckby can. Dated 1930s?

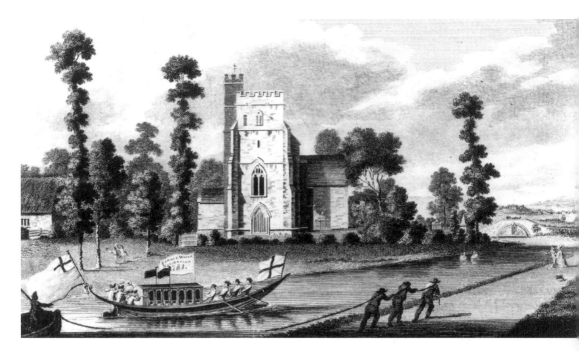

St Cyr's Church, Stonehouse, 1781. Notice the man towage, the company inspection barge and the towpath promenaders. This is probably accurate as far as man towage was concerned. It was commonplace on the Severn. However a horse towing path did not exist in 1781 so the width is the imagination of the artist.

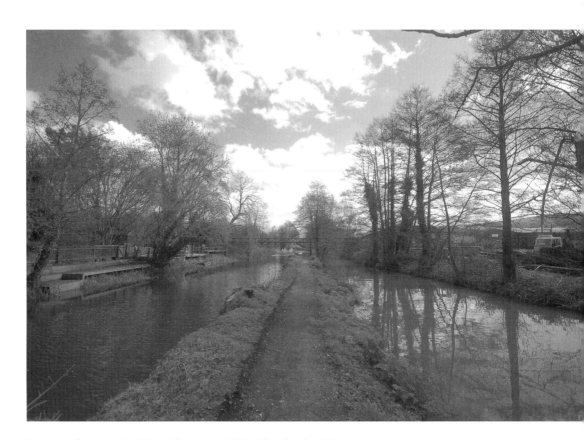

Junction of the canal and River Frome near Ebley. Dated early 1970s.

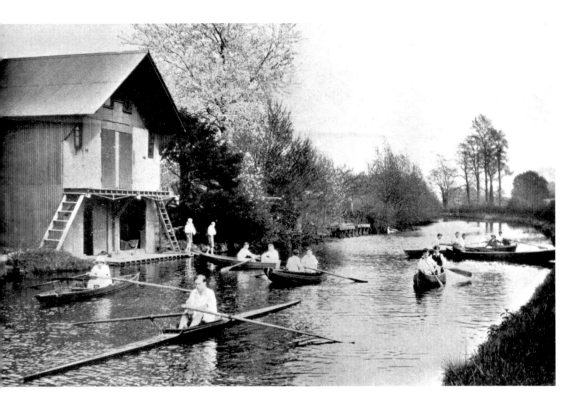

Wycliffe College boathouse. Dated 1915.

Moorings on the Stroudwater, with a former lifeboat in view. A boatyard exists here too, complete with tower crane.

Junction of Painswick Stream and canal near Stroud. The warehouse at Wallbridge is on the extreme right. Dated early 1970s.

Newtown Roving Bridge: the towpath changed sides here. Dated 1980.

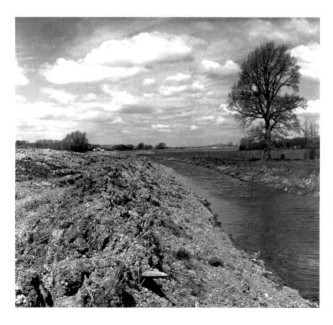

Left: M5 cuts the canal
The motorway cometh – and blocks the canal. Dated early 1970s

Opposite: Carter's Close, Framilode. The dispute here in August 1775 brought the Stroudwater Company before Gloucester Assizes where they lost their case and decided to apply for a new Act of Parliament, *GCRO D1180 10/3*.

RIVER SEVERN

High Land

Close

Mr Tomms

CARTERS Orchard

B
69

Yate Esqr
3
Graeon

Cut

Yate Esq
94

Canal Road

Framiload
Mills

To Longney

N.63. The figure
from Cut to the t

Late Mr Farmes

c

C

Mr Pinter
Street
49

Mr Walbank

River

To Saulge Head

Moor

Foot Bridge

W E

S

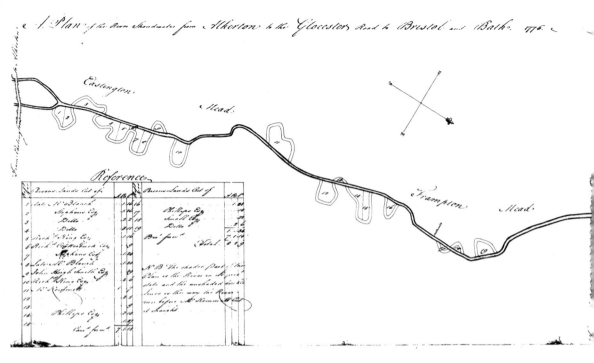

'A Plan of the River Stroudwater' 1776 showing 'the way the River ran before Mr Kemmett cut it straight'. *GCRO D118 10/1.*

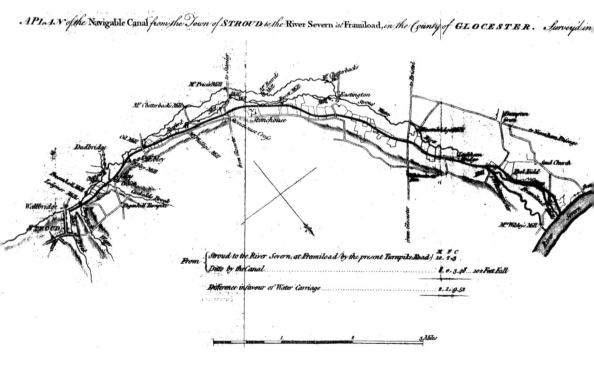

Plan of navigable canal Stroudwater
General Plan of the Canal, 1776.

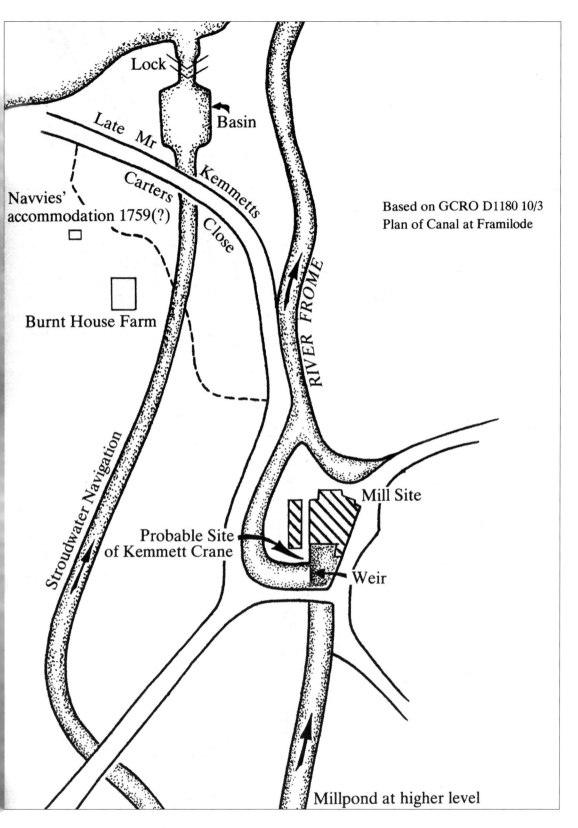

Lock

Basin

Late Mr Carters

Kemmetts

Close

Navvies' accommodation 1759(?)

Burnt House Farm

RIVER FROME

Based on GCRO D1180 10/3
Plan of Canal at Framilode

Stroudwater Navigation

Mill Site

Probable Site of Kemmett Crane

Weir

Millpond at higher level

Plan of the canal at Framilode Mill Site (River Severn at top)
Based on GCRO D1180 10/3

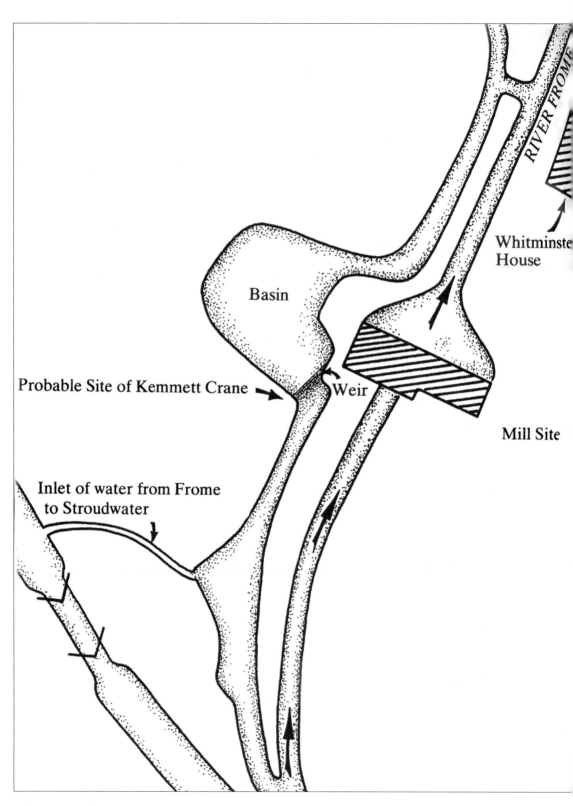

RIVER FROME

Whitminster
House

Basin

Probable Site of Kemmett Crane → Weir

Mill Site

Inlet of water from Frome
to Stroudwater

Whitminster Mill Site
Based on GCRO P362 S0/21 Tithe Map 1838 and
D1180 10/3 Plan of Stroudwater Canal.

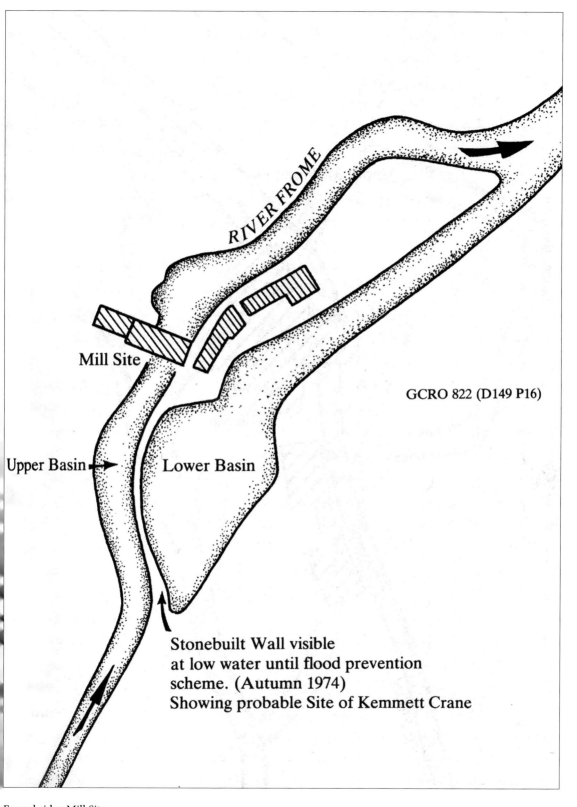

RIVER FROME

Mill Site

GCRO 822 (D149 P16)

Upper Basin →

Lower Basin

Stonebuilt Wall visible
at low water until flood prevention
scheme. (Autumn 1974)
Showing probable Site of Kemmett Crane

Fromebridge Mill Site
GCRO 822 (D149 P16).

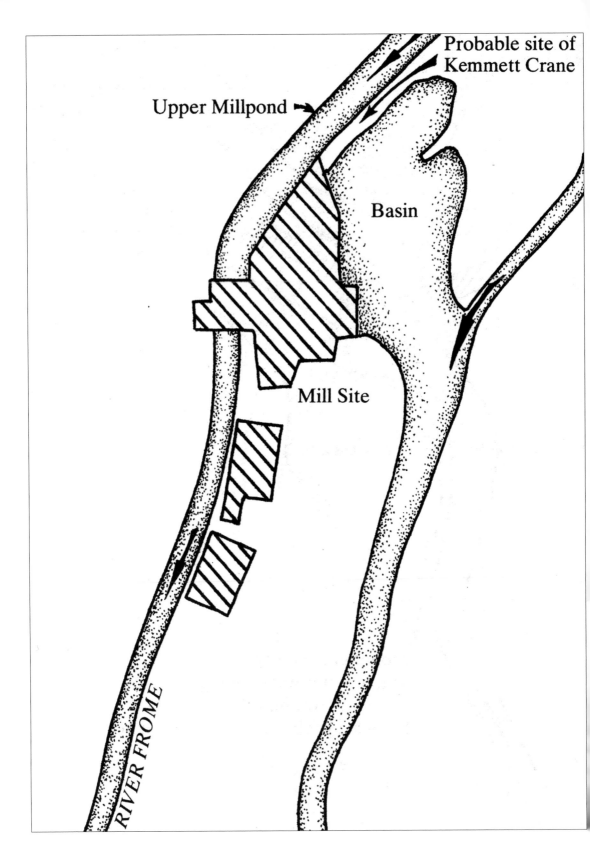

Probable site of
Kemmett Crane

Upper Millpond

Basin

Mill Site

RIVER FROME

Churchend Mill Site
Based on GCRO P127 SD/21 Tithe Map c. 1841

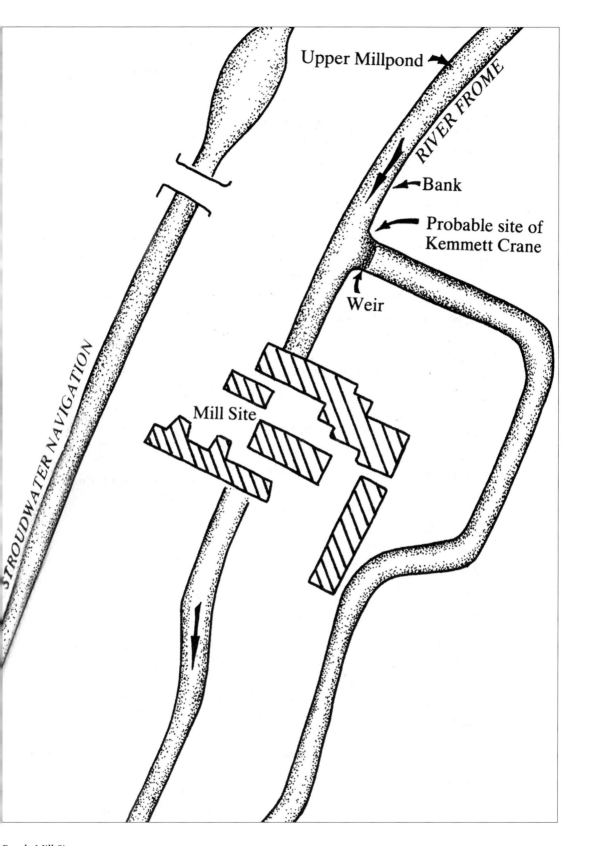

Upper Millpond

RIVER FROME

Bank

Probable site of
Kemmett Crane

Weir

STROUDWATER NAVIGATION

Mill Site

Bonds Mill Site
Based on GCRO P316a 5D2 1839 Tithe Map

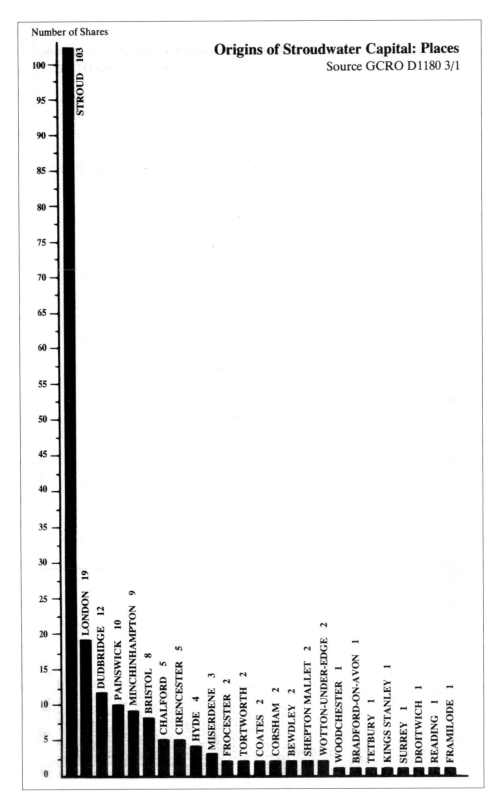

Origins of Stroudwater Capital: Places
Source GCRO D1180 3/1

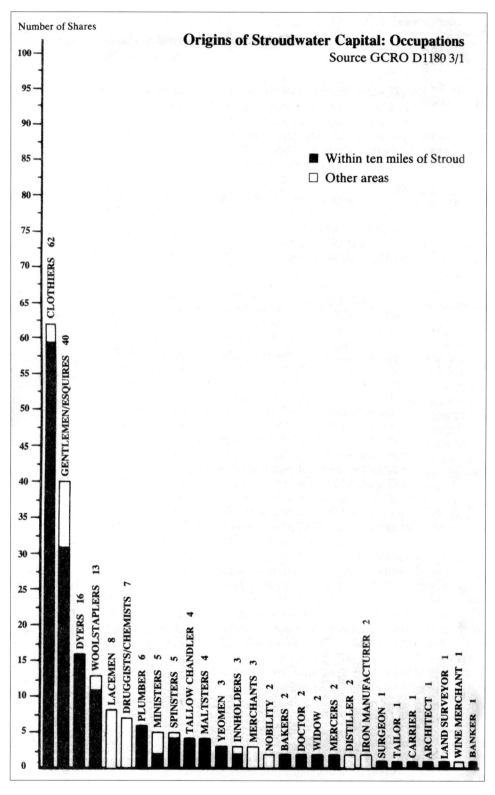

Origins of Stroudwater Capital: Occupation
Source GCRO D1180 3/1

Men and Materials

Even before the new Act reached the statue book the committee of directors began preparing for a general resumption of work. In March 1776 Edward Hinton, who had tested local clay for the company in January 1775, submitted proposals to make 600,000 bricks from clay dug out of the intended line at Whitminster for 6s 0d (30p) a thousand provided the company supplied coal to fire the bricks and all other raw materials. Hinton probably intended to make these bricks at Framilode for early in April the committee allowed him five guineas 'for Loss Sustained by the Tide'. The directors soon agreed to his terms though it was fortunate Benjamin Grazebrook advertised for other brick-makers to supply the 'many Millions' of bricks needed to build locks, bridges and line the canal below the puddled clay. Within a month Edward Hinton had run away and no more was heard of him.[1]

At this stage, however, the main attention of the directors centred more on getting construction started rather than any immediate supply of building materials. Following standard contemporary practise and Yeoman's own specific instructions 'by no Means … to contract with any Person for the whole', the committee agreed to subcontract different parts of the construction and decided to advertise these 'several Parts of the Work' in the London Birmingham and Gloucester newspapers. A few days later the *Gloucester Journal* asked 'Any … Persons willing to undertake to finish the Navigation, agreeable to a Plan which may be seen at Mr Grazebrook's, … to send their Proposals, and Security for Performance, to the Committee … who meet on Thursday at the George Inn'.[2] Shortly afterwards the directors concluded agreements with Robert Perry, John Gleave, James Houghton and James Cocksey to supervise teams of cutters to dig out the bed of the canal.[3]

The directors now turned their attention to their engineer John Priddey. They may have considered replacing him as early as 16 March for between then and late June they received several applications for his post. Certainly by 3 April the committee had reached a decision and asked Joseph Grazebrook to visit Priddey and pay his outstanding salary 'upon his giving a full Discharge of all Demands' on the company. Although there is no record of any friction between the committee and their engineer, the fact that Priddey was only the second of several engineers who came to work for the company and then left before the canal was completed suggests the directors may have been exacting and exasperating taskmasters. They were no doubt concerned about the delay Purnell's successful objection had caused, worried that the cost of the case of Gloucester Assizes and the escalating costs of construction would bite deeply into the capital of £20,000, determined not to fail to complete the navigation for a fifth time and perhaps anxious to have a full time engineer and surveyor on site permanently to supervise all aspects of construction. The real reason for the friction, however, probably stemmed from the failure to decide on any specific division of responsibilities between the committee and their engineer. The result of this was that the committee were constantly interfering with the work of the engineer and issuing whole lists of trivial instructions to him at every meeting of director. Respected engineers like Priddey could have been frustrated by this persistent tendency of the directors to involve themselves in day to day constructional decisions which were not properly within their concern and certainly not within their competence. It must have appeared,

however unintentionally or inaccurately, to reflect a poor opinion on the judgement of their engineer. Perhaps Priddey conveyed this view vigorously to the committee. Perhaps, too, their previous industrial experience predisposed the directors to errors of this sort. They were after all mostly established local industrial magnates used to directing large numbers of employees and outworkers as well as coordinating many different manufacturing processes at the same time. This dominating and successful experience in running their own show in the clothing trade could have encouraged them to think the same methods would be equally suitable for canal construction. But it was the engineer rather than the real culprits who got the blame. In any event the directors decided to give Priddey three months notice on 2 May 1776 which he accepted during the following week. His salary of £100, already in arrears and possibly itself a bone of contention, was terminated from 2 August 1776 when Benjamin Grazebrook paid him in full.[4] It was not long before the committee were well supplied with prospective engineers and surveyors to replace him.

One of the first was Thomas Dadford who had already worked on surveys for the company on at least two previous occasions. Dadford now proposed to superintend construction and promised to reach the the terminus at Wallbridge within three years. He recommended cutting should be paid for by the yard, bridges by agreement for a set sum and locks according to a set day rate or by agreement. In addition he would need a clerk to receive money and pay wages as well as measure the land and cutting as he could not do it himself. Dadford asked for a total sum of £500 for this supervision which included his expenses and undertook to be present at the works over half his time leaving either his son or another capable person in charge during his absence. Although Dadford was asked to attend the committee and Joseph Grazebrook visited him at Compton, he was unable to attend at the appointed date because of his duties on the Staffordshire & Worcestershire Canal.[5]

On 4 April John Glyn submitted his own far more comprehensive proposals to act not only as engineer and surveyor to the company but also as chief contractor for the whole navigation as well. These proposals included plans to make 'all cuts, turf and puddle the banks, build locks, bridges, aquaducts, waste gates … (and all) workmanship an materials for … that part of the navigation that is not now begun viz: from the Lower Comer of Mr King's Orchard at Whitminster to Wallbridge' for a total of £18,656 19s 3d (£18,656.96). The directors seems to have been impressed by Mr Glyn (or the voted him eight guineas for his trouble (which had to be refunded if he undertook the navigation), sent their thanks for his Candid Behaviour' and asked him to supply plans and estimates for each bridge and lock. A fortnight later John Glyn offered to survey the work but the directors deferred his application and when he wrote again over a month later apologising that his plans were still unfinished Joseph Grazebrook replied that 'according to the present plan, we fear we may not want them.'[6] By this stage several new names had entered the running.

Towards the end of April a Mr Sharrow of Northallerton in Yorkshire and William Wright of Warwick both offered their services as surveyor to the company. Benjamin Grazebrook replied to both applicants enclosing a plan with details of the locks and informing Mr Sharrow, then in London, that he could see a plan of the navigation at the Parliament Street Coffee House or at Mr Need's. Nothing more is heard of Mr Sharrow although the company did provisionally accept Wright's offer for himself and his partners to build part or the whole navigation. On 16 May William Wright appeared before the committee and told them he was surveyor of the Birmingham Canal where he had directed the construction of twenty locks and other works. The committee arranged that Joseph Grazebrook would show Wright the line of the canal the following day and that Wright would tell the committee soon afterwards the terms on which he would survey the works 'and … give his Whole Time for that Purpose.'

William Wright was impressed by what he saw. He approved the existing plans, thought 'it would be a good Navigation … easily Effected' and promised to send his detailed proposals within a fortnight.

A few days later Wright offered to act as surveyor, engineer and overall contractor for the whole canal and to cut the navigation at½d a yard under the present price.[7] The committee decided to follow up his offer and Thomas White, one of the directors, agreed to contact his relation in Birmingham to enquire about Mr Wright's character 'especially his honesty, ability, surveying knowledge, his knowledge of construction … etc'. The committee asked Wright to attend their meeting on 20 June to discuss his proposals and in the meantime submit his terms for surveying alone. At this point Wright appears to have changed his mind. Meeting the directors in Stroud as arranged, Wright now declined to contract for the whole canal but offered instead to act solely as surveyor and engineer for £200 a year or a set fee of five hundred guineas until the work was completed. The committee asked for time to consider his new proposals and then agreed Benjamin Grazebrook and his co-director Robert Ellis should visit Warwick and Birmingham to enquire into the characters of William Wright and Edmund Lingard, previously engineer of the Coventry Canal and now apparently an applicant for the post, and appoint either of them or some other person to the post. Shortly afterwards Grazebrook and Ellis reported the results of their 'strictest enquiries' to their fellow directors who decided to offer the post to Lingard on a temporary basis for six to eight weeks at a salary of two guineas a week. During this period Lingard was to survey and direct construction and, provided the committee approved his conduct, they would then appoint him on a permanent basis and accept his proposals for a fee of £300 for supervising the complete construction.

Edmund Lingard entered the company's service on 8 July 1776 and established an immediate rapport with the directors. By 16 July they had determined he should be 'put in charge immediately'. William Wright, writing on 25 July for a 'conclusive answer' on his employment, was told the company could not now accept his terms. The company were even loath to pay the costs of his journeys to meet the directors in Stroud on the grounds that Wright, and not they, had originally suggested a visit to the locality. Eventually the directors agreed to pay Mr Wright's Bill of nine guineas.[8]

The directors, however, did not wait for a surveyor and engineer to be appointed. Anxious to get constructions under way as soon as possible the committee now began to conclude direct labour contracts with a number of specialised workmen including John Pashley, Edward Keene, James Bough, Thomas Howell and Samuel Smith. On 4 April John Pashley, recommended by the directors of the Ripon Canal, was instructed to complete the carpentry work on the first lock and soon afterwards was reported as 'on the road to Framilode'. His work on the already half completed lock continued during June, when he was promising to complete the lock gates within a month, and was probably finished by 16 July when Lingard reported the stop gates were put up, the swing bridge at Framilode completed and the whole of Carters Close cleared. In any event Pashley must have completed the work by the end of August when he submitted his account for making lock gates, cloughs and stop gates intended to prevent the Severn flooding back up the canal.[9]

Like many other directly employed workmen, Pashley stayed some tune with the company and moved on to work on the Whitminster, Bristol Road and Westfield locks as soon as other directly employed workmen had completed the foundations and masonry. By the end of 1776, when the canal was open as far as Bristol Road, Pashley was given additional responsibilities on top of his regular carpentry work on the locks. Earlier in December Samuel Collins Junior had been appointed to take account of each barge load passing through Framilode lock and to collect the 1s 0d (5p) a ton toll for each vessel travelling as far as Bristol Road. These monies should have been handed over to Benjamin or Joseph Grazebrook periodically when Collins should be paid 'what shall be deemed responsible for his trouble.' Within a fortnight Collins was discharged for unspecified reasons paid only 2s 6d (12½p) for his trouble and Pashley was appointed in his place. The speed of his dismissal and the precise instructions issued to

Pashley suggest Collins may have falsified the tonnages, probably without the connivance of the masters, and kept back a proportion of the tolls for himself. Pashley, now resident in the newly built lock cottage at Framilode and possibly with some sort of carpentry workshop on site as well, was given a new set of instructions for collecting tolls which included a double check by the company clerk. When each vessel returned unladen from the Bristol Road, Pashley was to collect the ticket the clerk had given each master when his goods were unloaded and then charge tolls according to the weight Joseph Grazebrook had checked and entered on the ticket. No craft could be let out of the canal until all outstanding tolls had been paid.

This arrangement appears to have continued satisfactorily until the end of August 1777 when the directors told Pashley to hand over the key of the lock and any outstanding tonnage money to Joseph Grazebrook, quit the house and consider himself immediately discharged. His son Benjamin Pashley, who probably acted as assistant carpenter on the canal and had certainly 'behaved himself agreeable to the Committee' was appointed to succeed his father 'in making of the Lock Gates' and to take charge of the cottage at Framilode. The immediate cause of John Pashley's dismissal was the alleged discovery of over-charging in his accounts although there had been a hint of earlier friction nine months earlier when Lingard had been instructed to 'immediately give absolute directions to Mr Pashley to make the Lock Gates at the Bristol Road, and all the remaining Locks of the same Angle as the Lower Lock, and to see that he strictly Adheres to it. Since Pashley was paid by piece work, like most other directly employed workmen, the directors now ordered that his work at Bristol Road and Westfield should be measured to clarify any alleged overcharging before his accounts were paid. The real reason for his dismissal, however, could be the lack of any adequate supervision by the surveyor or some sort of financial connivance with him. Pashley's sudden departure in August 1777 certainly had an immediate effect on the career of Edmund Lingard.[10]

In July 1776 James Bough, the Birmingham stonemason recommended by a local canal company, was employed to undertake all stonework on the navigation probably with the assistance of four or six workers of his own. Bough undertook to arrange delivery of all the stone he needed and to complete the work 20% below any comparable estimate. Within a few weeks Bough was hard at work, supervising the delivery of stone for bridges and stop gates and visiting the Forest of Dean to find suitable stone for the locks. Acting on committee instructions Benjamin Grazebrook often accompanied Bough on these journeys to make sure the stone was good quality material. On their first excursion they found excellent stone near Blakeley which Bough thought 'very proper … for their purpose. In a month or two Bough was using his locally acquired knowledge to advise the committee to use Tintern stone for hollow quoins, coping and culverting and Hanham stone for the foundations of locks and bridges as far as the high water line with sound bricks above it. The committee accepted his opinion on this and several other occasions. During his five years with the company Bough supervised the supply of stone from Hanham and Chepstow, bricks from Bonds Mill and Frampton, pebbles from Aberthaw and timber from Gloucester as well as building several bridges, locks and culverts. Apart from one complaint about the quality of his mortar in the Bristol Road bridge, the company seem to have found Bough a reliable and expert workman. At various times he produced plans for a wall to secure the land below Framilode lock, took levels with Edmund Lingard on Mr James' land at Eastington to fix the site of Eastington (later Turnpike) lock, did the same with John Gleave to settle the rise at Lower Nassfield (later Blunder) lock, built bridges at Bristol Road, Stonehouse Farm, Mr Halliday's, Bridgend Road, Mr Reddall's swing bridge, Haywards Field and Wallbridge, constructed culverts at Ryeford, Lodgemore and Wallbridge, supervised Edward Keene's insertion of an elm trunk to carry the Painswick Water under the canal and bui t Bristol Road, Westfield, Court Orchard (later Dock), Eastmgton, Lower Nassfield and

Upper Nassfield locks. By November 1777 the committee had come to rely on Bough to such an extent that they voted to allow him 5s 0d (25p) a day for attendance when he was called off his work to attend to business of the proprietors.[11] The carpenter Edward Keene was also employed directly although his work was more general than the lock carpentry of John and Benjamin Pashley. Keene had already made wheelbarrows for the company before Purnell's case came to the Gloucester Assizes. Now Benjamin Grazebrook ordered a hundred wheelbarrows as soon as possible to get construction under way. At various other times Keene was involved in examining timber at Broad Oak, Blakeley, Monmouth and Newnham, building wooden swing bridges at Fromehall, Ebley and elsewhere, completing joinery in a company house and warehouse, building wooden culverts for the river at Fromehall and Lockham Bridge and making a board of rules for erecting at Bristol Road.[12]

Samuel Smith began working for the company in May 1776 as the foreman of a gang involved in general construction. Smith was paid a wage of 10s 0d (50p) a week to supervise digging and wheeling clay out of the river, make bricks at several sites including Chippenham Platt coal wharf and to examine the restack bricks at several brickyards operating along the line of the canal. On one occasion he rejected 20,000 bricks made by Thomas Barnard and at another, when he himself had reported the Eastington Road was 'very dangerous', the directors had asked him to lay faggots of wood, old bricks and gravel on the road to improve the surface. Finding him a loyal and efficient servant, the company appointed him to receive the tonnages for all goods landing at Chippenham Platt in February 1778.[13]

In June 1776 the directors appointed Thomas Howell as full time company smith in preference to Thomas Smith and Mr Underwood who had both applied for the same post quoting terms identical to those of their successful rival. Howell's duties included supplying all ironwork for the locks at 1s 0d (5p) per 3 lb and attending on site whenever gates were hung. Once again the company seemed well pleased with his work for, apart from one minor grumble about the speed at which he provided ironwork for the bridges, Howell worked for the company until March 1781 and was still called in for occasional repairs well into the 1790s.[14]

Finally the company retained the partnership of Robert Perry and John Gleave in their employ. Perry and Gleave had supervised teams of cutters working on the canal during the spring of 1775 before John and William Purnell had brought the company to court. Shortly after the new Act had been passed in late March 1776, Perry and Gleave tried to gather new teams of cutters together again and in early April started to dig out out the canal between Carters Close and the Bristol Road. It seems probable Perry and Gleave operated these teams both in unison and separately simultaneously since the company accounts record payments to them jointly and severally at the same time.[15] Towards the end of the year the company became dissatisfied with Robert Perry for on Boxing Day 1776 Edmund Lingard was instructed to measure his work, pay him up to date and then discharge him. A reconciliation followed since by February 1777 Lingard was sending soil to the banks Perry and Gleave were building in Saul Field. Even then relations were not always harmonious. The committee told Lingard to stop their money unless they completed the banks properly and repaired the puddling in the canal at Pool Field where water was coming out of the banks. The partnership between Perry and Gleave may have broken up shortly afterwards as the last recorded payment to them jointly was on 15 March 1777.[16] Both Perry and Gleave remained with the company in their separate capacities and continued to supervise teams of workmen until February 1778 and April 1780 respectively.

Once these key workmen had been engaged, the company was ready to begin construction.

Chapter Fifteen References

1 GCRO D1180 1/1 Committee minutes 3 April 1776, 2/1 General Account 1776 – 94 6 April 1776 – 18 May 1776, 2/17 Cash Book 1775–79 20 January 1775 – 18 May 1776, 9/20 Proposals by Hinton to make Bricks 20 March 1776, GJ 1 April 1776

2 GCRO D1180 1/1 Committee minutes 4 April 1776, GJ 8 April 1776 Benjamin Grazebrook signed this although his son Joseph had replaced him as clerk four days earlier suggesting perhaps the advertisement was drafted before the directors' meeting

3 GCRO D1180 1/1 Committee minutes 22 August 1776, 2/1 General Account 1776–94 20 April 1776, 18 May 1776, 8 June 1776, 17 August 1776, 31 August 1776, 2/10 Ledger 1775–1802 20 April 1776, 17 August 1776, 31 August 1776, 2/17 Cash Book 1775–79 20 April 1776, 15 May 1776, 8 June 1776, 17 August 1776, 31 August 1776

4 GCRO D1180 1/1 Committee minutes 3 April 1776, 18 April 1776, 2 May 1776, 9 May 1776, 25 July 1776, 9 August 1776, 2/17 Cash Book 1775–79 23 July 1774, 4 May 1775, 7 July 1775, 14 October 1775, 24 October 1775, 6 April 1776, 26 July 1776

5 GCRO D1180 1/1 Committee minutes 18 April 1776, 25 April 1776, 2/17 Cash Book 1775–79 27 June 1774, 6 February 1776, 9/20 Mr Dadford's proposals to take the work of the Navigation 6 March 1776

6 GCRO D1180 1/1 Committee minutes 4 April 1776, 30 May 1776, 9/20 Proposals by Mr Glyn to take the work 4 April 1776

7 ½d is approximately 0.2p. This is presumably 0.2p a cubic yard under the present price paid by other cutting contractors like Perry and Gleave

8 GCRO D1180 1/1 Committee minutes 25 April 1776 – 7 November 1776

9 GCRO D1180 1/1 Committee minutes 4 April 1776, 18 April 1776, 11 June 1776, 16 July 1776, 25 July 1776, 9 August 1776, 12 September 1776, 2/10 Ledger 1775–1802 31 August 1776

10 GCRO D1180 1/1 Committee minutes 12 December 1776, 26 December 1776, 28 August 1777 – 11 December 1777, 2/1 General Account 1776–94 3 January 1777, 2/17 Cash Book 1775–79 3 January 1777 11 GCRO D1180 1/1 Committee minutes 4 April 1776 – 18 June 1778 11 GCRO D1180 1/1 Committee minutes 16 July 1776 – 30 October 1779, 2/1 General Account 1776–94 17 August 1776 – 6 July 1782,2/10 Ledger 1773–1802 22 November 1774–20 April 1779, 2/17 Cash Book 1775–79 22 November 1774 – 20 April 1779; 2/18 Cash Book 1779 – 88 24 April 1779 6 July 1782

13 GCRO D1180 1/1 Committee minutes 9 January 1777 – 27 August 1778, 2/10 Ledger 1775–1802 4 February 1779

14 GCRO D1180 1/1 Committee minutes 11 June 1776 – 19 February 1778, 2/1 General Account 1776–94 29 April 1776 – 13 October 1794, 2/10 Ledger 1775–1802 30 October 1776–30 March 1781, 2/17 Cash Book 1775–79 29 April 1776 – 30 March 1781

15 GCRO D1180 Robert Perry 2/1 General Account 1776–94 and 2/17 Cash Book 1775–79 18 May 1776 – 28 February 1778, John Gleave 2/1 General Account 1776–94 and 2/17 Cash Book 1775–79 8 June 1776 – 15 April 1780, Perry and Gleave 2/17 Cash Book 1775–79 20 April 1776– 15 March 1777

16 GCRO D1180 1/1 Committee minutes 26 December 1776, 20 February 1777, 6 March 1777, 2/1 General Account 1776–94 28 February 1778, 15 April 1780, 2/17 Cash Book 1775–79 15 March 1777

Chapter Sixteen
Carters Close to Bristol Road

While these negotiations were continuing several matters arose which needed attention before cutting could begin in earnest. On 11 April 1776, for example, the directors decided to alter the line of the canal at Whitminster and John Jepson, the company solicitor, contacted Richard Owen Cambridge advising him they now wished only to cross the millpond and build the navigation along the north side of the pond rather than using the full length for the canal. Cambridge later gave his consent to this variation which was within the limits allowed by the Act although he deferred answering until a surveyor was appointed and the line at Whitminster finally fixed.[1] Further consideration was given to lock sizes but it was soon agreed these should be the same breadth as Framilode especially after Benjamin Grazebrook measured several vessels and found a maximum beam of sixteen-foot, two-inches. There was some concern as well about the tail of Framilode Lock which was beginning to suffer from the scouring effects of the powerful Severn tides. The committee ordered the lock to be piled and made secure early in April and continued the instructions during May when it was instructed 'to be done immediately', but the work was not started until June. In the same month the directors applied to the landholders of Fretheme and Saul for their consent to and assistance in opening parish ditches and making proper drains through their lands where the canal cut across existing drainage lines. Benjamin Grazebrook enlisted help from William King, one of the most important local tenants, who promised his efforts to persuade the landholders to agree. These drains were built or improved later in the year but John Saunders of Fretbeme maintained they were neither wide enough nor deep enough to convey water from these low lying lands and the ditch from Saul Field to Frampton was improved as a result.[2]

The most serious immediate problem facing the company, however, was an acute shortage of navvies for cutting, bricking and puddling the canal. The teams of around two hundred men Perry and Gleave had built up during the spring and early summer of 1775 had been dispersed when Purnell won his case at Gloucester Assizes. Now Perry, Gleave and other cutting masters had to concentrate on building up their teams once again.[3] This seems to have been a particularly difficult problem for the directors took the unusual step of giving Edmund Lingard complete discretion to hire and fire workmen and to direct them 'to such parts of the work … he shall think necessary.' This navvy shortage evidently persisted for on 25 July the committee decided construction needed speeding up and asked Lingard to 'immediately sett out for the North … to treat with some more Persons to come and undertake the cutting.' Soon afterwards Lingard visited 'several places' in Warwickshire and Leicestershire where he engaged a 'Considerable number of Men'. Some had already arrived by 9 August and the committee noted 'that more are coming in every Day'. A month later Lingard reported nearly a hundred cutters were now employed on the canal.[4]

Information on the origins, wages, conditions and numbers of canal navvies is notoriously deficient for most waterways.[5] The Stroudwater records have been further depleted since most of the remaining wages sheets were dumped on a bonfire in the yard of the former company headquarters at Wallbridge several decades ago. So far as is known only six wages sheets covering parts of the period 10 June to 19 August 1775 have survived and they all refer to the earlier canal building period before the new Act when about

two hundred cutters were employed.[6] Lingard's travels suggest strongly most Stroudwater navvies were not recruited locally but were engaged from other navigations being built at the time. This is reinforced by an outline glance at the surnames of the men employed. The seventy seven known names, however imperfect as a detailed guide, represented about 38% of the navvies then employed. Although lack of any firm evidence about navvies origins keeps this crude measure well within the realms of speculation, only one name; Isaac Clutterbuck, stands out immediately as a possible local recruit unless a listed John Lawrence is the same man as the local millman who gave evidence before the Parliamentary committees. Only one name too; John Higgins, suggests possible Irish connections whereas thirteen others – Thomas, Joseph and Edward Davis, Edward and William Griffiths, Thomas Griffin Bough, Richard Evans, Owen Bowen, Samuel Roberts, William Thomas, Thomas Jones, William John and James Richards – suggest possible Welsh origins. Even if this were accurate it is not possible to determine whether these men came direct from Wales to Stroud or, more likely, indirectly through earlier work on the midland canals.

The predominant absence of local labour is at first surprising in view of the temporary downturn in the local woollen industry at the time.[7] Perhaps questions of relative status played a part if skilled, at least nominally self employed, woollen workers considered them selves superior to such unskilled heavy manual work. If it did it was not a wholly accurate impression of navvy work which besides digging the canal, rampering the ground and puddling clay included several skilled trade like bricklaying, carpentry and ironwork. More likely, perhaps navvy wages and conditions, though possibly not ungenerous by the national standards of the time, were not attractive enough or permanent enough to local workers in an essentially prosperous and long established industrial area like Stroud. Two navvies, William John and Thomas Wells, received only 4*d* (1.7p) and 6*d* (2.5p) a day respectively during August 1775 giving a weekly wage of 2*s* 4*d* (11.5p) and 3*s* 6*d* (17.5p) for a six day week plus the equivalent of one day overtime.[8] Most Stroudwater navvies however received at least 1*s* 3*d* (6.5p) a day and the overwhelming majority got 1*s* 6*d* (7.5p), 1*s* 9*d* (8.25p), 1*s* 10*d* (8.75p) or 2*s* 0*d* (10p) a day giving a weekly wage of between 9*s* 0*d* (45p) and 14*s* 0*d* (70p) for an effective seven day week. By comparison Arthur Young in his tour of the county eight years earlier recorded wages varying from 5*s* 3*d* (26p) a week for labourers to 10*s* 0*d* (50p) and 15*s* 0*d* (75p) for pinmakers and 12*s* 0*d* (60p) to 14*s* 0*d* (70p) for woolcombers all presumably for a six day week.[9] In 1776 the company itself referred to labourers' wages of 10*s* 6*d* (52.5p) a week and 10*s* 0*d* (50p) a week for Charles Wheeler, the company carter.[10] For already skilled workers therefore Stroudwater navvy wages were probably not attractive in either terms or conditions particularly if they remembered the detailed supervision such employment would entail; something they at least often managed to escape by working on their own looms in their own cottages. In these circumstances the company were obliged to recruit most navvies from lower wage areas where alternative forms of industrial employment were not so available or so attractive.

Yeoman had earlier advised the committee not to 'contract with any Person for the whole [canal]' although 'the greatest Part of the Digging … may be lett … and perhaps … some of the Bridges done by Contract: But the *Locks, Aquaducts, Stopgates* and other important Works, I earnestly recommend to be done by your own people in the best and most effectual Manner'.[11] Taking this advice the company followed their earlier arrangements of letting sections of the canal out to different cutting masters who organised each cutting team of around nineteen or twenty men on a daily basis laying them off when materials were in short supply or there were some other impediments. During June and the first part of July 1775 all navvies worked only three or four days a week. Although no navvies worked on Sundays, by late July and all August virtually all men were putting in the equivalent of six and three quarters or seven day weeks while there was work to be had during the light summer evenings. All this time Benjamin and Joseph Grazebrook kept a close eye on each navvy, recording whether or not be put in a full or part day and then paying the cutting masters each Saturday evening in full.

With so few wages sheets available it is not possible to estimate turnover with any degree of accuracy. Comparing the periods 31 July to 5 August and 14 August to 19 August 1775, seventeen of the nineteen navvies remained on two comparabl wage sheets. But with navvies probably divided into groups with different skills it seems likely there was a good deal of interchange between different cutting teams as the type and volume of work varied on each cutting section. At one time, for example, cutters may be in demand and once their job was completed they might have moved into another team where the volume of cutting work was expected to increase. Meanwhile ramperers, bricklayers and puddlers would in turn start work on the original section the cutters had completed and then move on themselves as their own skills were needed in other parts of the work. Several navvy names like Edward Catstree, John Insull and John Lawrence reappear elsewhere during the construction period suggesting perhaps the most able and talented workers may have been promoted to particular posts of responsibility.

There is some suggestion too that some navvies were related to each other. Perhaps father and son, two brothers or uncle and nephew had left home together to seek work on the canals. Apart from Thomas and Joseph Hide, Richard and Robert Taylor, there was John and George Baker as well as James and Robert Perry.[12] Occasional scraps of information on the navvies are scattered sparingly through the records providing only a brief and insubstantial glimpse into their world. Some workmen like 'Ships Carpenters', probably helping John Pashley build lock gates, were in sufficiently short supply for the company to pay Thomas Cullis for their board and lodging at the New Inn, Framilode, as well as for 'liquor for the men' at unspecified times between April 1776 and November 1780. In November 1776 another publican, Richard Lewis, was paid for 'Ale for the Men whilst digging out ye stanks at the Millpond' probably at Whitminster and at some other unknown date Henry Hathaway submitted Bills for 'beer for Mr Pumell's men assisting with the mud'.[13] Accidents and even death are also recorded. Griffith Cooper received £2 17s 10d (£2.89) in August 1776 for burying Richard Golding and four months later Thomas Jennings was paid £1 1s 0d (£1.05) for 'reducing Williams' dislocated shoulder and Catstree's fractured rib'.[14]

During this period too the directors began to concern themselves with making arrangements for the supply of building materials needed in constructiqn. First of all, though, they asked their new clerk Joseph Grazebrook, freshly appointed at that first general meeting on 4 April 1776, to visit Richard Hall at Framilode to check the inventory of tools and equipment. By this stage Richard Hall had decided to retire from the company and a few weeks later handed over the details of the cutters' work which he had kept since the earliest days of construction. When the company settled their final accounts for 'Bills of fare' at his New Inn just before he handed over to Thomas Cullis, Richard Hall at first refused an extra ten guineas the directors offered him for his 'extraordinary trouble' but later accepted it.[15] In the meantime discrepancies in the inventory led to the firm declaration that no servant could sell or otherwise dispose of any materials or tools belonging to the company 'at the Peril of the Person so offending'.[16] William Pritchard took Pierend Clissold to prison soon afterwards perhaps for breaking this instruction.

By and large the company drew virtually all its construction materials from within a radius of thirty or forty miles although the greater part of this came from even more local sources. Bricks, for bridges, aquaducts, warehouses, lock chambers, lock houses and to line the canal bed, were a basic raw material of construction.[17] During the summer of 1776 Edmund Lingard and Benjamin Grazebrook negotiated with a number of local brickmakers including Edward Hinton, Thomas Barnard, Thomas Davis, James Hawkins and Joseph Morris for the supply of several hundred thousand bricks at prices from 11s 0d (55p) to 12s 0d (60p) a thousand. Both Hinton and Barnard had supplied bricks during 1775 before Purnell had brought the directors to the Gloucester assizes and both were ready to begin work again before the general meeting on 4 April. Although Hinton soon left the company's service in an unexplained hurry, Barnard and most of the other brickmakers continued to supply bricks until the canal was finished.

For the first few months after the general meeting and before these brickmakers could get sufficient production under way, supplies of brick were unable to keep pace with bricklayers lining the bed of the canal and the company imported bricks from Frampton and elsewhere to make up the deficit. When this supply also proved insufficient, navvies were laid off for several days until supplies were made up again. To try and supplement these sources the company asked Mr Hassell of Trentham in the Potteries if he would propose terms for making over a million bricks. Although Lingard wrote to Hassell explaining the usual procedure was for the corn pany to supply clay dug out of the line and for each brickmaker himself to supply all other raw materials, Hassell and the company never agreed terms. By this stage James Bough had successfully proposed to supplement the erratic workload of his own team temporarily by making bricks as well. The shortages were eased still more soon afterwards when George Maskell began to supply bricks and continued to fire them for nearly two years. At the same time George Edwards began to make bricks in tens of thousands and rapidly became chief supplier to the company. Over the years Edwards sold over two-and-a-half million bricks to the company which, excluding the unnumbered bricks made by Mr Bough's own men, represented about half the total used in construction.

Usually brickmakers fired bricks adjacent to each section of canal as it was constructed by taking clay the cutters had dug out of the line nearby. Often the brickmakers either moved their yards eastwards as the cutters worked from Framilode towards Wallbridge or the directors employed men like Samuel Ping, William Seal or Edward Loton to transport bricks from various canalside yards to wherever construction was under way. The complete picture is rather more complex than this, however, for not all clay was useable, many bricks were imported from outside the immediate area of construction and George Maskell was making bricks at Wallbridge some time before the cutters were there in earnest. When Lingard supervised a trial baking of three clay types only two were found suitable for brickmaking. Similarly, the directors told Maskell to close his yard at Wallbridge when the culvert had been completed there and to 'immediately set all his hands to work ... in Mrs Bond's land near Bonds Mill' at Stonehouse. When Maskell failed to comply a fortnight later, the committee ordered 'no more money be paid him until he setts his men to work there'.[18] Apart from these yards, Maskell, Edwards, Bough and Barnard all had brickyards at Stonehouse while two other yards both run by Barnard were located above Butt Lane bridge and in Mr Martin's land near Lockham Bridge. Joseph Morris had a yard at Pool Field, Saul, and there were doubtless many other yards whose locations are unknown. Equally although most bricks were made on site, the company imported bricks from other sources when locally burnt bricks were in short supply. During the first year of construction, for example, directors bought regular trow loads from Frampton and Hock Ditch. By July 1777 local supplies were keeping pace with construction needs and the earlier acute shortage disappeared completely. When the committee reported 'no want of any more brick to be made at Wallbridge for some time' they made no attempt to move them to the main construction site but sold them for 'ready money' instead.[19]

For several months imports of bricks were substantially reduced until another shortage developed during the winter of 1777–78. This second shortage was probably aggravated by a heavy demand during the previous summer which prevented brickmakers laying up sufficient stocks before the onset of winter. In November the directors found remaining stocks inadequate and enquired after bricks at Frampton once again. Apart from these bricks Thomas Barnard had on site for 11s 0d (60p) a thousand, they only located 150,000 'very good bricks' at Frampton Platt for 11s 6d (57½p) a thousand. Bough visited Thomas Davis at Frampton to buy 'all he can secure' and sent the company trow to fetch them. Even regular trow journeys over several weeks proved insufficient to meet the bricklayers demand and Joseph Grazebrook went to Hanham near Bath to try and procure more vessels. Richard Davis was told to take his own vessel to Frampton 'immediately' and Benjamin Grazebrook, unable to locate an available craft, offered

his own trow instead. This the committee gladly accepted.[20] To increase supplies still further Benjamin Grazebrook pegged out Mr Webb's lower meadow at Wallbridge so brickmakers could use the clay there. Extra cargoes of bricks from Stourbridge and possibly Stourport too arrived at Chippenham Platt. As late as March 1778, however, the company house planned for Samuel Smith at Eastington was postponed when the bricks were needed for the locks nearby. Even with more casual brickmakers employed during the spring on terms the 'same as last season' the directors could still prohibit any more bricks being sold 'except those already con tracted for'. From the summer onwards the supply position gradually improved and proceeded uneventfully until the canal was completed.[21]

Even when bricks were available there were occasional complaints about their quality. At one time Joseph Morris' bricks were 'very badly burnt' and other 'sundry persons' confirmed the bricks Barnard was making at Stonehouse were 'exceedingly had and unfitt for our purpose, owng to their not being properly burnt'. Once the committee msisted they would only pay for bricks Benjamin Grazebrook or.another company representative had approved the general quality seems to have improved.

Similar shortages affected supplies of stone during the first few months of renewed construction. The company needed stone for the foundations of locks and bridges, for coping lock sides, for quoins where the lock gates were attached to the banks, and for banking at wharves and bridge holes. Benjamin Grazebrook lost no time planning deliveries from Griffith Cooper, Thomas Gethen and Peregrine Martin but even then regular shipments of good quality stone took several months to arrange. Early in April 1776 Benjamin Grazebrook visited Griffith Cooper in the Forest of Dean to contract for deliveries of local stone at 8s 5d (42p) a ton delivered to Newnham on the banks of the Severn. Griffith Cooper had supplied several hundred tons of stone during 1775 which had been used to construct Framilode Lock foundations and sides strong enough to withstand the powerful Severn tides. Now Griffith Cooper could promise to deliver some stone later in the month and agree to allow the company to hew stone themselves from his quarry but could not guarantee regular supplies to the company. In June Grazebrook visited the Forest once again and exammed stone near Blakeney which James Bough thought excellent for their purpose. The owner agreed to allow the company to use the quarry for twenty years for a total of £35 provided the company found transport from the quarry to the Severn and from the river to Framilode. Within a month or two Grazebrook and Lingard took two men along with them to repair the road from the quarry to the riverside and William Lodge was engaged to carry the stones to the construction site.[22]

Even this was not sufficient and in August 1776 the company advertised in the *Gloucester Journal* for 'Any Person … willing to supply … good Weather Stone and hard-burnt bricks fit for building Locks etc' to send proposals to Joseph Grazebrook with prices including delivery to Bristol Road and Chippenham Platt. Although James Bough could still complain of 'an immediate want of 600 of proper stone for culverts' a few weeks later, the advertisement put the company in touch with several useful suppliers. Within a month or two again the company ordered a thousand tons of key stones and James Bough had examined some at Hanham, which he thought suitable for lock and bridge foundations, and at Chepstow and Tintern Abbey in the Forest of Dean, which he preferred for quoins, coping and culverts. Before the end of the year Benjamin Grazebrook concluded agreements with quarry owners at Hanham and Tintern Abbey as well as with Walter Bowen of Chepstow who became the largest single supplier of granite to the company.[23]

The supply position improved markedly over the next few months. Samuel Simmons made regular voyages to Hanham and Tintern Abbey in the 'Stroud' and William Deague undertook to provide two hundred tons a month after a successful tnal run from Hanham. Adequate supplies were still doubtful in May when Bough visited Hanham to speed up deliveries and make sure only 'fit stone' was sent. It was not until December 1777, when the company was offered full supplies from Hanham,

that they eliminated occasional loads from Shropshire and Rugeley in Staffordshire. Leaving aside one delivery John Wilcox brought from Higley Quarry and a contact with Richard Wall for ragg stone from Rodborough Hill for Ryeford culvert, Dudbridge bridge and 'other purposes' the company were now regularly supplied with sufficient stone from their three main sources.[24]

The company also required limited amounts of limestone for cement. Part of this came from Barrow in Leicestershire, part from stones dug out of the canal, mainly in the early stages of construction before it was found unsuitable, but most came from the mouth of the River Thaw west of Barry in south Wales although it was usually bought from local agents like Mr Hill of Berkeley rather than carried in company owned or company tendered barges.[25]

The most serious and persistent shortages, however, were in supplies of oak timber 'immediately wanted for the locks' as soon as the first general meetmg was over. Benjamin Grazebrook started to look for suitable timber before the end of April and contracted for the delivery of sixteen oak trees a few days later but here again regular supplies of good quality timber proved an almost permanent headache for the company.[26] At first Benjamin Grazebrook and John Pashley concentrated their attention on timber belonging to Richard George and examined oak timber in Bristol, Upton-upon-Severn and 'up the Severn' near Gloucester. Richard George had supplied timber for Framilode Lock ates during the autumn of 1775 and was now approached to supply it for Whitminster and Bristol Road locks. Some of his deal planks were considered 'improper' and returned but George delivered timber regularly until September 1780 and became the largest single supplier to the company. Similar problems arose with John Kemmett, now apparently recovered from his earlier financial embarrassments and praetising as a Bristol ironfounder. Kemmett delivered oak timber from Deerhurst to Framilode but when it arrived the directors found 'a considerable quantity of his timber … was equally 'improper for our use' and only paid a reduced price for pieces they approved. Even the timber Benjamin Grazebrook looked at near Gloucester was too small to be of any use.[27] In August, therefore, the company contacted Ralph Sheward of Upton-upon-Severn who agreed to deliver oak planks to Framilode at 1s 9d (9p) a foot. By early November, when the timber had been shipped to the construction site, Pashley found it 'very defective … not fite' for use and much of this too was rejected. Itwas the first and only dealing the company had with Sheward.[28]

At this stage the directors decided to try and alleviate the shortage by advertising for 'good seasonal timber' in both the Shropshire and *Gloucester Journals*.[29] Through these and other contacts the company was soon in touch with timber merchants in Shropshire, Worcestershire and Hereford as well as about half a dozen in tJ;ie For st of Dean. Even this new selection brought its share of disappointments. The clerk received no reply from the letter sent to Mr Field of Shropshire in October 1776 and by the time George Oakes of.the same county was asked to bring down a bargeload of oak tunber a few months later all his stock had been sold. Oak held out some prospect of supplies later in the year but hts name fails to reappear in the minutes and there are no accounts of any purchases from him.[30] Similarly David Price of Hereford and an unnamed Worcestershire timber merchant are only mentioned once in passing and although John Pashley certainly visited a Mr James in Hereford and recommended timber at five pence a foot delivered to Framilode, there is no further word of any delivery or payment to him either. Some of the Gloucestershire timber merchants proved equally unpromising. For a start, the company received no answer from Mr Lewis at Purton passage. John Wall of Cam and John Linton both offered oak timber but this was found unfit' and 'no good' upon examination. Edward Keene visited Newnham to look at reportedly seasoned oak timber belonging to Mr Bowen but since be too came away empty banded we may presume none was suitable for company needs.[31]

The company was more successful with other local timber mer chants. John Edmunds of Newent supplied timber worth £73 17s 0d (£73.85) including some used for the cills of locks and after a load Edward Keene had bought from Thomas Powell of Brad Oak was held up waiting for a spring tide, it too finally

arrived safely at Framilode. The elm trees from Richard Martin's land lying along the intended route of the canal, together with many small purchases from landowners like Daniel Chance who were in a similar position, proved useful supplements to company supplies. There is some evidence to suggest Mr Lewis of Woolerstone near Blakeney and Richard Bigland both sold timber to the directors although there is no record of any payments to them for timber. In February 1777 Richard Davis offered to deliver oak timber to Chippenham Platt at 1s 8d (8½p) a cubic foot including some oak posts and ash railings to fence the towing path and company lands. Although snow prevented Edmund Lingard examining the timber for several weeks, Richard Davis became one of the chief suppliers over the next two-and-a-half years with repeat orders for posts, poles and oak. Only Endell and Evans of Monmouth, who delivered a hundred and twenty oak trees in September 1778, and Richard George exceeded the value of timber Davis supplied.[32]

Even when some local timber merchants agreed to supply the company they could not always be relied upon to keep their word. Even though Keene was detailed to attend 'from time to time to see it is cut proper for our purpose' and Richard Davis promised to send only 'what Mr Keene' approves, the company later discovered the poles he supplied were not those Keene had looked out in Davis' grove. In March 1777, when Anthony Keck was touring Gloucestershire and Worcestershire searching for suitable timber he concluded an agreement with William Price of Gloucester to deliver oak scantlings to Framilode for 1s 9d (9p) a cubic foot. Five weeks later the timber had not arrived and James Bough was sent to Gloucester to accelerate delivery. In June another company representative, this time the more authoritative Benjamin Grazebrook, visited Price with specific instructions to threaten legal proceedings if the timber failed to arrive. Shortly afterwards Price delivered part of the timber promising scantling for another lock in a fortnight or so. When Price still failed to deliver in full by early July Anthony Keck wrote advising him the company intended to take 'proper measures to enforce' the contract if he failed to fulfil it. The saga continued through August when some more scantlings arrived although part of this delivery was 'bad and cannot be used'. In September the matter passed to John Colbome who wrote again outlining company intentions to sue if the full order was not supplied. Price promised to deliver 'in a fortnight' but had not kept his word by the beginning of October. A week or two later Price was paid in full for all timber .he had delivered so far and Anthony Keck was told to enforce the contract he entered into with Price on behalf of the company. No more is heard of this dispute. Despite these difficulties, the company continued to buy timber from Price for a further six months; a clear indication that earlier timber shortages were still not overcome as late as April 1778 and that in spite of the obvious frustrations irregular supplies from Price were preferable to the prospect of an even more serious shortage.[33]

During 1776 the company relied mainly on suppliers or carriers to convey all these building materials to the various construction sites. Men hauling stone from Hanham or Tintern Abbey, for instance, were expected to provide their own labourers and not rely on company personnel. If they did borrow company employees on occasions they were expected to pay for it. The same policy applied to company property. Edwards, the brickmaker, had £5 5s 10d (£5.29) deducted from his pay for using company wheelbarrows and planks and on one occasion in 1778 Edward Keene was charged 10s 6d (52½p) for borrowing the 'Stroud' to fetch timber from Newnham. Towards the end of the year this policy was modified, at least as far as labour was concerned, and in an attempt to cut transport costs the committee decided to employ direct labour instead to bring most materials to Framilode. Benjamin Grazebrook bought a barge and a small boat from Benjamin King for £20 and the trow 'Stroud' from Richard Hall for £52 10s 0d (£52.50). William Esthop was engaged as master at the wages of four guineas a voyage to the quarries and 3s 6d (17½p) for every thousand bricks brought from Frampton. To help earn its keep the 'Stroud' was expected to carry general return cargoes wherever possible when the freight charges would 'be placed to the Credit of the Company.'[34]

The same pattern began to emerge for company road services after the committee asked Benjamin

Grazebrook to buy carts, waggons and a team of horses to collect the building materials from Framilode or their local point of origin and distribute them along the line of construction. Within a week or two Grazebrook had bought two horses and a cart and employed Charles Wheeler as company carter for 10s 0d (50p) a week. Soon afterwards the wheelwright Richard Povey was engaged to build an additional waggon and cart both with six inch wide wheels to minimise the worst deficiencies of the local roads. At the same time Edmund Lingard bought four more horses, including one from Farmer Kersey and two from Gloucester fair, arranged to rent Richard Martin's stable in exchange for the horses' dung and tried to provide regular hay supplies for the animals. This proved a difficult problem on occasions. At one time Lingard reported 'an immediate want of hay' and at another found part of a hayrick bought from Mr Wathen at Ebley was partially damaged by damp.[35]

The company did not need to wait until all these labour, material and transport problems were solved before cutting could start again. Early in April 1776 the first team of navvies were put to work at Framilode and John Pashley was preparing to complete the carpentry work on the lock there, left unfinished and protected from the weather the previous autumn when Purnell had stopped construction. Once again the master of each cutting team was paid a set sum for each square yard of canal his gang dug although he was allowed to draw 10s 6d (52½p) a week from the treasurer for each man employed until the land was properly measured by Edmund Lingard or some other company servant. This time cutting went ahead unhindered and by the end of June the two main cutting masters, Robert Perry and John Gleave, had been paid nearly £750 for their work.[36] On 23 May the company paid the generous terms agreed a few days earlier for John Purnell's land and Framilode 'directly wanted to proce.ed with the work' and sent cutters into the long disputed Carters Close at once to complete the work begun the previous year. By the middle of July, when John Pashley was well advanced with his carpentry at Framilode Lock, Lingard re ported the whole of Carters Close was now cleared and completed, the swing bridge was in place and the stop gates inserted at the bridge narrows were erected to prevent the Severn flooding back up the cut. When the engineer let water into this short section a few days later, however, the directors found part of the cut was too shallow and immediately ordered it should be deepened to the six feet ordered in the original instructions.[37] There is no direct evidence to suggest this deficiency stemmed from poor workmanship or inadequate supervision although it may be significant Edmund Lingard was given comprehensive powers the same day to discharge any day workmen 'he shall think proper', direct them to whatever section of the work needed the greatest attention and to prevent masters employing additional men without his particular consent. At the same time the directors ordered a level to enable Lingard to check cutting depths and the volume of land cut more accurately. Ten days later Lingard told the committee the canal was now drained ready for deepening to a proper six feet depth.[38]

By early August, when Lingard had engaged several dozen more navvies from Warwickshire, Leicestershire and elsewhere, cutting was proceeding apace. At first the committee asked Benjamin Grazebrook and Lingard to peg out the line to Bristol Road but changed their minds almost immediately and asked them to 'set out the lands' as far as Chippenham Platt instead. The line was soon pegged out at least to Bristol Road and all cutters were put to work there straight away under the detailed supervision of the several masters ofcutters. By this stage, James Cocksey, James Houghton and Samuel Smith were each supervising teams of cutters to supplement the workmen employed by Perry and Gleave. Perry and Gleave often combined their teams under their joint control but the new masters of cutting seem to have kept their teams under separate control at all times.[39] Apart from coping stones, still awaiting delivery from the Forest of Dean, Framilode Lock was completed before the end of August when John Pashley submitted his account for building the lock gates there. Although there is no direct evidence again, the navvies had probably cut out the site of Whitminster lock chamber by this time and James.Bough may

have laid the basic stone foundations as well so that Pashley could move on to Whitminster lock as soon as Framilode was completed. Whitminster lock was certainly completed and useable before the end of the year even though Pashley did not send his account in until February 1777.[40]

Even though minor jobs like cutting drains, levelling and soiling banks, finishing Moor Street culvert to drain Saul and Pool Field 'with all possible speed', puddling the canal through Pool Field and gravelling the road over Moor Street canal bridge still remained to be completed, the main centre of construction had shifted to Whitminster by September 1776. Benjamin Grazebrook and Lingard selected a site for a bridge on Lord Middleton's land there and the cutters had certainly entered both his, James Clutterbuck's and Samuel Peach's land by the end of the month. Around the same time, too, the committee were calling in estimates for masonry work on the foundations of Bristol Road bridge and lock.[41] Cutting towards the Bristol Road continued during the late autumn. Around 24 October some navvies were working at Lockham bridge piling op earth dug out of the canal to build approaches to the accommodation bridge the company had promised to build there for Richard Martin even though the bridge itself was not started until several weeks later. By early November most of the cutting west of Bristol Road was completed for the committee specifically instructed that the 'Cutters must not … [cut] this side of Bristol Road until they bave cleared up and finished all work' as far as the projected new main road bridge. Edmund Lingard was asked to measure up all the final cutting as far as the road and submit balances of work completed. At the same time difficulties over supervising about a hundred or so cutters working under several different masters seem to have come to a head. Lingard was instructed to stand in for the committee on a day to day basis and take the 'whole of the Cutting … under his immediate inspection and care; to let it out in several parcels to a man, or setts of Men, as he shall see fit for the Company's interest'. In an attempt to speed up decision making Lingard was also empowered to conclude individual agreements with cutters for specific jobs provided each job did not exceed £10.[42]

Sometime after 7 November, when there was still no water in the Moor Street length at Saul, the canal was opened to Bristol Road. On 12 December Samuel Collins Jnr was appointed to take tonnages of cargoes, collect 1s 0d (5p) a ton for all goods carriea up to the new Bristol Road wharf receiving 'what shall be deemed reasonable for his trouble' in return. Five days later, on 17 December 1776, the trow masters Richards and William Doughty locked their two craft through Framilode and brought the first toll paying cargo of over sixty tons of coal to the temporary bead of navigation at Bristol Road.[43]

Chapter Sixteen References

1 GCRO D1180 1/1 Committee minutes 11 April 1776 – 25 April 1776

2 GCRO D1180 1/1 Committee minutes 11 April 1776, 25 April 1776, 30 May 1776, 11 June 1776, 20 June 1776, 4 July 1776, 29 August 1776, 26 September 1776

3 GCRO Hyett Pamphlet 353 Verse 21 *The Chronicles and Lamentations of Gotham* 'And behold the same thereof went up through all the country of the north, and there came two hundred chosen men, men dexterous at the mattock, and such as were skilled in wheeling the barrow '. This poem, written before the new Act of 1776, refers to the earlier period of February to August 1775

4 GCRO D1180 1/1 Committee minutes 4 April 1776, 11 April 1776, 2 May 1776, 9 May 1776, 16 July 1776 25 July 1776, 9 August 1776, 12 September 1776

5 Burton, Anthony, *The Canal Navvies*

6 GCRO D2571; David Boakes, I Riveredge, Framiload; single wages sheet donated by M. A. Handford 10 GCRO; GCRO D1180 2/72 single wages sheet; Duncan Young, Middle Hill Farm,

Chalford; Frederick Rowbotham, 76 High Street, Stonehouse; Stroud Museum 57.26 and 66.67 single wages sheets, courtesy of Lionel Walrond. Two further sheets have recently been discovered too late to be included. They confirm the points made in the text.

7 GCRO D1180 5/1 Dallaway, William, *The Case of the Stroudwater Navigation*

8 Frederick Rowbotham's wages sheet

9 Young, Arthur, *A Tour Through the Whole !sland of Great Britain 1641767*

10 GCRO D1180 1/1 Committee minutes 4 April 1776, 6/1

11 GCRO D1180 5/1 Extract from *Gloucester Journal* with Yeoman's letter dated 19 November 1774

12 GCRO D1180 2/17 Cash Book 1775–79 23 November 1776

13 GCRO D1180 2/1 General Account 1776–94 30 April 1776 – 9 November 1780, 2/18 Cash Book 1775–79 November 1776

14 GCRO D1180 2/1 General Account 1776–94 1 August 1776, 13 December 1777

15 GCRO D1180 1/1 Committee minutes 11 June 1776, 2/1 General Account 1776–94 and 2/17 Cash Book 1775–79 both no date, Samuel Collins 2/1 General Account 1776–94 30 April 1778, John Longney 2/1 General Account 1776–9416 June 1778, Anthony Keck 2/10 Ledger 1775–1802 20 July 1780, William Easthop 2/10 Ledger 1775–180210 February 1777, 14 February 1777

16 GCRO D1180 2/10 Ledger 1775–1802 Samuel Collins 6 December 1777, 2/17 Cash Book 1775–79 John Longney 29 March 1777 – 28 May 1781

17 GCRO D1180 2/17 Cash Book 1775–79 Edward Hinton 20 January 1775 – 18 May 1776, 2/17 Cash Book 1775–79 Thomas Barnard 21 December 1776 –20 November 1778, 2/17 – 2/18 Cash Books 1775–1788 Thomas Davis 27 May 1776 – 21 September 1781, 2/17 Cash Book 1775–79 James Hawkins 6 July 1776– 21 December 1776, 2/17 Cash Book 1775–79 Joseph Morris 20 April 1776–12 April 1777, 2/17 Cash Book 1775–79 George Maskell 18 January 1777 – 3 January 1779, 2/17 Cash Book 1775–79 George Edwards 21 December 1776– 20 November 1778, 1/1 Cominutes 20 June 1776, 4 July 1776, 22 August 1776, 21 November 1776, 8 December 1776, 2/10 Ledger 1775–1802 22 November 1777 'John Anables is Joseph Morris' workman'

18 GCRO D1180 1/1 Committee minutes 24 October 1776, 7 November 1776, 21 November 1776, 5 December 1776, 17 April 1777, 5 July 1777, 24 July 1777, 7 August 1777, 4 September 1777, 29 January 1778, 26 September 1778, 2/1 General Account 1776–94 26 September 1778, 24 November 1778, 8 May 1779, 2/10 Ledger l 775–1802 no date and May 1777 November1779, 2/17 Cash Book 1775–79 7 October 1777

19 GCRO D1180 1/1 Committee minutes 5 December 1776, 29 May 1777, 2 June 1777, 12 June 1777, 26 June 1777, 24 July 1777, 7 August 1777, 5 November 1777, 12 November 1777, 2/1 General Account 1776–94 16 June 1778, 2/10 Ledger 1775–1802 no date

20 GCRO D1180 1/1 Committee minutes 5 November 1777, 12 November 1777, 20 November 1777, 4 December 1777, 11 December 1777, 15 January 1778, 19 February 1778, 26 February 1778, 16 March 1778, 26 March 1778, 21 May 1778, 2/1 General Account 1776–94 16 June 1778, 2/10 Ledger 1775–1802 6 December 1777

21 GCRO D1180 1/1 Committee minutes 22 January 1778, 29 January 1778, 26 February 1778, 5 March 1778 6 April 1778, 18 June 1778, 2/1 General Account 1776–94 2 May 1778

22 GCRO D1180 1/1 Committee minutes 11 April 1776, 18 April 1776, 11 June 1776, 20 June 1776, 22 August 1776, 29 August 1776,2/1 General Account 1776– 94 P Martin 15 June 1776–27 July 1776, 2/17 Cash Book 1775–79 G Cooper 3 June 1775, 1 September 1775, 2/17 Cash Book 1775–79 T. Gethen 10 April 1776

23 GCRO D1180 1/1 Committee minutes 26 August 1776, 12 September 1776, 26 September 1776, 15

October 1776, 24 October 1776

24 GCRO D1180 1/1 Committee minutes 6 March 1777, 20 March 1777, 1 May 1777 11 December 1777, 27 November 1777, 4 December 1777, 5 February 1778 9 January 1777, 20 February 1777, 2/1 General Account 1776–94 6 December 1777, 12 December 1777 Samuel Wilcox and John Wild, 2/10 Ledger 1775–80 27 May 1777–26 June 1778, no date Bough and Edge, 14 August 1777 John Wilcox, 7 September 1778 William Lodge, 1779 no date William Franklin

25 GCRO D1180 1/1 Committee minutes 26 March 1778, 6 April 1778, 7 May 1778

26 GCRO D1180 1/1 Committee minutes 25 April 1776, 2 May 1776

27 GCRO D1180 1/1 Committee minutes 2 May 1776, 9 May 1776, 25 July 1776, 9 August 1776, 22 August 1776, 29 August 1776, 26 February 1778, 2/17 Cash Book 1775–79 4 September 1775 – 22 February 1780

28 GCRO D1180 1/1 Committee minutes 9 August 1776, 3 October1776, 5 October 1776, 24 October 1776, 7 November 1776, 2/1 General Account 1776–94 9 November 1776

29 GJ 28 October 1776

30 GCRO D1180 1/1 Committee minutes 7 November 1776, 20 February 1777–20 March 1777

31 GCRO D1180 1/1 Committee minutes 15 October 1776, 24 October 1776, 7 November 1776, 21 November 1776, 12 December 1776, 26 December 1776, 9 January 1777, 23 January 1777, 6 March 1777, 20 March 1777

32 GCRO D1180 1/1 Committee minutes 26 December 1777 – 19 February 1778, 2/1 General Account 1776–94 12 April 1777 – 24 May 1777, 5 July 1777 – 30 December 1779, 7 July 1778 –26 September 1778 John Bisley of Grays sold two hundred feet of oak post to Edward Keene

33 GCRO D1180 1/1 Committee minutes 31 March 1777 – 16 October 1777, 29 January 1778 – 26 March 1778, 2/1 General Account 1776–94 11 October 1777 – 10 April 1778

34 GCRO D1180 1/1 Committee minutes 20 June 1776, 22 August 1776, 7 November 1776, 12 December 1776, 26 December 1776, 23 January 1777, 4 April 1778, 26 June 1777 ('Company to find freight and cariage of stone. Bough to pay for loading and unloading of same'), 29 January 1778, 2/1 General Account 1776–94 14 December 1776

35 GCRO D1180 1/1 Committee minutes 9 January 1777 – 24 July 1777, 2/17 Cash Book 1775 – 79 4 April 1777 – 13 June 1777

36 GCRO D1180 1/1 Committee minutes 4 April 1776, 18 April 1776, 20 June 1776

37 GCRO D1180 1/1 Committee minutes 16 May 1776, 23 May 1776, 16 July 1776, D2501 Cl/17 An undated letter of after 1768 which could refer to these discussions. Mrs Davies to her daughter Mrs Thomas following a discussion of the Purnell family 'I am surprized at Carters losing a bargain he appeared to be so very intent upon getting [for] so small a sum as two or three pounds which I believe is all he stands out for'

38 GCRO D1180 1/1 Committtee minutes 25 July 1776

39 GCRO D1180 1/1 Committee minutes 9 August 1776, 22 August 1776, 2/1 General Account 1776–94 26 July 1776

40 GCRO D1180 2/10 Ledger 1775–1802 31 August 1776, 1 February 1777

41 GCRO D1180 1/1 Committee minutes 26 September 1776, 24 October 1776, 29 May 1777, 1/2 Committee minutes 23 November 1776 Alexander Clark 8/2 Measurement of the Canal and Towing Path belonging to the Rt Hon Lord Middleton 27 May 1777, Measurement of the Estate of the late Samuel Peach 13 April 1786

42 GCRO D1180 1/1 Committee minutes 24 October 1776, 7 November 1776

43 GCRO D1180 1/1 Committee minutes 7 November 1776, 12 December 1776, 4/1 Tonnage Book 17 December 1776

Chapter Seventeen
Bristol Road to Chippenham Platt

Within a few days of opening the directors were seriously disturbed by reports of 'Impositions on the Publick'. 'Attempts have been already made', their minutes from the extraordinary committee meeting on 30 December complainingly record, 'to enhance the Price of Coals … brought up the … Canal'. It is possible part of the higher than expected prices coal merchants were charging stemmed from genuine cost increases, from some seasonal or temporary shortage in supply or that the directors had overestimated the savings a mile or two of improved transport facilities would bring. In their own mind, however, the committee were convinced they faced blatant racketeering by suppliers of this scarce, expensive and vital industrial commodity. To help counteract this and enable 'the poor as well as … Manufacturers … [to] have Coals delivered … as Cheap Terms as Possible' the directors decided 'all Coals sold to Waggons at a price not exceeding twelve Shillings and Sixpence [62½p] per Ton Shall be free of Wharffage, and all sold above that Price Shall pay One Shilling [5p] per Ton … for the same'. [1]

An advertisement in the *Gloucester Journal* on 6 January 1777 found their rhetoric more subdued but their determination unimpaired. To ensure a regular supply of this 'necessary Article' at competitive prices the company established 'A Subscription … for purchasing Ten Thousand Tons of Coal, to be delivered on the wharfs … before 1 May' and asked 'Any Persons willing to contract for the whole or any Part of the above Quantity … to give in their Proposals to Joseph Grazebrook, of Stroud'. [2] This deliberate policy of forming a coal importing company had several important objectives. In the first place the directors hoped it would replace the persistent shortages and often irregular supplies of coal with a certain, regular and voluminous supply of a raw material crucial to any expansion of the local economy. Secondly, they intended the sale of these large tonnages would bring down coal prices in the locality and provide sufficient competition to prevent other coal merchants maintaining the high priced coal market which had so often been one of the clothiers' principal complaints. Thirdly the directors considered large and easily available supplies of competitively priced coal would not only build up a demand for the most important canal carried cargo but encourage a general expansion of the local woollen industry which in turn would lead to even greater demands for canal-borne coal imports. Fourthly, and the discretion of the directors forbade any mention of this, a large, regular and expanding traffic in coals on their now partially opened waterway would build up receipts from tolls, ease any cash flow problems and increase the company's income and profits. There was at least one further reason why the directors in general and perhaps Joseph Grazebrook in particular, were anxious to build up a successful import trade in coal. The expansion of the coal trade would provide an ideal basis for the newly established firm of Grazebrook & Co., canal carriers, who soon emerged not only as the largest single carriers on the waterway but also traded on 'Specially reduced terms agreed by the company of directors. The business acumen and entrepreneurial talent of the Grazebrooks was apparent as early as 1769 when Benjamin Grazebrook, the 'enterprising tradesman' of the town, had constructed a private reservoir behind the gardens of the White Hart Inn in Stroud using his own capital, filled it with water from nearby Gainey's Well and supplied piped water to those houses in the neighbourhood prepared to pay a generous annual

fee.[3] Their substantial holding of canal shares, their associated banking interests and their profitable canal carrying business provided the talented Grazebrook family with ideal vehicles for their financial and social achievement. It would not be many years before Benjamin Grazebrook, erstwhile plumber and tradesman, would build and occupy the spacious mansion called Far Hill on Cainscross Road and be referred to as 'Gentleman of Stroud.'

During the first quarter of 1777 the basic pattern of eastward moving coal cargoes dominating the company traffic books was established.[4] Although westward moving cargoes from Stroud eventually grew to around 10% of ton miles and non-coal cargoes reached around 30% of ton miles and even the main source of coal itself shifted from Shropshire to the Forest of Dean this original pattern of predominantly eastward moving coal cargoes remained essentially unchanged throughout the life of the canal despite substantial changes in the total volume of traffic over the years. In these early days too it was company based, if not company owned, carriers and company subsidiaries which formed the spearhead of the carrying trade. Most cargoes at this time were carried either by Grazebrook and Co. or by trows charted by the newly established coal company. The virtual absence of timber, stone, brick and other building material imports from the first traffic book, when evidence elsewhere confirms they were arriving waterborne at construction sites along the canal, confirms that company bought materials were carried toll free on the waterway.

All these cargoes were now discharged on the Bristol Road wharves and either sold locally or carried on to markets in Stonehouse Ryeford, Stroud and elsewhere by carts and packhorse trains. Even though the canal was open to a temporary head of navigation, minor improvements, material shortages and occasionally faulty standards of construction still kept some contractors busy on the two bottom pounds well into 1777. Although John Pashley completed Whitminster lock during the autumn of 1776, for example, he could not fit additional ground cloughs to supplement the existing gate cloughs until March 1777 because of a shortage of stone. Similarly Whitminster Mill pond proved insufficient for loaded trows and Robert Perry was instructed to widen this part of the navigation after asking Mr King of the mill the most convenient time for emptying the pond so the contractors could clear and bottom it. Alexander Clark, a jobbing contractor the company often employed, improved the bank above Framilode Lock and repaired a breach at Pool Field in December 1776. John Moore and the partners Perry and Gleave both raised and strengthened the banks near Saul but leakage at Pool Wall reoccured a few months later when the directors ordered the banks there should be freshly puddled and money kept back from the contractors until the weeping' was cured. It is possible leakage at Pool Field may have become serious at this time or some other points of weakness discovered for in June 1777 Lingard was instructed 'to tell each meeting [of directors] what leakage there is'. These leakages were repaired shortly afterwards when Joseph Morris' brickyard in Pool Field was levelled the banks there cleared of thistles and weeds and the restored lands returned to their former occupiers.[5]

A recurrence of earlier troubles at Framilode similarly concerned the company around this time. The lock there stood on a small headland on an outer bend of one of the Severn meanders. In April 1776 powerful river tides had begun to erode both banks below the bottom lock gates. The directors feared the reappearance of this problem would eventually undermine the lock foundations completely leading to their ultimate collapse. They therefore ordered both banks should be piled with oak as soon as this 'can be procured'. Two months later, still awaiting a delivery of timber, they repeated the request. After a further delay of several weeks the directors decided to make a virtue of necessity, concluded timber would not be strong enough for the purpose and advertised in the *Gloucester Journal* for a stonemason instead to supply stone and build a wall according to a plan James Bough had produced. Walter Bowen, John Couch and Daniel Harrison of Uphill, Somerset, each submitted their proposals for securing the

lock but by this time the worst of the erosion must have passed for the directors decided to delay the work until the following spring.[6]

Despite these minor diversions construction during 1777 was centred primarily between Bristol Road and Chippenham Platt. Even before the canal was open to Bristol Road, preparations were already underway for work on this second length of construction. In November 1776, for example, two existing cutting masters; John Gleave and James Houghton, sent in proposals to cut the rest of the canal to its terminus at Wallbridge. John Beswick, a new name on the cutting scene, sent in similar proposals about the same time. Early in December, too, John Pashley was starting to make the lock gates for Bristol Road. There is some evidence to suggest that the Perry and Gleave partnership was not the easiest of relationships at this time and that Gleave may have hoped to form a new partnership with Houghton or continue alone in his present employ. The directors were certainly disturbed by Perry's activities though after he had 'made Submission … for some unspecified 'iregular behaviour' and promised to 'behave better', they agreed he should 'be continued in the work'. The Perry and Gleave partnership did split up a few months later, however, though both continued cutting for the company independently and John Beswick was brought in to supplement the ranks of masters of cutting teams. By this stage too the company was insisting that all new contracts for cutting, stone and bricklaying etc included provision for around £1,000 security against non or poor performance of contract.[7]

The first month of 1777 saw John Insull complete the brick built house on Bristol Road wharf for the company clerk, George Maskell begin to cut clay and make bricks in land the company bought from John Webb at Wallbridge and the partnership of John Couch and John Hern conclude an agreement to build stone foundations for locks and bridges.[8]

Now the canal was open for traffic to Bristol Road there were occasional problems of administration which needed the directors' attention. In March the company told Lingard the names of both owner and steersman should be placed on some conspicuous part of each vessel using the canal. Trow masters were also forbidden to leave any surplus clay cut from the line of the canal on the banks or throw it back into the canal but to carry it back to the Severn with them and dump it over board in tidal waters. About the same time too Samuel Simmons replaced William Esthop as master of the *Stroud* and continued to fetch company supplies of timber from Broad Oak and Gloucester, bricks from Frampton, coals from Newnham and stone from Hanham and Tintern Abbey until July 1778 when he 'set out on his [regular] Voyage to Hanham and ran away.'

Theft, false declarations of cargoes and other forms of embezzlement by employees, suppliers and contractors proved a permanent headache for the directors. In May 1777, for example, 'owner Deague's conduct regarding freight of stone' from Hanham and Tintern Abbey was investigated and William Deague, who chartered his own trow to the company, was paid off and discharged. In June the directors ordered that only company-supplied baskets could be used in future to weigh slack coals. 'Mr Smith', they added, pointing a finger of suspicion, should 'take note' of their directions. Smith was in trouble again a few days later after he had sold company planks for a fence on Nathaniel Davis' land and then blamed the theft on Mr Davis. Discovering their mistake after initiating a prosecution, the directors told Smith to retrieve the planks or lose his job. Several weeks later William Morris was arrested for stealing coals the previous winter and fined £10 10s 0d (£10.50) for infringing his contract of employment. In August Edmund Lingard's hay, supplied to the team to overcome a local shortage, proved 'so very bad' that the rest of his supply was cancelled. A field of hay belonging to Mr Ford was bought for £36 to replace it.[10]

The hull of the company trow, bought from Richard Hall barely seven months before, also gave cause for concern when the directors found it 'immediately necessary' to sheathe it. Instead of taking

it to Broad Oak in the Forest of Dean as they had originally intended, Joseph Grazebrook and Samuel Simmons found two men to repair it on the canal banks to minimise its period out of commission. During the summer too the directors decided to erect an extract of navigation clauses and related penalties from their act to help regulate the behaviour of masters and crew. Regardless of whether trow crews could read or not, John Hollings drew up an abstract of clauses and Dudbridge Keene provided, after a three months delay in which the directors became increasingly agitated, a board of rules which was erected at Bristol Road. The master Joseph Madeley fell foul of these clauses as soon as they were put up and was fined £5 for making a false declaration of tonnages carried and for entering the canal without owner and steersman's names on the craft.[11]

During the early months of 1777 the company took a full inventory of all the land it owned and began to pursue a more vigorous policy of disposing of surplus pieces left over as each section of canal was completed. As construction progressed, and the company became more adept at land purchase, they moved gradually towards paying for land after a section of canal had been built. In these circumstances the company could measure the precise acreages used and so eliminate purchasing surplus lands except where local landowners were left with isolated small plots of little commercial value. When this ocurred the company bought these additional plots to secure agreement with the local landowners. During this earlier period, however, the tendency was sometimes to buy the land first and then dispose of any surplus areas afterwards. The usual procedure here was for Lingard to locate the surplus areas and then call in John Merrett of Frampton-upon-Severn, a land surveyor who taught writing and arithmetic to supplement his income, to measure the acreages. Once this was done the directors tried to encourage riparian owners to buy back these sometimes pocket-sized sections or persuade nearby tenants to rent them from the company. Most landowners or tenants came to some sort of agreement with the company often as part of a general land purchase contract. However the company were not averse to using a little gentle pressure to achieve their ends especially when the landowner was not noted for his amenability. When Ellis James requested that the towpath through his lands at Eastington should be on the turnpike road side instead of through Eastington Park, the company agreed provided James bought the banks of the off side once these were properly levelled and sown. James agreed and the towpath crossed over from the south to the north bank at Pike bridge and back again at the bridge at Newtown village.[12]

The directors' main concern during the first few months of 1777, however, concentrated on building the bridge and lock at Bristol Road and cutting the canal from there to the bottom of the five locks at Westfield. Couch and Hem probably started on the bridge soon after their contract was signed in late January though this was interrupted in March when Edward Edge, 'our newly-appointed Surveyor of Masonry Work' found some of the mortar unsatisfactory. Edge left instructions to have the work 'well-bonded' with a sufficient quantity of good mortar to make them 'light and waterproof'. James Bough was called in for a second opinion and told to keep a close watch on the contractors. The company were still not satisfied with the bridge in late May when they ordered 'no more money to be paid Mr Hern' until he had taken down the parapet walls and rebuilt them 'with goodrange [stone] work of their present thickness according to his agreement.' Eventually, towards the end of July, Bough, Lingard and Grazebrook measured and examined the bridge, pronounced it acceptable and the directors settled their accounts with the contractors. A month later, the committee was instructing Bough and Edge, now apparently concluding the work, to cover the bridge with stone and gravel an additional eight inches thick and finish it 'in a complete and substantial manner'. Although part of the long delay in completing the bridge stemmed from these constructional disagreements, periodic shortages of stone probably aggravated the situation and caused men to be laid off or diverted to other work. On at least one occasion Edward Edge declared that if no stone was available at any time all further work was to await its arrival. [13]

The lock at Bristol Road, probably started about the same time as its contiguous bridge, was at least partially constructed by mid-March when Edward Edge was supervising the removal of mud which threatened to block the lock chamber. A few weeks later, when the lock cutting was presumably completed, the company stonemason James Bough was called in to lay the foundations and 'sett forward the lock at … Bristol Road'. The chamber was finished by the middle of May and only a shortage of timber prevented Pashley completing the lock gates. Soon afterwards the directors asked Lingard to remove surplus stone left on the towpath near the lock and collect up the sand which lay about the bridge 'to prevent its being wasted'. When the lock gates were finally fitted, probably late in July, 'sundry people' reported the upper gates leaked hadly and Pashley was told to repair them immediately before his Bill was paid.[14]

The report of the general meeting of proprietors that spring clearly illustrates the contemporary attitudes of the directors. The minutes convey an outgoing, optimistic and self congratulatory tone with news of over £215 income from tolls during the first quarter of operation and generous thanks to the treasurer 'for his good Services during the last Year'. Anxious to be included in this general distribution of gloire, the directors proposed and carried unanimously a vote of thanks 'for their [own] Assiduous endeavours in Carrying forward the Navigation'. Such votes of thanks are conspicuously sparse at later general meetings.[15]

Cutting proceeded apace between Bristol Road and Westfield with various sections under the control of different cutting masters. Towards the end of February 1777 some cutting teams were sufficiently well advanced for the directors to ask John Gleave 'or any other person who finished first' to transfer to uncompleted sections. By early April, when James Cocksey's team were approaching Westfield, the committee told Lingard to set at least eight men to cut out the lock site there, mark out the line from there to Chippenham Platt with 'the utmost expedition' and start to cut out Court Orchard and Turnpike lock sites as well. At this point there is the first direct evidence that Edmund Lingard, possibly angered by their persistent interference in decisions he thought properly his own and perhaps annoyed by the slighting promotion of Edward Edge, was not always following committee instructions. The Turnpike lock site, for example, was not fixed for another four months by which time there is further evidence of a continued deterioration inrelations between the directors and their surveyor. However, within a month of their April instructions the canal was cut, puddled and completed to Westfield with all the banks levelled and sown with seed. Cutters then removed the bank there to allow a feeder to fill the length and enable trows laden with building materials for the several locks at Chippenham Platt to navigate above Bristol Road. The committee recognised nevertheless there might be insufficient water in the pound until the canal was linked to Mr James' own supply at Chippenham Platt so Lingard instructed a vessel bringing timber for the locks from Monmouth to unload at Bristol Road if there was not enough water to convey it to Westfield. Toll-paying trows were still excluded from this pound although there is some suggestion a few tried to evade the restrictions at first.[16]

During the summer of 1777 the centre of construction now focused for the first time on the five locks lifting the canal towards New town. With work at Westfield already underway and John Pashley supplying the gates and cills there, James Bough submitted his proposals for the next three locks. Edward Keene, who may have been assisting Pashley but who was certainly making gates and cills as well, sent in his own carpentry estimates, probably for Court Orchard lock. By early August, when Bough and Edge had signed articles for masonry at all four remaining locks at Chippenham Platt, Lingard and Bough had taken levels on Ellis James' land to fix the Turnpike lock site and cutters were excavating the earth ready for the stone foundations. The Bough and Edge team, meanwhile continued bricklaying at Westfield, on new lockhouses at both Court Orchard and Eastington locks. Rising labour costs, however, obliged

the company to offer them £1 4s 0d (£1.20) for laying a thousand bricks instead of £1 1s 0d (£1.05) for all the next four locks.[17]

The directors minuted their rising dissatisfaction with Lingard at the committee meeting on 7 August when Joseph Grazebrook was asked 'to attend laying bricks at … sundry locks now building at Chippenham Platt … take account of the number of bricks laid … [and] be allowed one guinea for his attendance'. This implied criticism was made more explicit when Grazebrook was instructed to take over part of Lingard's responsibilities and specifically to 'attend the whole time to inspect the work; and particularly … see the stone laid according to … contract.' Growing impatience and distrust between the directors and Lingard was aggravated by new evidence of embezzlement and mismanagement for which Lingard was held responsible. When the committee examined John Pashley's Bill for Westfield lock they found 'many articles overcharged' and instructed 'a proper person' to measure his carpentry both there and at Bristol Road. Pashley was 'immediately discharged' and although his filial assistant, Benjamin Pashley, tendered for the lock work at Turnpike, Upper and Lower Nassfield locks on the same terms as his father, the committee delayed signing the contract until Pashley's old account was settled.[18]

The directors now circumscribed Lingard's actions even more severely. When water was let into the Chippenham Platt pound early in September Lingard was specifically instructed to connect up Mr James' additional water supplies, examine the levels afterwards and report any leakage, all matters well within the discretion of any engineer. Then the committee advised Lingard to record all work engaging the company team of horses and present it before every board meeting. Next they ordered a dam built at Chippenham Platt 'to receive the land flood and prevent soil running into the canal'. Most serious of all, the company now drafted in James Bough as well to help survey construction and produce supplementary plans.[19]

Deteriorating personal relations were paralleled by signs of financial difficulties for which Lingard may have been blamed. With virtually all of the original capital spent, the company had less then two miles of canal open to toll paying traffic. Some additional costs, such as heavy legal expenses from Gloucester Assizes and the new Act or higher land and constructional Bills stemming perhaps partially from inflationary effects of the American war, were outside any company control and certainly affected the financial position adversely. One typical example was the extra farthing (0.104p) a pound the directors agreed to pay the company smith, Thomas Howell, 'in consideration of the advanced price of iron'. Others … like the long, expensive committee dinners at the George Inn at Stroud … did come within the directors' powers but were still continued. Earlier extravagances had included a luxurious company seal ordered during the euphoric spring of 1776. Even then the directors had second thoughts after giving some designs 'their approbation' and told Ralph Bigland not to have it cut if the price exceeded five guineas. Bigland, however, reported a Mr Pinge of London had already made a steel seal for £20 and an iron chest to keep it in for £7 10s 0d (£7.50). The committee were incensed declaring they 'cannot consent to … so enormous a Sum', were certain they had 'no occasion' for the chest and asked Pinge to fix 'a reasonable price' for the seal. On this and other occasions the directors paid for their poor financial control and eventually sent Pirige £20 16s 0d (£20.80) for both seal and chest telling Benjamin Grazebrook to keep it safe 'in some proper place at his House'. Rightly or wrongly Lingard became the scapegoat for these financial and managerial deficiencies.[20] When the new Act was being drafted two years before, some directors foresaw expenditure might exceed the original estimates and had included clauses to cover this contingency. The more sober general meeting on 2 October 1777 resolved to effect these and raise an additional £10,000 'amongst themselves' by the approved series of extra calls on each £200 share. For good measure the previous half yearly toll receipts of £177 19s 2d (£177.96) were added to the available balances.[21]

By this time Lingard was subjected to regular detailed instruc tions on all aspects of his work. In mid October, for instance, the directors told him to clear out mud from Court Orchard lock brought in by the new feeder and hang bottom gates both there and at Westfield. Directorial tempers frayed again a fortnight later when they discovered both sets of gates remained unhung. To make matters worse, Lingard agreed 'many of the posts he bought from Mr Davis are not worth the money he agreed to pay'. Lingard, the directors insisted, must hang upper and lower gates at both Westfield and Court Orchard immediately, return Mr Davis' posts or buy them cheaper, survey the whole of the canal to Framilode 'at least' twice a week and see that all their orders were executed immediately without fail. This final statement of no confidence brought relations to breaking point. Lingard refused point blank 'to Survey in such manner [as] he was directed' and on 5 November Edmund Lingard was discharged by the 'unanimous Opinion of the Committee'. The directors agreed to bring his two guineas a week salary, much in arrears and no doubt itself both a cause and result of friction, up to date and then set about finding replacements.[22]

Disappointed with the general results of forays into the wider world of waterway engineers over several years, the committee determined to divide the functions between several trusted contractors or employees, at least for the time being. Samuel Smith, general contractor was asked 'to superintend … and take particular Account of … Work done by the Team'. John Gleave, cutting master, became 'Inspector of Puddling' with responsibility for 'extra wheeling and other [related) works'. Gleave was detailed to visit Framilode twice a week 'to see everything is all right', inspect 'every other work' the directors ordered and always to 'give a faithful account of the state of works'. To ensure he remained at his post, unlike some earlier surveyors and perhaps including Lingard, Gleave forfeited 5s 0d (25p) from his salary each day he was absent from duties. The company stonemason, James Bough, continued as regular advisor to the directors but in view of any additional responsibilities which might now accrue to him the committee allowed him 5s 0d (25p) for each day he was called from his work 'to attend any other particular business we require'[23]

As winter drew in work at Chippenham Platt approached completion. James Bough ordered more stone to complete coping on Westfield and Court Orchard locks. John Merrett measured land for an enclosed wharf adjacent to Westfield lock which itself was drained to clear accumulated mud from the chamber. Adjacent banks were raised and levelled and both pairs of gates were hung at the two locks. John Gleave reported a slip at Court Orchard which was soon removed and the banks there were strengthened with elm piling. On 4 December the directors assembled at Chippenham Platt about ten o' clock to view the works and just before Christmas contractors turned water from Ellis James' millpond into the canal. Promising to allow the first thousand tons of coal landed to pay only 1s 2d (6p) toll, a promise they failed to keep, the directors now prepared to open a second section of canal. On 1 January 1778 a Grazebrook and Co. trow locked through Westfield and Court Orchard locks and unloaded twenty five tons of lead and timber at the new wharf and temporary head of navigation next to the turn pike bridge at Eastington.[24]

Chapter Seventeen References

1 GCRO D1180 1/1 Committee minutes 30 December 1776
2 GJ 6 January 1777
3 Fisher, Paul Hawkins, *Notes and Recollections of Stroud* 30 1871 According to Fisher, Richard Arundell had tried this unsuccessfully in 1744

4 GCRO D1180 4/1 Tonnage Book January– March 1777
5 GCRO D1180 1/1 Committee minutes 20 February 1777, 6 March 1777, 29 May 1777, 12 June 1777, 10 July 1777, 24 July 1777, 7 August 1777, 28 August 1777, 4 September 1777, 11 September 1777, 18 September 1777, 2/1 General Account 1776–94 23 November 1776, 4 January 1777, 26 April 1777
6 GCRO D1180 1/1 Committee minutes 31 March 1777, 29 May 1777, 26 June 1777, 10 July 1777, 7 August 1777
7 GCRO D1180 1/1 Committee minutes 21 November 1776, 12 December 1776, 9 January 1777, 20 February 1777, 2/1 General Account 1776–94 15 March 1777
8 GCRO D1180 1/1 Committee minutes 26 December 1776, 9 January 1777, 23 January 1777, 2/1 General Account 1776–94 18 January 1777, 24 February 1777, 8/2 Articles between Samuel Webb and Benjamin Grarebrook 7 January 1777
9 GCRO D1180 1/1 Committee minutes 20 March 1777, 2/1 General Account 1776–94 19 April 1777, 2/10 Ledger 1775–1802 20 April 1777 – 26 June 1778
10 GCRO D1180 1/1 Committee minutes 29 May 1777, 2 June 1777, 12 June 1777, 26 June 1777, 10 July 1777, 24 July 1777, 7 August 1777, 4 September 1777
11 GCRO D1180 1/1 Committee minutes 12 June 1777, 26 June 1777, 10 July 1777, 24 July 1777, 7 August 1777, 4 September 1777, 11 September 1777, 18 September 1777, 25 September 1777, 1 October 1777, 16 October 1777, 5 November 1777, 12 November 1777. Fisher mentions, on page 47, that Edward Keene, possibly a relation of Dudbridge Keene, kept a carpentry shop in Bedford Street in Stroud but does not make it clear whether this was before, during or after his work for the company.
12 GCRO D1180 1/1 Committee minutes 9 January 1777, 20 February 1777, 15 May 1777, 29 May 1777, 7 August 1777, 28 August 1777 GJ 15 October 1770
13 GCRO D1180 1/1 Committee minutes 31 March 1777, 3 April 1777, 29 May 1777, 10 July 1777, 24 July 1777, 7 August 1777, 28 August 1777, 2/10 Ledger 1775–1802 25 July 1777
14 GCRO D1180 1/1 Committee minutes 3 April 1777, 15 May 1777, 26 June 1777, 7 August 1777, 2/1 General Account 1776–94 15 March 1777, 2/10 Ledger 1775–1802 12 September 1777
15 GCRO D1180 1/1 Committee minutes 3 April 1777
16 GCRO D1180 1/1 Committee minutes 20 February 1777, 3 April 1777, 1 May 1777, 24 July 1777, 28 August 1777 Court Orchard and Eastington (or 'Easton') locks later became Dock and Pike locks respectively.
17 GCRO D1180 1/1 Committee minutes 29 May 1777, 26 June 1777, 24 July 1777, 7 August 1777, 21 August 1777, 2/10 Ledger 1775–1802 1777 page 183
18 GCRO D1180 1/1 Committee minutes 7 August 1777, 18 September 1777, 25 September 1777, 5November1777, 12 November 1777
19 GCRO D1180 1/1 Committee minutes 4 September 1777, 25 September 1777, 1 October 1777
20 GCRO D1180 1/1 Committee minutes 16 May 1776, 22 August 1776, 3 October 1776, 9 January 1777, 19 February 1778
21 GCRO D1180 1/1 2 October 1777
22 GCRO D1180 1/1 Committee minutes 16 October 1777, 30 October 1777, 5 November 1777, 12 November 1777, 27 November 1777, 4 December 1777
23 GCRO D1180 1/1 Committee minutes 5 November 1777, 12 November 1777
24 GCRO D1180 1/1 Committee minutes 16 October 1777, 5 November 1777, 20 November 1777, 27 November 1777, 4 December 1777, 29 December 1777, 2/1 General Account 1776–94 20 December 1777

Chapter Eighteen
Chippenham Platt to Ryeford

At least nine months before the first toll paying cargoes arrived at Chippenham Platt wharf, the directors started planning construction to the Wallbridge terminus. In April 1777 they ordered 500.000 bricks to be made near Bonds Mill for use between there and Eastington road. George Edwards, then brickmaking at Stonehouse was asked to get his men digging in Ellis James' land at Eastington ready to supply two million bricks the following year. Both the yet undischarged John Pashley and Edward Keene tendered unsuccessfully for a wooden swing bridge near Bonds mill around the same time. By the summer of 1777 cutting was proceeding in Meddalls meadow, Mr Phillips' land at Ryeford and Mrs Ball's fields at Stonehouse. After months of negotiation Rev. John Pettat finally agreed to a minor variation of the line at Stonehouse which cut several feet off his churchyard. At Wallbridge William Seal and his men were wheeling bricks and for a time Charles Woodcock was cutting a culvert there until defects were noticed. Woodcock was discharged and Bough completed the work.[1]

As the canal at Chippenham Platt approached completion during the autumn, the pace and scale of works nearer Stroud continued to increase. Lingard cut a gutter through 'lands already agreed for' to speed up construction by bringing water directly to navvies puddling the canal on the Stonehouse pound. The commissioners met to settle a land purchase dispute with Ellis James and, perhaps encouraged by an impatient and worried board of directors, conceded most of the claim 'so [the] canal may be cut, and … bridges erected' without further delay. Within hours cutters were working in James' lands and.later carefully contracted the cut above Eastington lock to preserve the hedge adjacent to the road and minimise incursions into James' estate. [2] Some disputes with landowners at this time stemmed from disagreements over land purchase prices and related issues. Others originated from damage navvies or company workers did to adjoining lands. Brickmakers were often the worst offenders. The tenants Farmer Clark and Samuel Apperley received £8 8s 0d (£8.40) for land brickmakers had damaged and when Thomas Barnard left 'surplus clay and rubbish bricks' in Richard Martin's field it eventually cost the company £21 10s 0d (£21.50) compensation. Some brickmakers trespassed on Samuel Peach's land by making a road across Mr King's tenanted wheatfield. On one occasion the company erected hurdles to prevent workmen trampling on Mr James' wheat at Eastington and at another the company issued a directive to prevent Samuel Smith making bricks on the Chippenham Platt coal wharf itself. [3] Apart from poor relations with a string of engineers and Ellis James some committee minutes record the directors were sometimes in dispute with others both landowners and their own contractors. They were even occasionally involved in differences between contractors and riparian owners or between contractors and employees although since most labour was hired by the various contractors themselves rather than employed directly by the corn pany this often only affected the directors indirectly.[4]

There were several cases of other workmen damaging adjacent property. In September 1777 Lingard bought stakes and posts to prevent cattle wandering over Henry Davis' 'Field of Pease' again after navvies had pulled out hedges in their way and let the animals roam. Around the same time Mr Chambers sustained damages on the towpath side at Court Orchard. Lingard erected fencing from Court Orchard

to Turnpike locks and kept the key safely at the new Eastington lock house but this did not deter later intrusions. A year later Edward Edge 'and his people' were specifically instructed not to trespass on Mr Chambers' land by making paths across it and to fill up a saw pit they had dug. Both Mr Chambers and Edmund Phillips also suffered from the appearance of 'hutts' on their land. Although these huts could have been intended for storing building materials, wording in the minutes, which prevents more being erected 'without committee consent', could imply they were a spontaneous response to accommodation shortages for navvies and that the directors, anxious to keep the labour force intact, encouraged some navvies to provide housing for themselves. The committee certainly provided company housing for their clerk the Framilode toll keeper, Samuel Smith and other key workers but there are no known reports of where the hundred or so navvies not to mention brickmakers, stonemasons, carpenters, smiths and the like were accommodated. It is not unreasonable to suppose the small rural communities of the lower Frome valley found it difficult to house such a sudden and substantial influx even assuming they wished to do so. In view of their known leisure pursuits on other navigations it is even possible neither husbands nor mothers may have welcomed them as lodgers. At any event when some navvies 'got into [an empty] … House' belonging to Ellis James, the company arranged an option of paying a rent or eviction.[5]

Mrs Ball of Stonehouse submitted a comprehensive and strongly worded claim for substantial damages. Apart from Mr Apperley's 'Temprey Trespass' and for the brickyard, Mrs Ball claimed for disturbances 'sustained by cutting down apple, pear and other trees, damage done to herbage in Vineyard Orchard, Evelands and Lady Orchard … and for … bounding out the Cows from our lands'.[6] Similarly the Activities of John Beswick and his cutting team brought them into regular conflict, this time with the directors. Disappointed with the progress of his work on the Stonehouse level, the committee told Beswick to 'set more hands to work' without delay. When Beswick ignored their demand the directors threatened to stop his money until he attended before them and explained himself. Eventually Pickston and Gleave lent some of their own navvies to supplement the Beswick team although according to the directors even this proved insufficient. The committee then decided to replace Beswick as cutting master unless he put an extra forty men to work within a fortnight. This practice of lending workmen may have been a regular one since it is mentioned several times at different periods. A typical example occurred when Samuel Deague received seven guineas 'for the use of Thomas Pritchard'. The dispute with Beswick was probably settled soon afterwards when the company agreed to pay him an extra 1s 9d (9p) a day for every additional man he employed.[7]

At another time the committee discovered Beswick's navvies refused to wheel turf cut out from the intended line on Mr Reddall's land at Stonehouse Cross 'a proper distance' to keep it separate from the sand and gravel. When cutters still failed to 'strictly observe' his directions for moving topsoil, Gleave was instructed to deduct an appropriate sum from Beswick's weekly Bill. Within a week, the erring cutters were back in line. A similar problem arose six weeks later. According to the committee, cutters, perhaps finding it awkward to use, were reluctant to use a puddling tool called the porcupine. After three attempts to enforce its use, Gleave issued another threat of deductions to get his way. By this time cutters may have learnt their lesson the hard way for when Gleave ordered them to remove all superfluous earth and gravel from Mr Reddall's land to across the old river and not leave it on his lands there were no committee complaints of negligence. Negotiations for damages already done to Mr Reddall's land still continued however. The minutes hint that difficulties with this team may have stemmed, in part at least, from poor relations between master cutter and men rather than between Gleave and the navvies themselves. Whatever else they thought of him, Beswick's men were certainly prepared to allow Gleave to examine their labours 'in any dispute between Beswick and his men relative to a measure of their work'.[8]

Only a few days before his dismissal Lingard settled rises or the three locks at Upper Nassfield, Lower Nassfield and Eastington where he included a substantial twelve-foot, six-inch rise on the Stroud side of the Eastington road. Joseph Grazebrook posted details of William Price in Gloucester so gate timbers could be ordered well in advance. Apart from excavating the chambers for these three locks stone and brickwork were again suspended during the winter to minimise damage from frost. Most contracting, therefore, was concentrated on cutting the Stonehouse level until the following spring. By the middle of October 1777, Mr Stephens' land above Eastington bridge was 'already cut thro' and Gleave was soon ready to tank both ends of the pound to fill it and complete the puddling. In all probability, too, the line from Ryeford to Wallbridge was marked out at this time since Beswick was certainly instructed to peg out the land from Wallbridge to Dudbridge in November and there are several contemporary reports of lands entered for construction in that vicinity. In December alone both Henry Wyatt's land at Lodgemore and Mr Andrews land at Newtown were already 'nicked out' and cutters were ready to enter Richard Cook's land near Wallbridge as well. Edward Keene, too, having lost the tender for Bonds millbridge was proposing to provide four pairs of gates for the two *locks at Dudbridge.* [9]

With the canal open to Chippenham Platt in January 1778 and traffic beginning to build up on a regular basis, the directors were disappointed to find that even working sections supplied their share of headaches. John Gleave found Whitminster and Westfield locks 'incomoded with Mud, and Gravel' probably aggravated by water drawn at Whitminster mill and construction work at Chippenham Platt. Both locks were cleared in a few days though it was months before workmen could dredge the millpond and remove the probable cause of the trouble at Whitminster. Part of the delay possibly originated from poor relations between the company and the mill tenant. William King had claimed a substantial sum for damages from brickyards working on his land a year or two earlier. When the company prevaricated, King retaliated. Benjamin Grazebrook told his landlord, Richard Owen Cambridge at Twickenham, that King made a 'Charge upon every Vessel that passes up his Millpond, which we apprehend cannot be with his countenance.' The company hoped to deepen the pond during the first available water shortage but when this either failed to materialise or King refused to cooperate, the directors settled King's account for damages and offered to pay compensation when the pond was drained and the millstopped. King, still smarting from his earlier treatment, drained the pond ready for work to begin. He opened all doughs wide together, flooded fields at Whitminster and caused about £5 worth of damage. Cambridge gently suggested the company gave the Framilode lockeeper discretion to open his doughs in future cases of emergency and the directors, outmaneouvered by King, hurriedly agreed. [10]

Apart from several slips at unspecified places, there are several reports of the canal overflowing during the construction period. In January 1778 water flooded Mrs Hort's land below Westfield lock and the banks there were raised soon afterwards. Later in the year Mr Stephens' land was damaged when a blocked drainage ditch caused an overflow weir to flood his fields. There was even some outline suspicion that Westfield lock itself was bulging inwards. Malicious damage, too, was an occasional problem. At several times the company offered £10 rewards for information leading to the conviction of the person who stole the lock from some unnamed swing bridge and, at another period, thrown off part of the coping stone on Moor Street bridge at Saul. In July 1778 the landowner John Hawker paid £5 12s 9d (£5.64) damages after Edward Clissold and William Pearce had been found 'obstructing the works' at Lodgemore. [11]

Boatmen, too, provided their share of company troubles. Alexander Clark sank a boat 'thro' carelessness' leaving the comapany to raise it and charge his account. At another time John Gleave raised a boat sunk and left at Bristol Road where a few months earlier a passing vessel had lifted a lockgate out of place. Benjamin Grazebrook tried to locate the culprit and bring him before the magistrates but

there is no record of any arrest or trial. Samuel Collins, the directors discovered, was unloading coals on wasteland near Chippenham Platt which the company had levelled for landing building materials. This 'will if continued', the minutes record, 'put a Stop to our Business' so Gleave told Collins to desist forthwith. A couple of days later Collins started to carry coal through the company wharf at Bristol Road without paying wharfage tolls until a substantial fence erected by 'our labouring carpenter' put a stop to this as well. This and similar actions like selling coals from trows before cargo weights were determined, soon became subject to a fine. Several months later both Collins and Samuel Stephens neglected to pay wharfage for coals landed at Bristol Road although this was eventually paid after Benjamin Grazebrook threatened to sue. Ironshod shafts were also prohibited on the canal, probably because of damage to gates and puddle. Each master was now required to exchange any ironshod shaft for a company owned wooden spikeless shaft at Framilode. The original shaft was exchanged again as each craft left the canal.[12]

Once Edmund Lingard was discharged the extra responsibilities shared between Samuel Smith, John Gleave and James Bough in November 1777 tided the company over for a month or two. But however reluctantly the directors faced it, the problem of a new engineer and surveyor remained unsolved. In January 1778 they were fortunate to secure the services of the noted canal engineer Thomas Dadford once again though only on a temporary basis because of his other commitments. Dadford's report on the condition of the waterway is not flattering to either the directors or former engineers. For a start the hollow quoins in several locks were disjointed and each needed to be removed, hewn more carefully and laid freshly with Barrow lime from Leicestershire. Although the company had originally used the top quality Barrow lime a combination of inadequate costings and rising costs of construction encouraged Gleave to test limestone dug out of the line instead. It soon proved false economy when these several quoins, including those at Court Orchard, needed attention.[13]

Dadford suggested Turnpike and Nassfield locks should rise fourteen-foot, six-inch and twelve-foot, six-inch respectively to eliminate the need for a second Nassfield lock. If the rise between Ryeford and Ebley exceeded sixteen-foot, he also proposed two smaller locks were preferable to one single deep one. Small aquaducts over Cuckolds Brook, the Painswick Water, and the Fore Brook and pond at Ebley mill were also recommended. In future too the sides and ends of locks should be rammed more carefully with puddled clay to prevent leakage from adjoining lands. Pressure from adjacent waterlogged land, possibly aggravated by leaks from the lock chamber, had already caused Westfield lock, suspect six months earlier, to bulge five-inches or sixty-one-inches. To minimise inconvenience to traffic and probably help remove one cause of the trouble, Dadford recommended moving the weir to the south side of the lock and that three-inch square holes should be built about six-foot below the bottom gates of all locks where adjacent waterlogged land was a problem. Dadford also found the strength of existing lock chambers unsatisfactory and advised all new chambers should have twenty lock ribs each including one below both bottom gates. Wall thicknesses should be increased to four-and-a-half bricks as far as five-foot, six-inches from the chamber floor narrowing to four and finally three-and-a-half bricks at the top. Each lock, too, needed the breadth of one dry brick in the four brick band to act as a drain at the back of the wall to drain below the bottom gates. In the meantime, the company bought a rod for measuring lock width which Joseph Grazebrook marked and took 'proper care' of at home.[14]

Most embarrassing of all Dadford found Nassfield Lower lock, already being excavated when be arrived, was being built on the wrong level. This evidently provoked merriment among the navvies and general contractors since some canalside wit immediately dubbed it 'Blunder lock'. It was several years before the directors, no doubt incensed by the discovery, worried by the incompetent management it implied, red faced at their newly named folly and perhaps even suspecting Lingard's deliberate hand in

this unfortunate publicity at a time when their finances were none too healthy, could bring themselves to use the name now firmly established in the local vernacular.[15]

Dadford, however, was 'engaged on sundry navigations' and unable to give the canal 'the attendance that is necessary' to sort out the problems of construction. Leaving the company on friendly terms, Dadford pocketed his fifteen guineas fee and promised to order a couple of hogsheads of Barrow lime for them on his return to the Midlands. Dadford recommended Mr Clewes as a reliable engineer and undertook to try and engage him for the company but Clewes too was unable to oblige. On 12 February Thomas Baylis wrote to Thomas Yeoman asking him to suggest a suitable engineer. 'Constant' attention, the directors said plainly, 'will be expected'. When this produced no immediate reply, Thomas Frewin was engaged to survey the work and give the committee 'his Oppinion and Observations thereon'. Benjamin Grazebrook, perhaps anxious to enlarge the scope of his talents, became his assistant. Frewin was employed for three guineas a week, plus two guineas expenses for attending the interview, from 25 February with instructions to inspect 'every part of the work' including bricklaying and masonry with a particular request to make sure only perfect bricks and proper quality; unburnt lime was used.[16]

Both Dadford and the committee had expressed some concern about brickmaking standards although it is uncertain whether the directors' complaints, regularly repeated during the winter of 1777 – 1778, reflected long held doubts or merely outlined a recent deterioration. Since Lingard's dismissal Samuel Smith had particular re sponsibility for making sure only 'perfectly sound' bricks were hauled to the construction sites. Smith visited all yards along the canal with a couple of labourers to stack up bricks 'well burnt and fit for use' separating them from soft or imperfect bricks. Within a few days Smith found about 8,000 had bricks at Eastington road alone. Extending his attention to other yards Smith discovered Edwards and Barnard had sold respectively 52,000 and 20,000 unuseable bricks to the company. Their accounts were swiftly amended. Spotting inferior materials in the brickyards was much easier than finding them in the works and there are no reports of poor bricks laid in the canal bed although many had undoubtedly slipped through before the checks. Water, quite literally, probably covered a multitude of material sins. In other cases the warnings came too late. Smith told Bough and Edge only to use bricks 'marked as sound' but soft bricks were removed from Pike lock a week or two later. All through the next summer Clement Atkins was employed to stack all newly made bricks, check their quality and throw water over them to dissolve any limestone in them before they were used. From then onwards it became standard practise for Benjamin Grazebrook or some other responsible person to check Edwards', Maskell's and other brickmakers stocks before payment was made.[17]

Thomas Frewin now set about his new job of engineer and surveyor. With the worst of the winter weather over by the middle of March, the directors asked Frewin to 'set forward' the work at Pike lock and outline a scheme for lifting the canal to the Stonehouse level. Frewin prefered the original plans for three locks to Dadford's recommendations for only two and suggested an eleven-foot rise at Eastington, an eight-foot rise at Nassfield Upper lock and a seven-foot, two-inch rise at what he coyly called the 'in between lock'. The directors were equally sensitve to the risk of other mistakes and its possible effect on shareholders quite apart from the unparalleled canalside mirth this would create. They insisted Frewin checked the levels of all three locks before any work began. For good measure, Benjamin Grazebrook and John Gleave reviewed the levels from Nassfield Top to the lock 'in Mr Andrews land' at Ryeford. This preliminary double–check, the committee decided, should now also be standard practise.[18]

Around this time Samuel Smith reported a 'great Complaint' that Eastington road was 'very dangerous and almost impassable'. The company accepted their team of horses moving building materials was mainly responsible for this although other traffic and seasonal weather probably aggravated an already indifferent road surface. The holes were immediately filled with faggots, gravel and damaged bricks at

company expense. Occasionally, the team had ventured to Gloucester or Framilode to collect cargoes like the Barrow lime Samuel Skey in Stourport sent on from Dadford. More usually, the team carried three loads of building materials or coal for lime burning each day from Chippenham Platt to the various points of construction on the Stonehouse level. Even then, carter and company had their differences. At first the company told their carter to harness the horses in Mr Power's newly rented stables at eight o'clock every morning and not return until four o' clock in the afternoon. Then the company employed a boy at 5s 0d (25p) a week to assist him and speed up deliveries. Finally in May 1778 the directors paid Clement Atkins 12s 0d (60p) a week to keep a check on work done by the several teams the company now employed.[19] Minor improvements continued on the open navigation. 'Farmer' William Coaley received damages as well as a small open boat and wharf to compensate for his now divided tenanted lands near Westfield. At Court Orchard the company built a watering place for Mr Chambers' cattle near the house James Bough had occupied. At Chippenham Platt Benjamin Grazebrook set company men to drain the wharf and then arranged for the directors to let this lucrative head of navigation land to his son Joseph for £3 a year. With tolls at Bristol Road fixed at 1s 3d (6p) a ton plus 3d (1p) wharfage, the new carrying company of Grazebrook and Company set about making their own wharf attractive to other carriers as well. A temporary warehouse was rapidly erected. Thomas Howell, meanwhile, made twenty fixed iron 'handles' for the five working locks although the full complement was temporarily delayed while the company searched for another house suitable as a forge for their smith until Mr Phillips was able to oblige.[20]

Apart from continued work on Pike, Blunder and Upper Nassfield lock chambers, the directors now broke their usual west to east building practice by setting men to work over the whole remaining length to Stroud. The general evidence suggests cutting received priority and that construction of the last four locks was temporarily postponed, possibly for financial reasons. Even before Christmas 1777 cutters were ready to enter Richard Cook's and Mrs James' lands at Lodgemore and Fromehall. Within a couple of months Benjamin Grazebrook had nicked out a basin 'in Mr Webb's Lower meadow' at Wallbridge ready 'for vessels turning after discharging cargoes' and pegged out Mr Wyatt 's land at Fromehall as well. There were preliminary preparations, too, for conveying the Painswick Water under the canal. Thomas Frewin produced a plan and Edward Keene built an elm trunk culvert suitable for the purpose. Although Lodgemore bridge was unfinished the main construction at Wallbridge was completed by the middle of 1778 when the banks were ready for seeding and Richard Cook's land cleared of stakes and timber. Neither Dudbridge locks were mentioned although several directors fixed the bridge site 'absolutley' and arranged William Franklin should build a good 'strong stone bridge' there for £200.[21]

At Ebley Thomas Frewin took the navigation across the mill race on a short aquaduct and into the millpond for a short length. Most of the Ebley level was cut by May 1778 when Gleave cut a drain from the river near Ryeford to fill the pound with water. A couple of weeks later he was turning water from the river every night to supply the pound. Around the same time the company thanked Anthony Keck for his plan and section of a double lock at Ryeford although there was still no signs of any impending construction there. This spread of construction from Chippenham Platt to Wallbridge probably originated from a desire to impress the shareholders with the news that the canal was approaching completion at last, especially as they had recently supplied an extra £10,000. Additionally the projected expense of building Ryeford Double Lock may have encouraged the committee to delay this work for the moment and concentrate available resources elsewhere. In part, too, the decision could have stemmed from extended negotiations with landowners like Rev. John Pettat or Mrs Ball on the Stonehouse level.[22]

On the Stonehouse level itself construction generally proceeded in a westerley direction 'to Chippenham

Platt from Ryeford'. Although the directors minuted to restrict cutting to this pound in January 1778, when earth was already being moved in Mr Phillips land below the projected Double lock site; the available evidence suggests only temporary variation from the previous plan to spread construction. Even so the committee issued regular instructions and keep a close watch on all developments. In February they told John Pickston, then supervising John Beswick's cutting team, to remove his men from Mr Reddall's land at Stonehouse Cross and confine them to Burryfield near Ryeford until that section was completed. Specific orders not to break fresh ground without written permission from the Grazebrooks probably indicates some cutting masters tried to claim as many sections as possible for their own workforce and to prevent other cutting masters starting on them. Pickston still had five men cutting in Stonehouse Church yard a week later when the committee warned he would not be paid 'One Shilling on Saturday next for any of his work', unless he removed them forthwith. By this stage Gleave was sending young Grazebrook the 'best [weekly] account of cutting he can … of each team's work 'for his government in paying them' every Saturday. When cutting details could not be determined exactly, masters usually received weekly payments on account. At the end of February 1778 when Beswick's team were approaching Bridgend road at Stonehouse, Pickston collected £25 on account plus an additional daily allowance for each man. Rising prices had pushed this daily wage from 1s 8d (8½p) to 2s 0d (10p) by this stage and, incidentally, encouraged the committee to be more generous to their most valued employees. Samuel Smith now received £5 a year towards his rent over and above his wages and when he also leased a small piece of land for a garden from Mr Martin for £2 10s 0d (£2.50) a year the committee agreed to make him an additional allowance for thls too if he judged the rent to be too high.[23]

The evidence on navvies wages from 1775 is limited to one short period during the summer. Equally limited evidence from October and December 1778 produces conflicting reports. At one point directors agreed not to employ 'day men' for more than 1s 6d (7½p) a day. This suggests either lower wages in winter, perhaps because of a shorter working day, or a distinction between regularly employed navvies and casual navvies employed on a day to day basis according to the volume or type of work available. John Pickston's accounts indicate a similar complication. The company paid him an extra £20 on top of the 1s 6d (7½p) daily allowance for each man plus an extra £40 on completion. Whether this reflects a general rise in contracting costs or an unofficial method of subsidising wages is never clarified.[24]

During the spring of 1778 Frewin and Gleave set forward culverts near Stonehouse Church and at Ryeford where 'a sufficient number of hard bricks [were] carried … from Wallbridge … ' and 'only Aberthaw lime', probably cheaper and more accessible than Barrow lime, was specified. Samuel Simmonds brought the lime from South Wales on company craft. Simmonds himself may have been under suspicion at this time. 'No goods whatsoever', the directors ordered in March, should 'be carried by any of [their] barges for any person except for … use [on the] works'. A few months later Simmonds 'set out on his Voyage to Hanham and ran away'. Richard Evans was paid 6s 0d (30p) to retrieve the trow. In the meantime James Bough prepared to build bridges at the top end of the Stonehous pound. These included Mr Phillips' swing bridge at Ryeford, brick bridge for the Kings Stanley turnpike, Mr Reddall's swing bridge at Stonehouse Cross, and Mr Hill's bridge in Stonehouse Church. James Bough usually built the brick bridges and foundations of swing bridges while Edward Keene and Thomas owell supplied timberwork and ironwork respectively for swing bridges. Nearly two years earlier the company had accepted Anthon Keck's proposal to have specially moulded bricks made for the sides and crowns of bridge arches. Although no report of such firings are recorded, few complaints of bridge brick qualities are mentioned. The directors also took particular care to repair local bndges it used and protect its own bridges from heavy traffic. Company workmen, for example, repaired Bonds Mill River bridge, close to the planned canal swing bridge, when it was found 'very dangerous and almost

impassable' and also the road over Mr Hill's bridge as well. Equally, John Gleave ensured bridge guard walls were secured and that roads over bridges were raised with stone and gravel to protect the arch. Frewin and Gleave also built a feeder drain from the Frome near Mr Phillips' projected bridge site at Ryeford, through lands already partially cut through and across the Stonehouse and Eastington roads to supply the Chippenham pound. Later enlarged to eighteen-inch width to supplement the supply, this canal bed drain fed the navigable pounds by topping up temporary sources near Chippenham Platt itself and, incidentally, assisted cutters puddling the Stonehouse pound.[25]

Bridges apart, the Ryeford to Stonehouse length was virtually completed by the end of May 1778 when Gleave checked Beswick had levelled all banks according to contract before they were sown with white clover seed. Even before this was concluded however the problem of an engineer arose yet again. The first hint of trouble came on 6 April when the directors reminded Frewin to 'attend wholly to building locks and bridges and see mortar well made'. 'His whole time and constant attendance', the committee imperiously recalled, 'is expected'. Directors probably voiced their concern again at the general meeting when the 'State of the works was … laid before the Proprietors' and £321 2s 2d (£321.11) tonnages 'apply'd towards compleating … the navigation'. Ten days later Frewin was told to produce 'dimentions' of brickwork at Eastington. Directors questioned several workmen at the same meeting. Perhaps these workmen, allowing 1s 0d (5p) for expenses attending the meeting but nothing for loss of earnings, were called to report on Frewin's behaviour. Perhaps Frewin heard of the questioned workmen. Perhaps Frewin suspected Benjamin Grazebrook, appointed as his assistant from the start, was a committee informer. Perhaps Frewin was insulted by the directors' request for Grazebrook senior and Gleave to check his levels or angered by non–payment of his salary. Perhaps Frewin was unsuitable or uncooperative. Perhaps the committee itself was up to its old tricks of issuing regular orders to capable engineers. What is certain is that Frewin's employment, barely eleven weeks old, was terminated on 11 May when his salary was finally paid.[26]

Thomas Baylis had contacted Stroudwater veteran John Kemmett in Bristol three weeks before Frewin was discharged. Kemmett visited the canal offering to superintend for two hundred guineas set fee. The directors refused this offer and only grudgingly paid him £10 10s 0d (£10.50) for 'money expended … in time and attendance on the Navigation'. Benjamin Grazebrook probably agreed to supervise construction while the directors looked around. John Lowdon of Birmingham, asked to quote his lowest terms for 'constant attendance' once again, was otherwise engaged. After a couple of months without a permanent engineer, the committee turned back to their trusted, proven and experienced former clerk, their active and valued fellow director already using his undoubted abilities and contracting experience to add to his string of other interests. Benjamin Grazebrook agreed to survey and direct the navigation for £200 until it was completed to 'the Quay … at Wallbridge'.[27]

By June 1778 brickwork was well advanced on the three top locks at Chippenham Platt. Ben Pashley completed and hung Pike lock gates while Edward Keene signed up to build gates for the tactfully listed 'two upper locks' in Nassfield. Contractors installed land drains behind Upper Nassfield lock, and possibly both other locks, to drain adjacent land and prevent water pressure forcing chamber walls inwards. These three locks were finished over the new few months although some coping stones were found to be undersized. These were taken up and replaced by the stones of the specified size when the directors refused to pay the Bill.[28]

Elsewhere the spread of work started under Lingard was probably now curtailed. Navvies certainly completed Ebley aquaduct after keeping water out of it for six days to let the mortar 'get dry', built a temporary bridge for Mr Cook at Lodgemore and probably continued some limited cutting on the Ebley level. William Franklin, too, continued building Dudbridge bridge and agreed to construct a stone lock

at Dudbridge for £465. In the second half of 1778, however, barely half a dozen minutes refer to the Ebley or Wallbridge pounds. A change in committee attitudes was equally noticeable with the appointment of a surveyor enjoying the complete confidence of both shareholders and directors. Apart from a request asking Grazebrook to set forward brickwork on the navigation as soon as possible, regular detailed instructions to the engineer virtually disappeared.[29] One serious disadvantage of the confidence in Grazebrook's businesslike approach and the apparent decision to let him operate largely unfettered is the sudden shortage of detailed information on the state of work. Whereas minutes for the first half of 1778 include several hundred references to various aspects of construction those for the second half include only a couple of dozen. This makes any detailed understanding of constructional progress after June 1778 more difficult. Since there are no indications of any slowdown, if anything the reverse, and most references mention Ryeford and the Stonehouse pound it is possible Grazebrook concentrated his attention on this area for the first six months or so. At Ryeford, for example, he continued work on the culverts and altered the site of the projected Kings Stanley road bridge to make it straight with the existing river bridge. The corn pany team hauled ragg stone from Rodborough Hill for 'underbuilding' Mr Phillips' house foundations. These needed strengthening now the canal ran close to the house and an adjoining warehouse standing in the line had been removed. Edward Edge was called in to contract for Ryeford Double lock in August but his proposals were deferred and eventually left unsigned.[30]

Apart from specific orders in August that cutters should 'immediately proceed to finish … through the Church Yard without further Delay', most work now approached completion on the Stonehouse pound. The indomitable Mrs Ball got new watering places for her cattle but had to wait until the level was completed before either towpath or former brickyards were fenced. Several other canalside watering places were graded to a more even slope. As autumn came in first Ellis James' banks and later some near the churchyard itself were levelled. Even though some cutters were still working below Ryeford in November, the directors feared Edward Keene, building Mr Phillips' and Mr Cook's swing bridges, would hold up the opening. Benjamin Grazebrook told him plainly to finish his timberwork on Mr Phillips' bridge the following week 'otherwise he will not be employed any more'. Keene finished his work before the end of December. Early in January 1779 half a dozen committee members examined the Stonehouse level and ordered the water to be turned in. The long pound carrying the canal from Chippenham Platt to Ryeford was now complete.[31]

Chapter Eighteen References

1 GCRO D1180 1/1 Committee minutes 17 April 1777. 29 May 1777, 17 June 1777, 21 June 1777, 26 June 1777, 10 July 1777, 24 July 1777, 7 August 1777, 9 September 1777, 2/1 General Account 1776–94 5 July 1777, 2/10 Ledger 1775 1802 17 July 1777 It is unclear why Ellis James allowed the company to dig clay for bricks on his land bur not to cut the canal itsetf at this stage. His case against the company would normally have excluded both.

2 GCRO D1180 1/1 Committee minutes 1 August 1777, 11 September 1777, 18 September, 27 November 1777, Cl/2 Commissioners' minutes 9 September 1777, 2 October 1777, 2/10 Ledger 1775 – 1802 7 October 1777. The line of the canal at Eastington was probably kept close to the road to minimise Ellis' opposition.

3 GCRO D1180 1/1 Committee minutes 31 March 1777, 25 September 1777, 1 October 1777, 15 January 1778 – 27 August 1778, 18 June 1778, 13 August 1778 22 October 1778, 2/10 Ledger 1775–1802 4 September 1777, 20 September 1777

4 GCRO D1180 1/1 Committee minutes 30 October 1777

5 GCRO D1180 1/1 Committee minutes 31 March 1777, 26 June 1777, 10 July 1777, 24 July 1777. 21 August 1777, 28 August 1777, 11 September 1777, 15 January 1778, 5 March 1778, 16 March 1778, 9 June 1778, 21 January1779, 28 January 1779

6 GCRO D1180 1/1 Committee minutes 25 June 1778, 8/2 Measure of Mr Clark's Temporary Trespass on Madam Ball's Estate 26 September 1777

7 GCRO D1180 1/1 Committee minutes 24 July 1777, 17 August 1777, 28 August 1777, 4 September 1777, 16 October 1777, 27 November 1777, 29 December 1777, 2/1 General Account 1776–94 5 November 1776

8 GCRO D1180 1/1 Committee minutes 8 January 1778, 15 January 1778, 22 January 1778, 5 March 1778, 16 March 1778, 26 March 1778, 21 May 1778, 26 May 1778, 26 November 1778, 10 December 1778

9 GCRO D1180 1/1 Committee minutes 16 October 1777, 20 October 1777, 12 November 1777, 4 December 1777, 11 December 1777, 18 December 1777, 2/10 Ledger 1775–1802 3 December 1782

10 GCRO D1180 1/1 Committee minutes 8 January 1778, 15 January 1778, 6 April 1778, 21 May 1778, 8 October 1778, 5 November 1778, 12 November 1778, 26 November 1778, 10 December 1778, 31 December 1778, 7 January 1779, 21 January 1779, 28 January 1779

11 GCRO D1180 1/1 Committee minutes 4 September 1777, 15 January 1778, 18 June 1778, 29 June 1778, 9 July 1778, 21 July 1778, 30 July 1778 12 December 1778, 31 December 1778, 21 January 1779, 4 February 1779, 18 February 1779

12 GCRO D1180 1/1 Committee minutes 15 January 1778, 22 January 1778, 29 January 1778, 26 February 1778, 5 March 1778, 16March 1778 26 March 1778, 9 April 1778 18 June 1778, 4 February 1779, 18 February 1779, 4 March 1779, 18 March 1779, 8 April 1779, 22 April 1779

13 GCRO D1180 1/1 Committee minutes 22 January 1778, 5 April 1778

14 GCRO D11801/1 Committee minutes 12 February 1778

15 GCRO D1180 1/1 Committee minutes 11 July 1780

16 GCRO D1180 1/1 Committee minutes 5 February 1778, 12 February 1778, 19 February 1778, 26 February 1778, 5 March 1778

17 GCRO D1180 1/1 Committee minutes 18 December 1777, 29 December 1777, 8 January 1778, 15 January 1778, 22 January 1778, 29 January 1778, 12 February 1778, 26 February 1778, 5 March 1778, 16 March 1778, 1 May 1778, 25 June 1778, 27 August 1778, 10 September 1778, 12 November 1778, 26 November 1778 2/1 General Account 1776–94 5 July 1777, 2/10 Ledger 1775–1802 George Maskell no date, 2/17 Cash Book 1775–79 7 October 1777

18 GCRO D1180 1/1 Committee minutes 12 February 1778, 19 February 1778, 16 March 1778, 26 March 1778, 6 April 1778

19 GCRO D1180 1/1 Committee minutes 8 January 1778, 15 January 1778, 19 February 1778, 26 February 1778, 16 March 1778, 26 March 1778, 6 April 1778, 22 April 1778, 7 May 1778

20 GCRO D1180 1/1 Committee minutes 8 January 1778, 15 January 1778, 5 February 1778, 19 February 1778, 26 February 1778, 11 May 1778, 21 May 1778, 2 June 1778, 18 March 1779

21 GCRO D1180 1/1 Committee minutes 11 December 1777, 18 December 1777, 5 February 1778, 12 February 1778, 19 February 1778, 26 February 1778, 5 March 1778, 16 March 1778, 26 March 1778, 6 April 1778, 9 April 1778, 22 April 1778, 11 May 1778, 18 June 1778, 25 June 1778

22 GCRO D1180 1/1 Committee minutes 9 April 1778, 22 April 1778, 7 May 1778, 11 May 1778, 18 June 1778

23 GCRO D1180 1/1 Committee minutes 18 September 1777, 15 January 1778, 12 February 1778, 19

February 1778, 26 February 1778, 5 March 1778

24 GCRO D1180 1/1 Committee minutes 1 Ocober 1778, 10 December 1778

25 GCRO D1180 1/1 Committee minutes 23 May 1776, 26 June 1776, 4 July 1777, 20 November 1777, 11 December 1777, 18 December 1777, 12 February 1778, 5 March 1778, 16 March 1778, 26 March 1778, 6 April 1778, 16 April 1778, 22 April 1778, 11 May 1778, 26 May 1778, 18 June 1778, 10 December 1778, 31 December 1778, 2/10 Ledger 1775–1802 25 June 1778

26 GCRO D1180 1/1 Committee minutes 15 January 1778, 19 February 1778, 26 February 1778, 16 March 1778, 6 April 1778, 9 April 1778, 16 April 1778, 11 May 1778, 26 May 1778

27 GCRO D1180 1/1 Committee minutes 22 April 1778, 30 April 1778, 9 June 1778, 18 June 1778, 25 June 1778, 29 June 1778, 9 July 1778, 21 July 1778, 30 July 1778, 13 August 1778, 27 August 1778

28 GCRO D1180 1/1 Committee minutes 26 March 1778, 9 June 1778, 22 October 1778

29 GCRO D1180 1/1 Committee minutes 18 June 1778, 21 July 1778, 30 July 1778, 22 September 1778, 5 November 1778, 26 November 1778

30 GCRO D1180 1/1 Committee minutes 30 April 1778, 30 July 1778, 13 August 1778, 27 August 1778, 10 September 1778, 22 September 1778, 1 October 1778, 8 October 1778, 22 October 1778

31 GCRO D1180 1/1 Committee minutes 9 July 1778, 30 July 1778, 13 August 1778, 22 September 1778, 5 November 1778, 26 November 1778, 10 December 1778, 31 December 1778, 7 January 1779

Chapter Nineteen
Ryeford to Wallbridge

By the spring of 1778 most local residents confidently expected the canal to be completed before long and bring considerable benefits to the area. Some property vendors, anticipating a greater demand and enhanced values for canalside premises, described their holdings in: glowing terms. At Wallbridge three adjoining dwelling houses and a garden were advertised as 'very eligibly situated on Account of its Nearness to the New River in the lower part of the town'.[1] There were other benefits more important for local clothiers, their employees and the general population. Apart from a more regular and regular supply of fuel helped by the new form of transport less subject to the vagaries of the weather, the high coal prices which men like William Dallaway had complained of so bitterly were now beginning to fall as the cheaper water carriage at least partially replaced the cumbersome and expensive overland transport from Framilode. In August 1778 Best Shropshire and Forest coals sold for 13s 3d (66p) a ton at Chippenham Platt with the more expensive Staffordshire coal fetching 15s 0d (75p). Including carriage of 3s 6d (17½p) a ton to Stroud, arranged and probably owned by the expanding Grazebrook haulage business, this came to around 16s 9d (84p) and 18s 6d (92½p) respectively compared with the 19s 0d (95p) to £1 2s 0d (£1.10) of earlier years.[2] Despite a general rise in fuel prices, the 'best sorts of COALS' were selling at Ryeford wharf for 13s 9d (69p) a ton for Shropshire, 14s 9d (74p) for Forest and 15s 3d (76p) for Staffordshire nine months later or 16s 9d (84p), 17s 9d (89p) and 18s 3d (91p) respectively including the extra 3s 0d (15p) a ton carriage on the now shorter land carriage to Stroud.[3] And Benjamin Grazebrook's five new coal trows, capable of carrying between sixty and seventy tons each, were conveniently available to accommodate the traffic.[4]

One way or another the last year or so of construction was dominated by the Grazebrook family. The father and son partnership of Benjamin and Joseph Grazebrook, respectively resident engineer and talented clerk, carried the company successfully through the final difficulties and completed the canal to Wallbridge. Whether by accident, design, skill, force of personality, through an understandable desire to protect their investment or any combination of these factors, they came to embody the company to sue an extent that min tes of directors'meetings suddenly become curiously empty and uninformative. The immediate effect of this is that details like start dates and construction times for Ryeford Double lock, the two Dudbridge locks and many other pertinent facts are omitted completely and can only occasionally be gleaned or deduced from other sources.[5]

One of the first difficulties facing the Grazebrook team was a squabble with the company solicitors Lane and Jepson. With the original £20,000 capital already increased by an additional £10,000, the company may have attempted to cut costs like legal expenses for some months, perhaps by employing cheaper solicitors. The last straw for Lane and Jepson could have come in June 1778 when the company decided not to execute any more conveyances at all for land taken in the canal and towpath but use the receipt for payment as evidence of transfer.[6] Almost immediately the committee reported, probably as a result of a complaint from Lane and Jepson, that the firm had for some time 'declined the Business of Attorneys for the navigation, owing to them not having the whole of the Conveyancing agreeable to the Contract when first engaged.[7] Althougb the committee disputed this interpretation of their original intentions, they now agreed Lane and Jepson should be employed in the whole business of the navigation'.

The most serious problem facing the committee, however, was another shortage of capital to complete construction. The first hint of coming troubles came in September 1778 when Joseph Grazebrook, acting on specific committee instructions, wrote to all defaulters from the most recent call asking them to clear any outstanding amounts before the general meeting on 8 October.[8] This shortage of resources was probably outlined at the general meeting although Joseph Grazebrook's wages, possibly with private encouragement from his father, were still advanced to a guinea a week 'with a further gratuity at finishing the work as shall be thought requisit by the committee.'[9] The deteriorating financial position must have been discussed at subsequent committee meetings especially as it was clear the previous summer toll income of £330 0s 8d, though spent for 'the use of the navigation', was far from sufficient. Early in December Mr Lane was desired to procure counsel's opinion on whether the company could borrow money to finish the canal or to advise by their next meeting 'what Legal mode he would recommend for raising a Sum to Compleat it.'[10] When legal opinion advised the company could neither increase its capital any further without a new Act of Parliament nor give any security as a corporate body for the additional £10,000 the directors wished to raise, Joseph Grazebrook requested any absent members to make particular efforts to attend the next committee when 'Special Affairs' would be discussed.[11]

Since an application to Parliament would delay completion, probably cause a temporary cessation of work bringing additional diffi culties with which the directors were already familiar and in any case certainly dissipate some of the extra capital in administrative expenses whether it was successful or not, there was no alternative for the committee but to try and raise the cash themselves. By concentrating exclusively on essential construction work needed to get the canal to Wallbridge the directors needed to raise only £2,000 instead of the £10,000 originally envisaged. The company could then defer dividends for several years while all contracting and land purchase debts were paid, the smaller Joans were redeemed and valuable ancillary works like lock houses, warehouses and extra wharves were financed from the extra toll income a fully opened canal would bring. The detailed position was outlined to the proprietors at the general meeting on 1 April 1779. 'The Original Subscription of £20,000' the directors explained 'and the Additional Subsription of £10,000 … have together with the money Received for Tonnage been nearly laid out and expended' leaving a balance of only £830 in hand. 'And Whereas', they continued, 'the sum of £2,000 will be wanting to compleat and pedect the said Navigation which Sum the Proprietors have no power under the … Act to advance and raise on the Credit of the said Tolls', some proprietors 'in order to prevent a stop being putt to the Navigation and being desirous to have the same Speedily Compleated as well for the Public good of the County in general as of the Body of Proprietors in particular have Voluntarily proposed to subscribe the said Sum of Two Thousand Pounds for that purpose'[12]. The principle was simple enough. Although the proprietors could not provide security for others there was no such limitation on their providing it for themselves, or at least some of their number. The general body of proprietors hastened to accept the proposal 'considering the necessity and Expediency of the measure', and to indemnify the subscribing proprietors for the repayment of the loans with interest from company tolls. Thomas Baylis, William Seville, Joseph Wathen, Benjamin Grazebrook, John Hollings, Samuel Arundell, William Battersby, Richard Gabb, John Colbome, Richard Bigland, James Winchcombe, Fream Arundell, William Knight, Thomas White, John Gardner, Christopher Chambers, James Dallaway, John Butt, James Croome and Richard Aldridge each advanced £100 on this understanding. This extra £2,000 secured all existing construction work and guaranteed the completion of the canal.

While financial problems were considered construction continued on the final pounds to Wallbridge although as usual brick and masonry work were suspended during the winter. The locks and bridge William Franklin was building at Dudbridge, probably started in April 1778 using stone from nearby Rodborough Hill, were well advanced by November 1778 when Benjamin Grazebrook covered them with turf to keep out the frost.[13] Originally called 'Franklin's lock' by other contractors, the company always referred to Lower

and Upper Dudbridge locks.[14] After completing the work at Dudbridge Franklin moved to Wallbridge whe
be built a quay wall 'of good ragg stone', fifty-feet long and seven-feet deep, so trows could unload at the
now enlarged wharf dug out of Webb's ground.[15] At Ryeford the directors first paid Benjamin Lewis seven
guineas to survey the lock site in July 1778 and then prevaricated during the uncertain financial climate
of autumn and early winter. When this began to clarify by January 1779, the directors anxiously began
preparations for building the Double lock only too aware it 'would be attended with more difficulty than
the other locks' which were all single and had lower total rises. 'More than usual precautions should be
observed', the committee minuted nervously, to make it 'perfectly secure and substantial'.[16]

This hesitant response to the costly, complex but essentially simple technical problem of building a double
lock accurately reflects the whole tenor of this final period of construction during the winter of 1778–79.
Chastened by an expenditure now approaching £29,000 – already substantially above their original estimate
– by the need to raise even more capital and no doubt mindful of the effect Blunder lock had produced on
shareholder confidence, it was in marked contrast to the brash self assurance and congratulatory motions of
earlier days. At the same time it is equally important to stress that the now sober and careful members of the
committee, however buffeted by the events of the last four years, still contained men just as determined to
make sure the project succeeded. There might be a delay of over six months between the first hints of financial
troubles and the general meeting approving the loan of extra capital but the money required was raised in the
end. Whether this delay masked shareholder unrest, directorial uncertainties or simply a lack of urgency while
most construction work was suspended for the winter is unclear. What is clear is that this time there was no
thought of abandoning the project and every intention the navigation should reach Wallbridge without fail.

The directors discussed possible construction methods for Ryeford Double lock with Anthony Keck, a
local architect from Kings Stanley and member of the committee, who thought a 'very secure' plan could
be easily adopted. Keck readily agreed to assist the company, surveyed the lock site and produced detailed
sections assuring the directors 'he was certain beyond a Doubt [it] would be effectively Substantial' for
an agreed cost of £760.[17] Further information on lock construction at both Ryeford and Dudbridge is
fragmentary. RyefordDouble lock was presumably under construction by early March 1779 when Keck
received £100 on account and John White was boating building materials to the lock. During May
more bricks were transported to the site while Edge was consolidating earth around the chambers. A
month later in mid June Edge hung some lock gates though it is uncertain whether this was at Ryeford,
Dudbridge or both. William Franklin certainly continued working at Dudbridge until around 14 August
1779 – probably tidying up odd points of construction since by then the lock was already in use.[18]

Cutting, building culverts and bridges are equally poorly documented for the Ryeford to Wallbridge
pounds. Company accounts suggest James Bough and Edward Edge were the main contractors during this
period. They were certainly responsible for repairs to Westfield lock, building a lockhouse at Chippenham
Platt and a warehouse at Dudbridge, consolidating earth at Dudbridge, at least some of the brickwork in
Upper Dudbridge lock, hanging lock gates, probably at Dudbridge, the wooden culverts at Cuckold's Brook,
Lodgemore and possibly the identical Ebley culverts too, coping locks and bridges on the final pounds as well
as 'sundry' expensive but unidentified 'jobs of daywork' at least until April 1780 and possibly August 1781.[19] The
coping Bough and Edge completed early in 1779 could have included work elsewhere on the canal, perhaps at
Chippenham Platt or on the Stonehouse pound where Hanham rather than Rodborough stone was used. In
October 1778, in response to a request from John Couch for some payment on account of Hanham stone already
supplied, Joseph Grazebrook had replied that a 'great part of the Coping as well as some of the Hollow Quoins
and Square Quoins, have not been Conformable to the Bill of Scantlings, and that as soon as he Confirms to the
said Bill … his request shall be immediately comply'd with'. When the company trow next arrived at Hanham for
stone, Couch refused to load without some payment and the boatmen loaded with limestone instead.[20]

Several other contractors worked on these finaJ pounds and like Bough and Edge often worked for the company until the early 1780's completing construction, ancillary works like warehouses or on various improvements. Edward Keene and Benjamin Pashley, freelance and company carpenters, were engaged on construction work until April 1781 and October 1782 respectively. During this time they were probably mainly engaged on warehouses, Iockhouses and the like, buildings delayed until the basic objective of Wallbridge was achieved and the financial position was at least a little freer. Both worked for the company later on, in Keene's case at least into the 1790s, on a freelance repair and maintenance basis.[21] Apart from occasional cutting jobs at unspecified locations, Edward Loton continued boating bricks, stone and other building materials to the various construction sites until May 1779. Some of the materials he transported went to build a company forge, probably at Chippenham Platt.[22] Thomas Howell, the blacksmith, worked through until early 1781 when his final accounts were settled.[23] Charles Edge, the carter, and his boy assistant worked until June 1779 when the company horse, waggon and cart were sold. Charles Edge may have continued working on incidental jobs for the company for in November 1779 he was gravelling part of Dudbridge wharf.[24] A month later Franklin's final account for his work on the quay wall at Wallbridge was settled apart from two guineas deducted for unsatisfactory workmanship.[25]

The bulk of essential construction work approached completion in the spring of 1779. The contractors George Maskell and Benjamin Birch both finished cutting at Wallbridge in March although then continued on gravelling towpaths and other sundry jobs needing attention before the canal could be opened. From then until October, when he finished work, Maskell started making bricks again. Thomas Davis carried on making bricks until May 1781 although his, like Maskell's, were probably directed more towards ancillary buildings, finishing off a few bridges and the improvements at Whitminster rather than on completing the final pounds.[26] William Seal & Company continued cutting at Wallbridge until July and then stayed on to finish other minor jobs until September.[27] In August 1779, with John Gleave engaged on improvements at Whitminster millpond where the early line proved unsatisfactory, the directors advised his services would not be required after 29 September. Even so Gleave continued in the company employ until March 1780 though his wages had been reduced to 10s 6d (52½p) a week in November.[28] Perhaps Gleave's work was either unsuccessful, unsatisfactory or not progressing at sufficient speed for after John Pickston had finished cutting at Wallbridge in April 1779 and been engaged on varied unspecified day work until January 1780, he and John Lawrence worked at Whitminster millpond until October 1781.[29] Like several other contractors such as John Mower and Charles King, John Goodman and company worked for about another year after the summer of 1779 setting hedges, seeding banks, lopping trees, finishing off posts and rails for bridge approaches, boating gravel and spreading it across bridge arches and towpaths.[30] By the middle of 1780, apart from some ancillary buildings still under construction and the work at Whitminster which in any case did not hinder through traffic, the canal linking the River Severn at Framilode to Wallbridge near Stroud was complete at last.

Chapter Nineteen References

1 GJ 16 March 1778
2 GJ 17 August 1778, 5/1
3 GJ 31 May 1779
4 GJ 19 January 1778
5 GCRO D1180 6/4 Account with Mr Keck for building the Double Lock
6 GCRO D1180 1/1 Committee minutes 18 June 1778

7 GCRO D1180 1/1 Committee minutes 29 June 1778

8 GCRO D1180 1/1 Committee minutes 10 September 1778

9 GCRO D1180 1/1 Committeee minutes 8 October 1778

10 GCRO D1180 1/1 Committee minutes 10 December 1778

11 GCRO D1180 1/1 Committee minutes 31 December 1778

12 GCRO D1180 1/1 Committee minutes 1 April 1779

13 GCRO D1180 1/1 Committee minuies 18 December 1777 John Cough is reported as delivering ragg stone to Dudbridge then suggesting perhaps even earlier preparations, 5 November 1778, 26 November 1778, 2/10 Bough and Edge Bill dating from August 1777, 2/17 17 April 1778, 2 May 1778, 23 May 1778. The '1778' inscription on the bridge adjacent to Franklin 'sJock suggesis it was nearly if not wbolly completed by November 1778.

14 Franklin received £465 for the bridge and lower lock but it is uncertain whether this also included work on the upper lock. If not it seems likely Bough and Edge built the upper lock and the cost was incorporated on their general accounts.

15 GCRO D1180 1/1 Committee minutes 18 February 1779, 4 March 1779, 18 March 1779, 30 December 1779, GJ 11 January 1779

16 GCRO D1180 2/l General Account 1776–94 17 July 1778, 2/18 Cash Book 1779–88 17 July 1778

17 GCRO D1180 1/1 Committee minutes 21 January 1779, 28 January 1779, 6/4 Account with Mr Keck for building the Double Lock

18 GCRO D1180 2/1 General Account 1776–94 8 May 1779, 2/1? Cash Book 1775– 79 9 March 1779, 27 March 1779–8 May 1779, 12 June 1779, 14 August 1779, 6/4. Account with Mr Keck for building the Double Lock. Ryeford Lock completed June 1779

19 GCRO D1180 1/1 Committee minutes 5 November 1778, 7 January 1779, 28 January 1779 4 February 1779, 18 February 1779, 4 March 1779, 16 December 1779, 4 January 1780, 9 August 1781, 2/10 Ledger 1775–1802 August 1777, 4 August 1781, 2/17 Cash Book 1775–79 24 April 1779, 8 May 1779, 10 July 1779, 7 August 1779, 21 August 1779, 16 October 1779 13 November 1779, 11 December 1779, 8 January 1780, 22 January 1780.

20 GCRO D1180 1/1 Committee minutes 22 October 1778, 5 November 1778

21 GCRO D1180 1/1 Committee minutes 31 December 1778, 30 September 1779,2 December 1779, 5 April 1781, 26 April 1781, 22 December 1781, 31 January 1782, 2/10 Ledger 1775–1802 24 October 1782

22 GCRO D1180 2/10 Ledger 1775–1802 2 January 1779, 30 January 1779, 2/17 Cash Book 1775–79 8 May 1779

23 GCRO D1180 1/1 Committee minutes 29 March 1781

24 GCRO D1180 1/1 Committee minutes 10 June 1779, 17 June 1779, 25 June 1779, 2/17 Cash Book 1775–79 2 August 1777 – 26 June 1779, 10 November 1779

25 GCRO D1180 1/1 Committee minutes 30 December 1779

26 GCRO D1180 1/1 Committee minutes 13 March 1779, 27 March 1779, 30 October 1779, 18 November 1779, 2 December 1779, 2/10 Ledger 1775–1802 29 May 1779, 3 July 1779, 16 September 1779, 18 September 1779, 8 January 1780 2/17 Cash Book 1775–79 18 May 1781

27 GCRO D1180 2/17 Cash Book 1775–7910 July 1779, 4 September 1779

28 GCRO D1180 1/1 Committee minutes 19 August 1779, 18 November 1779, 30 March 1780, 5 May 1780

29 GCRO D1180 2/17 Cash Book 1775–79 24 April 1779, 5 January 1780, 5 May 1780, 4 October 1781, 2/18 Cash Book 1779–88 26 June 1779

30 GCRO D1180 1/1 Committee minutes 28 October 1779, 18 November 1779, 2 December 1779, 25 March 1780, 3 April 1780, 2/10 Ledger 1775–1802 1 January 1780, 22 April 1780, 2/17 Cash Book 1775–7927 November 1779, 3 April 1780

Chapter Twenty
'Stroudwater Triumphant'

The original £20,000 capital was spent by March 1778. At Christmas, with the canal open only to Ryeford bridge, expenditure exceeded £28,000. When the company was advised during the winter of 1778–1779 that raising additional capital from external sources was impractical, the directors decided to concentrate available resources on completing the actual canal itself to Wallbridge and to delay most other ancillary works for the moment. This priority alone seemed the only way of reaching the terminus and tapping extra toll income from the through passage of boats to Stroud. The toll income could then be used for finishing essential works like warehouses, wharves and lockhouses, settling outstanding accounts with a sizeable sprinkling of landowners and employing contractors on the dozens of minor hedging, ditching and gravelling type works which still needed attention before the navigation was truly complete.

By the spring of 1779 the committee were making their first preparations for opening the canal. Apart from a circular letter to all shareholders desiring 'their attendance at Stroud on that day' and planning a special announcement in the *Gloucester Journal*, the directors ordered a barge of pleasure from Mr Hillhouse to convey the assembled worthies down the new navigation.[1] A few weeks later perhaps tom between the conflicting needs to entertain a substantial number of these gentlemen generously and tbe parsi mony encouraged by a somewhat uncertain financial state, the directors increased the boat size to thirty five feet long and ten feet wide but fervently expressed the hope 'it will not make any material difference in the Price'.[2] In the meantime workmen built a recess for the boat in the canal bank at Lodgemore and later completed a boathouse to protect it from the weather.[3] The directors' hopes about limited expenditure do not seem to have been fulfilled. A Bill for £102 5s 0d (£102.25) from Mr Hillhouse remained unpaid at the general meeting of proprietors in March 1780 when 'some Objections were made to it' though it is uncertain whether these came from shareholders criticising directorial extravagance or from the directors themselves. Eventually after putting the boat 'in thorough repair', work possibly caused by company delay in building the boathouse and pitching the roof securely – Mr Hillhouse reluctantly accepted £94 13s 0d (£94.65) in August 1780.[4] Accidentally or deliberately, the company had received the best of both worlds; a pleasure boat for the opening in July 1779 and payment over a year later when its financial position was less insecure.

As the appointed day of Thursday 22 July approached the pleasure boat was completed and other company boats were cleaned up and fitted out for the opening. Then at the beginning of July the directors suddenly brought the opening day forward to Wednesday 21 July perhaps because final work on the Dudbrige locks was slightly ahead of schedule.[5] At the same time later company records suggest a possible ulterior motive. Ryeford lock was completed in June 1779 and 'immediately after [it] was finished Building it was perceived that the wall on the north side thereof began to give way and got from its perpendicular Direction'. Later in the autumn it 'Continued to do so from time to time untill it was gone nearly two feet from its Original place and Obstructed many vessels from passing the said Lock'.[6] Ifthe directors were aware of this at the beginning of July and remembered some of the satirical literature which had lampooned them in earlier years, they would perhaps seek to keep the details private and try

to move the date forward as far as they could to avoid the prospect of another fiasco like that at Blunder Lock. This time, especially if it was in full public view of the assembled county population, shareholder confidence might not survive.[7]

Early in July advertisements in the *Gloucester Journal* announced two special events for the opening day. From Wallbridge a 'good Band of Musick'would accompany a 'Procession on the Water' down the canal at lunchtime. In the evening there would be 'a Ball … at the Town Hall, to which every Gentleman's Ticket will introduce himself and a lady'. Ordinary citizens, on the other hand, were urged to keep on the other side of the canal and attend a 'PUBLIC BREAKFAST … on the Bowling Green at Cainscross' at 9 a.m. where the assembled crowds 'will have a favourable Opportunity of seeing the Procession on the water, and joining in that Festivity with which the Day will be celebrated'. Tea and coffee, price 1s 0d (5p) each, would be served. In contrast, tickets for a place in the flotilla and for the ball were available in advance from the George and Swan Inns for 10s 6d (52½p) where 'ordinary' tickets for a place in the towpath could also be purchased.[7]

At last Wednesday 21 July came. A little before eleven o' clock a 'respectable number of gentlemen' including Sir George Onesiphorus Paul 'ye Chairman', Sir William Guise and William Bromley Chester Esq 'Members of Parliament for ye County' and many 'principal Gentlemen and Tradesmen' honoured the gathering with their company and met the proprietors 'at a spacious tent' or 'large Booth' covered with cloth and erected specially for the purpose on the 'Pitching' or 'area before ye Market House'. At a signal from some guns assembled to celebrate the occasion, they formed a procession from there at eleven o'clock led by company clerk Joseph Grazebrook carrying a plan of the navigation. Grazebrook was followed by 'the several workmen with their different tools, the colours of the navigation, and other flags of various devices, accompanied by a band of music'. The proprietors themselves followed this band of music, flags and banners with the directors and visiting notables at the rear. The whole procession toured through different parts of the town which 'was decorated with triumphal arches and hung with cloths of various colours, that had a very pleasing effect'. Eventually the procession came to the quay at Wallbridge where they embarked on the new horse drawn pleasure boat, bedecked with a 'Genteel present of flaggs' presented by Ralph and Richard Bigland of Frocester, and other decorated company craft. They proceeded through the first two locks at Dudbridge to Ebley Mill where they met three laden barges 'freighted with Coal, Wooll, Salt and other goods'. These vessels accompanied the party back to Wallbridge 'amidst the acclamations of thousands assembled upon the occasion, who expressed the greatest satisfaction at the completion of a work, which does honour to the county'. As the first trow moored up in Wallbridge basin a whole ox, which had been roasted at the quay head 'for ye Populace' was cut up and shared out among the waiting crowds.[8]

Three eye witness accounts relate the main events of the opening day but only Benjamin Harman mentions it was a 'feary raine day'. No one who has left us any records seems to have noticed whether or not the directors showed any particular concern at the inclement weather or gave any sign of their financial worries over a navigation which had already cost them over £31,895 and was to cost them a good deal more before it was finally completed. In private the directors were probably concerned about some outstanding Bills for land, the general shortage of essential ancillary facilities like warehouses and perhaps the latest disturbing news on the condition of Ryeford Double Lock. In public they dined happily 'with great Festivity and Harmony' alongside their guests in the spacious marquee specially erected for the opening day. The dinner was no doubt concluded with speeches and congratulations possibly including the 'Cause and Nature' of how the original canal proposals had developed with a 'short descant upon the general advantage of inland Navigations' which the far sighted William Dallaway had penned over half a decade ago.[9] As the party made its way towards the town hall for the rest of the evening entertainment

the committee of directors could take comfort from their achievement. Whatever the future might bring they had something to look back on with pride. They and their predecessors had fought hard for a canal to bring coal cheaply and easily to their woollen mills in the now bustling neighbourhood of Stroud. Through fifty years, three acts of Parliament, four unsuccessful attempts, a school of engineers and all the worries and troubles of soaring construction costs and financial shortages they had finally brought their canal to Stroud. The new navigation from the River Severn at Framilode to Wallbridge was open at last. Tomorrow was time enough to think of the Bills. The future for the canal, for Stroud, even for England embroiled now in the middle of the American War of Independence was always uncertain. And that, as they say, is another story.

Chapter Twenty References

1 GCRO D1180 1/1 Committee minutes 1 April 1779, 2/1 General Account 1776 – 94 no date, 2/18 Cash Book 1779–88 no date
2 GCRO D1180 1/1 Committee minutes 13 May 1779
3 GCRO D1180 1/1 Committee minutes 22 April 1779, 22 June 1779
4 GCRO D1180 1/1 Committee minutes 2 March 1780, 30 March 1780, 13April 1780, 8 June 1780, 1 August 1780
5 GCRO D1180 1/1 Committee minutes 17 June 1779, 1 July 1779
6 GCRO D1180 6/4 Account with Mr Keck for building the Double Lock
7 GJ 12 July 1779, 19 July 1779
8 GCRO D1180 1/1 Committee minutes 26 July 1779, 12 October 1779 P320 IN 1/6 Note of opening in Register of Marriages 1837–5S, GJ 26 July 1779
9 GCRO D1180 5/1 Hints for the Opening, Notebook in Stroud Museum reading 'The New River Broght hup to Stroud July the twentey frst 21 1779. A ole ox rosted upon the cay head at Stroud as the fust trow Corn up and it tws a feary raine day Beagman Harman his book 1779 your humble servant strutingStroud' 'Strutting Stroud' is part of the local rhyme 'Beggarly Bisley, Painswick Proud, Mincing Hampton, Strutting Stroud

Chapter Twenty-One

Restoration, Retrospective and Prospective

We are in a new canal age. The last fifty years have seen an astonishing change in both public and political perceptions of inland waterways. Restoration is no longer some lunatic ideal but one accepted as obvious and desirable by the man or woman in the street. If you need any proof of this go to the centre of Birmingham or Leeds where the new developments of pubs, nightclubs and restaurants face the canal not back on to it. Properties facing the canal fetch a premium of around 20 per cent compared with identical properties that do not.

Money has not really been a problem. The costs of restoration escalate with health and safety requirements and the greater difficulty of later canal schemes. At the same time we have had Manpower Services, Heritage Lottery, Regional Development Agencies, European Union money and others. The ease of accessing money has waxed and waned. Nevertheless I remain to hear of any well-managed, well-respected, well-planned scheme held up for lack of money. Of course schemes need to fight for money and progress here can be maddeningly slow. But it is progress even so.

So what has been achieved?

First-generation restorations like the Kennet & Avon Canal have been completed. Here the entire track remained in the same ownership and each obstacle was manageable with engineering solutions. Even the formidable Caen Hill flight of locks at Devizes is only one lock to restore twenty-nine times. Given that, and given money from Heritage Lottery, the restoration was simple and straightforward when compared to later schemes.

The second generation of restorations was more difficult. Schemes like the Forth & Clyde, Union, Rochdale and Huddersfield Narrow Canal had the benefit of essentially single ownership (apart from the Falkirk flight of locks) and the disadvantage of major obstacles. In the case of the Rochdale Canal, this involved moving a supermarket, repositioning a motorway and nearly two miles of concrete infill. The Huddersfield Canal had Standedge Tunnel and the Bates factory. Nevertheless, given access to funding and engineering expertise, solutions were found and restorations completed. The Montgomery Canal is also in this category and restoration proceeds – slowly, but the important fact is that it does proceed.

The third generation of schemes is with us now. Restorations like the Cotswold Canals have part of the track intact and part of it lost. Part is held in one ownership (The Company of Proprietors of the Stroudwater Navigation) and part (mostly the Thames & Severn eastern side) is in multiple ownership. So the issues to be resolved include repurchasing and rebuilding lost sections of canal. Here again £25 million sourced from Heritage Lottery funds, Regional Development Agency and others is now restoring the canals from Stonehouse on the Stroudwater Canal to Brimscombe on the Thames & Severn. The next objective will be to restore the Stroudwater Canal from Saul to Stonehouse, thereby linking the canals to the national network.

The fourth generation of restorations is also with us. Examples include the Wey & Arun and the Herefordshire & Gloucestershire canals. Here there are issues of both tracks which are not intact and multiple ownership. This is not entirely true for the Ledbury to Hereford length of the Herefordshire & Gloucestershire but the essential problems of reassembling land ownership remain. Despite these

substantial issues, restoration in both cases proceeds with impressive expertise and achievement. Big money has not arrived yet though the Wey & Arun Canal Trust in particular are skilled at raising eye-watering sums of money from volunteers and other sources.

What could happen as these schemes approach completion? I suspect that the fifth generation of restorations will follow. This could include restoration and completion (for some were not completed) of the Kington, Leominster & Stourport; the Chard; the Dorset & Somerset; the Bude; and other canals. Here there are formidable obstacles – virtually no track, multiple ownership. Yet even here each obstacle could be solvable with expertise and money. The Bude Canal has a restoration trust and an active members society. The others, including the Salisbury & Southampton Canal and the Itchen Navigation, do not.

Is there a sixth generation to come? I suspect there is. These are most likely to be new canals linking existing destination waterways that are connected with the national system at only one end. So we may see new canals linking the Oakham and Stamford, the Grantham and Sleaford, the Cambridge to Lee and Stamford, the Broads and the eastern waterways, Gloucester & Berkeley Canal to Bristol, Cromford to Chesterfield and (via the Peak Forest Tramroad) to Whaley Bridge in the Peak Forest, Ashby to the Trent and Mersey and/or to the Charnwood Forest, Keilder Water to Ripon, Newtown on the Montgomery to the Kington, Leominster & Stourport, Herefordshire & Gloucestershire Canal at Hereford to Brecon on the Brecon & Abergavenny Canal and others.

Is this impractical? Go back, I ask you, and remember the totally impractical, enormously difficult and expensive, pointless proposals to restore the Kennet & Avon Canal in the 1950s. We have made the future in the form we wanted. The fact that there are first and second generations of schemes completed and third and fourth generations taking place speaks for itself. If you do not believe this is possible, you need to explain why we can put men on the Moon but not restore the fifth and build the sixth generation.

M. A. Handford
May 2012

Appendix
Guide to Appendix

1/1, 1/2 first and second volumes of committee minutes
Cl/1, Cl/2 first and second volumes of commissioners' minutes
2/1 'General Account of moneys expended in making the Navigation of Stroudwater'
1776–94
2/10 Ledger 1775–1802
2/17 Cash Book 1775–79
2/18 Cash Book 1779–88
8/2 Documents as listed under relevant names in chapters thirteen and fourteen
PRO Q/RD 1/1–9 Gloucester Quarter Sessions
All documents from Gloucestershire County Record Office unless otherwise stated. Full details of the abbreviated references in the index are found under the names of the same individuals in the references for chapters thirteen and fourteen.

Land Purchase Costs

Name	Date	Price/Acre	Type	Total	Running total	References/Comments
Robert George Dobyns-Yate						Land bought by John Purnell before Co. purchase completed
John Purnell	16.5.76	66.67		52.50	52.50	1/1 11 April 1776 – 23 May 1776, 11 January 1776, 29 March 1775 – 20 April 1775, 10 February 1783: 2/1 20 May 1776, 6 February 1783: 2/17 20 May 1776, 6 February 1783: Cl/1 9 May 1776: 8/2

Richard Aldridge	27.7.75			150.00 226.75	202.50 429.25	These two payments may duplicate each other. It is possible they include the £60 compensation due to Mrs. Wilding for her house. Neither payment is listed by the Company, possibly because Co. shares may have been provided in lieu 9 May 1775 – 27 May 1775: 1/124 May 1775: 8/2
Elizabeth Partridge	29.3.75	59.50	Pasture	82.00	511.25	1/1 29 March 1775, 11 January 1776: 2/17 23 May 1776, 24 May 1776: 8/2
Richard Hall	9.3.75	20.00	Arable	3.25	514.50	1/15 July 1775, 9 March 1775: 2/1 27 December 1777: 8/2
Samuel Walbank	9.3.75	20.00	Arable	11.40	525.90	1/19 March 1775: 2/18 20 November 1779: 8/2
John Saunders	29.3.75	20.00 35.00 59.50	Arable Arable Pasture	(63.85	589.75	1/1 29 March 1775: 2/17 24 June 1775:2/18 24 May 1775: 2/10 15 April 1782: 8/2
Benjamin Watkins	21.6.75	20.00	Arable			Included with John Saunders 8/2
Rev. Mr Prosser	21.6.75					Possibly included with John Saunders 8/2 1/1 21 June 1775
Rev. Henry Davis	12.6.76	59/50	Pasture	127.25	717.00	1/1 25 September 1777, 21 September 1779: 2/1 12 June 1776, 10 December 1777: 8/2: 2/17 12 June 1776, 10 December 1777
Ann Morse	29.3.75	20.00 59.50	Arable Pasture	28.40	745.40	1/1 29 March 1775: 2/10 24 June 1775: 8/2
Phillipa Grove/ Eliz. Heathcote	24.5.75					Possibly included with Richard Clutterbuck 8/2 17 November 1775: 1/1 9 March 1775, 24 May 1775, 23 May 1776

Richard Clutterbuck				17.50	762.90	D149: E65
James Clutterbuck	15.1.76	60.00 20.00	Pasture Arable	77.50	840.40	1/19 March 1775, 29 May1777, 26 June 1777, 10 July 1777, 24 July 1777, 11 October 1781, 17 February 1780: 2/10 15 January 1776, 22 Febrary 1780, 20 November 1781: 8/2 says land cost £118–0–2¾
Richard Cambridge	29.3.75 27.5.79	59.50 35.00	Pasture Arable	461.81	1302.1	1/1 2 February 1775 – 9 May 1776, 13 May 1779 – 27 May 1779: 8/2 21 August 1778: 2/10 30 March 1780, 14 April 1780, 13 June 1780, 27 October 1781, 21 August 1778
Richard Martin	15.2.77	59.50	Pasture	102.99	1405.20	1/1 29 March 1775, 21 June 1775: 2/1 15 February 1777, 20 September 1777: 2/10 15 February 1777, 20 September 1777: 2/17 15 February 1777, 20 September 1777: 8/2
Lord Middleton/ Colston A.	16.5.76					1/1 11 April 1776 – 15 May 1777: 8/1 14 May 1776: 8/2 13 May 1777, 27 May 1777
John Smith/ Ann Hort	22.12.76	59.50	Pasture	28.87½	1434.07½	1/1 12 October 1776 – 6 February 1777: 2/1 29 January 1777: 2/17 29 January 1777: Bristol R.O AC/WO 14 24 (c): 8/2
John Ford						8/2 No record of any payment
Edmund Phillips	26.8.77			55.12½	1489.20	1/ 17 November 1776, 21 August1777 – 18 September 1777, 4 December 1777 – 18 December 1777: 2/1 3 April 1778: 2/17 3 April 1778: 8/2 21 August 1777, 9 November 1777: D149 EY26 August 1777

Dudley Baxter	29.11.76	50.00 25.00	Pasture Arable	225.31	1714.51	1/1 3 October 1776 – 12 December 1776, 8 April 1779– 4 January 1780; 8/129 March 1775: 8/2: 2/10
Nathaniel Stephens	6.11.77					1/1 25 September 1777 –9 June 1778: 2/1 11 December 1777, 9 July 1778: 2/17 11 December 1777, 9 July 1778: 8/2 Probably included in Rev. Robert Stephens
Richard Stephens	6.11.77	43.75 105.00 60.00 70.00	Arable Orchard Pasture Pasture	52.76	1767.27	1/1 30 October 1777, 6 November 1777: 8/2 C1/2 6 November 1777: 2/1 14 October 1778: 2/17 14 October 1778: 2/10 February 1779
Ellis James	31.3.77	59.50	Pasture	342.86	2110.13	1/1 6 March 1777 – 31 March 1777, 9 July 1778 – 22 April 1779: 6/3 4 July 1782: 2/10 31 March 1777 – 2 September 1778: 6/3 2 October 1777: C1/2 2 October 1777, 9 September 1779, 4 Jul 1782: 2/17 31 March 1777 – 2 September 1778
Rev. Robt. Stephens	22.8.76	70.00		241.50	2351.63	1/1 22 August 1776– 29 August 1776:2/10 8 December 1777: 8/2 2/17 29 August 1776, 11 December 1777, 8 July 1778: 8/1
Samuel Beard						Possibly included with Henry Eycott
Henry Eycott	7.5.78			11.80	2363.43	5/1 18 November 1775: 1/1 7 May 1778: 8/1: 2/17 May 1778: 8/2: 2/17 7 May 1778
Rev. John Pettat	9.7.78			43.35	2406.78	1/1 26 February 1778 – 13 August 1778: 2/1 9 July 1778, 13 August 1778: 2/17 9 July 1778, 13 August 1778: 1/1 8 October 1778: 8/2 8 October 1778: 1/1 12 October 1779

Mary Ball	20.3.77	57.00		395.08	2801.86	1/16 March 1777 – 24 October 1780:2/1 8 March 1777 – 17 June 1777: 2/10: 2/1 21 October 1780: 8/3 4 July 1778: 2/17 8 March 1777 – 17 June 1777: 2/18 21 October1780: 8/2
Gabriel Harris	12.9.77	35.00	Arable	6.12½	2807.98½	1/1 11 September 1777 – 18September 1777: 2/1 12 September 1777: 2/10 12 September 1777 :2/17 12 September 1777 :2/18 12 September 1777: 8/2
Daniel Smith	9.9.77	35.00	Arable	14.62½	2822.61	1/1 11 September 1777: 2/1 9 September 1777 –4 May 1792:2/17 9 September 1777, 4 May 1792:½ 4 June 1787, 5 December 1791: 2/10 9 September 1777, 4 May 1792: 8/2
Ambrose Redall	8.11.77	105.00 35.00	Orchard Arable	254.40	3077.01	1/1 27 November 1777 – 5 March 1778: 1/2 6 November 1777: 8/: 2/17 15 December 1777: 2/11 5 December 1777
Halliday Phillips	9.9.79	87.50	Orchard	227.05	3304.06	1/1 21 August 1777 – 8 January 1778, 17 June 1779 – 16 May 1782: 8/1:Cl/2 9 September 1779: 8/2 26 December 1777: 2/1 29 August 1780: 2/1 18 May 1782: 2/18 18 May 1782: 2/10 29 August 1780
John Andrews	5.11.77	87.00	Pasture	200.95	3505.01	1/1 28 August 1777 – 7 May 1778: Cl/2 6 November 1777: 2/115 95.00 for extra December 1777: 2/17 15 December 1777 land
Richard Pettat	30.10.77			128.00	3633.01	1/1 16 October 1777 – 8 January 1778 2/1 8 January 1778: 2/17 8 January 1778: 8/2

Name	Date	Amount	Type	Acreage	Total	Notes
William Knight		52.50				½ says Richard Pettat (for Wm. Knight has met committee – will pay £45–10.0 for remaining part of Little Harry's acre but does not say whether Pettat pays the committee or the committee pays Pettat. Sale of surplus lands to Pettat seems possible. 1/1 16 October 1777 – 8 April 1782: 1/28 Janu ary 1784 – 4 June 1787: 8/2 Samuel Remington 14.10.79 87.00 Orchard 8.15 3641.16 1/1 14 October 1779, 20 January 1779 2/10 3 June 1779, 7 July 1779: 8/2 14 October 1779
Samuel Remington	14.10.79	87.00	Orchard	8.15	3641.16	1/1 14 October 1779, 20 January 1779 2/10 3 June 1779, 7 July 1779: 8/2 14 October 1779
Christian Ellis	16.10.77	80.00 87.50	Orchard Garden	116.05	3757.21	1/1 16 October 1777 – 6 May 1779: 8/2: 2/17 14 October 1777, 30 January 1779, 21 February 1780: 2/10 24 October 1778: 2/1 14 October 1777, 30 January 1779, 21 February 1780
G.A. Selwyn/ Corp of Gloucester	30.4.78	122.50 87.50	Orchard Pasture	259.87½	3917.08½	1/1 5 November 1777 – 26 February 1882 – 9 January 1784: 2/18 27 February 1782 – 9 January 1784:½ 8 January 1784, 19 February 1784
John Morley	6.11.77	52.50 70.00 60.00	Pasture Pasture Pasture	131.60	4048.68½	20 November 1783 – 21 May 1794: Cl/2 6 November 1777, 7 May 1787: P.R.O. Q/RD 1/1–9 8/2: 8/1: 2/1 6 April 1781 – 3 September 1794: 2/18 6 April 1781 – 3 September 1794
John Butcher	9.9.79	105.00	Orchard	15.00	4063.68½	1/1 28 October 1779: Cl/2 9 September 1779: 8/2 2/1 6 June 1781: 2/18 6 June 1781

Daniel Chance	6.11.77 30.4.78	186.67 105.00 70.00 193.50 87.50	Orchard Pasture Orchard Pasture Pasture	443.81	4507.49½	26 August 1783 Cl/2 6 November 1777 2/17 11 May 1778 2/10 11 May 1778 – 26 August 1783: 2/1 8 January 1780, 26 August 1883
Henry Wyatt	6.11.77	52.50 70.00	Pasture	17.06	4524.55½	1/1 16 October 1777 – 2 March 1780 2/10 20 October 1777, 3 December 1782: Cl/2 6 November 1777: 2/1 3 December 1782
Ann James	20.10.77	52.00 35.00	Pasture Arable	13.78	4537.73½	1/1 16 October 1777 – 13 September 1781: 2/1 20 October 1777, 9 February 1780: 2/10 20 October 1777, 26 September 1781, 2/17 20 October 1777: Cl/2 6 November 1777
Nathaniel Beard						8/2: No record of any payment
Richard Cook		87.50		120.00	4657.73½	1/1 16 October 1777 –17 February 1780: 2/18: 2/1017 February 1780: 2/1 17 February 1780: 8/2
John Webb	7.1.77		Pasture	623.50	5281.23½	8/2 1/1 12 December 1776 – 13 May 1779: 2/10 14 January 1777, 8 June 1778, 22 May 1779, 10 July 1779, 3 April 1780: 2/1 14 January 1777, 8 June 1778, 22 May 1779, 10 July 1779, 3 April 1780: 2/18 10 July 1780, 3 April 1780: 2/17 14 January 1777, 8 June 1778,
Mr. Loyde	8.7.79	100.00	Garden	1.72	5282.95½	1/1 1 July 1779 – 15 July 1779: 2/18 12 July 1779

| Mr. Playne | 17.6.79 | 100.00? | Garden | 11.19 | 5294.14½ | 1/1 10 June 1779 17 June 1779: 2/10 16 August 1779–23 August 1779: 2/18 31 August 1779. This includes a Bill for £4.89 from Wm. Franklin & Co. 'for wheeling stone for Mr. Playne's wall etc'. |
| Samuel Peach | | 54.75 | | 271.04 | 5565.18½ | 1/1 26 March 1778 – 29 June 1778: 2/12June1786: 8/2: 1/2 15 May 1786 – 5 October 1786: 2/18 2 June 1786. Total Land Purchase Costs Approx. £5565.18½ |

Complicating Factors

	Total	Running total	Comments
1. *Sales and Repurchases* Samuel Reamington	87.00	5478.18½	Deduct
2. *Reversionary Rights* Mrs Phelps?	25.92	5504.10½	
3. *Payments or Services in Lieu* Samuel Peach for abridge	40.00	5544.10½	
4. *Interest* G. A. Selwyn/ Corp. of Gloucester			
Halliday Phillips	49.22	5593.32½	
John Mosley	59.06	5652.38½	For interest and damages
Mrs Ball	94.94	5747.32½	
Dudley Baxter	19.25	5766.57½	
Henry Wyatt	8.80	5775.37½	
Thos. Cooper	4.25	5779.62½	
Mrs Phillips	105.89	5885.51½	
Daniel Chance	61.16	5946.67½	
	25.38	5972.05½	

5. *Rents*			
Richard Cook	12.60	5984.65½	
James Clutterbuck	12.12½	5996.78	
Daniel Chance	0.17½	5996.95½	
John Saunders	11.25	6008.20½	
John/Saml Webb	29.60	6037.80½	
6. *Tenants Compensation*		6043.93	
Mrs Hannah White	6.12½		
7. *Loss of Tangible Assets*			
Mr Phillips	7.75	6051.68	
Richard Cook	50.00	6101.68	
Richard Cambridge	39.50	6141.18	
Ann Morse	2.10	6143.28	
Edmund Phillips	11.87	6155.15	
Saml. Remington	0.80	6155.95	
Daniel Chance	3.70	6159.65	
Mrs Wilding	60.00	6219.65	
8. *Damages*			
Daniel Chance	6.00	6225.65	
John Morley	3.90	6229.55	
Rev. Robt. Stephens	34.54	6264.09	
Mrs Ewan	2.10	6266.19	
Rev. Henry Davies	1.05	6267.24	
Richard Stephens	9.85	6277.09	
Richard Martin	28.81	6305.90	
John Saunders/Ann Morse	14.85	6320.75	
John Purnell	4.17	6324.92	
Christian Ellis	74.97½	6399.89½	land and damages
Henry Stephens	80.45	6480.34½	
Wm. Young (for Saml. Peach?)	8.37½	6488.72	
Halliday Phillips	1.00	6489.72	
William Halliday	3.10	6492.72	
Mrs Ann James	4.00	6496.82	
John Saunders	4.57½	6501.39½	
John Mosley	5.75	6507.14½	
James Clutterbuck	14.50	6521.64½	
Mary Ball	44.29	6565.93½	
Daniel Chance	23.65	6589.58½	
Ellis James	98.15	6688.53½	

9. *Legal Costs*			
Mr Vizard	4.41	6695.94½	
John Skinner Stock	135.13	6828.07½	
John Colbourne	48.17½	6876.25	
Lane & Jepson	489.17½		
Lane & Jepson	489.56	7365.81	
John Webb	16.60	7382.41	
Lane & Jepson	11.40	7371.01	Deduct
	66.65	7304.36	Deduct
	70.00	7234.36	Deduct
	21.52½	7212.83½	Deduct
10. *Taxes and Tythes*			
Poor Rates	16.57	7229.40½	
Land Tax/Highway	7.67½	7237.08	
Tythes	29.96	7267.04	
Total Cost		7267.04	
Ancillaries		1701.85½	
Land		5565.18½	